D0119734

WITHDRAWN

The Education of the Filmmaker in Europe, Australia, and Asia

GLOBAL CINEMA

Edited by Katarzyna Marciniak, Anikó Imre, and Áine O'Healy

The **Global Cinema** series publishes innovative scholarship on the transnational themes, industries, economies, and aesthetic elements that increasingly connect cinemas around the world. It promotes theoretically transformative and politically challenging projects that rethink film studies from cross-cultural, comparative perspectives, bringing into focus forms of cinematic production that resist nationalist or hegemonic frameworks. Rather than aiming at comprehensive geographical coverage, it foregrounds transnational interconnections in the production, distribution, exhibition, study, and teaching of film. Dedicated to global aspects of cinema, this pioneering series combines original perspectives and new methodological paths with accessibility and coverage. Both "global" and "cinema" remain open to a range of approaches and interpretations, new and traditional. Books published in the series sustain a specific concern with the medium of cinema but do not defensively protect the boundaries of film studies, recognizing that film exists in a converging media environment. The series emphasizes an historically expanded rather than an exclusively presentist notion of globalization; it is mindful of repositioning "the global" away from a US-centric/Eurocentric grid, and remains critical of celebratory notions of "globalizing film studies."

Katarzyna Marciniak is a professor of Transnational Studies in the English Department at Ohio University.

Anikó Imre is an associate professor of Critical Studies in the School of Cinematic Arts at the University of Southern California.

Áine O'Healy is a professor of Modern Languages and Literatures at Loyola Marymount University.

Published by Palgrave Macmillan:

Prismatic Media, Transnational Circuits: Feminism in a Globalized Present
By Krista Geneviève Lynes

Transnational Stardom: International Celebrity in Film and Popular Culture
Edited by Russell Meeuf and Raphael Raphael

Silencing Cinema: Film Censorship around the World
Edited by Daniel Biltereyst and Roel Vande Winkel

The Education of the Filmmaker in Europe, Australia, and Asia
Edited by Mette Hjort

The Education of the Filmmaker in Africa, the Middle East, and the Americas (forthcoming)
Edited by Mette Hjort

The Education of the Filmmaker in Europe, Australia, and Asia

Edited by Mette Hjort

THE EDUCATION OF THE FILMMAKER IN EUROPE, AUSTRALIA, AND ASIA
Copyright © Mette Hjort, 2013

First published in 2013 by
PALGRAVE MACMILLAN®
in the United States—a division of St. Martin's Press LLC,
175 Fifth Avenue, New York, NY 10010.

Where this book is distributed in the UK, Europe and the rest of the World,
this is by Palgrave Macmillan, a division of Macmillan Publishers Limited,
registered in England, company number 785998, of Houndmills, Basingstoke,
Hampshire RG21 6XS.

Palgrave Macmillan is the global academic imprint of the above companies
and has companies and representatives throughout the world.

Palgrave® and Macmillan® are registered trademarks in the United States, the
United Kingdom, Europe and other countries.

ISBN: 978–0–230–34143–2

Library of Congress Cataloging-in-Publication Data

The education of the filmmaker in Europe, Australia, and
 Asia / edited by Mette Hjort.
 pages cm. — (Global cinema)
 ISBN 978–0–230–34143–2 (alk. paper)
 1. Motion pictures—Production and direction—Study and
 teaching—Europe. 2. Motion pictures—Production and
 direction—Study and teaching—Australia. 3. Motion pictures—
 Production and direction—Study and teaching—Asia.
 I. Hjort, Mette, editor of compilation.
 PN1993.8.E85E38 2013
 791.4302′3071—dc23 2012049146

A catalogue record of the book is available from the British Library.

Design by Integra Software Services

First edition: July 2013

10 9 8 7 6 5 4 3 2 1

For Tammy Cheung and Vincent Chui

Contents

List of Figures

Acknowledgments

Lingnan University established a Centre for Cinema Studies (CCS) in 2011 and generously offered to bring the scholars involved in the two-book "Education of the Filmmaker" Project to Hong Kong for discussions of their ongoing research. The opportunity to have contributors share their early findings at what became the CCS's inaugural conference helped to bring central issues into clear focus and to create a strong sense of shared purpose, all of which is reflected, I believe, in the chapters. I am deeply grateful to Lingnan President Yuk-Shee Chan and Vice-President Jesús Seade for their generous support for Cinema Studies more generally, and for research on practice-based film education specifically. Wendy Lai from the Human Resources Office dealt effectively with unexpected visa requirements. CCS colleagues Meaghan Morris, Mary Wong, John Erni, and Red Chan helped to make the discussions in Hong Kong fruitful. New media artist Zoie So brought talent to various design issues, while Hong Kong artist Chow Chun-fai kindly allowed images of his paintings based on scenes from well-known Hong Kong films to be featured on the CCS website, as well as on the poster and banner for the "Education of the Filmmaker" conference. Felix Tsang Chun Wing, senior research assistant to the CCS, provided consistently gracious and efficient help at all stages of the project. Student volunteers from across the Faculty of Arts—Kara Chan, Felicity Chau, Emily Choi, Terence Choi, Amis Kwok, Lilian Ngan, Law Kwun Kit, and Sally Lau—deserve thanks for their help and for being utterly dependable, and so genuinely committed to the project.

CCS Advisory Board member Stephen Teo (Head of the Broadcast and Cinema Studies Division at Nanyang Technological University in Singapore) made being at the inaugural conference a priority, for which I am truly grateful. Carving out time from punishing Hong Kong schedules, critics, researchers, filmmakers, and festival organizers from across Hong Kong moderated sessions and contributed to a concluding round table discussion. These figures are as follows: Xavier Tam (Vice Chairperson [hearing], The Second Hong Kong Deaf Film Festival), Law Kar (Hong Kong Film Archive), Tammy Cheung (filmmaker and Founding Director, Chinese Documentary Film Festival), Teresa Kwong (Director of ifva—Incubator for Film and Visual Media in Asia), Wong Ain-ling (film critic and researcher), Jessica Yeung Wai Yee (actress, translator, and scholar at Hong Kong Baptist University), Esther M.K. Cheung (Chairperson, Comparative Literature, Hong Kong University), Camille Desprez (Academy of Film, Hong Kong Baptist University), and Emilie Yeh (Director, Centre for Media and Communication Research,

Hong Kong Baptist University). The support of CCS members Cheung Tit-leung, Mike Ingham, Li Bo, and Paisley Livingston is also gratefully acknowledged.

I am grateful to Katarzyna Marciniak, Anikó Imre, and Áine O'Healy, editors for Palgrave's Global Cinema series, for having thought to approach me, and for having immediately taken a keen interest in what I had to propose. Robyn Curtis, Samantha Hasey, and Desiree Browne, all at Palgrave Macmillan, have been supportive throughout. Their willingness to accommodate a two-book project made it possible to solicit more in-depth case studies and from a much wider range of contexts. The contributors to *The Education of the Filmmaker in Europe, Australia, and Asia* and *The Education of the Filmmaker in Africa, the Middle East, and the Americas* deserve special thanks for having been a delight to work with and for having written so compellingly on the models and values driving practice-based film education around the world.

The Education of the Filmmaker in Europe, Australia, and Asia is dedicated to filmmakers Tammy Cheung and Vincent Chui, whose efforts to develop the independent filmmaking milieu in Hong Kong, also through film education, have been tireless.

Introduction: More Than Film School—Why the Full Spectrum of Practice-Based Film Education Warrants Attention

Mette Hjort

Adapting Simone de Beauvoir's well-known phrase, one is not born a filmmaker, but becomes one.[1] To ask about the nature of practice-based film education as it has emerged around the globe and exists today is to begin to understand how filmmakers become filmmakers. Inquiry along these lines sheds light on the process of becoming not only a filmmaker, but also a particular *kind* of filmmaker, where "kind" encompasses skills, as well as narrative and aesthetic priorities, preferred modes of practice, and understandings of what the ideal roles and *contributions* of film would be.

A few suggestive anecdotes from the field of film practice help to set the stage for a more scholarly account of the questions, commitments, and aspirations that are behind *The Education of the Filmmaker in Europe, Australia, and Asia* (vol. 1) and *The Education of the Filmmaker in Africa, the Middle East, and the Americas* (vol. 2). Evoking both a desire to make meaningful, authentic choices and questions having to do with what counts as a genuine justification for the costs of filmmaking (in terms of money, effort, and time), Danish director Lone Scherfig reflects as follows on the process of selecting her next script from among an array of possible choices: "I'm quite marked by an experience that I've had twice, uncannily. My father died while I was shooting *Italian for Beginners* and my mother died while I was shooting *An Education*. When I watch these films I can't help but ask myself whether they were worth it. When you start to look at the whole filmmaking process with those eyes, there are really a lot of scripts that life is simply too short for."[2]

In an exchange about *The Video Diary of Ricardo Lopez* (2000), documentary filmmaker Sami Saif—who, like Scherfig, is a graduate of the National Film School of Denmark—foregrounds his commitment to taking his responsibilities as a filmmaker seriously. Saif's film is based on Lopez's webcam recordings, which had been sensationalized by the media, inasmuch as they captured his suicide

shortly after having mailed a bomb to Icelandic singer Björk, with whom he was obsessed. In response to a question as to why *The Video Diary of Ricardo Lopez* remains difficult to get hold of, and why the filmmaker prefers to be present when audiences watch the film, Saif says: "I have a lot at stake in being able to stand by what I've done with the material. I want to be able to explain why I edited it the way I did, why I saw it as important to make the film, and how I understand Ricardo Lopez. My desire to engage very directly with the audiences who see the film also has to do with the fact that Ricardo Lopez is dead. [...] I want to be there when people see the film, because there are all sorts of things about Ricardo Lopez on the internet. I like to be able to talk to people about what it is they've actually seen."[3]

One last anecdote, this one referring to developments in Hong Kong, on the Chinese mainland, and in South Korea, suffices to draw attention to filmmakers as agents of moral deliberation with significant choices to make that extend well beyond the punctual craft-based decisions required by any given filmmaking project. The year 2012 saw the well-known sixth-generation Chinese filmmaker Jia Zhangke "installed as the dean of the Busan International Film Festival's Asian Film Academy (AFA)." Called on to describe the experience of working with 23 young filmmakers in workshops and seminars spanning 18 days, Jia spoke of his commitment to "mak[ing] honest films and films that will make people think." Jia sees his values as reflected not only in his films, but also in his efforts to mentor young filmmakers through his company, Xstream Pictures. His ongoing efforts to establish a funding program called the Renaissance Foundation, in Hong Kong, in collaboration with "fellow filmmaker Pang Ho-cheung, author Han Han, and musician Anthony Wong Yiu-ming," are similarly an expression of an understanding of the film practitioner as an agent of moral choice. As Jia puts it, "It is all about giving young artists the freedom to create. Through that comes honesty—and artists should be honest."[4]

Over time, what emerges through filmmakers' professionally relevant and publicly available actions—by no means limited to the actual making of films—are patterns of choice that are indicative of certain values and thus amenable to assessment in broadly ethical terms. That is, filmmakers have decisions to make not only about whether a given story (if the film is a narrative one) is really worth telling and warrants the time, cost, and effort needed to articulate it in moving images, but also about how to treat the actors and other practitioners with whom they work, about the environmental costs of their filmmaking practices, the possible ideological implications of their work, and the terms in which they choose to discourse about it. Examples of filmmakers having made poor choices are not at all difficult to find. Titles that come to mind include Danny Boyle's *The Beach* (2000), James Cameron's *Titanic* (1997), and fifth-generation Chinese filmmaker Chen Kaige's *The Promise* (2005), all three of them for reasons having to do with a failure to take the environmental duties of filmmakers seriously. Duties, after all, may be moral in nature, rather than strictly legal, requiring considered action even in the absence of (enforcement of) rigorous laws preventing the remodeling of beaches in the Phi Phi Islands National Park in Thailand (*The Beach*), the

chlorination of sea water in Baja California (*Titanic*), or the killing of trees in the gardens of Yuanmingyuan, China (*The Promise*).[5]

Filmmaking is usually an intensely collaborative process, making it difficult to draw firm inferences about a specific practitioner's values, and equally so to assign responsibility for decisions made and for the consequences arising from them. Furthermore, every instance of filmmaking takes place within a series of larger, interconnected contexts, in environments, for example, shaped by the ethos of a studio as it interacts with the constraints and opportunities of a larger (economic) system. Thus Richard Maxwell and Toby Miller see "[t]he wider background to the ecologically destructive filmmaking" evoked earlier as being "the message of economic structural adjustment peddled by the World Bank, the International Monetary Fund, the World Trade Organisation, and the sovereign states that dominate them."[6] Yet, acknowledging the interconnected ways of decision making in the world of film, and the constraints, tendencies, and enticements of larger forces, by no means obviates the need to ask questions about the values of filmmakers, as individuals, but also, just as pertinently, as members of communities where common knowledge and shared practices reflect ways of being in the world through filmmaking.

Burkinabé filmmaker Gaston Kaboré, whose alternative film school IMAGINE in Ouagadougou provides film training for aspiring filmmakers from across francophone Africa, is clearly motivated by a conception of what film is all about that is quite different from that of, say, James Cameron. As Burkinabé actor Serge Yanogo puts it in *IMAGINE FESPACO Newsreel 3*, a 15-minute documentary produced through a training initiative involving filmmaker Rod Stoneman, director of the Huston School of Film and Digital Media in Galway, Ireland, and Kaboré's alternative film school, "most films in Africa involve learning."[7] Yanogo, who had a leading role in Kaboré's award-winning *Wend Kuuni* (1983), was responding to a question put to him by a filmmaking student in the context of an outdoor, night-time screening of the film, which the organization Cinémobile had mounted in a village distant from Ouagadougou and its many well-frequented cinemas. Yanogo's point is borne out by a film such as Ousmane Sembène's *Moolaadé* (2004), which takes a moving and critical look at female genital mutilation. In Samba Gadjigo's documentary entitled *The Making of Moolaadé* (2006), Sembène identifies a desire to have *Moolaadé* function as a vehicle of enlightenment and emancipation in remote villages throughout Senegal and elsewhere in Africa.

A conception of both fiction and nonfiction filmmaking as contributing to authentic cultural memory and to the causes of justice and fairness was like a clear red thread running through conference, exhibition, and screening activities taking place at Kaboré's alternative school during the 2011 edition of FESPACO (Panafrican Film and Television Festival of Ouagadougou). One evening, for example, the newly whitewashed wall in the school's courtyard became the screen for animated shorts produced by young Burkinabé children (in the context of training workshops conducted by Golda Sellam from Cinélink and Jean-Luc Slock from the Liège-based Caméra-etc). A feature common to all of the films, which

were being screened with the children and their families present, was that they drew on indigenous traditions of artistry—the topic of a fascinating poster exhibition at Kaboré's IMAGINE, which was also hosting a related conference focusing on ancestral myths—and highlighted social issues from everyday life. *Leila*, a five-minute film produced by eight Burkinabé children, drew attention to the problem of child labor through the figure of a "cut-out" girl who becomes a donkey when the new family in which she finds herself exploits her. The central and clearly educational question asked by the film is, "What has to happen for the donkey to become a girl again?"

But are the values and commitments of a Kaboré or a Sembène, as these find articulation in cinematic narratives or training initiatives aimed at capacity building on the African continent, as the case may be, really connected, in any nontrivial sense, to the paths through which these filmmakers became film practitioners? Do they reflect a specific kind of practical induction into the world of film? Kaboré was trained at the École supérieure d'études cinématographiques (ESEC) in Paris, and graduated with a degree in film production in 1976. Sembène, who was largely self-taught as a filmmaker, spent one year at the Gyorki Film Studio in Moscow, having failed to get into filmmaking programs in France and elsewhere: "I learned how to make films in the Soviet Union. I didn't have a choice. To get training, I initially turned to people in France, notably Jean Rouch. I had written to America, Canada etc. and was rejected everywhere without being given a chance. Then I got in touch with Georg Sadoul and Louis Daquin. They suggested the Soviet Union. I spent a year there (1961–1962). It must be said, before I went there I had my ideas and my ideology. I'd been a unionist since 1950. I was very happy that it was eventually the Soviet Union that offered me a scholarship."[8]

So at one level the paths were very different, in terms of the geography of the training, its institutional environment, and its wider political contexts and social systems. What these filmmakers do share, however, is the experience, among other things, of having had to leave Africa, whether for western or eastern Europe, in order to achieve the training they saw as necessary. Further common ground is to be found in the experience of making films in sub-Saharan Africa without adequate indigenous personnel to draw on, and in a shared understanding of film as a medium well suited to fostering change in societies where oral traditions, as compared with the written word, are strong.

There can be no one-to-one correspondence between the profile of a given film school, on the one hand, and the priorities and values of its graduates, on the other. After all, film schools are subject to the full range of complexities that characterize institutional life. Among other things, they are in constant evolution, be it as a result of changes in leadership, incorporation into educational parameters such as the Bologna Accord (Anna Stenport, this volume) or the sorts of major historical changes that have affected key institutions in a once-divided Germany (Barton Byg and Evan Torner, this volume). And then, of course, there is the not so small matter of human psychology, which, thankfully enough, can be counted on to generate differences that are anything but trivial. If being a filmmaker is the outcome of a process of becoming, factors shaping that process are not merely to be sought in the institutional landscape of film schools and practice-based training

programs. Also, filmmakers may choose, temporarily or over the longer run, to *resist* the training they receive, including the values that are ultimately driving it. It would be wrong to suggest that Eva Novrup's interview with Phie Ambo in *The Danish Directors 3: Dialogues on the New Danish Documentary Cinema* shows that this award-winning documentary filmmaker has rejected the training she received through the National Film School of Denmark's well-known documentary program (discussed by Hjort, with reference to initiatives in the Middle East and North Africa, vol. 2). At the same time, it is fair to note that Ambo understands herself as having asserted her strong desire at a certain point to counter aspects of her training:

> After film school I had a real need to undertake a process of "de-film-schoolification." I wanted to do something that involved shooting from the hip. [. . .] I had a strong desire to put aside all that learning I'd acquired, all those sophisticated ways of articulating things, so that I could just follow my instincts and go for what seemed like fun. When I look at the film now, I can easily identify all the things I'd learnt and that I'd started to do almost automatically, without even being aware of it, the things that had become second nature. But [making] *Gambler* [about filmmaker Nicolas Winding Refn, 2006] was about a desire to get film to flow through me again, instead of having constantly to stop the creative elevator for a bunch of obligatory consultations with consultant A, B, and C.[9]

That the question of *values* is important in the context of a consideration of film schools and, arguably by extension, the fuller field of practice-based film education is clearly suggested by the topic chosen for a recent conference organized by the International Association of Film and TV Schools (CILECT). The organization meets biannually for an Extraordinary General Assembly, and in 2011 the theme for the conference, which was hosted by the Film and TV Academy of the Performing Arts (FAMU) in Prague, was "Exploring the Future of Film and Media Education." Subthemes providing further foci for discussion were "the fundamental *values* [emphasis added] of film education;" "benchmarking and evaluation;" and "the impact of internationalization."[10] CILECT "was founded in Cannes in 1955 with the intention of stimulating a dialogue among film schools in the deeply divided world of those times. Its membership was drawn from eight countries: Czechoslovakia (presently the Czech Republic), France, Great Britain, Italy, Poland, Spain, the USA and the USSR (presently Russia). By the year 2012, CILECT had grown to include 159 institutions from 60 countries on five continents. A significant number of the world's leading film and television makers are graduates of member schools." CILECT sees itself as "deeply committed to raising and maintaining the standards of teaching and learning in its member schools, and to exploring the potentials of new technologies for education, information and entertainment." What is more, the organization envisages "a new level of international cooperation" made possible by "the relaxation of international tensions among the great powers, the diminishing of national frontiers and the emergence of new technologies."[11] Membership in CILECT involves meeting strict criteria, as verified in a vetting process. Unsurprisingly, membership is a coveted badge of honor in a world where education is increasingly

globalized, with student recruitment often a matter of intense competition on national, regional, and global levels. What membership potentially means is clearly suggested in a press release featured on the University of Auckland's website, which makes reference to "elite CILECT membership" having been secured by the Department of Film, Television, and Media Studies' Screen Production Program, following an "exhaustive audit" and a vote among the existing members.[12]

There are, of course, many reasons for studying film schools, some of them having little or nothing to do with the *values* that are constitutive of what I have called "practitioner's agency."[13] At this stage in the argument, the issue is not one of determining what the full range of research questions looks like once practice-based film education is seen as warranting careful scrutiny through various lenses, including historical, political, ethical, industrial, and institutional ones. Rather, what must first be settled is the question of institutional scope. What kinds of institutions merit attention? Of the relevant kinds, which specific instantiations of the more general types are particularly worthy of study? What sorts of principles might legitimately be invoked to inform decisions regarding inclusions and exclusions when answering both of these questions? Let it be clear: It is my firm belief that the questions being asked here have many possible legitimate answers. The answers to which I am committed, and which are reflected in the design of *The Education of the Filmmaker in Europe, Australia, and Asia* and *The Education of the Filmmaker in Africa, the Middle East, and the Americas*, are shaped by a range of factors, including, most importantly, a dogged interest in small nations and their film cultures (including minor cinemas and their various politics of recognition),[14] and in the ways in which systemic constraints are transformed, through practitioners' agency, into creative opportunities and the conditions needed for an entire milieu to thrive. Another factor, relevant in terms of the global reach of this two-volume project published in the "Global Cinema" series, is my own personal and institutional history, which has offered affiliations, networks, and solidarities linked to practitioners, researchers, institutions, and sites of training in Africa, Canada, Denmark, and HK China (where I have lived as a nonlocal academic for well over a decade).

We have the possibility as film scholars, or as practitioner-scholars (which many of the contributors to the "Education of the Filmmaker" project are), to affirm certain kinds of initiatives, institutions, and organizations and to bring awareness of valuable and effective practices to a wider audience, including researchers in the first instance, but also filmmakers, policy makers, and practitioners working in sites of training located at a considerable cultural and geographical remove from those under discussion. We have the opportunity to learn from practices that are innovative, hopeful, and in some cases at least partially transferable. Even the discovery of challenges may be promising, for if these turn out to be a matter of shared problems, then they provide a potential basis for new alliances and partnerships.

But what should the focus be, and is it enough to focus on film schools? My response to the second part of this question is emphatically negative, and this, in turn, helps to define the scope of the research efforts contributing to the present project.

Practice-Based Film Education: Sites, Types, and Systems

Anyone interested in investigating (among other things) the impact that practice-based film education has on the values and practices of filmmakers, and thus on the communities and industries in which they work, is faced with a vast array of stand-alone conservatoire-style or industry-oriented film schools, as well as professional programs delivered within the context of universities, from which to choose. A US-based Academy of Television Arts and Sciences Foundation publication entitled *Television, Film and Digital Media Programs*, which presents itself as a guide for anyone "hoping for a life in the competitive world of TV, film, and the fast-growing field of digital media,"[15] describes *556 Outstanding Programs at Top Colleges and Universities across the Nation*, as the book's subtitle indicates. And then there are the 159 CILECT members, drawn from 60 countries, which further expands the potential field, although paradoxically enough, by no means sufficiently. Indeed, it is the premise of the current project that crucial practice-based initiatives are being run through institutional arrangements that have little of the institutional robustness that is a feature of the CILECT schools, and thus the scope of analysis extends well beyond this network.

With reference to the first, US-based context of analysis suggested by the above guide, the point to be made here is that the amount of space given to institutions serving as direct feeders of the US film industry has been deliberately limited, in keeping with the aims of the "Global Cinema" series, among others. *The Education of the Filmmaker in Africa, the Middle East, and the Americas* includes a section on "The Americas," but this has but one chapter devoted to schools in the USA (Toby Miller). Discussion of US schools is, however, also pursued in another section, devoted to the Middle East, where Hamid Naficy (vol. 2) draws out the ambivalences, values, challenges, and opportunities arising from American branch campus initiatives in such places as Qatar. Like many of the contributors to the "Education of the Filmmaker" project, Naficy is able to speak from firsthand experience of the institutional arrangement about which he writes, having been a key player in Northwestern University's development of programs to be delivered through a branch campus located in Education City (alongside other American, British, and French branch campuses) in Doha, Qatar.

Included in "The Americas" section are the results of research focusing on a range of initiatives that are neither US-based nor (likely ever to be) captured by the reach of CILECT's network: George Yúdice's chapter focusing on community-based initiatives aimed at promoting audiovisual literacy in Brazil (Central Única das Favelas/Central Union of Slums and Escola Livre de Cinema/Free Cinema School) and Uruguay (Usinas Culturales/Cultural Factories); Scott MacKenzie's account of the process-oriented Independent Imaging Retreat or Film Farm school established by Canadian filmmaker Philip Hoffman (who is also on the faculty of York University in Toronto); Christopher Meir's discussion of the energies and aspirations driving efforts to build practice-based film cultures in the anglophone Caribbean; and Armida de la Garza's analysis of the contributions made by the Mexico-based civil association known as La Matatena to the area

of practice-based film education for young children, and through this, to society more generally.

As for the second possible context of analysis—provided by the CILECT network—it should be noted that some of the case studies presented in the two-volume "Education of the Filmmaker" project provide in-depth analysis of institutions linked to CILECT. Toby Miller's contribution, entitled "Goodbye to Film School: Please Close the Door on Your Way Out" (vol. 2), takes a critical look at well-established American film schools that are part of the CILECT network. The School of Motion Picture Medium and Live Performance in Cape Town, South Africa (AFDA), figures centrally in the chapter entitled "Audience Response in Film Education," by Anton Basson, Keyan Tomaselli, and Gerda Dullaart (vol. 2). In Ben Goldsmith and Tom O'Regan's chapter (this volume), the histories, profiles, and current roles of Australian members of CILECT (Victorian College of the Arts in Melbourne, the Australian Film and Television School in Sydney, and the Griffith Film School in Brisbane) are discussed, as part of a more wide-ranging analysis of the ecology of practice-based film education in Australia. In Nicolas Balaisis' chapter, entitled "The School for Every World: Internationalism and Residual Socialism at EICTV" (vol. 2), the transnational and ethical commitments of the Cuban CILECT member, Escuela Internacional de Cine y TV, are considered in light of changing historical circumstances. My own chapter, also in the second volume, looks at the one Danish member of CILECT, The National Film School of Denmark, and, more specifically, at its efforts, through partnerships with NGOs in the Middle East and North Africa and institution building in Jordan and Lebanon, to make transnational networking an integral part of the school's documentary programs.

References to the work of Yúdice, MacKenzie, Meir, and de la Garza help to evoke what is at stake in expanding the context of discussion beyond the institutional models figuring centrally in the CILECT network. It is not just a matter of trying to be comprehensive by bringing a fuller spectrum of *models* of film education into play, but of trying to ensure that models that are clearly fueled by values having to do with inclusion, fairness, sustainability, and authentic expression are given the attention they deserve. Inasmuch as many of these models are prompted by a clear sense of social, creative, or political needs, they may rely on what Renata Šukaitytė (this volume), referring to the specific context of Lithuania within the Baltic region and as a former Republic of the Soviet Union, calls tactical reasoning. One of the defining features of the relevant type of rationality is the awareness of challenges, and of the need for constant adjustment and flexibility, and this in connection with terrain that is anything but stable or secure. Making references to a host of serious social problems in Nigeria, Osakue Omoera(vol. 2) makes the case for investing in film training programs, as a means of creating alternative paths for youths otherwise easily absorbed into lives of crime. Charlie Cauchi (this volume) takes up issues arising from the absence of a well-developed system of practice-based film education in Malta, and in the course of her discussion the significance of various forms of self-teaching and of amateur societies becomes clear. Yoshi Tezuka's chapter (this volume) looks closely at the role that informal communities of filmmakers in Japan have played in developing filmmakers'

skills, and thus in keeping Japanese filmmaking alive, following the collapse of the studio system in the 1970s. Moinak Biswas (this volume) discusses the Media Lab that was established at Jadavpur University in Calcutta, as part of a Digital Humanities initiative that aimed to make space for critical and alternative forms of image production in a landscape almost entirely dominated by industry norms and industrial conceptions of skill. Interestingly, the broader historical perspective that Biswas provides is one that links current developments at the Media Lab to the type of education that Satyajit Ray received in India in the pre-film-school days of the 1940s.

In addition to the issue of geography or location (and what these mean within the larger scheme of things), and that of models, there are *systemic dynamics* to consider. Goldsmith and O'Regan's chapter (this volume) is helpful in drawing attention to the benefits of situating the different models of practice-based film education existing within a given national context in relation to each other. The premise, clearly, is that while it is important to achieve clarity about the various types on offer—about their modes of operation, for example—it is equally important to grasp their respective roles within a larger *system*. Is the dynamic governing interaction among the different models one that agents contributing to their operation find productive or are there tensions or outright conflicts within the system, some of them the product of competing values? This is the sort of question that is clearly well worth asking, and not only in the context of Australia.

If we return to Gaston Kaboré, for example, we may note that there are two main sources of film training in Burkina Faso, both of them with a regional role to play in sub-Saharan, francophone Africa: IMAGINE and ISIS (Institut Supérieur de l'Image et du Son). There is a clear division of labor between these two schools, with IMAGINE providing short courses within the context of an alternative and often somewhat precarious set-up that contrasts with the model of a well-developed stand-alone school with a full range of programs, all of them accredited and funded. ISIS, which is funded by the European Union, Africalia, and Stockholms Dramatiska Högskola (Stockholm Academy of Dramatic Arts), is the one Burkinabé member of CILECT. IMAGINE has been dependent on short-term sources of funding, but also on Kaboré's own film earnings and support provided by his wife Edith Ouedraogo, who is a pharmacist. Sources of external funding include the "Danfaso Culture and Development Programme for Burkina Faso" and a grant from the Center for Kultur og Udvikling/CKU (Danish Center for Culture and Development/DCCD).[16] The international networks into which ISIS and IMAGINE tap, as instantiations of two quite different models of practice-based film education, are to some extent shared, with Madeleine Bergh from Stockholm Academy of Dramatic Arts participating in collaborative initiatives with ISIS during FESPACO 2011, and also eager to be involved in the seminar that Rod Stoneman, Kaboré, and Hjort mounted at IMAGINE, titled "L'Enseignment et la formation professionnelle au cinéma en Afrique" ("Film Training and Education in Africa: Challenges and Opportunities"). Motandi Ouoba, who has played a central role at IMAGINE, has also offered film training courses at ISIS, before going on to mount an independent training initiative focused on children. Teaching at ISIS provided a source of income for Ouoba, but also made him an

important human link between two quite different sites, and indeed models, of training, both of which contribute to crucial capacity building in West Africa. Rod Stoneman has played a significant role in the context of African filmmaking, initially as a commissioning editor for Channel 4 and, over the last ten years or so, through his involvement in workshops at IMAGINE. Drawing on his own experiences with capacity building through short courses at IMAGINE, and also in the Maghreb, Vietnam, and the Middle East, Stoneman's chapter (vol. 2) provides insight into the workings of a model of film training that has strong elements of the transnational and the peripatetic.

Alia Arasoughly's chapter (vol. 2), focusing on Palestinian Shashat (which she founded), but also on the features of various university-based programs in Palestine that partly provide the rationale for this NGO's existence, helps to drive home the point that if the full significance of a given practice-based institution, university program, or NGO-driven framework is to be grasped, it must, to some extent, be understood in relation to the larger system in which it operates. Arasoughly's account of Shashat's pioneering work in Palestine strongly suggests that the success of practice-based film education often depends on the energies and vision of a practitioner whose milieu-building efforts are decisive. It also shows that while peripatetic training initiatives may be valuable in many respects, they can hardly be seen as problemfree.

Entitled "Film Schools in the PRC: Professionalization and its Discontents," Yomi Braester's chapter (this volume) is finely attuned to the dynamics between different kinds of practice-based film education in the People's Republic of China (PRC). Braester provides a contrastive explication of the models underwriting the conservatoire-style Beijing Film Academy (BFA), on the one hand, and Wu Wenguang's Caochangdi Station and the Li Xianting Film School, both "unaccredited institutions [that] have repeatedly incurred the authorities' disapproval," on the other. Braester's point, which can be adapted and extended to the larger collective project to which his chapter contributes, is this: "The juxtaposition of these extremes is not intended to condemn one or to show the weaknesses of the other, but rather to foreground the unique set of constraints within which each operates."

Entitled " 'We Train *Auteurs*': Education, De-centralization, Regional Funding and Niche Marketing in the New Swedish Cinema," Anna Stenport's analysis (this volume) of recent developments in the greater Gothenburg region of Western Gotland in Sweden draws attention to the question of how a well-functioning system of film education, consisting of mutually supporting elements, actually evolves. Clearly the answer given to any question concerning the evolution of an entire ecology of film education will vary from case to case, just as it seems unlikely that any one set of causes and causal relations could be identified as the preferred and somehow normative one. The Swedish example discussed by Stenport is especially interesting, however, because of the apparently emergentist nature of its processes, with agents coordinating and calibrating their activities without reference to any overarching blueprint or set of directives. Duncan Petrie's account (this volume) of initiatives taken toward the establishment of a Scottish film school, and of the collaboration between Napier University and Edinburgh College of Art,

which has yielded a well-functioning Scottish Screen Academy, sheds further light on the conditions and actions through which a larger system of film education evolves. Entitled "Sites of Initiation: Film Training Programs at Film Festivals," Marijke de Valck's chapter (this volume) adds another dimension to the discussion of the causal factors driving change and innovation within a larger system. With access to various interlinked film industries becoming ever more competitive, film festivals, de Valck argues, have emerged as sites where networking and training combine in ways that are critical to the success of aspiring filmmakers, including those who have graduated from well-established film schools.

The ecology of practice-based film education may be balanced or imbalanced, finely differentiated, or dominated by a single model, among other possibilities. In some cases, the idea of a system of film training consisting of well-differentiated and mutually supportive constitutive elements is mostly an aspirational one. Indeed, there are contexts where the lacks are so substantial that the nation or subnational entity in question becomes dependent, among other things, on the efforts of mutually supportive amateurs, on the transnational reach of robustly developed institutions situated elsewhere, and on the sorts of boundary-crossing partnerships and solidarities that make collaborative projects possible and, through them, some kind of development of a milieu.

Small Nations and Transnational Affinities

The design of *The Education of the Filmmaker in Europe, Australia, and Asia* and *The Education of the Filmmaker in Africa, the Middle East, and the Americas* is necessarily a reflection of the editor's interests and even research trajectory. As a film scholar my research has been intensely focused on small nations, especially Denmark. The study of small nations, including debates about what counts as a small nation, is an entire field of its own. Suffice it here to say that there are several measures of small nationhood, including, as Miroslav Hroch has argued convincingly, rule by non-co-nationals over a significant period of time.[17] Other measures include a country's GDP, its population size, the extent to which its national tongue is spoken by non-nationals, and so on.[18]

The aim in earlier projects has been to understand the specificity of the challenges that small nations face in their pursuit of filmmaking and to identify the conditions that have allowed some small-nation contexts, most notably the Danish one, to thrive in a range of different ways. Motivating these pursuits was a desire to see whether partnerships built on affinities derived from small nationhood might help to trouble a world order that often placed large nations at the center of things, and small nations on the peripheries or margins. This same desire is evident in both of the "Education of the Filmmaker" volumes. In *The Education of the Filmmaker in Europe, Australia, and Asia*, for example, Europe is evoked through the lenses that realities in Lithuania, Scotland, Sweden, Malta, Germany, and the European Union provide. And in the case of Germany, the only national or subnational context that does not match crucial criteria associated with small nationhood, much of the discussion concerns key institutions in

the former German Democratic Republic, which clearly did (having involved rule by non-co-nationals over a significant period of time). The discussion of China in the first of the two volumes brings official and alternative practices in the People's Republic of China into clear focus (Yomi Braester, this volume), and thereby the efficacy of various "minor" practices, to use Gilles Deleuze and Félix Guattari's term. The complexity of practice-based film education in a Chinese context is further explored in a second chapter devoted to China in the post-Handover era. Evoking the contributions of Hong Kong Television Broadcasts Limited (HKTVB) up until the late 1980s, and the lacuna that its retreat from the field of training created, Stephen Chan (this volume) discusses the promise of such recent initiatives as the Hong Kong International Film Festival Society's Jockey Club Cine Academy. As a player in a "One Country, Two Systems" arrangement, and as a former British colony, Hong Kong, quite clearly, counts as a small nation following some of the most crucial measures of size.

Interest in practice-based film education is, quite simply, an inevitability given the concerns relating to small nations evoked above, as even the most cursory reference to various texts makes clear. The access to filmmakers that film scholars enjoy in small-nation contexts made possible the production, over a period of 15 years, of three interview books with directors: *The Danish Directors: Dialogues on a Contemporary National Cinema* (with Ib Bondebjerg); *The Danish Directors 2: Dialogues on the New Danish Fiction Cinema* (with Eva Jørholt and Eva Novrup Redvall); and *The Danish Directors 3: Dialogues on the New Danish Documentary Cinema* (with Bondebjerg and Redvall).[19] Together these books comprise 55 film directors' responses to research-oriented questions, including ones having to do with the sites of education and training through which the relevant practitioners entered the world of professional filmmaking. Whereas *The Danish Directors*, featuring dialogues with mostly an older generation of filmmakers, underscores the significance of "learning by doing," of mentoring within various production companies, and of training afforded by such "foreign" institutions as FAMU, *The Danish Directors 2* and *The Danish Directors 3* draw attention to the nature of the training offered at the National Film School of Denmark, an institution that must be central to any attempt to explain the various forms of success that Danish cinema has enjoyed for about two decades. Yet, what also emerges from these conversations is the significance of the Video Workshop in Haderslev, the Film Workshop in Copenhagen, the European Film College in Ebeltoft, and the Copenhagen Film and Photo School Rampen, in short the workings of a rich and diversified landscape of practice-based film education. A section titled "Learning to become a filmmaker in Denmark: The National Film School of Denmark, Super 16 and the Film Workshop in Copenhagen," in *The Danish Directors 2*, provides a summary account of this landscape, as does the chapter "Denmark," in *The Cinema of Small Nations* (co-edited with Duncan Petrie).[20] In "Denmark" the National Film School of Denmark's emphasis on teamwork, interdisciplinarity, and creativity under constraint is seen as having worked in synergy with effective cultural policy and exceptional artistic leadership in one of the milieus of actual film production

to produce unusual conditions of viability for the cinema of a small Nordic nation.

The idea of small nations coming together in solidarity based on affinities having to do with shared culture, values, problems, or aspirations was explored through analysis of the so-called "Advance Party Project." A rule-governed project, built on the efficacies of the Dogma 95 initiative, Advance Party was initially a three-film effort involving a partnership between filmmaker Lars von Trier and his Copenhagen-based Zentropa Film Town, and Gillian Berrie and her production company Sigma Films, based in Govan Town Hall, Glasgow. The point of the rules, and, indeed of the partnership, as expressly stated by Berrie in an interview, was to deliver capacity building and mentoring that was seen as sorely lacking on the Scottish scene. "Affinitive and Milieu-Building Transnationalism: The Advance Party Project" explores the implications of an initiative that was designed to link novices to established filmmakers, for mentorship purposes.[21] Attention, more specifically, is called to the role that innovative film projects have to play, as a vehicle for the articulation of policy-related ideas, in contexts where institutional development pertaining to film training falls short of the aspirations of practitioners.

In 2009 Duncan Petrie hosted "The University of York Film Schools Seminar," which became an opportunity to continue collaboration initiated through *The Cinema of Small Nations*. The seminar included three sessions, one focusing on the historical significance of film schools, a second on film schools today (and especially the international dimension of film education), and a third on education and training. As one of the three partners in this event, Hjort chaired the third session and contributed a paper titled "Official and Unofficial Film Schools" to the second session. This paper explored the differences and relation between the well-established National Film School of Denmark and the alternative film school Super 16 that was created by a number of applicants who had sought, but failed to gain admission to the official, national school. The point was to expand the discussion beyond a certain institutional model and to draw attention to what can be achieved in the area of practice-based film education through "gift culture," the gifts, in the case of Super 16, being a matter, among other things, of professionals teaching more or less for free and facilities being lent to the unofficial (but not unstructured) school by the production company Nordisk.

Designed by Petrie and Rod Stoneman, the program for the Film Schools Seminar brought key figures such as Ben Gibson (director of the London Film School) and Igor Korsic (CILECT) into the conversation about film schools, as efforts were made to identify the crucial areas for research.[22] The Film Schools Seminar led to Hjort joining Stoneman at Gaston Kaboré's alternative film school, IMAGINE, in February 2011. Stoneman was conducting a ten-day practice-based workshop for students at IMAGINE (some of them from Burkina Faso, others from other West African countries). The workshop produced three "Newsreels" focusing on FESPACO, all of which were shown on TV in Burkina Faso and in the cinemas ahead of the FESPACO features. Serving as the team's translator and

subtitler, Hjort worked alongside the student editors in the IMAGINE film studio. Stoneman, Kaboré, and Hjort also organized the seminar referred to above, "Film Training and Education in Africa: Challenges and Opportunities," with speakers including Dorothee Wenner (director of the Berlinale Talent Campus), Golda Sellam (Cinélink), Daphne Ouoba (Cinomade), Motandi Ouoba (IMAG-INE), Don Boyd (filmmaker, producer, and governor of the London Film School), and June Givanni (programmer and jury coordinator, Africa International Film Festival), among others.

What has emerged through these various interactions, friendships, and collaborations is a loosely connected series of research projects that will work together, we hope, to develop practice-based film education as a vital and innovative field of research. Petrie's interest in the history of conservatoire-style film schools has yielded key articles, namely: "Theory, Practice and the Significance of Film Schools," "Theory/Practice and the British Film Conservatoire," and "Creative Industries and Skills: Film Education and Training in the Era of New Labour."[23] Petrie and Stoneman are co-authoring a book on the past, present, and future of film schools; Petrie and Stoneman have both contributed to the "Education of the Filmmaker Project" (EOFP); and in 2013 Hjort once again joined Stoneman at IMAGINE, this time for a workshop focusing on film and human rights, organized in tandem with the short film training program that supports students in their production of Newsreels documenting Africa's largest and most important festival, FESPACO. Projects that take the issue of film education into other networks are designed to provide further density to the research. An example of such a project is *The Blackwell's Companion to Nordic Cinema*, edited by Hjort and Ursula Lindqvist, which includes a section on film education to which the following Nordic scholars are contributing: Heidi Philipsen (University of Southern Denmark), Astrid Söderberg Widding (Stockholm University), Mats Jönsson (Lund University), and Hjort.

The Larger Context: Different Kinds of Writing on Practice-Based Film Education

Linked to the Society of Film Teachers and later the Society for Education in Film and Television, the influential journal *Screen* has been an important space for discussions of film education, especially within schools. The same can be said of the journal *Screen Education*, which was also established in the 1960s. The work published in these two journals provides an historical context for the kind of research that is being pursued through the EOFP. For the most part, however, writing on practice-oriented film education and its institutions has been very limited. Also, the most salient work on the topic can be characterized as narrow in focus. The tendency has been (1) to focus on the West, especially the United States and the UK; (2) to write in a popular, non-research-oriented vein; (3) to focus on well-established film schools and university-based programs where industry needs are served; (4) to neglect the diversity of models of practice-oriented film education; (5) to fail to articulate the core values that are constitutive of various models

of practice-oriented film education; (6) to overlook the diverse purposes that practice-oriented film education can serve; (7) to neglect the collaborative educational initiatives that various globalizing processes have made possible; (8) to focus on practice-oriented film education aimed at relatively mature individuals who aspire to become professional filmmakers; (9) to neglect practice-oriented film education aimed at children and young people; (10) to neglect community-oriented film training initiatives; (11) to neglect practice-oriented film education that aims to provide solutions to specific social and political problems; and (12) to ignore the interest of fostering a transferability of models with significant social contributions to make.

Film School Confidential: Get In. Make It Out Alive by Tom Edgar and Karin Kelly is a good example of popular writing on film schools.[24] Focusing on 29 film schools, this book provides a descriptive account of the curricula and costs associated with specific film training programs in the United States as well as advice to the aspiring filmmaker on how to select a film school, gain admission to it, and make the transition from film school to the filmmaking industry. A more scholarly relevant category of writing on practice-based film education and its institutions draws heavily on two genres: the practitioner's interview and the memoir. The most research-relevant, book-length publications on film schools belong in this category. *Projections 12: Film-makers on Film Schools*, edited by John Boorman, Fraser MacDonald, and Walter Donahue, provides a series of interviews with staff members and former students from such schools as the National Film and Television School in London, the London Film School, and film programs at NYU, Columbia, USC, and UCLA.[25] Ni Zhen's *Memoirs from the Beijing Film Academy: The Genesis of China's Fifth Generation* is a moving instance of life writing that clearly suggests the extent to which the visual and narrative tendencies that scholars and critics discern on the world's screens are traceable, in many instances, to the institutional culture and priorities of specific sites of practice-oriented film education.[26] The existence of such research-relevant books as *Projections 12* and *Memoirs from the Beijing Film Academy* suggests just how significant a role the institutions of film education play, yet these works cannot fill what is a clear lacuna in the scholarly landscape of film.

With the growing interest in "practitioner's agency," film scholars have begun to see the value of studying practice-oriented film education in a systematic way. Some of the most promising scholarly work on practice-oriented film education, not surprisingly, is being produced by scholars who are located within the kinds of small-nation contexts that facilitate empirical, case-based research that is informed by ongoing exchanges, over a significant period of time, with policymakers, institution builders, and a whole range of film practitioners, including those who dedicate themselves to the training of others. Working independently of each other, and making good use of the scholarly access to film practitioners that small-nation contexts provide, scholars such as Eva Novrup Redvall, Heidi Philipsen, and Chris Mathieu have published pioneering work that convincingly shows that the priorities and philosophies of institutions devoted to practice-oriented film education have a decisive impact on filmmakers' creative outlooks, working practices, and networks, shaping not only the stylistic (visual and narrative) regularities

that define distinctive bodies of cinematic work but the dynamics of a given film industry. Redvall's "Teaching Screenwriting to the Storytelling Blind—The Meeting of the Auteur and the Screenwriting Tradition at The National Film School of Denmark"[27] clearly demonstrates that at the institution under discussion auteurist traditions have been consciously replaced in recent times with a model of collaborative authorship, to positive effect. Heidi Philipsen's dissertation, entitled "Dansk films nye bølge" ("Danish Film's New Wave"), shows that Denmark owes much of its success with film over the past two decades to the values, methods, and principles that figures such as Jørgen Leth, Mogens Rukov, and Henning Camre brought to the National Film School of Denmark, and made an integral part of its institutional culture.[28]

The Institutional Turn in Film Studies

Research on practice-based film education is necessarily oriented toward institutional culture and processes of institutionalization, since the film schools and universities, where much of what counts as film training takes place, are, quite simply, institutions. Yet, it is imperative that research energies also be channeled toward goals, values, practices, and arrangements that are not necessarily well served by the *standard* forms of what I want to call "robust institutionalization." Practice-based film education, it is clear, admits of many models, some of them having a far stronger tendency toward institutional visibility, stability, and persistence than others. Thus, for example, Moinak Biswas (this volume) is interested in understanding "humanist [practice-based film] education in its indeterminate relationship with institutions," just as Renata Šukaitytė (this volume) evokes the remarkable achievements of "anti-institutionalist" activists such as Lithuanian filmmakers Jonas Mekas and Šarūnas Bartas. At the same time, it is important to recognize that institutions and institution building are phenomena that can themselves be rethought in innovative and creative ways. In some cases, the very process of articulating an alternative model of practice-based film education provides rich opportunities to rethink the ways and means of institution building, and its more standard manifestations. Philosopher Cornelius Castoriadis' groundbreaking work on social imaginaries, creativity, and the work of instituting and world making can be usefully evoked here. Castoriadis puts a key point as follows in *The Imaginary Institution of Society,*

> [W]hat is essential to creation is not "discovery" but constituting the new: art does not discover, it constitutes; and the relation between what it constitutes and the "real," an exceedingly complex relation to be sure, is not a relation of verification. And on the social plane, which is our main interest here, the emergence of new institutions and of new ways of living is not a "discovery" either but an active constitution.[29]

It is, I believe, uncontroversial to assert that in-depth, sustained analysis of the practice-oriented educational initiatives that are upstream of actual film production and constitutive of film's institutional dimensions has much to contribute

to what might be called the "institutional turn" being encouraged by developments in film studies. On the one hand, there is growing interest in practitioner's agency, understood not in terms of abstract philosophical reflections on the nature of authorship, but in terms of *actual* agents' reasoning about their practices in relation to preferred self-understandings, artistic norms, and the constraints and opportunities that specific institutions and policies bring to the world in which these practitioners live their personal and professional lives as filmmakers. On the other hand, film scholars have long understood that film policy is an area warranting careful attention if film's institutional underpinnings are to be properly understood. Important work on relevant issues has been done, *Cultural Policy*, co-authored by Toby Miller and George Yúdice, being a case in point.[30] More recently, remarkable efforts by researchers with an understanding of the need for team- and network-based research in Film Studies have helped to bring the roles and workings of film festivals into sharp relief. I am thinking here of Dina Iordanova and her Dynamics of World Cinema team, and of Marijke de Valck and the Film Festival Research Network (FFRN) that she and Skadi Loist established together.[31] Among other things, the findings that emerge from such work depict the institutions and the processes of change where much of the creative work of instituting occurs. Practice-oriented film education deserves the same kind of rigorous scholarly attention that phenomena such as film policy and film festivals have received. Establishing practice-oriented film education as a legitimate and worthwhile area of inquiry is no doubt a task that can be achieved on older models of research that have long dominated the Arts and Humanities: stand-alone articles and monographs written by scholars working largely on their own. The second task, which has to do with achieving the kind of density of findings that would count as significant progress in the research area in question, will, however, require a commitment to precisely the sorts of principles and practices that are characteristic of the film festival field, as a research area: mutually supportive partnerships between researchers and practitioners, team-based research, and loose, yet meaningful synergies among research projects being pursued on a more individual basis.

The Aims of the "Education of the Filmmaker" Project (EOFP)

The EOFP is driven by a number of goals that can only be partly realized through the two volumes published in Kasia Marciniak, Anikó Imre, and Áine O'Healy's Global Cinema series. The hope is that these goals will be further pursued and, indeed, revised as necessary, as new scholars, institution builders, and film practitioners join the conversation about the hows, whys, and wherefores of practice-based film education. Some of the goals informing the design of the EOFP can be described as follows:

1. To establish practice-based film education as a central area of scholarly research;
2. To shed light on the aspiration to establish film schools in contexts where these do not yet exist;

3. To identify the "pre-institutional" modes of practice-based film education that often prepare the ground for full-blown efforts at institution building;

4. To identify the full spectrum of types of practice-based film education and their specificities, including constitutive values, recurring challenges, and characteristic contributions;

5. To chart the impact of historical forces and political change on well-established film schools;

6. To analyze the impact of different kinds of globalization on practice-based film education, as well as the challenges and advantages arising from transnational and network-based initiatives;

7. To examine the motivations for, and significance of, practice-based film education aimed at children and young people;

8. To clarify the implications of new technologies for practice-based film education;

9. To explore the role that practice-based film education plays in the building of sustainable communities;

10. To assess the use of practice-based film education in contexts focused on health, well-being, and social inclusion;

11. To profile practice-based initiatives that have proven themselves to be especially valuable and, through this, to facilitate various forms of knowledge transfer;

12. To draw attention to the agents—the people—who have developed such valuable initiatives;

13. Through all this, to constitute networks and bodies of knowledge that can be mobilized in conversation with policymakers and government representatives, among others.

As books, *The Education of the Filmmaker in Europe, Australia, and Asia* and *The Education of the Filmmaker in Africa, the Middle East, and the Americas* have a somewhat unusual history, for whereas conferences often lead to publications, in this case a team-based book project involving an advance contract for a single edited volume became the impetus for a conference and then grew into a two-volume project. Prompting the organization of The Education of the Filmmaker—Views from around the World conference was the creation of a new research center—The Centre for Cinema Studies (CCS)—at Lingnan University in Hong Kong. The contributions presented at this conference, which was held at Lingnan in the spring of 2012, were seen as breaking new ground in genuinely substantial ways, and thus as meriting the kind of scope for development that only the addition of a second edited volume would provide. That the series editors and acquisitions editors at Palgrave Macmillan agreed to a request along these lines is a reason for considerable gratitude, as is the decision (made by Lingnan's senior management team, especially President Yuk Shee Chan and Vice-President Jesús Seade) to make Cinema Studies a priority area for the University. The latter decision is an unlikely, but a welcome one in today's academic world, inasmuch as it is never "resource-neutral." Resources—in the form of conference funding, a full-time senior research assistant, and precious

space dedicated to the CCS—have helped to bring unexpected momentum to the EOFP. Intense interaction among the contributors to the two volumes, with members of the CCS' advisory board, and with scholars and practitioners from the wider Hong Kong community, did much to clarify the central issues and effectively transformed a series of coordinated, but ultimately individually pursued, parallel projects into a genuine team effort. That the EOFP was enthusiastically adopted, not only by Lingnan's president and vice-president, but by all members of the CCS says a lot about the synergies between the project's goals and the aims of the Centre, which are: "To create a dynamic research environment for emerging and established researchers; to contribute to policy-related discussions in Hong Kong; to stimulate public interest in film culture; and through various forms of community engagement, to support filmmakers' efforts to develop independent filmmaking in Hong Kong and on the Chinese mainland."[32]

Interest in film education, it must be acknowledged, is not new at Lingnan, for in May 2010 noted poet and film scholar Ping-kwan Leung partnered with Shu Kei, a filmmaker and dean at the Academy for Performing Arts in Hong Kong (APA), to organize a two-day workshop, "Film in Education." Held at both Lingnan University and at the APA's Bethanie Landmark Heritage Campus, and with the participation of filmmakers such as Ann Hui and Johnny To, the workshop was designed to explore how synergies could be created between the academic and theoretical study of film, on the one hand, and practice-based approaches to film, on the other. The focus for the workshop was film education in Asia, especially China. Among other things, my own contribution to the workshop was an attempt to test the relevance, as perceived by scholars and practitioners based in Hong Kong and China, of an envisaged research proposal focusing on practice-based film education (which has since been developed and funded by the Hong Kong government's Research Grants Committee). This research project, titled "Practice-oriented Film Education and its Institutions: Values, Methods, Transferable Models," is funded for a three-year period and aims, among other things, to shed light on the Nordic countries' growing involvement in training partnerships in West Africa, East Africa, the Middle East, and China.

The EOFP Team

Readers of *The Education of the Filmmaker in Europe, Australia, and Asia* and *The Education of the Filmmaker in Africa, the Middle East, and the Americas* will find chapters written by emerging and established scholars, by authors working in their mother tongue, and by authors for whom English is but one of several languages spoken. An important feature of the volumes is that many of the contributions come from practitioner-scholars, that is, from people who have been actively involved in making films, in delivering practice-based film education, and in helping to develop the milieus in which all this happens. Key figures in this regard are Yoshiharu Tezuka, Moinak Biswas, Ben Goldsmith, Rod Stoneman, Keyan Tomaselli, Anton Basson, Gerda Dullaart, Hamid Naficy, and, finally, Alia

Arasoughly, who, working against all odds, has managed to carve out a vital, enabling space for practice-based film training in Palestine through Shashat. While some of the film scholars in the two contents tables cannot claim to be makers of films, all are committed to ensuring that their research on practice-based film education is informed by the self-understandings of relevant practitioners, through practitioner interviews and practices of participant observation, where possible. Several of the scholars in question have collaborated with filmmakers or spent time at film schools, or in various training contexts, in connection with their research. The research that has been carried out for the project can legitimately be seen as having a strong empirical dimension, with concepts being introduced on an "as-needed" basis and in constant conversation with specific examples and concrete cases. All of the contributors write as authors with something genuinely at stake in the cases on which they have chosen to focus. In this sense *The Education of the Filmmaker in Europe, Australia, and Asia* and *The Education of the Filmmaker in Africa, the Middle East, and the Americas* combine elements of advocacy, critique, celebration, and problem solving. As we discussed the issues together in Hong Kong, we found this to be a fruitful mix, capable of encouraging new alliances and of suggesting new lines of research engagement. The hope is that the conversation will continue, and that new voices, some of them belonging to readers of these two books of ours, will become part of it.

Notes

1. Simone de Beauvoir's famous phrase is "One is not born a woman, but becomes one." See *The Second Sex*, trans. Constance Borde and Sheila Malovany-Chevalier (New York: Vintage Books, 2011).
2. *The Danish Directors 2: Dialogues on the New Danish Fiction Cinema*, ed. Mette Hjort, Eva Jørholt, and Eva Novrup Redvall (Bristol: Intellect Press, 2010), 231.
3. *The Danish Directors 3: Dialogues on the New Danish Documentary Cinema*, ed. Mette Hjort, Ib Bondebjerg and Eva Novrup Redvall (Bristol: Intellect Press, 2013).
4. Mathew Scott, "The View Finder," *South China Morning Post*, November 4, 2012, The Review section.
5. See Richard Maxwell and Toby Miller, "Film and the Environment: Risk Off-screen," in *Film and Risk*, ed. Mette Hjort (Detroit: Wayne State University Press, 2012), 272. See also, Mette Hjort, "The Film Phenomenon and How Risk Pervades It," in *Film and Risk*, 20–22.
6. Maxwell and Miller, "Film and the Environment," 272.
7. IMAGINE FESPACO Newsreel 3 (2011), http://www.youtube.com/watch?v= CUwUlJ IdtqM (accessed November 5, 2012).
8. "African Cinema Is Not a Cinema of Folklore," in conversation with Siradiou Diallo, in *Ousmane Sembene: Interviews*, ed. Annette Busch and Max Annas (Jackson, MS: University of Mississippi Press, 2008), 58.
9. *The Danish Directors 3*.
10. http://cilect.org/posts/view/114 (accessed November 7, 2012).
11. http://cilect.org/ (accessed November 7, 2012).
12. http://www.auckland.ac.nz/uoa/home/about/perspectives/videos-and-performances/ CILECT (accessed November 7, 2012).
13. I develop the concept of "practitioner's agency" in *Lone Scherfig's "Italian for Beginners"* (Washington, Seattle and Copenhagen: University of Washington Press and Museum

Tusculanum, 2010) and in *The Danish Directors 2*. Research based on investigations of "practitioner's agency" has been encouraged through the Nordic Film Classics series, for which I am founding co-editor, with Peter Schepelern. As I see it, being committed to understanding practitioner's agency involves giving explanatory priority to the self-understandings and subjective rationality of those who are, in some capacity, involved in the filmmaking process.

14. Mette Hjort, "Danish Cinema and the Politics of Recognition," in *Post-Theory*, ed. Noël Carroll and David Bordwell (Madison: University of Wisconsin Press, 1996).

15. Staff of The Academy of Television Arts and Sciences Foundation and the Staff of The Princeton Review, *Television, Film, and Digital Media Programs: 556 Outstanding Programs at Top Colleges and Universities across the Nation* (New York, NY: Random House, 2007).

16. Danish Center for Culture and Development (DCCD), "Danfaso Culture and Development Programme for Burkina Faso, 2011–2013," http://www.cku.dk/wp-content/uploads/DANFASO-Culture-and-Development-Programme-for-Burkina-Faso.pdf (accessed November 8, 2012).

17. Miroslav Hroch, *The Social Preconditions of National Revival in Europe: A Comparative Analysis of the Social Composition of Patriotic Groups among the Smaller European Nations* (Cambridge: Cambridge University Press, 1985); see also Mark Bray and Steve Packer, *Education in Small States: Concepts, Challenges, and Strategies* (Oxford, England and New York: Pergamon Press, 1993).

18. See Mette Hjort, *Small Nation, Global Cinema* (Minneapolis: University of Minnesota Press, 2005), and Mette Hjort and Duncan Petrie, "Introduction," in *The Cinema of Small Nations*, ed. Hjort and Petrie (Indianapolis and Edinburgh: University of Indiana Press and Edinburgh University Press, 2007).

19. *The Danish Directors: Dialogues on a Contemporary National Cinema*, ed. Mette Hjort and Ib Bondebjerg (Bristol: Intellect Press, 2001); *The Danish Directors 2*; *The Danish Directors 3*.

20. Mette Hjort, Eva Jørholt, and Eva Novrup Redvall, "Learning to become a filmmaker in Denmark: The National Film School of Denmark, Super 16 and the Film Workshop in Copenhagen," in *The Danish Directors 2*: 22–26; Mette Hjort, "Denmark," in *The Cinema of Small Nations*.

21. Mette Hjort, "Affinitive and Milieu-Building Transnationalism: The Advance Party Project," in *Cinema at the Periphery*, ed. Dina Iordanova, David Martin-Jones, and Belén Vidal (Detroit: Wayne State University Press, 2010). See also, Mette Hjort, "On the Plurality of Cinematic Transnationalism," in *World Cinemas, Transnational Perspectives*, ed. Nataša Durovicová and Kathleen Newman (London and New York: Routledge, 2010).

22. See Duncan Petrie's "Film Schools Symposium Report for TFTV Research Committee" (2009), www.york.ac.uk/.../FILM%20SCHOOL%20SYM.... (accessed November 5, 2012).

23. Duncan Petrie, "Theory, Practice and the Significance of Film Schools," *Scandia* 76 (2010); "Theory/Practice and the British Film Conservatoire," *Journal of Media Practice* 12 (2011); "Creative Industries and Skills: Film Education and Training in the Era of New Labour," *Journal of British Cinema and Television* 9 (2012).

24. Tom Edgar and Karin Kelly, *Film School Confidential: Get In. Make It Out Alive* (New York, NY: Perigee, 1997).

25. *Projections 12: Film-makers on Film Schools*, ed. John Boorman, Fraser MacDonald and Walter Donahue (London: Faber & Faber, 2002).

26. Ni Zhen, *Memoirs from the Beijing Film Academy: The Genesis of China's Fifth Generation* (Durham: Duke University Press, 2001).

27. Eva Novrup Redvall, "Teaching Screenwriting to the Storytelling Blind—The Meeting of the Auteur and the Screenwriting Tradition at The National Film School of Denmark," *Journal of Screenwriting* 1 (2010).

28. Heidi Philipsen, "Dansk films nye bølge" ("Danish Film's New Wave") (PhD diss., University of Southern Denmark, 2005).

29. Cornelius Castoriadis, *The Imaginary Institution of Society* (Cambridge: Polity Press, 1987), cited by Meaghan Morris and Mette Hjort in "Introduction: Instituting Cultural Studies," in *Creativity and Academic Activism: Instituting Cultural Studies*, ed. Meaghan Morris and Mette Hjort (Hong Kong and Durham: Hong Kong University Press and Duke University Press, 2012).

30. Toby Miller and George Yúdice, *Cultural Policy* (London: Sage Publication Ltd., 2002).

31. For Dina Iordanova and the Dynamics of World Cinema project, see http://www.st-andrews.ac.uk/worldcinema/; for Marijke de Valck and The Film Festival Research Network, see http://www.filmfestivalresearch.org/ (accessed July 30, 2012).

32. Centre for Cinema Studies at Lingnan University, http://www.ln.edu.hk/ccs/ (accessed June 9, 2012).

Part I

Europe

Practice-Based Film Education in Lithuania: Main Actors and Sites of Struggle

Renata Šukaitytė

The aims of this chapter are to identify the main Lithuanian agents operating in the field of practice-oriented film education, and to analyze their position and positional shifts in the field of culture and art education in general from the perspective of recent history. I will regard the respective field as a "site of struggles" and "power," as Pierre Bourdieu puts it, in which operating agents use different "activities and specific strategies"[1] in order to transform or maintain traditional relations in a given area. In so doing, I hope to identify the key stages of practice-based film education in Lithuania and to reveal the importance of different forms of training or tutoring: those linked to a conservatoire-style model of the film school, and those driven by a search for alternatives and a commitment to "learning by doing." I further argue that Lithuania is quite distinctive as a country when it comes to the "tolerance" it exhibits toward self-trained filmmakers and their ideas. There appears, I contend, to be a kind of intuitive appreciation of the sorts of "molecular" structures that Gilles Deleuze and Félix Guattari have identified in a quite different context,[2] and of the ways in which such structures contribute to a vital kind of creativity that can be crucial for a given milieu.

The History of Film Education and Film Culture in Lithuania

In Lithuania, as in other Baltic Republics, professional practice-oriented film education is relatively young, as is the study of the relevant practices by academics. This situation is caused by such factors as a long period of Soviet control, during which the film sector (including policy, film education, and distribution) was subject to institutional centralization; and the contraction of the local film industry in the years of political and economic transition, when the country had to make new laws and establish new institutions and networks. During this period

of transition, film, quite simply, was not on the government's list of priorities. The Lithuanian film directors and cinematographers who started and developed their careers during the Soviet period were largely trained at the State Institute of Cinematography (VGIK) in Moscow. The VGIK was not only a leading film school; for a long time it was the only available state film school in the entire Union of Soviet Socialist Republics (USSR). Moreover, the school was seen as attractive, inasmuch as the young professionals who graduated from it were guaranteed a job. As David A. Cook puts it, "filmmakers were trained in their specialty at the VGIK in Moscow and then sent out to work in one of the twenty regional or specialized studios [...]."[3]

Despite the prevailing prestige of the VGIK, opinions on the overall quality of the teaching at the School varied inasmuch as talented filmmakers and teachers but also ideological "masters" were entrusted with the task of educating a new generation of Soviet filmmakers. Controversy about this issue is regularly mentioned in memoirs by, and interviews with, Lithuanian graduates of the VGIK. Auteurs such as Vytautas Žalakevičius, Gytis Lukšas, Šarūnas Bartas, and others recall the difficulties they faced when submitting their diploma films, which were considered irrelevant to the ideological program of the School. Even in the late 1980s Šarūnas Bartas found it necessary to switch his specialization from documentary film directing to fiction film direction for similar reasons. Probably because of this incident, during the meeting with students at the Lithuanian Academy of Music and Theatre on April 15, 2012, he responded with considerable reserve to a question about the importance of the VGIK in his life and professional career. His succinct response was as follows: "It was the only available school at that time, and so it couldn't be compared to any other film school. If you wanted to be qualified to work in the professional film industry, and to be seen as credible, you simply had to have a VGIK diploma. It's as simple as that."

That the VGIK has played a crucial role in Lithuania is, however, undeniable. Over a period of 12 years (1953–1965) highly talented and intelligent Lithuanian film directors such as Vytautas Žalakevičius, Marijonas Giedrys, Almantas Grikevičius, and Raimondas Vabalas graduated from the School, as did the cinematographer Jonas Gricius. These names are important ones, for they identify figures who are considered the founders and framers of the so-called "Lithuanian poetic cinema," which encompasses films such as *Laiptai į dangų* (*Stairway to Heaven; dir. R. Vabalas, 1966*), *Niekas nenorėjo mirti* (*Nobody Wanted to Die; dir. V. Žalakevičius, 1965*), *Jausmai* (*Feelings; dir. A. Dausa and A. Araminas, 1968*), *Vyrų vasara* (*Men's Summer; dir. M. Giedrys, 1970*), and many others. At the same time, it is important to emphasize that there were other professionals as well, people who had found an alternative route into filmmaking. These were the Lithuanian Film Studio filmmakers, the most talented and influential "artisans," who succeeded in achieving both national and international recognition. I have in mind here such film directors as Arūnas Žebriūnas (a graduate of the Vilnius Art Institute, who after several years of work at the Lithuanian Film Studio finally attended a short film scriptwriting and directing course at the VGIK in 1962), Algirdas Araminas (a studio-trained cinematographer and film director), Henrikas Šablevičius (a theater actor trained at the Lithuanian Drama

Theater Studio), as well as the cinematographer Algimantas Mockus (a self-trained photographer and a studio-trained cinematographer).[4] Still, the VGIK was crucial in forming the generations of Lithuanian film professionals who emerged in the 1960s and 1970s. The academic culture of the VGIK had a role to play in this regard, thanks to professors Grigorij Aleksandrov, Lev Kuleshov, Mikhail Chiaureli, Aleksandra Chochlova, Igor Talankin, among others. Also, the School offered Soviet filmmakers (and student filmmakers) opportunities to meet their international colleagues, and thus to learn about the novelties of world cinema. Internationally celebrated filmmakers visited the VGIK, and while there, they offered master classes, screenings of their films, and so on.

In spite of differences having to do with modes and sites of training, the film professionals identified above all share a common cultural background, as well as the experience of dramatic historical events in Lithuania. All of them were born, and spent their early youth, in Lithuania before the Second World War— that is, they remember Lithuania as an independent country. They were born into families belonging to the local intelligentsia, which was closely linked to Kaunas, once the temporary capital of Lithuania. These film practitioners all witnessed and experienced the Second World War and their country's occupation by the Soviets. They and their families were dramatically affected by these events. The fear of being killed or deported was constant, and there was the loss of friends and family members, of property, and of social status. It is not surprising that glimpses of these traumatic experiences and memories frequently re-emerge in their films. Moreover, as Vabalas indicated during an interview, the distinctiveness of Lithuania's national cinema (much like the cinemas of Georgia, Latvia, and Estonia) originates in national art traditions, especially those of literature and the visual and performing arts.[5] The theater of Juozas Miltinis has been of special importance, for his unique way of working with actors was very much appreciated not only by Lithuanian directors but also by other prominent Soviet film directors such as Andrei Tarkovsky, Semyon Aranovich, Aleksandr Zguridi, and Vladimir Basov, among others, who, recruited actors whom he had trained for leading roles in their films. Actors who deserve to be mentioned in this connection include Donatas Banionis, Bronius Babkauskas, Eugenija Šulgaitė, and Algimantas Masiulis.

The emergence of an *auteur* cinema (frequently referred to by film critics as a New Wave of Lithuanian cinema) in the 1960s is crucial. The distinctiveness of this cinema in the Soviet context has been accurately defined by the Lithuanian film critic Saulius Masaitis (a graduate of VGIK, with a specialization in film criticism): "First of all, this kind of filmmaking cannot be called Soviet. Talented Russian filmmakers of the time, sensing the 'thaw,' attempted to rethink their own revolutionary history without forgetting to praise their idols. Lithuania has never been the country of revolutions. Thus, young filmmakers chose a different path for their work than Russian directors." Masaitis further noted that: "In the best films of the time, the issues of tragic divisions in post-war Lithuania when brothers killed each other transcended a concrete geopolitical level and reached a universal dimension. Another issue, namely that of survival without losing [one's] conscience and basic human values, was raised in films associated with the so-called poetic

Lithuanian filmmaking."[6] These films were usually seen as belonging to a category of "black Lithuanian film" by the State Committee for Cinematography officers (Goskino), because they lacked a positive attitude toward Soviet life and Soviet people. As such, they often risked being shelved or being allowed only internal distribution (i.e. only in the cinemas of the Soviet Republic of Lithuania).

Lithuanian films of the 1960s and 1970s bring to mind fables such as those of Aesop, for they are rich in allusions, metaphors, and citations. There is minimal verbal expression in these films, which are stylistically comparable to the works of French poetic realism, Italian neorealism, and the new waves of Central Europe. As already mentioned, the works of Raimondas Vabalas, Vytautas Žalakevičius, Almantas Grikevičius, Marijonas Giedrys, Gytis Lukšas, Algimantas Puipa, and Robertas Verba (all of whom belong to the "middle generation" of the VGIK graduates) cannot be seen as Soviet "products" entirely shaped by the VGIK. Besides, it is difficult to measure the impact of the Soviet film school on the relevant directors' filmmaking, especially since their most acclaimed works were mainly produced through the Lithuanian Film Studio and with major participation from local artists (painters, composers, actors, writers, and photographers) who, for the most part, studied in the local academic milieu and nurtured their talents in the local cultural scene. Significant in terms of the national identity of these films is the fact that many contain political and cultural subtexts (expressed via songs, references to art works or historical/cultural figures) that appeal exclusively to Lithuanian audiences and are only intelligible to them. It is thus fair to say that the Lithuanian Film Studio mainly produced local stories aimed at local audiences, to paraphrase Graeme Turner's concept of what counts as a national film industry.[7] During the Soviet period, Lithuanian national cinema was regarded as a form of cultural maintenance, as a means of countervailing the cultural dominance of foreign films originating from an environment that was stronger in industrial and ideological terms. In Lithuania, that stronger context was intimately connected with mainstream Soviet cinema.

It was clear to many Lithuanians that the establishment and development of local academic programs devoted to the training of local filmmakers was a matter of considerable importance, both politically and culturally. Consequently, in spite of the strong centralization of higher film education in the USSR, in 1970 the first TV directing students started degree studies at the Lithuanian State Conservatoire (currently the Lithuanian Academy of Music and Theatre), in the Department of Acting, and under the guidance of the film and TV director Algimantas Galinis. This initiative was a reasonable and, indeed canny, *tactical* step toward the creation of a national film school, for the "small" cinematic genres—documentary and TV dramas produced for the republics' TV screens—were mainly shaped for regional audiences, with no intention of having them reach the big screens of the USSR. There was, in other words, a well-justified, even "natural," need for local "TV craftsmen." Many saw this initiative as decisive for a Lithuanian national cinema, for, as Tom O'Regan aptly puts it, national cinema is "simultaneously an aesthetic and production movement, a critical technology, a civic project of state, an industrial strategy and an international project formed in response to the dominant international cinemas."[8]

Not surprisingly, it was only after the restoration of independence in Lithuania, in the early 1990s, that the first film directing course and degree program in cinematography were launched at the Lithuanian State Conservatoire, with sound directing and film production being established and developed by internationally acclaimed Lithuanian film professionals: Vytautas Žalakevičius, a scriptwriter and film director, Jonas Gricius, a cinematographer, Algimantas Apanavičius, a sound director, and Robertas Urbonas, a film producer. Moreover, in 1993 the Film and TV Department and Educational Film and TV Studio were launched at the Lithuanian Academy of Music and Theatre, thanks to the very considerable efforts of actor and documentary film director Professor Henrikas Šablevičius. Though modest in size, and with only limited funding and equipment, the Film and TV Department has gradually developed and currently manages all major film study programs, including film directing, scriptwriting, cinematography, film editing, sound directing, and film production. The Department also contributes to related study programs, such as film acting and theoretical film studies, at the Lithuanian Academy of Music and Theatre. Currently, the Academy offers the broadest choice of practical film studies degree programs in the Baltic countries. Moreover, with the Lithuanian Ministry of Education and Science granting the Academy the authority to implement a practice-based doctoral program in film and theater in 2012, a new scheme for graduate students will be launched in 2013.

Sadly, in spite of the developments outlined above, film education in Lithuania still has to fight for its rightful place within the field of national art education and for funding. Clear challenges persist although there is growing interest in the relevant fields of study on the part of students, and, interestingly, other academic institutions. The Vilnius Art Academy, the Vilnius Gediminas Technical University, and Vilnius University are slowly developing infrastructure and curricula in the area of audiovisual studies. Names can be revealing, a case in point being that of one key institution, the Lithuanian Academy of Music and Theatre. The absence of any reference to film in this official designation is clearly symptomatic of the problematic nature of the current status quo. The unfavorable situation in question can be explained by the fact that film studies programs and various structural units related to the audiovisual sector are the "new entrants" at the Academy. In Pierre Bourdieu's terms, they have to contend with "the power relations which are imposed on all agents entering the field—and which weigh with a particular brutality on the new entrants."[9] In other words, practice-based film studies have to compete with the performing arts for space, and these have far greater "symbolic capital." "[A]ccumulated in the course of previous struggles, at the cost of specific activities and strategies,"[10] this symbolic capital is embedded in a far longer history of institutionalization and reflected in greater social recognition, and in the support and involvement of a larger community.

This sidelining of the field has clear financial implications, for although the fields of film practice enjoy great popularity among Lithuanian students and generate an excellent rate of employment in the creative industries, they are largely underfunded by the Lithuanian Academy of Music and Theatre and the state. The very need to train film professionals in Lithuania and to maintain a film

school of "our own" has been periodically questioned by representatives from the local film industry, who have suggested that it would be economically more practical to fund young people's studies at prestigious film schools with a global reputation than to maintain the Film and TV Department at the Lithuanian Academy of Music and Theatre. Justifications for this line of thinking include the idea that the Lithuanian institution is incapable, because of what is seen as necessarily limited funding, of meeting rapidly changing demands linked to the infrastructure of teaching.[11] Despite these challenges, the Film and TV Department has managed to provide artistic and pedagogical personnel in core areas. Guided by a powerful commitment to a tradition of pedagogy based on individual work with students, these teachers have nurtured several talented, internationally renowned filmmakers. Key figures in this connection include three documentary film directors: Audrius Stonys (the only Lithuanian winner of the European Felix; in 1992, for *Neregių žemė* [*Earth of the Blind*, 1991]), Arūnas Matelis (the only Lithuanian winner of the Directors Guild of America Award; in 2007, for *Prieš parskrendant į žemę* [*Before Flying Back to Earth*, 2005]), and Audrius Juzėnas. Other names warranting mention in this context are Ramūnas Greičius and Audrius Kemežys (both of whom are cinematographers), sound director Saulius Urbananavičius, and film editor Danielius Kochanauskis (who mainly works with Šarūnas Bartas and Sergei Loznitsa), among many others. Interestingly, the current Head of the Department—TV and film director Janina Lapinskaitė—was a member of the first cohort to graduate from the then Lithuanian State Conservatoire in the 1970s. She is credited with achieving a fine professional balance between the best traditions of the School and innovation, in the form, for example, of new curricula and teaching modes, and the recruitment of young teachers having graduated from the Academy itself or from foreign film schools.

It should be noted that after the 1990s (and especially after 2004, when Lithuania joined the European Union), all sectors of state life, including science and education, were gradually integrated into a transnational European milieu. As a result of these developments, new possibilities emerged, with students and graduates able to develop their skills and knowledge in quite different contexts and through new training programs. Salient in this regard are the practice-based opportunities offered by European Audiovisual Entrepreneurs (EAVE), Eurodoc, and Sources, all of which are supported by the EU MEDIA programs. Foreign film schools and institutions also became more readily accessible, and young Lithuanians can now hope to pursue their filmmaking aspirations at the Film and TV School of the Academy of Performing Arts in Prague (FAMU), at the Tbilisi Theatre and Film Institute in Georgia, at the Bournemouth Screen Academy in the UK, and at the Fondation Européenne pour les Métiers de l'Image et du Son in Paris, France (FEMIS). Those looking to deepen their knowledge of independent cinema are now better able to spend time at the Jonas Mekas Anthology Film Archives in New York, among many other places.

With the help of the Educational Film and TV Studio, the Film and TV Department at the Lithuanian Academy of Music and Theatre has been able significantly to internationalize its activities. This was achieved by joining international

networks and, since 1995, by organizing an international summer school for film students on an annual basis. Thanks to the hard work of Inesa Kurklietytė, the director of the Educational Film and TV Studio, whose funds are provided by the EU MEDIA programs as well as by the national budget, the initiative to internationalize evolved into a small international consortium in 2003–2004. The consortium brought together the Lithuanian Academy of Music and Theatre, the Latvian Academy of Culture, the Helsinki Metropolia University of Applied Sciences, and the National Academy of Theatre and Film Art in Sofia, Bulgaria. Every year this consortium organizes a two-week workshop—Summer MEDIA Studio—in Lithuania, with the participation of an international team of students and professors, who come to the Baltic country with an eye to networking, exchanging *know-how*, learning about new cinematic phenomena, and actually making films (for most of the students, this is their first experience of professional collaboration on an international level).

It is helpful to consider the Lithuanian situation within the larger, regional context of the Baltic states. What is clear is that in the other Baltic countries, the institutionalization of practice-based film education, and its integration into academia, developed on a parallel ground and started with very modest initiatives focusing on directorial training for film and TV production. For instance, the Latvian Academy of Culture was founded in Riga in 1990–1991 as the main state school for educating theater and film professionals. Some ten years later, in 2002, the Academy established the Department of Theatre and Audiovisual Arts, which offers programs in film directing and film studies.[12] If we look to Estonia, we note that "in 1992 an undergraduate program in filmmaking was launched at the Tallinn Pedagogical University (now Tallinn University),"[13] from which the Baltic Film and Media School (a structural unit of Tallinn University) emerged in 2005, as a result of the patronage and passionate work of the film director and professor Jüri Sillart. It is worth indicating that, from the very first moment of its existence, this new school had an ambition to become a central film school in the Baltic region, the intention being to attract large numbers of students and generous public funding from all three countries (Lithuania, Latvia, and Estonia). However, the Lithuanian Ministry of Culture as well as the Ministry of Education and Science decided to maintain distance from the project and, instead, to invest in their own infrastructure and to build a new unit at the Academy, in cooperation with the Lithuanian Film Studio. This unit, known as the Audiovisual Arts Industry Incubator, was seen as a place for students and young graduates, offering them opportunities to work on their creative projects during an early stage in their careers. Meanwhile, the National Film Centre of Latvia would annually allocate grants for Latvian students to study at the Baltic Film and Media School after Boris Frumin, a Latvian émigré filmmaker and professor from the Tisch School of the Arts at New York University, was appointed head of the MA program in Film Arts at the Baltic Film and Media School in 2006 (Frumin would hold this position for only a couple of years). However promising, this initiative was not adequate in terms of meeting the needs of the growing film industry in Latvia. Thus, in 2008 the Riga International School of Economics and Business Administration started a new international postgraduate studies program in Audiovisual

Media Arts, and this in cooperation with the biggest national film industry players, namely Cinevilla Studio and Riga Film Studio.

What the above account makes clear is that in the Baltic countries academies as well as schools and universities belonging to the tertiary sector are sites of struggles on behalf of practice-based film education, and against its marginalization. But these "fights" have what Bourdieu terms "specific stakes," and "the power and prestige"[14] that are pursued thus have to be built on accumulated capital of both a symbolic and an economic nature. With regard to the former, the quality of the professoriate, the curricula, and the student body is key, whereas the latter is reflected in the quality of the infrastructure (whether it is up to date, for example) and in the impact of the various training programs on the growth and competitiveness of indigenous industries.

The struggles have an international dimension that will soon become more intensive for the Baltic agents, because of unfavorable demographic factors and the existence of much stronger competitors in the field. "[F]ilm schools," after all, "have mushroomed throughout the United States and Europe in the last decade, with even small liberal arts colleges—from Montana to New Mexico, and in Europe, from Stockholm to Budapest—offering an education in film production."[15] Compared to the countries of Central Eastern Europe, where national film schools were founded in the 1940s (e.g. FAMU in Prague and the Leon Schiller National Film, Television and Theatre School in Lodz, Poland) and 1950s (e.g. the Institute of Cinematographic Art and Theatre in Bucharest, currently the Caragiale University of Theatrical Arts and Cinematography), Lithuania, Latvia, and Estonia have very modest traditions when it comes to conservatoire-style film education. In light of this, it is not difficult to see why, up until the mid-1990s, the role of national film schools was partly assumed by the national film studios, as well as by amateur film clubs. These other sorts of organizations offered new generations of filmmakers spaces where they were nurtured, and where a rebellious and free filmmaking spirit was fostered and sustained. The importance of local film studios in creating indigenous film cultures is recognized by David A. Cook, who claims that "despite the strong central control of Goskino, the State Committee on Cinematography in Moscow, and the economic dominance of the Russian studios Mosfilm and Lenfilm, each of the national studios [associated with the various republics] produced a cinema with its own ethnic, cultural, and linguistic traditions."[16] The studios and their film professionals can thus be seen as having played an especially important role. In effect, they provided spaces that functioned as creative incubators, spaces where younger generations of filmmakers were brought up with respect for local filmmaking traditions. These, as a result, have survived until the present.

Alternatives to the Conservatoire-Style Model of Film Education

The intent at this stage in the discussion is to identify and examine initiatives pertaining to practice-oriented film education that have mainly been fostered by institutions functioning outside the system of higher education. While outsiders

in this specific respect, these institutions have, nonetheless, exhibited a strong commitment to producing high cinematic culture and to nurturing the new talents who might be able to create distinctive cinematic content. Primarily, these are independent film studios and *art house* cinemas, which operate within the film industry field, and as such they "have political interests which ultimately determine which films are made, not to mention which films are seen."[17] Indeed, analysis of the activities of such institutions revealed that involvement in informal film education strengthened their position within the national and international film field, as their "symbolic power" was enhanced by a certain social or artistic distinction. Reference was made earlier to how outstanding Lithuanian filmmakers of the Soviet era—Algimantas Mockus and Algirdas Araminas, for example—gained their professional skills by working mostly in the Lithuanian Film Studio, and it is appropriate now to examine the impact of this and other studios. Filmmakers such as Mockus and Araminas started out as assistants to film directors or cinematographers and ended up as *auteurs* and producers of exclusive cinematic content frequently referred to as "Lithuanian poetic cinema" (by local and international film critics or festivals agencies) or "Lithuanian black cinema" (by Goskino, the USSR's State Committee for Cinematography). By "producing" new talents and distinctive content (identified by certain stylistic markers and issues proximate to those of other forms of indigenous artistic expression), the Lithuanian Film Studio strengthened its brand, and thus, its importance, both within the Soviet cinema field (where it was recognized by *auteur* filmmakers and by film critics) and within the local (Lithuanian) cultural field. However, growing prestige brought certain contra-actions from the side of Goskino—a certain "symbolic exclusion" was enacted (by shelving films or allowing them only to benefit from "inner distribution"). Such exclusions were possible due to clearly defined "limits of the field" (Soviet cinema schemata), which, in Bourdieu's terms, reveal the tensions and struggles within a field and ensure that certain people have "power over the capital held by all the other producers, [...] through the imposition of a definition of legitimate practice (...)."[18] It is important, however, to acknowledge that such struggles and tensions are not unique to the Soviet cinema field. Every new generation of filmmakers, indeed all peripheral cinematic communities, have to face the definition of the limits of the field or, to be more precise, grapple with questions such as these: What counts as good cinema? How is commercial cinema to be understood? What is a national cinema? For Bourdieu, situations such as these are "the permanent struggles that oppose the ever-emergent avant-gardes to the recognized avant-garde (and which must not be confused with the struggle which sets the avant-garde in general against 'bourgeois artists')."[19]

In an effort to clarify the contributions made by independent film studios to practice-based film training in Lithuania, I discuss several case studies below. More specifically, the aim is to shed light on the involvement of studios such as Kinema, Tremora, Monoklis, and Era Film in the production of new *auteurs* and new forms of "symbolic capital." Before focusing on these production companies, it is helpful, however, to evoke a larger context for understanding the contributions of institutional arrangements that do not fit a conservatoire-style, or film school, model. In her book titled *Is There Life after Film School?*, Julie MacLusky questions the

importance of what film schools have to offer in connection with success on the job market and with a future professional career. Her stated aim is to give "a more realistic idea of the working practices of the film industry"[20] and to demystify certain film professions, for instance, film directing. She points to the importance of a combination of several individual traits and acquired skills (namely, "talent," "brains," "self-confidence," "perseverance," and the "luck [required] to get the first break"), all of which are seen as necessary if entry to this field of intense struggles and tension is to be achieved. MacLusky notes that "at film schools [. . .] the overwhelming proportion of students put all their energies into pursuing the small number of directing jobs available," and she explains this phenomenon by pointing to a specific cause: "the students' obsession with the director's role," which is stimulated by the general tendency in media and film culture to "glamorize" that job; the glamor, in turn, fosters public opinions about the film director as a "genius" creator.[21] The result of all this, MacLusky contends, is that there are "thousands of film students—as well as recent graduates and prospective applicants—who are investing [. . .] time, energy, and money in their education [although they] receive no [. . .] assurance [of entry, let alone success]. Yet applications to film schools continue to rise at an exponential rate."[22]

Seen through the kind of lens that MacLusky provides, training offered within the context of production companies, as well as amateur studios, has much to be said for it. Interestingly, in Lithuania, nationally and internationally acclaimed film directors—namely, Algimantas Puipa, Šarūnas Bartas, and Valdas Navasaitis—can be seen as having benefited from at least two types of film training: before entering the sole film school to which they had access (VGIK), these figures learnt the craft of filmmaking in local amateur film studios, where they were able to experiment freely with the language of film in collaboration with others. There can be no doubt that this period of informal auto-didacticism within the context of a film collective was crucial in developing what is ultimately a mix of group and individual styles, evident in a certain approach to framing, editing, lighting, use of color, and in the preference for nonlinear narratives. What is more, the most internationally renowned of Lithuanian filmmakers, Jonas Mekas (who has lived and worked in exile in the United States of America since 1949), is also largely a self-trained *cinéaste* (having participated at most in a few film workshops and seminars). Yet, this filmmaker managed not only to develop an influential and intimate cinematic style (in the form of a film diary) but also to build a groundbreaking film-milieu in New York,[23] and to inspire future generations of filmmakers (including Lithuanians Audrius Stonys, Algimantas Maceina, and Vytautas V. Landsbergis, among others).

These filmmakers, especially Mekas and Bartas, can legitimately be seen as anti-institutionalists or as film activists, as practitioners who are able to foster "minor cinemas" through the strategies of a "micropolitics," as it has been described by Gilles Deleuze and Félix Guattari in *A Thousand Plateaus: Capitalism and Schizophrenia* (and other works). More specifically, these filmmakers appear to be finely attuned to the dynamics of what Deleuze and Guattari term a process of "becoming molecular." They see the mission (or task) of a political film as involving an ability to actualize and produce certain phenomena (or

subjectivities) via a relational circuit of disparate life elements (or through connections between them), and by forging "lines of escape" from dominant powers. A major film industry—indeed, any type of majoritarian production—is at the service of corporate (dominant) power, as is clearly suggested by the Soviet examples of Mosfilm and Lenfilm, and also the American example of Hollywood. Yet, it is crucial to grasp the point that a minor cinema (such as the ones produced, for example, by Georgian and Lithuanian studios) can be powerful too. A minor cinema, more specifically, may "produce" (and multiply) a "becoming-minor" within a certain field of power. It may, for example, exert a strong influence on the ethics of filmmaking and on certain styles or modes of filmmaking, as a result of the symbolic capital that it acquires and through strategies that it effectively "borrows" from dominant cinemas and transforms. A "micropolitics," in short, produces "molecular minorities," which, as Audronė Žukauskaitė claims, point to "a [kind of] becoming-everybody/everything (*devenir tout le monde*)."[24] As Žukauskaitė sees it, a minority is characterized by multiplicity and dynamism, which constitute its actual power. Like Žukauskaitė, I share Deleuze and Guattari's appreciation of the "molecular" dimension of things, inasmuch as it tends to bring vital creativity to a given milieu and can help to destabilize certain arrangements and perceptions.

A good example of a powerful minoritarian "molecular cinema" is the cinematic phenomenon that Šarūnas Bartas helped to produce, and indeed to "multiply," by establishing and running the Kinema Studio. Launched in 1989, in the era of Gorbachev's *perestroika*, Bartas' Kinema Studio was the first private film studio (engaged in professional filmmaking) to be established in Lithuania. During the era in question, the Soviet people were allowed to establish cooperatives aimed at various commercial activities. The problem for filmmakers, however, was that the creative industries were not seen as belonging to the field of commerce. As a result, Bartas basically had to break the "limits of the field" (and to rock the "molar structure" of the Soviet bureaucracy) in order to achieve his goal. Soon his remarkable success in achieving a degree of "autonomy" within the field in question encouraged other filmmakers of his generation to create their own studios and to produce their own content.[25] At this time the Lithuanian Film Studio, not to mention the entire (former) USSR, was trying to survive economic bankruptcy and cultural agony. The conceptual, financial, and structural support that young filmmakers needed was not easy to find in the periods of *glastnost*, *perestroika*, and, finally, Lithuanian *sąjūdis* (Lithuania's national movement toward independence from Russia). In this context Kinema Studio emerged as a new site of production for a new generation of filmmakers (Audrius Stonys, Artūras Jevdokimovas, Rimvydas Leipus, and Valdas Navasaitis, among others), who, much like their peers in other Eastern or Central European countries, were rebelling against the old, centrally controlled film production system. In Lithuania, these new filmmakers were also opposed to the kind of narrative cinematography that had been nurtured by the avant-garde Soviet-Lithuanian filmmakers who had achieved a degree of recognition.

Thanks to his talents and luck as an entrepreneur, and to his possession of precisely the sorts of qualities that MacLusk emphasizes—"brains," "self-confidence," and "perseverance"—Bartas managed to fund the films that his studio produced

with monies derived exclusively from private sponsors. In the late 1980s and early 1990s, no national scheme for supporting film and culture was available in Lithuania, and so private monies, whether from companies or persons, were the only available option. It was only in the mid-1990s, after gaining international recognition, that Kinema started to coproduce with foreign producers and broadcasters (i.e. TV Ventures, WDR [Germany], Gemini Films [France], Madragoa Filmes [Portugal], Sodaperaga Productions [France]), and thus to cofinance its productions. Equally significant was Bartas' approach as a producer and a mentor: young filmmakers were allowed to shoot what and how they wanted, and this trust that the studio was seen as having in its filmmakers is widely understood to have been very enabling. Kinema productions achieved international recognition at prestigious film festivals relatively quickly, including at Oberhausen, the Berlinale, IDFA, Karlovy Vary, and Rotterdam. Prizes and nominations allowed the studio to accumulate much needed symbolic capital: *Trys dienos* (*Three Days*; dir. Šarūnas Bartas, 1991), for example, premiered at the Berlinale and was nominated for the European Felix'92 in the category of "Young European film"; *Neregių žemė* (*Earth of the Blind*; dir. Audrius Stonys, 1991) won the Felix'92 for "Best European documentary"). Recognition of this kind enabled Kinema to assume a respectful position in the national cinema field and rapidly to multiply the achievements of its "micro politics."

Šarūnas Bartas' leading position in Lithuanian film of the 1990s has been acknowledged not only by his peers but also by his older colleagues, such as film director Algimantas Puipa.[26] Bartas' obvious talent, coupled with his entrepreneurial outlook and methods, made him an inspirational figure for the filmmakers of his generation, many of whom were influenced by his filmmaking style, with its emphasis on non-narrative, nonverbal storytelling, on long takes, on the involvement of amateur actors, and so on. The cinema to which Bartas contributed, whether directly, as a director, or indirectly, as a source of influence, is "imperfect" from a technological and narrative point of view. Like most "new waves," it has clear elements of what Deleuze calls the "time-image."[27]

Bartas' early films, namely *Praėjusios dienos atminimui* (*In the Memory of a Day Gone By*, 1990), *Trys dienos* (*Three Days*, 1991), and *Koridorius* (*The Corridor*, 1995), accurately document the vanishing remains of a once "powerful" empire and question the loss and disappearance of a previously common territory and form of shared belonging. The films do this, among other things, through an emphasis on close-ups and long shots. Film characters (who unmistakably are antiheroes) silently observe the outside world and each other, but are not able to establish sensible relations with each other or to change their lives. They are closed inside their own world, which consists of an assemblage of recollections and dreams, and a sense of an unstable present. The editing in these films intentionally lacks logical connections so as to give an impression of spontaneity and uncertainty with reference to the newly crystalizing nation and state. These films have the feel of a kind of "mnemonic device"—a sort of artificial memory—referencing a past associated with sadness, uncertainty, and alienation. Examples include the works of other filmmakers: *Dešimt minučių prieš Ikaro skrydį* (*Ten Minutes Before the Flight of Icarus*; dir. Arūnas Matelis, 1991) *Rudens sniegas* (*The Autumn Snow*;

dir. Valdas Navasaitis, 1992), and *Neregių žemė* (*Earth of the Blind*; dir. Stonys, 1992). The filmmakers can be seen as aiming to provide a take on the historical and societal shifts occurring not only in Lithuania but also in the wider region. Also, the aim, clearly, was to experiment with film genres and conventions. In this connection, a certain insistence on time, and on a kind of liquidity of being, became emblematic of the real in these films, all of which took a symbolic approach to the depiction of significant social, cultural, and political changes taking place in the country at the time.

The key point to be made about Šarūnas Bartas in the present context is that he developed his personal cinematic style, and the cinematic infrastructure that has served him and his colleagues so well, beyond the reach of the cinematic or artistic establishment and without support from a public framework. In this he is by no means alone, for the same can be said of Jonas Mekas, who also warrants discussion, but can only be mentioned in passing here. Significantly, Bartas seriously downplayed the importance of formal film schooling in developing film talent. He himself made his first films at the age of 17, and a few years later, in 1983, he made a number of independent films at the Kaunas-based experimental (amateur) film studio, Banga, supported by the state Banga TV and Radio Factory. The studio was installed on the roof of the factory—a former building belonging to the Resurrection Church—where a chapel once stood. In this former chapel, a cinema hall was created, and there was also a small editing room. Young people who were affiliated with the Banga studio also ran a film club and a small studio that was available to children and the general public. So, in addition to filmmaking, Šarūnas Bartas, Valdas Navasaitis, and Leonardas Surgaila, all of whom were involved with the Banga studio, were also active in film education, which was not being promoted in any kind of official way. In this studio Bartas, working together with his colleague Valdas Navasaitis, produced his first internationally celebrated documentary *Tofolarija* (*Tofalaria*, 1985/86). Although the film is of high quality, in both artistic and technical respects, unfortunately, it could travel only on the circuit of film festivals for amateur filmmakers. That is, the situation in the Soviet Union was such that a filmmaker's work could enter a wider network of public distribution, or be featured at prestigious film festivals, only if the director had a bona fide diploma in filmmaking. Seeking, then, to legitimize himself as a filmmaker, Bartas finally applied to, and entered, the VGIK in 1989, as did his colleague Navasaitis. It should be noted, though, that he was an infrequent participant in classes, for all along he was busy with activities being run through his independent studio, Kinema.

Bartas' initiatives inspired many studios, among which are Era Film (established in 2001 by film producer Rasa Miškinytė), Tremora (established in 2005 by film producer Ieva Norvilienė), and Monoklis (founded in 2006 by film director Giedrė Beinoriūtė, theater director Antanas Gluskinas, and film producer Jurga Gluskinienė). All of these studios have consistently contributed to the training of filmmakers in Lithuania, just as they have been involved in helping aspiring filmmakers to develop their projects. In Lithuania, there are very few opportunities to become involved in training initiatives outside the established degree-conferring arrangements. Rare exceptions include seminars organized by the MEDIA Desk

Lithuania, activities mounted in connection with film festivals or *art house* cinemas (such as Skalvija Cinema Centre and Pasaka Cinemaboutique in Vilnius). Tellingly, this unfavorable situation is mentioned in the report produced in 2009 by the KEA European Affairs, in association with the researcher Norbert Morawetz. This report states that the "limited existence of further training [for young and established professionals] complicate[s] Lithuania's ability to retain its industry's skills level."[28] Because no arm of the relevant agency exists in the local field, Lithuanian filmmakers quite frequently participate in training sessions and forums funded by the EU MEDIA program. Examples include Sources, ScripTeast, Ex Oriente Film, and Eurodoc, among many others. Meanwhile, certain film studios, especially Tremora and Era Film,[29] are occasionally "transformed" into *temporary media laboratories*, the aim being to provide training sessions and master classes.

According to media theorist Geert Lovink, a *temporary media lab* tends to experiment with "social interfaces, visual language, and cultural-political processes" and does not limit its activities to "an ongoing event but, instead, targets the hands-on production of content in and around an already-existing group or network of groups and individuals."[30] Lovink is very enthusiastic about this dynamic form of social interaction inasmuch as its "immediate outcomes can be presented at the end of the session," while their real impacts in turn can be multiplied and fully realized later, and, indeed, elsewhere. That the relevant creative process can be neither fully predicted nor controlled is at once its defining characteristic and its strength. Among the possible impacts, no doubt, is the rise of a "creative class" in Lithuania, to use Richard Florida's term. As Florida understands it, this term picks out an important sociocultural phenomenon, one that involves a bottom–up force that drives innovation and helps to create a dynamic cultural and public domain.

One of the most active players in the field of informal education is the studio Tremora. Working with the Vilnius International film festival Film Spring, as well as with tutors from the script development workshop Sources 2 (i.e. David Wingate) and ScripTeast (i.e. Christian Routh), Tremora organizes master classes in scriptwriting on an annual basis, the view being that the Lithuanian film industry suffers from unprofessional scripts. The Tremora studio works mainly with emerging film directors (namely Kristina Buožytė and Ignas Miškinis) and self-educated cinéastes (such as Saulius Drunga), whose scripts are seen as meriting further development and input of a professional nature. It is noteworthy that Ieva Norvilienė, the studio's director and its principal producer, is herself an active participant at international forums and training sessions (especially those initiated by the Film Business School in Ronda, Spain, by the European Post Production Connection, the East European Film Alliance, the European Film Promotion, EAVE, and the Toronto Producers LAB). Norvilienė's active participation in this network of training initiatives has, no doubt, contributed to the success of the Tremora studio's films, which have been relatively quick to gain national and international visibility. For instance, *Artimos šviesos* (*Low Lights*; dir. Ignas Miškinis, 2009), the director's second feature, was coproduced by the German company Dagstar Film, with support from Lithuanian and German public funds as well as monies from pan-European sources (Eurimages and MEDIA). The film was shown at numerous international film festivals (Karlovy Vary, Warsaw,

Pusan, and Hamburg, among others) and was promoted by international sales agent Media Luna, and by national and international distributors. Also, *Anarchija Žirmūnuose* (*Anarchy in Žirmūnai*, 2010)—the feature fiction debut of a trainee from ScripTeast and Sources called Saulius Drunga—gained recognition from the MEDIA program. More specifically, the program's experts granted Drunga the New Talent Award in 2007 for Best Script. This in turn gave the film an important point of entry to the international festival circuit.

It is noteworthy that Lithuanian film studios are more and more keen to trust filmmakers who have no professional training. In the last few years the indigenous film industry celebrated several outstanding directorial debuts by "amateurs," by anthropologists Mantas Kvedaravičius (*Barzakh*, 2011) and Mindaugas Survila (*Stebuklų laukas/Field of Magic*, 2011), and by painter Emilis Vėlyvis, whose black comedies *Zero* (2006) and *Zero II* (2010) have topped the national box office and are among the most financially successful films in the Baltic countries. Apparently, until now the most surprising and astonishing directorial debut has been the documentary *Barzakh* (2011), which was directed, shot, edited, and coproduced by Mantas Kvedaravičius, a doctoral student in cultural anthropology at the University of Cambridge, who has been writing a dissertation on the painful effects caused by political regimes in Chechnya. Interestingly, Mantas Kvedaravičius has no film or art training at all. Nevertheless, the concept of Kvedaravičius' film and its visual material (prepared by Kvedaravičius himself) attracted the attention of Finnish *auteur* and entrepreneur Aki Kaurismäki, who got involved in the project as a coproducer and also brought on board the Finnish Film Foundation and the national broadcaster YLE TV2. The film premiered at the Berlinale in 2011 (and won several awards, including the Special Mention awarded by the Ecumenical Jury) and continues to travel to prestigious international film festivals and to garner awards. Survila's documentary *Stebuklų laukas* (*Field of Magic*, 2011) was developed at and produced by the Vilnius-based studio Monoklis, where it benefited from considerable support from documentary filmmaker Giedrė Beinoriūtė and producer Jurga Gluskinienė. The film takes an empathetic, respectful, and convincing look at the homeless people whose temporary home for several years has been the Kariotiškės dump and Buda wood, located 40 kilometers from Vilnius. Programmers of several film festivals, namely Toronto, Doc Point, and Hot Docs, among others, have included this film by an amateur without film training in their prestigious programs.

The success of *Barzakh* and *Field of Magic*—both of them conceptualized, shot, and directed by anthropologists having no formal or professional experience in the filmmaking field—can be partly explained by the civic sensibility that they express. At the same time, it is important to recognize the role that the involvement of a professional crew, as well as backing from respectful players in the film field, likely played. Another important factor here is a certain conceptual shift in the professional filmmaking milieu in Lithuania. That milieu seems to have recognized a point that Graeme Turner has made about film more generally, in connection with certain shifts that he sees as desirable: filmmaking "is not essentially an aesthetic practice; it is a social practice which mobilizes the full range of meaning systems within the culture,"[31] inasmuch as "we can locate evidence of the ways in

which our culture makes sense of itself"[32] in the stories filmmakers tell. Seeing filmmaking in this light, claims Turner, marks a shift away from well-established paradigms and is also a precondition for a new reconnection of "films with their audiences, filmmakers with their industries, [and] film texts with society."[33] In the sphere of practice-oriented film education in Lithuania, initiatives mounted on an informal, flexible, bottom–up, and often temporary basis appear to be highly effective accumulators and accelerators of national and international film culture and industry. Driven by a sense of like-mindedness, by a commitment to sharing resources, including skill and expertise, and by an understanding of film's value to society, these initiatives offer ideal opportunities "to recharge the inner batteries in the age of short-lived concepts,"[34] as Geert Lovink playfully and sharply puts it.

Concluding Remarks

This account of key agents in the field of practice-based film education in Lithuania, and of the sites where they operate, reveals crucial differences having to do with preferred approaches and practices, philosophies of culture, and understandings of the film industry. It highlights the importance of educational activities undertaken by both the film schools and the independent film studios, in terms of building the filmmaking milieu and educating new talents. Interestingly, the slow (and still ongoing) recognition of conservatoire-style and informal practice-oriented film education—as a significant segment of contemporary national education and as critical to the thriving of the film industry—started with gradual support from within the industry itself. What has been crucial is the active participation of filmmakers in developments toward a national film school (first at the Lithuanian State Conservatoire and subsequently at the Academy of Music and Theatre) and in film education practices mounted by art house cinemas, festivals, and production houses. Within the general field of national culture and education in Lithuania, the situation of practice-based film education involves a "tactical existence," to use Michel de Certeau's terms. Practice-based film education in this Baltic country has nothing like a domain or territory of its own. What is more, in its operations, practice-based film education is generally dependent on the prevailing conditions at any given moment in time, and on any favorable circumstances that might happen to emerge, as government bodies with the authority to regulate and fund the culture and education sectors go about their policy work. At the time of writing, neither the Ministry of Culture nor the Ministry of Education and Science administers a particular funding scheme dedicated to film and media education. Equally troubling is the fact that the relevant sector is entirely marginalized in a new edition of the national Film Act, passed on December 22, 2011 (no. XI-1897). It is possible that the acquisition of what counts as solid symbolic capital, along with demonstrable and measurable impacts on the local film industry, as well as on the education sector, will change the current status quo. In the meantime, there is hope to be found in the good use that is being made of the temporary media lab model, which has been widely embraced by Lithuanian organizations working in the film education field.

Acknowledgments

I would like to express my sincere thanks to the editor of this book, Mette Hjort, for her valuable feedback and thoughtful comments at different stages of the writing, and for her editorial help. Research for this chapter was undertaken with the financial support of the EU Structural Funds project entitled "Postdoctoral Fellowship Implementation in Lithuania."

Notes

1. Pierre Bourdieu, "The Intellectual Field. A World Apart," in *Theory in Contemporary Art since 1985*, ed. Zoya Kocur and Simon Leung (Oxford: Blackwell Publishing, 2005), 11–18.
2. Gilles Deleuze and Félix Guattari, *A Thousand Plateaus. Capitalism and Schizophrenia* (London: Continuum, 2010).
3. David A. Cook, *A History of Narrative Film* (New York and London: W.W. Norton & Company, Inc., 2004), 699.
4. In the first decade after the Second World War, the Lithuanian Film Studio accepted technical workers (who gradually became creative workers) without a graduation diploma from the VGIK or its equivalent, because education was not accessible for most young people at this time (as they had to rebuild the devastated country). During the 1970s–1990s each film director, scriptwriter, cinematographer, producer, and other member of a given creative team was required to graduate from the VGIK, the Leningrad Institute of Theatre, Music and Cinematography, or republican equivalents.
5. A fragment of an interview with Raimondas Vabalas (conducted by film critic Rasa Paukštytė) was published in a catalogue of films for a retrospective held from September 13–20, 2002, in Cinema Skalvija in Vilnius.
6. Saulius Macaitis, "The Sixties," in *The World of Lithuanian Images. Litauische Bilderwelten*, ed. Myriam Beger, Lolita Jablonskienė, Birutė Pankūnaitė, and Rūta Pileckaitė. English translation by Artūras Tereškinas (Vilnius: Contemporary Art Information Centre of Lithuanian Art Museum, 2002), 8.
7. Graeme Turner, introduction to the chapter titled "Industries," in *The Film Cultures Reader*, ed. Graeme Turner (London and New York: Routledge, 2002), 135.
8. Tom O'Regan, "A National Cinema," in *The Film Cultures Reader*, ed. Graeme Turner (London and New York: Routledge, 2002), 139.
9. Bourdieu, "The Intellectual Field," 12.
10. Ibid.
11. In the report titled *The Impact of European Support Programmes on the Audiovisual Industry in Lithuania*, which was commissioned by the Media Desk Lithuania and implemented by KEA European Affairs in association with Norbert Morawetz, it is claimed that "Satisfaction with the current standard of training at the LMTA was rather modest among several stakeholders consulted. The Academy itself indicates in its Strategic Action Plan for 2008–2010 that it suffers from 'perpetual insufficient financing', which increasingly poses a threat to its competitiveness in the international market of art education." (*The Impact of European Support Programmes on the Audiovisual Industry in Lithuania*, Vilnius: The Media Desk Lithuania, 2009, 30).
12. *Business Models and Value Chains in Audiovisual Media. Research within the Framework of the Baltic Sea Region Programme FIRST MOTION 2007–2013.*

Research carried out by SIA Jura Podnieka studija (Riga: SIA Jura Podnieka studija, 2010), 4; http://www.firstmotion.eu/art/MediaCenter/FirstMotion/Results %20and%20Outcomes/BalticSectoryStudy.pdf (accessed June 1, 2012).

13. Lauri Kärk, "Estonian Film: From Bear Hunt to Autumn Ball. Notes on Estonian Film History," *Kinokultura*, Special Issue 10: Estonian Cinema (March 2010), http://www.kinokultura.com/specials/10/kark.shtml.

14. Bourdieu, "The Intellectual Field," 13.

15. Julie MacLusky, introduction to *Is There Life after Film School? In Depth Advice from Industry Insiders* (New York and London: Continuum, 2003), xi.

16. Cook, *A History of Narrative Film*, 699.

17. Graeme Turner, *Film as Social Practice* (London and New York: Routledge, 2006), 182.

18. Bourdieu, "The Intellectual Field," 14.

19. Ibid., 13.

20. MacLusky, introduction to *Is There Life after Film School?*, xiii.

21. Ibid.

22. Ibid., xi.

23. Jonas Mekas established himself as a globally recognized filmmaker and as the ideological leader of the New American Cinema Group without support from any established film institution. For example, in 1946–1948 he studied philosophy at the University of Mainz while housing himself at a camp for displaced persons. Soon after arriving in the USA, in 1949, Mekas, along with his brother Adolfas, got involved in a wide range of cultural activities. He also immediately purchased his first camera, a Bolex, and started to document the life of Lithuanian immigrants in Williamsburg, Brooklyn, and the cinematic and cultural life of New York. (In 1951 Mekas attended Hans Richter's courses at City College Film Institute.) It was not until the mid-1960s that Mekas began to realize his diary-shaped film project; encouraged by Gerald O'Grady in 1967 he edited his first "diary film" titled *Diaries, Notes, Sketches, or Walden*, after which (in the 1970s), he made other well-known films, namely *Reminiscences of a Journey to Lithuania* in 1971–1972 and *Lost Lost Lost* (1976). In addition to filmmaking he organized avant-garde film screenings in the independent art galleries and cultural centers of New York, became an editor of the film magazine *Film Culture*, and participated in establishing an infrastructural framework for independent filmmakers, namely Film-Makers' Cooperative (FMC), The Film-Maker's Cinematheque, and Anthology Film Archives.

24. Audronė Žukauskaitė, "Ethics between Particularity and Universality," in *Deleuze and Ethics*, ed. Nathan Jun and Daniel W. Smith (Edinburgh: Edinburgh University Press, 2011), 196.

25. In 1992, after graduating from the Lithuanian State Conservatoire with a focus on film and TV directing, Arūnas Matelis established the second indigenous independent film studio, Nominum. Kinema and Nominum are still vibrant production houses in Lithuania, actively involved in coproductions with international companies.

26. Mindaugas Klusas, "Puipos tvirtovė moterų gynybai," *Lietuvos žinios* (January 12, 2012), http://www.lzinios.lt/Pramogos/A.Puipos-tvirtove-moteru-gynybai-video (accessed October 15, 2012); Laima Žemulienė, "Nutapytas gyvenimas už kadro," *Lietuvos diena* (June 24, 2011), http://www.diena.lt/dienrastis/priedai/sokoladas/nutapytas-gyvenimas-uz-kadro-360441#axzz29SRGoWTk (accessed October 15, 2012).

27. In *Cinema: 2: Time-Image* (1985), Gilles Deleuze develops the concept of "time-image." He argues that a direct "time-image" (or pure representation of time) "clearly goes beyond the purely empirical succession of time—past-present-future," as it is "a coexistence of distinct durations, or of levels of duration; a non-chronological order." For Deleuze the "time-image" is open to change, inasmuch as it involves a set of temporal

relationships from which a potentially variable present flows. The problems confronted and reflected on in "time-image" films are never fully resolved, for these films pose questions rather than trying to provide answers or solutions. This openness strengthens the sense of the flow of time and points to the future as open to change. This kind of filmmaking emphasizes thinking and was seen by Deleuze as being closely associated with the *auteur* cinema (especially from the 1940s–1970s). See, Gilles Deleuze, *Cinema 2: Time-Image* (London: Continuum, 2010), xii.

28. *The Impact of European Support Programmes on the Audiovisual Industry in Lithuania*, 33.

29. See, for example, the residency programme DOCRES VNO, which was launched and supported within the context of the Vilnius–European Capital of Culture 2009 initiative. See, http://www.erafilm.lt/en/docres-vno

30. Geert Lovink, *Dark Fiber: Tracking Critical Internet Culture* (Cambridge: MIT Press, 2002), 249.

31. Turner, *Film as Social Practice*, 236.

32. Ibid., 4.

33. Ibid., 236.

34. Lovink, *Dark Fiber*, 249.

2

Mapping Film Education and Training on the Island of Malta

Charlie Cauchi

While on location, shooting *Casino Royale* in 1968, British director Val Guest wrote an article for *The Times of Malta*, in which he described the small, newly independent island as an up-and-coming, low-cost alternative to more established runaway production sites like Italy, Spain, and France.[1] Albeit quaint, Guest depicts a country eager to lure Hollywood to its shores. "I knew," he asserts, "there was an emergent film industry in Malta when the uniformed boy who brought my baggage up to my hotel room informed me that should I ever need them, his whole family, numbering nine, could always make themselves available for work as extras."[2]

Much like the eager bellboy, from the early 1960s Malta was more than willing to make itself available to accommodate foreign producers; but with no adequate infrastructure in place for at least 40 years, international production remained sporadic and haphazard at best. It was not until the establishment of a film commission in the early 2000s that Malta eventually emerged as a viable contender in the global film production network, or, as Daniel Rosenthal christened it in *The London Times* in 2002, "the mini-Hollywood of the Mediterranean."[3] Unlike Hollywood, however, Malta does not have a vast pool of talent experienced in the field of film production, there are no adequate sound stages for large-scale productions, and there has been no *official* or *recognized* tradition of producing or promoting domestic films locally or internationally. Perhaps this is set to change.

The title of this chapter is borrowed from Malta's National Cultural Policy (NCP) in order to foreground the island's commitment, not only to the cultural and creative sectors but specifically to audiovisuals, presenting the latter as "a significant cultural industry that now plays a very important cultural and economic role in Malta."[4] Acting as a framework for the cultural sector in Malta, the policy, officially launched in 2011 under the governing Nationalist Party, outlines the government's initial plans to incentivize the creative industries. There has been a considerable increase in state support for culture and the arts in recent years, with government seriously considering the effects a creative industry can have on the country's socioeconomic development. It can be assumed that it is the external

pressure brought by EU membership (Malta joined in 2004), coupled with the Council of Europe's decision that Malta host the European Capital of Culture in 2018, which has, in part, influenced government's substantial investment in culture.

Included in the policy are measures aimed at developing the island's audiovisual infrastructure, with the term "audiovisual" encompassing "broadcasting, new media, creative online content, film and cinema."[5] The fact that the latter two categories are defined in cultural and not merely economic terms is not to be taken lightly. The incorporation of film and cinema within a cultural context is a breakthrough for Malta, as local authorities had previously regarded the medium as a mere means of generating inward investment, essentially through film servicing, rather than as a national cultural endeavor. Prior to the creation of the NCP, film had seldom been incorporated into public discourse or discussed in specifically cultural terms. This inclusion of film in the NCP allows the medium to be recognized as a cultural product. Indeed, it situates film firmly within a comprehensive framework where stakeholders are identified and objectives related to the relevant medium are outlined and defined.

The Culture and Audio-visual Unit (henceforth AV Unit) within the Parliamentary Secretariat for Tourism, the Environment and Culture has identified a number of key issues to be addressed in relation to film, including reforms to education, exhibition, censorship, and copyright. But the main objective, it maintains, is to support indigenous film production. While most other nations have long recognized the benefits of indigenous filmmaking, Maltese authorities have only recently become cognizant of the impact that a domestic film industry can have, not only economically but also culturally. To quote the NCP directly:

> The fostering of the Maltese Film industry remains high among the cultural priorities of government and functions as a necessary complement to support structures aimed at attracting foreign large-scale audio-visual productions.[6]

The policy incorporates film servicing and indigenous film, allowing both officially to sit side by side, in black and white. As part of its proposed strategy and vision, the government intimates a commitment to develop Malta's cultural and creative industries, and additionally ratifies the impact education can have on the professional advancement of its citizens. With particular reference to local capacity building in the area of filmmaking, the policy states the following:

> By bringing together the key stakeholders in the sector, government shall ensure that educational and training provision for the sector is strengthened and reflects current developments in the industry and in the relevant supportive technology.[7]

This chapter will attempt to map and assess the educational and practical training schemes offered to local film practitioners, be they established or amateur, working within the confines of the film-servicing sector, on their own indigenous productions, or both, hereby opening up hitherto uncharted territory. It will examine the official initiatives that have been created through higher education programs and by governmental agencies. Furthermore, it will consider the influence of nongovernmental organizations, specifically the Malta Cine Circle (MCC)

and Kinemastik, on local filmmaking practices. The MCC, originally the Malta Amateur Cine Circle (MACC), is an NGO established in 1952; Kinemastik was set up in 2005. Therefore, this work will span a period of roughly 70 years. This chapter will also attempt to determine how such initiatives have contributed to Malta's own filmmaking output, and how local filmmakers perceive such schemes.

Traversing the Maltese audiovisual landscape has been bumpy, to say the least, proving more often than not to be an arduous journey, where I have had to navigate rumor, speculation, and negation, a customary process in the Maltese context. Currently, the audiovisual sector is highly fragmented, split across a number of ministerial portfolios and institutions, and without any formal connection to a central organization. As yet, there is no national cinematic institution or lead strategic film body, and at present both the Ministry of Finance, the Economy and Investment and the Ministry for Tourism, the Environment and Culture (MTEC) share (though not in equal measures) responsibilities related to film. Add to this the disparate number of NGOs that also have a stake in film and the fact that film-related material and data have gone undocumented or are lost or unavailable, and it becomes clear that any attempt to chart and analyze activity related to this field of enquiry is fraught with problems. This study may, therefore, contain gaps and inconsistencies, its development at times being hindered by forces beyond the author's control.

As there is no comprehensive archive for film, and because much of the material that does exist is held in private hands, this study has necessitated more than a little detective work. Maltese cinema history is yet to be written, and to my knowledge, besides my own research (which I must emphasize at this stage is still a work in progress), there is no published material on the subject. Therefore this investigation predominantly draws its information from primary sources, including interviews, official state documents, and newspaper articles. Not only did these interviews prove to be thought provoking, but in some instances they seemed to provide the interviewee with the opportunity for happy recollection, stimulating debate, and, at times, catharsis. This work would not have been possible were it not for the numerous individuals who were willing to share their time and expertise with me. I am especially grateful to Daniela Blagojevic Vella, head of MEDIA Desk Malta; Culture and Audio-Visual coordinator Caldon Mercieca; filmmakers Mark Dingli and Pierre Ellul; MCC chairman Vincent Lungaro-Mifsud; and Kinemastik president Slavko Vukanovic. The subsequent section provides a brief overview of the domestic context, and the environment from which this study originates, and in which Maltese filmmakers operate.

A Veritable Micro-State

The Maltese archipelago consists of five islands: Malta, Gozo, Comino, Filfla, and Cominnotto. The latter two are uninhabited. With a population of just over 412,000 (30,000 of which reside in Gozo, and four on Comino) and an area of 316 km², Malta is reported to be the most densely populated of the 27 EU member states. Malta's limited scale and population mark it out as a "veritable micro-state."[8] However, Godfrey Baldachino asserts, "Malta may be small but it is

nevertheless a total society," and adds, "Malta's small size also makes it a very convenient social laboratory in which all social phenomena active in larger societies present themselves just the same but on a manageable scale."[9]

Economies of scale aside, Malta differs from other European microstates in that it is an island. Situated in the center of the Mediterranean, midway between Europe and Africa, its position adds the further disadvantage of insularity, and peripherality. Furthermore, as Thomas Eccardt has indicated, "Unlike its fellow mainland European micro-states, Malta has no big sister—it does not use the language of a big neighbor."[10] Ruled and fought over by a series of invaders—Phoenicians, Greeks, Romans, Byzantines, Arabs, Normans, the Knights of St. John, the French, and the British (among others)—the persistent occupancy of foreigners is reflected in the national vernacular. Though small, Malta has its own distinct language, combining Semitic roots with Romance (mainly Sicilian) influences and, to a lesser extent, English. With its modified Latin alphabet, Maltese did not become a standardized language until the 1930s. Today, Maltese and English are the constitutionally enshrined languages of Malta.

The continuous domination by outsiders still appears to manifest itself culturally, as colonialism is ingrained in the Maltese psyche. It would be difficult, and beyond the scope of this work, to endeavor to provide an elaborate account of the Maltese "condition." But, it is helpful in the present context to highlight some of the fundamental characteristics that make the Maltese, "Maltese," for this facilitates a greater understanding of the sociocultural milieu in which the individuals who populate this work operate. To quote Baldachino:

> [...]the Maltese are largely individualistic, competitive and wary of taking risks, [...] are prone to resort more to individual manipulation than to collective or cooperative action to improve their social position and to defend or promote their interests. This dominant cultural pattern, fuelled by the long historical rigors of colonialism for strategic interests [is] [r]einforced by Catholic imagery, the islands' scarce resources and high-population density, [and] is a powerful force [...].[11]

One has only to examine Maltese sayings and proverbs to discover "images reflecting fears, hopes, knowledge about how the system works, or about how to work the system."[12] Here are some examples: *Aħjar ħobż xott f'darek milli frisk għand haddiehor* ("It is better to have stale bread in your own home, than fresh bread at somebody else's"); *Aħjar jikluk il-klieb milli tiġi bżon in-nies* ("It is better to be eaten by dogs than to need other people's help"); and, my grandmother's all-time favorite, *Ħadd ma jaħsillek wiċċek biex tkun aħjar minnu* ("Nobody washes your face for you in order for you to appear better than they do").[13] All three suggest a suspicion of the Other. This mistrust has possibly engendered an anxiety toward cooperation and, I would argue, extends into local filmmaking practices. Many of those filmmakers interviewed convey this fact. Two in particular were telling in their responses, one claiming, "The filmmaking community lacks community [...]. It's still coming together. There is also a certain amount of 'looking after one's self' and competitiveness. This is a shame and restricts development [...]. I see it in other aspects of Maltese society as well. It might be a result of being in

such a small, restricted territory where it's each man for himself. Pity." Another filmmaker makes a related point: "I [...] strive to network and help others when in need, but I'm the minority in Malta. [...] Remember, we're all competing for a limited market outlined by jealousy and territorialism."

A colonial past along with Malta's small-scale and geographical insularity have also, to some extent, impacted upon the island's institutional structures, specifically those of church and state. With particular reference to the political system, although the voter–party relationship may slowly be starting to change, Malta is in effect a dual society. A competitive two-party system still divides the nation intensely between the Partit Nazzjonalista (Nationalist Party) and the Partit Laburista (Labour Party), and while voting is not compulsory, Malta's electoral participation is the highest in the world.[14] Added to this are the following issues:

> Partisanship in this polarized polity is so pervasive, ingrained and linked to class ideology and locality that preference patterns are known by street. Loyalties are strong, stable and rooted in social and family background ... [C]andidates can employ networks of family and friends to promote their election chances and to achieve greater social control over their sympathizers. They may also be able to reward their known supporters if elected.[15]

While others have written extensively on the subject, it is useful simply to evoke in passing the impact that Malta's political system can have on the day-to-day running of government departments. The potential repercussions that may occur should there be a change in government are outlined by Michelle Cini, who offers that in Malta's polarized political system, the upper ranks of the civil service risk a loss of position.[16]

Adding to the complexities of the political landscape, the Catholic Church continues to have a pervasive influence on Maltese society. Coupled with its relationship to the two-party system, both church and state can affect everyday life, their influence extending to local cultural output. Censorship is a case in point. As the NCP indicates, much needed revisions are also set to be made to Malta's archaic, opaque, and often contradictory censorship laws. For instance, in 2010, a spate of controversial censorship measures taken by Malta's Film and Stage Classification Board—including the banning of the internationally renowned play *Stitching* by Anthony Neilson—ignited a backlash from public and government alike. However, besides being regulated by the Board, a certain amount of self-censorship also occurs. This is due to the sociopolitical intricacies outlined above, coupled with Malta's dense population and small-scale nature. The combination of these factors creates a claustrophobic atmosphere, where close interpersonal relationships can cause individuals to be apprehensive about dealing with certain topics. A key example is Pierre Ellul, who, following the release of his documentary *Dear Dom* (2012), found himself under attack. The film centered on former prime minister Dom Mintoff, causing a furor, essentially among PL figureheads and supporters.[17]

With regard to the economy, Malta's GDP—just under €9 billion in 2011—makes it the least wealthy of the European microstates.[18] As Malta has a high

dependency on exports and a complete lack of natural resources, it privileges the service industry, with the film-servicing sector being a lucrative niche within this bracket that has made a significant contribution to the local economy in recent years.

Open for Business

The year 1998 was a turning point for film servicing in Malta. That year, two big-budget productions visited the island: Ridley Scott's *Gladiator* (2000) and Jonathan Mostow's *U-571* (2000). *Gladiator*, which was shot on location in Malta for 11 weeks and brought an inward investment of US$28 million, was seemingly the motivation government needed finally to maximize Malta's potential as a production location. In 1999 George Hyzler, former parliamentary secretary in the Ministry for Economic Services, unveiled plans to establish a film commission and to shape legislation related to film servicing. In February 2000, the Malta Film Commission (MFC) was established and a film commissioner appointed under the auspices of the aforementioned ministry. Prior to this no official records were kept regarding the amount of production work executed in Malta, though rough approximations for the period between 1991 and 1999 reveal that only 11 feature films, 4 television series, and 11 commercials were partly shot in Malta.[19] With the establishment of the commission, records indicate that in 2000 alone, five film, two television, and five commercial productions visited the island. Although production levels had risen, the government still needed to devise more effective ways to attract inward investment. Despite being less developed than other locations, Malta still had a lot to offer foreign producers: a temperate climate, surface sea-facing water tanks, unique historic locations, and excellent artisanal craftsmanship; while compact in size, it has the ability to double as many other countries (exemplified by Steven Spielberg's 2005 *Munich*, where 42 different locations doubled as seven countries, including Israel and Palestine). But the primary incentive for any foreign producer considering migrating to foreign shores is whether or not it is economically advantageous. That is, while selecting visually attractive or well-suited locations is important, the main factors influencing a production's migration to foreign shores are ultimately economic ones.

Taking this into account, in 2005 the commission was finally labeled a government agency and the Malta Film Commission Act was implemented, thereby granting the commissioner power to award financial incentives to foreign producers. This allowed Malta to differentiate itself further in an already crowded global marketplace. Richard Millar argues that "a fiscal incentive communicates that a territory is 'open for business,' that it is film friendly. In some respects this may seem counter-intuitive, as the presence of a fiscal incentive indicates that a territory is not competing solely on the basis of low costs. So the incentives become a symbol of a territory's 'film maturity.'"[20] With the implementation of the MFC Act in 2005, foreign producers were offered "[u]p to 20 percent of eligible expenditure of the Malta budget of a qualifying production . . . as a cash grant once filming is complete."[21] This remained the case until 2007, when EU State Aid rules were

administered, making Malta a more appealing location by including, amongst other things, an increase in the maximum rebate on expenditure to qualifying productions from 20 to 22 percent, and 32 percent for low-budget films. Instead of simply focusing on intermittent middle- to large-range international features, the Act also made it possible to cater to smaller, more independent projects, often considered necessary to sustain a constant flow of work. An in-depth study is required to assess the impact such incentives have had, though it is possible to assert that the revised fiscal measures introduced in 2007 helped markedly to increase foreign production. The year 2007 is significant in Malta's film-servicing history as it was the first year that a production was either in-prep or in production almost daily, and Malta has managed to sustain this momentum. Although the implementation of tax schemes and financial measures is aimed at attracting foreign investment, it is also expected to provide direct economic benefits as well as support for the local film infrastructure. The increase in demand has also provided some individuals with the opportunity to increase their skills by working on many high-profile productions.

Nevertheless, the recent influx of productions has drawn attention to the serious lack of qualified below-the-line workers in the industry. In February 2011, many service companies expressed concern over the increase in the number of visiting productions, claiming that it would put a strain on local human resources. One industry professional estimated that "there are only about 15 Maltese freelancers who dedicate themselves fully to the film servicing industry [...]. Another 30 to 40 or so actively try to keep themselves free for film servicing but have other jobs, usually in local TV or media related industries."[22]

Many of those working within film servicing are able to develop their skills by working on higher-budget international productions, although the drawback is that expertise often remains limited to a small pool of individuals. However, many practitioners are conscious of the fact that working solely within the confines of film servicing can have its drawbacks: according to filmmaker Mark Dingli, who frequently works on foreign productions, "it's a dead end job," citing the fact that visiting filmmakers bring their own department heads. Keith Abela, an enthusiastic 20-year-old, has gained many of his "production skills by working as a floor and production office runner on foreign film productions." Yet he has decided to continue his "training abroad." This is, in his own words, "because I want to improve my chances of getting into the international film industry and, also because work in Malta is sporadic and unreliable in the long-term, especially at this time."

A report commissioned by MEDIA, published in 2005, similarly emphasizes the urgent need for more training, highlighting the skill gaps of film practitioners in Malta.[23] The report focuses on the training provisions available in the audiovisual industries of 32 countries, including Malta. Besides placing emphasis solely on educating below-the-line workers employed in film servicing, the report also advises that Malta nurture an indigenous industry by offering training in all areas related to film, specifically "scriptwriting and development, production management skills, finance and legal skills, particularly in regard to international coproductions and the maintenance of technical and craft skills."[24]

Contrary to the fact that many reports highlight the lack of indigenous filmmaking, there are, in fact, films being made in Malta by the Maltese that are being consumed domestically. This is never reflected in foreign data or, for that matter, truly acknowledged locally. The Maltese entry for the 2011 edition of the *International Film Guide* written by Daniel Rosenthal also displays this kind of omission: "Although the wait continues for locally produced feature films telling Maltese stories to an international audience, Malta's [. . .] servicing industry experienced record levels of visiting productions in 2010, with more than 300 shooting days."[25] While the other entries collected under the guide's "World Survey" banner manage to draw attention to those domestic products that have been popular within their own national contexts, Malta's entry denies space to more populist works, focusing only on a lack of international visibility. This is not to suggest that Rosenthal is purposefully dismissive of Maltese films or is actively opposed to acknowledging their existence; it is important to clarify that the author's status as an outsider could prevent him from knowing the full extent of the workings of the local audiovisual sector. I would argue that local sources are reluctant, or slightly embarrassed (due perhaps to a perceived lack of aesthetic or narrative quality), to draw attention to those cinematic works that have become increasingly popular with local audiences. There is more work being made locally, in Maltese, and screened in local cinemas now than there ever has been.

Records for Maltese productions are not easily accessible. The only official figures I have managed to obtain—provided directly by Malta's sole distribution agency, KRS Film Distributors—show that more Maltese films are now competing with big-budget films in local cinemas, and proving popular with audiences. According to KRS, of the seven films released since 2007, all have averaged four weeks in the top-ten, some spending over a week at number one.[26] This data excludes a number of films circulated independently by the filmmaker or production company. For instance, the two spoof films *Maltageddon* (Alan Cassar, 2009) and *Maltaforce* (Alan Cassar, 2010) spent a month in the cinema during the Christmas period of 2009 and 2010 respectively, and both remained at number one for the entire month. Similarly, Mark Dingli's self-funded first feature *Kont Diġa* (*I Was Already*, 2009), which according to Dingli was denied distribution by KRS because it was a Maltese film, managed to attract roughly 850 people to the cinema when it was released at St. James Cavalier Centre for Creativity in Valletta.[27] Furthermore, 2008 saw the implementation of the Malta Film Fund, a scheme originally set up by the MFC in conjunction with the now disbanded Ministry for Education, Culture, Youth and Sport. The lack of reference to the scheme in Rosenthal's piece strikes me as unusual.[28]

But it is not just the international press that excludes Maltese productions from filmmaking discourse. On his appointment as film commissioner, Peter Busuttil, in an interview with *Malta Today*, also apparently fails to acknowledge domestic productions:

> While the journey remains uncertain, the goal seems to be quite clear cut: the establishment of an indigenous film industry will be marked by the production of the very first "Maltese film," by which Busuttil means a 90-minute or so feature which can be

screened in mainstream cinemas both in Malta and abroad . . . which, according to Busuttil, doesn't exist yet.[29]

I would suggest that consistent references to nonexistent domestic films effectively negate the existence of the filmmaker. There is a lack of engagement with film, not only from the lower-budget and popular end of the indigenous filmmaking spectrum, but also with those films that are produced by amateur cine enthusiasts. In an interview conducted by Elliot Kotek at the Association for International Film Commissioners pavilion at the Cannes Film Festival in 2012, Busuttil describes Malta's indigenous industry as follows: " . . . there are very few locally grown [filmmakers] . . . there are some Maltese who do work abroad, in Australia for example [. . .] there is this Maltese writer [. . .] who is preparing a project—she's already a film producer and director in her own right—which will be using Malta, but technically speaking that's still Australian Maltese, it's not Maltese, Maltese."[30] So what work, if it exists, is "Maltese, Maltese"?

From Hobby-Nation . . .

A few years ago I met Elio Lombardi, an amateur, self-taught filmmaker who occupies an intriguing place within Maltese filmmaking, simultaneously managing to be a popular yet marginal figure. Lombardi started making films in the early 1980s. Since then he has made around 80 works. He is an industry unto himself, writing, casting, directing and starring in his films, and also distributing his own work personally, among other things by visiting rental shops on the island. When we met he was in the process of shooting his 59th feature. Not only does he produce his pictures independently, he does so on a nonexistent budget. His work has never been screened in local cinemas and is available only on VHS or DVD through an occasional broadcast on local television. Lombardi is not an anomaly. There are others like him in Malta (though possibly not as productive), some of them working with film at an amateur level, and others in a more professional capacity. Their existence has yet to be acknowledged in writing on Malta and film.

As is the case with the majority of the films produced by these filmmakers, Lombardi's budgetary restrictions and lack of support, encouragement, and training are evident in the work itself. Since many amateur productions are perceived to be lacking in quality, in terms of their narratives or aesthetics, they are often dismissed by the more culturally informed viewer. It is reasonable to assume that these films would not succeed in competing in international markets, although Lombardi's work has achieved some success with diasporic audiences in Australia. Perhaps as a consequence of the Hollywood-driven exhibition system, many films made locally are (whether amateur or not) often pitted against mainstream professionalized cinema. For the filmmakers who work with more conventional modes of narration, often attempting to mimic dominant forms of filmmaking, it is understandable that their texts inevitably invite comparison with the works of their trained and professional (and foreign) counterparts. The same can be said of those, like Mark Dingli, who work with a more art-house aesthetic. Again, their films are often assessed against a mainstream benchmark.

Returning to Lombardi, though he has not received state support during his lengthy career, and his work is rarely discussed publicly, he has achieved a relatively moderate following on homeground with a specific Maltese demographic. His popularity, perhaps, stems from his employment of popular generic conventions that are inherent in many of the traditions of Maltese theater, chiefly those associated with *farsa* (slapstick comedy) and *dramm* (melodrama). Both genres have filtered through to popular entertainment to become a staple feature of local audiovisual productions. Vicki Ann Cremona, in her study of Maltese theater from 1960 to 1990, explains that both genres are part of a collective memory of popular theatrical performances dating back to the beginning of the twentieth century. She further remarks that: "This type of [. . .] entertainment, which [. . .] presents melodramatic plots in a style imitative of foreign soap operas, still has a huge popular following. Even in the theatre this type of performance is preferred over more complex and innovative theatre, which is followed mainly by the more affluent classes."[31] The same, I would argue, applies to a number of these amateur audiovisual productions. The term "amateur" is employed cautiously here, and not simply as shorthand to denote inferiority, as is most often the case, or to suggest a lack of professionalism in the approach of these practitioners. I also do not want to imply that all the work done by these practitioners is the same: diverse configurations and attitudinal positions appear within the amateur filmmaking world. It is useful to consider that, "As with works of folk art, amateur films do not fit neatly into classification systems. [. . .] They aren't all just 'home movies.' And even if they were, the millions of home movies around the world in the twentieth century represent a corpus far too vast and diverse to dismiss."[32]

Nonetheless, it is an undeniable fact that when used in relation to filmmaking, the label *amateur* does generally evoke associations with home-movie making, perhaps as it still unconsciously recalls the postwar origins of this practice, when advancements in technology and the appearance of more affordable equipment made it possible for people to produce their own material for domestic consumption. Such works were soon able to move from the domestic space to more public realms. In Malta, the formation of the MACC in 1952 soon established a popular hobbyist filmmaking movement. The organization's role in Maltese image culture deserves more serious attention, as it was the starting point for many filmmakers and practitioners. It would be of benefit to enter the domain of the anonymous, uncelebrated amateur, especially considering that amateur film culture is a dominant part of the local visual landscape, partly due to the fact that Malta itself is a hobbyist nation "[. . .] hav[ing] a long tradition of amateur cultural groups and associations, originally connected to Church-run parish centers and band-clubs. After political Independence in 1964, this activity proliferated [. . .] [A]lthough there is increased recognition of the professional status of employment in the cultural sector, the majority of artists in Malta still operate on a relatively amateur or semi-professional level."[33]

The MACC actually precedes independence, with the first general meeting held in Valletta on December 16, 1952. According to an original document containing the minutes of that meeting, "four promoters" and "thirty-eight prospective members [. . .] attended [the meeting] in response to [. . .] a notice in the local

papers published in English."[34] The initial aim of the circle was "to bring cine enthusiasts together for them to exchange ideas, raise the standard of amateur cinematography generally and to ensure a better supply of cine material and apparatus."[35] The MACC was founded by four businessmen, including Major Gerald Strickland, who was described as "one of the keenest enthusiasts in 8mm cine film."[36]

The profiles of the "promoters" and the manner in which members were recruited accentuate the fact that the organization initially catered to the upper- and middle-class echelons of Maltese society. Besides the names of the individuals associated with the establishment of the organization, especially that of Major Strickland, class distinction is also reflected in the choice of publication and language used to advertise the event as it targeted a particular group. This must be seen in the context of the time, when readership of *The Times of Malta* (where the advertisement originally appeared) was essentially aimed at the Anglo-Maltese and British expatriates. MCC chairman Vincent Lungaro-Mifsud confirmed that the majority of the members during this period were from the British expat community, and "even non-cinema enthusiasts became members, so it also became a sort of film club for the British." Amateur filmmaking in those days was also an expensive hobby. Not only was equipment costly but unprocessed stock would have been sent abroad, given the absence of film-processing labs in Malta at the time (a situation that remains unchanged).[37]

In its heyday, the MACC had over 300 members, but according to Lungaro-Mifsud participation started to dwindle with the introduction of local television in the 1960s.[38] Prior to this, exhibition was an essential component of the MACC experience. "Once a month," explains Lungaro-Mifsud, "up until the late 1960s, the organization held 'guest nights' at the Phoenicia Hotel in Valletta, where members could watch amateur films from all over the world."[39] Besides programming 90 minutes' worth of international amateur film, supplied by a variety of associations, such as the Institute of Amateur Cinematography in the UK, the "guest nights" would also showcase the work of MACC members. In addition, the event would attempt to emulate the cinema-going experience by incorporating into its program a 15-minute newsreel that would preface the main selection. According to Lungaro-Mifsud, the newsreel "was produced by the more experienced, core-group of members. Each month, the selected filmmakers were provided with a roll of film and an assignment. They had to shoot news coverage for the newsreel, add sound and edit it together. We have an archive of these newsreels, dating from roughly 1955 to 1962."

Unfortunately, these newsreels, and other films held by the MCC, are, as of yet, inaccessible. Their films, records, and ephemera are in desperate need of preservation and archiving. Exactly what these filmmakers were producing, I am unable to say, but it is possible to determine from my conversations with Lungaro-Mifsud that several genres were covered, including documentaries, documentations, comedies, and other forms of narrative fiction.

It seems that rather than provide actual training to its members, the club allowed for their work to be screened and evaluated by their peers. Originally, the club proposed that "importers of cine materials give demonstrations to the club

of any new apparatus which comes out from time to time."[40] By the late 1970s, a selected group of members were, annually, provided with the opportunity to take part in a workshop, with the objective of producing their own work under the guidance of a more experienced member, who would act as mentor, taking their work from script to screen. The MCC still organizes workshops, but rather than taking a hands-on approach, the workshops are lecture based, usually tackling subjects like editing and lighting, and given by members who work in a professional capacity in the audiovisual sector.

There is one individual who cannot be overlooked: Cecil Satariano. Originally a member of the circle, his departure from the MACC came in 1972 when one of his entries did not win a competition hosted by the organization. Nevertheless Lungaro-Mifsud acknowledges his contribution to the amateur cinema movement, and Maltese filmmaking generally. Satariano took up filmmaking in 1969 producing films such as *I'm Furious Red* (1971), *Guzeppi* (1972), *The Beach* (1973), *Ilona* (1973), and *Katarin* (1977), the latter being feature-length.[41] *Guzeppi*, the most successful film of his career—which tells the story of the eponymous crippled vagrant—won awards in short film competitions in Nagasaki, London, Cannes, Tokyo, New York, Lisbon, and Hiroshima. *Katarin* also proved successful. Originally shot on 16 mm, it was later enlarged to a 35 mm print by EMI, which purchased the rights to the film. Curiously, it was not released in its native language but was dubbed into English; the dubbing, unfortunately, erased any linguistic nuances. *Katarin* was screened in Malta and London's West End. According to a number of sources, it was the first full-length production by a Maltese ever to be shown abroad, though I have, up to now, found no record of its British release. Unable to comment on the British reception of *Katarin*, I can confirm that on home-ground the film proved controversial, because of its overt sexual content.

Interestingly, Satariano was on the Board of Film Censors, and was also a film critic for one of the leading English language newspapers. More importantly, he published a book on amateur filmmaking in 1973. The book, titled *Canon Fire: The Art of Making Award Winning Movies*, was commissioned by a British publishing company. According to the author, the publication is "a modest compendium of observations, reflections and confessions [that] will make the reader a little more conscious of the creative possibilities of the film medium."[42] *Modest* is perhaps not the word I would use to describe Satariano's manual. The latter, rather, is a testament to his skills and professionalism and operates as a comprehensive guide covering an abundance of topics, including casting, location scouting, and dissemination of the final product. It was, however, a book originally conceived by a foreigner (publisher Cecil Turner), written in English, and aimed at an international market.[43]

According to Lungaro-Mifsud, by the mid-1970s, easier access to technology did not have the resultant effect the Circle had anticipated:

> It's funny, because the cheaper and more user friendly the equipment became the fewer members we had. When video cameras were introduced, there was a massive decline. One year we even had to cancel our national competition. But after the Communications degree was introduced at the University [in the early 1990s], and then MCAST, there has been an increase in the number of submissions.[44]

He also suggests that those students attending courses at the University or MCAST have more of a professional approach than the older members: "They're also more innovative, though most try replicating the big-budget Hollywood films they watch . . . but on a small budget and this really doesn't work."[45]

In Malta many filmmakers deemed amateur by the majority of the public consider themselves professionals and are often working in a paid professional capacity within the local audiovisual sector. The fact that the MACC decided to drop the "amateur" to become MCC in the late 1990s is telling. As one interviewee puts it, "The word amateur connotes . . . well . . . home movies or something else." This hobbyist mentality can be leveled at many cultural pursuits, but really affects filmmakers. A number of interviewees are frustrated by this, with one being especially articulate about the complaints:

> Malta doesn't offer the necessary framework to have an indigenous industry, so it's hard for locals to produce quality films. I'm aware that every country has its difficulties [. . .] [H]ere the general mentality towards filmmaking is [. . .] [that it is] a hobby someone does in his/her free time. Of course, those striving to make a living out of this trade have limited options. [. . .] Also film is not on the government agenda, so it's not a regularized industry so immediately one will be competing with people with lower standards and lower costs. If this industry [were to] be regularized like any other, it would improve on the overall quality of the Maltese film. This will give rise to [a situation where] the trained professionals striving to create valid content overall [. . .] manage to survive.

On the contrary, the government is, in fact, aware that the current perception of locally produced artistic work is that it is "predominantly amateur or hobbyist" and has responded by increasing financial support mechanisms to those working within the creative industries, including film.[46] Although such initiatives are still in their infancy, according to government the success of such schemes are nonetheless "highly dependent on the interest and potential of operators to leap into professional activity and address the aversion to creativity-related risk."[47] The Creative Economy Working Group (CEWG) within the Office of the Prime Minister (OPM) was established in 2009 by MITI and the MTEC to provide a cohesive policy and strategic legislative framework for the development of the Culture and Creative Industries (CCI). The CEWG's Draft National Strategy, published for public consultation in 2012, stresses the need for professionalization in the CCIs, affirming that the key way this can be achieved is to "consolidate the educational framework" and provide accredited, "quality-driven" education and training schemes.[48]

. . . to Professionalization?

In recent years there has been much development in higher and tertiary state education, providing an "upgrade of educational levels of structures to meet evermore demanding international pressures."[49] State education in Malta is free of charge from primary to tertiary level. Thanks to legislation passed in 1977, students who qualify for entrance into higher state institutions are supplied with

financial backing in the form of a monthly stipend.[50] Focusing on state education provided to postsecondary and tertiary students, courses in film offered by the University of Malta (UOM) and the Malta College for Arts, Science and Technology (MCAST) will be analyzed, where possible. The former constitutes a more theoretical strategy, but provides no specific film-focused degree, while MCAST applies a specialized, practical approach to film training.

A diploma course in Communications Studies was first established at the UOM in 1986. The Honors degree program followed, with the first batch of students graduating in Communication Studies in 1992. A Centre for Communication Technology (CCT) was inaugurated in 1993 and in 1995 the Communications Programme became the Department of Communications within the Faculty of Education. In 2001 the CCT became the Faculty of Media and Knowledge Sciences, which houses the Department of Media and Communications. Film education at UOM takes the form of theory-based lectures in cinema, with some practical elements apparently incorporated into the courses. Film studies senior lecturer Dr. Saviour Catania is praised as an inspiration by many of his former students, especially Kenneth Scicluna, a professional Maltese filmmaker whose film *Daqqet Ix-Xita* (*Plangent Rain*, 2010) was one of the first films to be funded by the MFF:"[...] I wouldn't be where I am today without Dr. Catania [...]. Without ever having touched a camera, or been on a set, Salvu has taught me more about filmmaking, than anyone else ever will. His lectures are a goldmine of knowledge [...] It is a shame, and it angers me that he is not given the recognition he deserves. And we are the ones who are missing out."[51] Dr. Catania aside, other alumni seem less content with the practical training offered, stating that as a whole, it lacks overall structure and professionalism: "Our university does no[t] function because the lecturers (in audio-visual) are below standard and have no international industry experience. MCAST also suffers from the same problems So how can you create a decent film-maker? Storyteller?"

MCAST, which was "in existence in the 1960s and 1970s but was phased out by 1977," was reestablished in 2000 as a postsecondary vocational institution.[52] Nine years later, MCAST added two courses offering students the opportunity to gain knowledge and technical competence, "opening pathways leading to careers within the Television and Media sectors."[53] Unlike UOM, MCAST admits students at various ability levels after the age of 16. Depending on their qualifications, students can choose a variety of courses, from Foundation to BA level. Its Institute for Art and Design offers three courses focused on audiovisual training: Extended Diploma in Creative Media Production, Higher National Diploma in Media (Moving Image), and BA in Media (Moving Image). Data for the diploma courses show an increase in the number of student enrolments.[54]

The courses offered by MCAST are awarded by BETEC Edexcel. The incorporation of a BETEC pedagogical framework creates a more vocational orientation, though perusing the college's prospectus it seems that the courses also incorporate theory-based modules. Furthermore, the recent inclusion of a Bachelor's degree displays a reorientation from a purely vocational education system to one that

is more academic. However, MCAST president Joe Farrugia makes the following point:

> MCAST is not [...] competing with the university, nor should it become a second university. [...] the courses offered will have a vocational rather than a purely academic orientation. Therefore, a graduate from MCAST will have a different set of skills that will complement, rather than replicate, those of a graduate from university. This complementary aspect works in the interests of the students in both institutions, as well as industry.[55]

It has not been possible to analyze the syllabus, leaving me unable to comment on the content and structure of the course. However, the creation of courses like these provides evidence of the government's commitment to indigenous audiovisual production, which has been articulated as follows:

> Investment in training professionals in this industry has lagged behind, although recent initiatives spearheaded by MCAST have managed to tap significant European funding for training facilities such as editing suites, video facilities, camera equipment, 3D Graphics software and related items. This complements past and current investments made by the Centre for Communication Technology at the University of Malta.[56]

Additionally, to tackle the professional skills deficiencies underscored by the MEDIA 2005 report, in 2009 the MFC (overseen by former film commissioner Louisa Bonello at the time), in conjunction with the AV Unit, announced plans to construct a year-long AV training course "to incentivize Maltese talent and to build the required capacity to strengthen this industry in Malta."[57]

While participants in the AV training course were expected to have some experience working in the local audiovisual sector, in reality, "we were working with a blank slate," asserts Daniela Blagojevic Vella, adding that this was the first time a training course like this had ever been developed for film professionals in Malta.[58] As the majority of applicants were English speakers and many of them had no experience in or exposure to the international film industry, the focus was predominantly Anglo-centric, and, therefore, the majority of models reflected approaches typical of a UK or Hollywood context. Lorianne Hall, a working professional with previous experience in both the European and Hollywood film industry, worked alongside the MFC and the AV Unit, to create a training program tailor-made for Malta. A comprehensive training plan that took into consideration the exigencies and complexities of the domestic film production context was devised. This program was to enable "participants to gain knowledge of the international marketplace and standard business practices [having to do with] the development of an indigenous filmmaking community." The thinking was that such knowledge would enable participants "to be competitive and [to] function to industry standards," also "on an international level."[59]

Hall, who had previously developed support schemes for filmmakers with organizations such as Skills Set and Moxie Makers, was able to use her past experience

to develop a broad syllabus that would act as a foundation for Maltese film professionals with no previous experience. Taking a more project-based, tutor-led approach, the participants were expected to develop their own project as the course progressed. The goal, it seems, was for each participant to finish the course with a project that could then be taken to the next level. The course provided participants with an extensive overview of the film industry; from scriptwriting, analysis, and development to markets and festivals. A diverse range of internationally recognized professionals were invited to share their expertise, and each individual was also assigned a mentor, either Hall herself or producer and writer Richard Holmes. Hall explained that as "we were working from ground zero," the main aim of the course was to act as a "building block" for future training programs that would allow the participants to then focus on more specific areas of filmmaking. A three-year training strategy had been developed, but never came to fruition. In fact, the course came to an abrupt end, allegedly due to an administrative conflict. "Unfortunately it [i.e. the course] was a failed attempt," concludes Hall, who strongly believes that there is a great deal of talent and enthusiasm in Malta, which is ultimately, and "unprofessionally," marred by institutional disputes and irregularity.[60]

Asked about their experience on the course, a number of the participants voiced the same concerns. One in particular described the course as "very promising, but we need clarity not constantly changing goal posts [...] The AV training was very good this year, but unfortunately fizzled into a dead end with no certification. We need workshops." Dingli also shared his experience, pointing out that "there are so few incentives we take anything we can get. The course was fantastic, and it was a great way to finally meet other people working in Malta too [...] But now we need a more sustainable path." That said, some would suggest that a general sense of apathy amongst the local filmmaking community has an influence. One such person is Pierre Ellul, who, besides working in film himself, is also Malta's national coordinator for EAVE (European Audiovisual Entrepreneurs). Ellul explained that in the four years he has held this post, no Maltese nationals have participated in EAVE, and the filmmaking community has shown little interest in the scheme. Ellul does admit that attending EAVE can be costly, but the lack of interest is also noted by others, Media Desk Malta head Daniela Blagojevic Vella included. Acknowledging that locals are working in a very particular context, Blagojevic Vella remarks that "the danger is when it becomes an excuse."

On the Periphery: Kinemastik

With its own distinct identity, Kinemastik has managed to carve out a niche for itself in the local cultural landscape, as an edgier counter to more standard forms of both film viewing and pedagogical practices in the Maltese public sphere. Like the MCC, Kinemastik operates on a membership basis, procuring funding through private sponsorships and ticket sales, and by tapping into cultural funds. Both NGOs foreground the voices of many working with the medium that might otherwise go unnoticed.

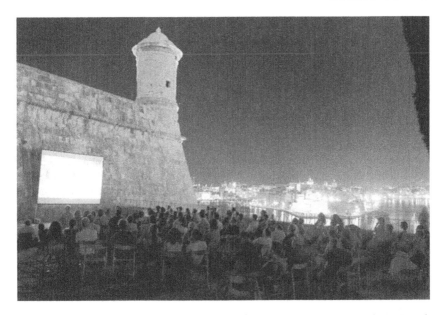

Figure 2.1 Kinemastik's annual International Short Film Festival at Herbert Ganado Gardens, Floriana, overlooking the Grand Harbour

Originally from Belgrade, Kinemastik founder and president Slavko Vukanovic came to Malta in the mid-1990s and established the NGO in 2005. Kinemastik takes a collaborative approach, working not only with filmmakers but also with artists, writers, designers, musicians, and illustrators, presenting a varied cultural program and creative vision. Kinemastik appropriates a variety of public spaces to host its cinema-related events and workshops throughout the year, but its key activity is the Kinemastik International Short Film Festival (KISFF) (figure 2.1). Held over several days in August at various venues across the island, KISFF incorporates a number of workshops for adults and children.

The first workshop was held in 2006, giving "local film enthusiasts [...] the opportunity to meet and interact," explained Vukanovic, adding that a traditional workshop structure is abandoned for something more informal, allowing filmmakers and cineastes freely to exchange ideas and experiences.[61] For a society that focuses on learning outcomes and work skills, Kinemastik's approach differs insofar as it is fuelled by enthusiasm:

> As an organization whose work is based around film, it is a natural step to try and provide some form of education in the process of filmmaking to anyone out there who is interested in the subject. The future of our organization depends on the involvement of people around us so it is not only our duty towards the society but also the basic need in order to maintain the quality of our existence. Without knowledge, there will be no progress in Maltese filmmaking and therefore no progress in what Kinemastik has to offer.

The workshops mounted by Kinemastik cover a wide range of topics, including animation and music videos. They are run by foreigners, but not always

by established filmmakers, inasmuch as workshop leaders often are young and up-coming artists who are starting to make a name for themselves internationally.

Asked about the improvement in the quality of local work submitted to the festival, Vukanovic said the following:

> I believe that it has, but in the aspect of place and cultural conditions of where we live, it's also the quantity that matters as much as the quality. We've received a number of entries from our audience, who, I dare to say, have not been exposed to short film before attending our festival. They have decided to make their own film and submit it for the festival, inspired by what they saw. This is maybe the credit that KISFF could take, however, the production quality needs much more than a festival to be developed.

Additionally, Kinemastik has begun workshops specifically for children. With a guided, practical approach, children up to the age of 12 are encouraged to create their own work in groups, focusing on narrative shorts. The finished product is shown alongside other films during the Kinemastik Children's Film Festival. Kinemastik expanded its audience range to include a 3-day documentary workshop dedicated to 13- to 16-year-olds.

When asked if these youth-focused workshops had stemmed from the realization that there was a gap in the market, Vukanovic vehemently replied, "It's not about gaps in the market. We just want to give kids opportunity. Here kids are often just left out and not taken into consideration. Now the trend is to tap into schools because the funding is there. But for us, it's not about marketing, it's about education." At the end of the day, it is about education, and perhaps not simply for the filmmaker.

Notes

1. Val Guest, "Sun Shines on Filmmakers," *Times of Malta*, October 26, 1968. Malta gained independence from the United Kingdom on September 21, 1964. On December 13, 1974 it was declared a republic within the British Commonwealth.
2. Ibid.
3. Daniel Rosenthal, "The Island of Everywhere," *Times of London*, April 19, 2002.
4. Parliamentary Secretariat for Tourism, the Environment and Culture, *National Cultural Policy: Malta 2011* (Malta: Parliamentary Secretariat for Tourism, the Environment and Culture, 2011), 77.
5. Ibid., 43.
6. Ibid., 78.
7. Ibid.
8. Roderick Pace, "Malta and EU Membership: Overcoming Vulnerabilities, Strengthening Resistance," *Journal of European Integration* 28.1 (2006): 33–49.
9. Godfrey Baldachino, *Worker Cooperatives with Particular Reference to Malta* (The Hague: Institute of Social Studies, 1990), 68.
10. Thomas Eccardt, *Secrets of the Seven Smallest Microstates in Europe* (New York: Hippocrene Books Inc., 2005), 223.

11. Baldachino, *Worker Cooperatives*, 79.
12. Godfrey Baldachino and Ronald G. Sultana, eds. *Maltese Society: A Sociological Inquiry* (Malta: Mireva, 1994), 1.
13. Brother Henry Grech, *Qwiel Maltin: Gabra ta 700 Proverbju* (Malta: De la Salle Brothers, 1979).
14. Herman Grech, "Malta Has Highest Free-Voter Turnout in the World," *Times of Malta*, February 15, 2009.
15. Wolfgang Hirczy, "Explaining Near-Universal Turnout: The Case of Malta," *European Journal of Political Research* 27 (1995): 258.
16. Michelle Cini, "A Divided Nation: Polarization and the Two-Party System in Malta," *South European Society and Politics* 7.1 (2002): 6–23.
17. Mintoff's daughter Dr. Yana Mintoff-Bland threatened to take legal action against the filmmaker. As the film had been awarded money by the Malta Film Fund, and had been set up and administered by the current Nationalist government, Dr. Mintoff-Bland denounced the film as a piece of propaganda. See Christian Peregin, "*Dear Dom* a Box-Office Hit," *Times of Malta*, April 4, 2012.
18. Central Intelligence Agency, *The World Fact Book: Malta*, https://www.cia.gov/library/publications/the-world-factbook/geos/mt.html (accessed May 2, 2012).
19. These figures have been acquired through various sources, predominantly parliamentary debates.
20. Richard Miller, "Production Financing: The Joy of Tax," *Screen International*, April 1, 2005, 15.
21. Geoffrey Macnab, "Blue Sky Thinking," *Screen International*, October 14, 2005, 24.
22. Claudia Calleja, "Fears of Local Crew Shortage as Film Productions Flow In," *Times of Malta*, February 14, 2011.
23. The study was carried out from November 2003 to August 2004.
24. Olsberg SPI, "Appendix 3: 10 New Member States Country Analysis," *Study of Continuous Training for Audio-visual Professionals in 32 European Countries Final Report* (February 25, 2005), 296, http://ec.europa.eu/culture/media/programme/overview/evaluation/studies/index_en.htm (accessed April 12, 2012).
25. Daniel Rosenthal, "Malta," in *The International Film Guide 2010: The Definitive Annual Review of World Cinema*, ed. Ian Hayden-Smith (Columbia: Columbia University Press, 2010), 185.
26. Charles Pace, e-mail to author, August 30, 2011.
27. *Kont Diġa*, DVD, directed by Mark Dingli (2009).
28. €233,000 are directed through the Malta Film Fund each year, aiding projects in development or production. In a recent turn of events, the fund, previously administered by the MFC in conjunction with the AV Unit, is now exclusively bound to the MFC, which is under the auspices of the MITI.
29. Teodor Reljic, "A Long Road Ahead," *Malta Today*, June 6, 2011.
30. "Beyond Cinema Speaks with Film Commissioner Peter Busuttil," (May 26, 2012), video clip on YouTube, http://www.youtube.com/watch?v=PkA4jhxTVX0 (accessed June 1, 2012).
31. Vicki Ann Cremona, "Politics and Identity in Maltese Theatre: Adaptation or Innovation?" *The Drama Review* 52.4 (2008): 123.
32. Melinda Stone and Dan Streible, "Introduction," *Film History* 15 (2003): 123.
33. Anthony Attard, "Compendium of Cultural Policies and Trends in Europe: Country Profile: Malta," *Council of Europe/ERI Carts* (February 2012), http://www.culturalpolicies.net (accessed May 18, 2012).

34. *MACC Foundation Meeting.* December 16, 1952. Vincent Lungaro-Mifsud, Personal Collection.

35. Ibid.

36. Ibid. The Stricklands are a notable Maltese family of an Anglophone bent. *MACC Foundation Meeting.* December 16, 1952.

37. According to Lungero-Mifsud, only one man developed his own stock at home. Alfred "Effie" Vella Gera, a film enthusiast active in the 1920s and 1930s, used nitrate film stock to produce his own work, and even "made his own camera." Unfortunately after his death, much of his work was discarded and is now lying at the bottom of the Mediterranean Sea. Only two of his films survive.

38. Malta has had access to Italian television since the 1950s. State broadcasting appeared in 1961. Pluralism was introduced in the 1990s, with an increase in local free-to-air stations and the introduction of cable. Two of the local television stations are run and owned by the two main political parties.

39. Vincent Lungaro-Mifsud, interview by author, Malta, June 27, 2012.

40. *MACC Foundation Meeting.* December 16, 1952.

41. *I'm furious Red*, unreleased, directed by Cecil Satariano (1971); *Guzeppi*, unreleased, directed by Cecil Satariano (1973); *Ilona*, unreleased, directed by Cecil Satariano (1973); *The Beach*, unreleased, directed by Cecil Satariano (1973); *Katarin*, unreleased, directed by Cecil Satariano (1977).

42. Cecil Satariano, *Canon Fire: The Art of Making Award Winning Movies* (London: Bachman and Turner, 1973), 11.

43. Satariano's films are in private hands, and no public copies of his work exist. Satariano died in 1996 at the age of 66.

44. Vincent Lungaro-Mifsud, interview by author, Malta, June 27, 2012.

45. Ibid.

46. Attard, "Compendium of Cultural Policies," 71.

47. Ibid.

48. Creative Economy Working Group, Ministry of Finance, the Economy and Investment, Ministry of Tourism, Culture and the Environment, "A Report on Malta's Creative Economy and a Strategy for the Culture and Creative Industries: Part 3," http://www.creativemalta.gov.mt/ (accessed August 6, 2012).

49. George Cassar, "Education and Schooling: From Early Childhood to Old Age," in *Social Transitions in Maltese Society*, ed. George Cassar and Jos Ann Cutajar (Malta: Agenda, 2009), 54.

50. "This year we have allocated 22.3 million euro for stipends, and this expenditure will continue increasing while the number of students is increasing. At present we have 18,000 students who receive a stipend at University, Junior College, MCAST, and ITS." Tonio Fenech, *Ministry of Finance, the Economy and Investment (Malta) Budget Speech 2012* (Valletta: Ministry of Finance, the Economy and Investment, 2011).

51. *Malta Today* (September 26, 2004), http://www.maltatoday.com.mt/2004/09/26/tw/index.html (accessed November 6, 2011).

52. Cassar, "Education and Schooling," 56.

53. MCAST, *MCAST Prospectus: 2012/2013* (Malta: MCAST, 2012), 71.

54. Melanie Mizzi, e-mail to author, June 18, 2012.

55. Noel Grima, "Giving 'Failures' a New Lease of Life," *Malta Independent*, January 8, 2012.

56. Parliamentary Secretariat, *National Cultural Policy*, 78.

57. Attard, "Compendium of Cultural Policies," 74.

58. Daniela Blagojevic Vella, interview by author, Malta, June 26, 2012.

59. Malta Film Commission, "Professional Training and Development for Filmmakers," (March 1, 2011), 1, http://mfc.com.mt/filebank/imagebank/pdf/MALTA%20FILM%20COMMISSION%20training%20course%20info%20for%20participants.pdf (accessed April 2, 2012).

60. Lorianne Hall, telephone interview by author, July 3, 2012.

61. Slavko Vukanovic, interview by author, Malta, June 27, 2012.

3

The Struggle for a Scottish National Film School

Duncan Petrie

Introduction

The history of national cinemas and nationally specific film movements demonstrates time and again the strategic role played by film schools in nurturing ideas and ambition, teaching technical skills and building a critical mass of creative activity, all of which are necessary preconditions for a dynamic and innovative moving image culture and industry. Soviet montage cinema in the 1920s, Italian Neo-Realism in the 1940s, the Polish School of the 1950s, the Czech New Wave of the 1960s, the New Australian cinema in the 1970s, the Fifth Generation Chinese cinema of the 1980s, New Danish cinema and Dogme 95 in the 1990s, the Berlin School in German cinema in the 2000s—these are all examples where film schools have underpinned significant creative achievement. Perhaps even more than being a catalyst for innovation, however, the enduring value of film schools has been their contribution to the maintenance of national cinemas and their underpinning industries and institutions over time, helping them to negotiate fluctuating critical and commercial fortunes, to embrace new challenges and opportunities, and to maintain a sense of vitality and purpose.

The expansion of film and television production in Scotland during the 1990s provided the basis for a brief flowering of a "New Scottish Cinema."[1] This had been made possible by a rising tide of cultural nationalism that emerged in the 1970s and developed rapidly in the 1980s as a response to political failure and the social divisiveness of Thatcherism, and new thinking about the potential value of public investment in the "cultural industries." In the case of Scotland, this led to an exponential rise in film production supported by public institutions like the Scottish Film Production Fund and subsequently Scottish Screen, which were charged with administering funds from the new National Lottery, in partnership with the public service broadcasters, notably BBC Scotland, STV, and Channel 4. In addition to the boost in filmmaking, the deregulation of British television and growth in independent production from the early 1980s also significantly enhanced the capacity for a

local infrastructure in Glasgow and Edinburgh that embraced a variety of production genres beyond drama to include factual and current affairs, entertainment, children's television, and sport.

While enlightened policy-making and advocacy within public agencies played a key role in these developments, this did not extend to any concerted sector-wide call for the establishment of a film school. There were some attempts to address the need for appropriate training provision, but these tended to be rather piecemeal and lacked sector-wide support. A modest initiative did emerge in the early 1990s, which I will examine below, but it proved to be short-lived, withering on the vine of institutional indifference and lack of funding. However, a decade later a new opportunity presented itself via a new UK-wide moving image training strategy devised and administered by Skillset, the sector skills council for the creative industries, and the UK Film Council, leading to the establishment of the Screen Academy Scotland in 2005.

This chapter will consider the struggle for a Scottish film school by looking closely at the development of various initiatives over the last three decades that also provide insights into questions of the purpose and efficacy of such an institution in an environment that is increasingly subject to the transnational realities of cultural production and consumption in the twenty-first century. The sphere of education and training must be located within the wider context of film policy, institution building, and debates about what kind of films and television programs a Scottish industry should aspire to produce. This, in turn, raises the perennial tension between the industrial and the cultural, which is articulated in terms of the value of film and television as high-profile entertainment industries providing employment, sustaining businesses, and attracting inward investment and tourism, on the one hand; and the importance of cultural expression to the ongoing process of defining or (re)imagining the specificity of a "national" community and its understanding of itself and its place in the world, on the other. In the case of Scotland, this tension has been increasingly cast in relation to the hegemonic force of economic neoliberalism and globalism, and the ramifications of devolution and the ascendancy of a distinctly nationalist political agenda.

Education, Training, and the New Scottish Cinema

The genesis of an idea for a film school in Scotland can actually be traced back to the moment when the UK government established the Lloyd Committee to investigate the case for a National Film School. In 1965 Jerzy Toeplitz, head of the renowned Polish Film School in Lodz, came to Edinburgh to deliver a lecture at the Film Festival, in which he explained the function and significance of his institution.[2] The lecture was recorded by a group of students from Edinburgh College of Art (ECA) including Colin MacLeod, Elizabeth Rowan, and Mervyn Morrison, who subsequently met with Toeplitz to discuss the lack of organized film training locally and to involve him in the production of a short film inspired by his presence at the festival. The ECA group also made a submission to the Lloyd Committee, making the case for film training in the regions, and particularly in

Scotland. Of this group, Macleod—who had worked in the design department on Peter Watkins' celebrated BBC film *Culloden* (1964)—would prove to be a significant figure in future developments. Indeed, the only other advocate for Scottish film education at this time was Donald Alexander, the distinguished documentary filmmaker and former colleague of John Grierson and Paul Rotha who after running the film unit at the National Coal Board had become head of Audiovisual Studies at the University of Dundee. But as this was a period in which production activity in Scotland was confined to a handful of units producing low-budget documentaries for the Films of Scotland Committee and other industrial sponsors, the idea of a film school was to remain little more than a utopian dream for the next 20 years.

The importance of enlightened institution building to the nurturing and development of a national cinema has been persuasively highlighted by Mette Hjort in relation to Danish Cinema in the 1980s and 1990s.[3] In the case of Scotland, a similar process began in 1982 with the creation of the Scottish Film Production Fund (SFPF) as a joint venture between the Scottish Film Council and the Scottish Arts Council. Established with an initial annual sum of £80,000 and a remit "to foster and promote film and video production as a central element in the development of a Scottish culture,"[4] the fund was subsequently boosted by subventions from Channel 4 in 1986 and BBC Scotland in 1989, increasing the total resources to £200,000 per annum. During the 1980s the SFPF prioritized feature film script development and production funding for low-budget projects, which included supporting graduation films made by Scottish students at the National Film and Television School (NFTS, in Beaconsfield, to the north west of London).

While NFTS was established to train new entrants for the British film industry, its founding director and guiding force for more than 20 years was Colin Young, a Glaswegian who had risen to prominence as Dean of Theater Arts at UCLA.[5] Young proved to be particularly receptive to encouraging talent from his homeland and set about establishing close links with the Scottish filmmaking community in addition to forging a close and enduring link with the Edinburgh Film Festival. As Alastair Scott has demonstrated, a considerable number of Scots made the annual cut of 25 new entrants to the National Film and Television School during the period of Young's tenure, making Beaconsfield the seedbed for a new generation of Scottish filmmakers who would come to prominence in the 1980s and 1990s.[6] Under Young the NFTS had initially concentrated on the formation of all-round filmmakers rather than craft specialists, an approach that chimed with the desire on the part of the Scottish Film Production Fund to discover and nurture Scottish filmmakers who could follow in the footsteps of inspirational auteurs like Bill Douglas, a graduate of the London Film School, and Bill Forsyth, who was part of the first intake at Beaconsfield in 1971 before subsequently dropping out. Among the Scottish students at the NFTS who benefited from SFPF support during this period were Gilles Mackinnon, Michael Caton-Jones, and Douglas Mackinnon, the investment in their graduation films helping to ensure they left the school with a high-quality "calling card" to assist their breakthrough into the industry.[7]

Beyond the small number of aspiring Scottish filmmakers who attended the NFTS, the London Film School, and other similar institutions, moving image training in the 1980s was confined to two very different environments. On the one hand, there were schemes supported initially by the Scottish Film Training Trust (SFTT), established in 1982 and supported by the Scottish Film Council, which created opportunities for small numbers of new trainees and tended to concentrate on "below the line" technical skills within the established industry, like production, sound, camera, and editing. In 1993 the SFTT became Scottish Broadcast and Film Training (SBFT), described by David Bruce as Scotland's first "full-time agency devoted to ensuring film practitioners received the best possible training to pursue their careers and advance standards of film and television programme making."[8] On the other hand, there were a number of independent franchised film and video workshops such as the Edinburgh Film Workshop Trust (established in 1977), Video in Pilton (1981), and the Glasgow Film and Video Workshop, subsequently Glasgow Media Access Centre or G-Mac (1983), which was founded as part of a wider UK film workshop movement and which constituted an alternative site of moving image culture and practice. While some workshops had very radical identities, often in relation to specific political agendas relating to class, race, gender, and sexuality, the Scottish workshops tended to have a broader function, offering a range of facilities, training, and support for basic introductory filmmaking up to broadcast documentary production.[9]

The 1990s saw the beginning of a shift toward a more market-oriented and industrial logic within the film-funding agencies and public service broadcasters. In the case of the Scottish Film Production Fund, this is manifest in a move from supporting a small number of aspiring auteurs to running short film schemes targeted at nurturing creative writer/director/producer teams. The flagship scheme in this regard was "Tartan Shorts," initiated in 1993 and financed by the SFPF in collaboration with BBC Scotland, and funding the development and production of three films a year, which, in addition to screenings at the Edinburgh and London Film Festivals, were given the opportunity to find wider international exposure on the festival circuit.[10] Collectively, these initiatives' schemes also constituted a potential ladder of career progression for filmmakers, while their various selection and development processes sought to encourage a new focus away from the individual auteur and toward creative collaboration between producers, writers, and directors—although ironically some of the most successful graduates of the "Tartan Shorts" were distinctive writer/directors like Peter Mullan, Lynne Ramsay, and David Mackenzie. To further emphasize the importance of developing both viable projects and the skills-base necessary for building a local production industry, in the early 1990s the Scottish Film Council also established Movie Makars, an annual training event aimed at emerging writers and producers. Thus a more overtly industrial model of training came to the fore as part of a major expansion in funding and production activity by mid decade, a process that saw the establishment of the Glasgow Film Fund in 1992 and the creation of a substantial new lottery film fund in 1995.

These developments attracted criticism from those who advocated alternative models of Scottish filmmaking, the most notable being Colin McArthur, who

argued that the failure of Scotland's film institutions "to articulate a meaningful production policy [lay] in their surrender to an industrial model rather than in posing the question in terms of a *cultural* need."[11] This, in turn, exacerbated a preexisting tendency toward the production of regressive and stereotypical representations of Scotland and the Scots that were saleable in the international market place. In contrast, McArthur advocated a "Poor Cinema," a low-budget alternative that would directly address questions of national culture by drawing inspiration from diverse sources. These included the experimental modernism of European art cinema, the revolutionary impetus of Third Cinema, and various individual expressions of low-budget filmmaking from Roger Corman to Derek Jarman. In a subsequent elaboration of his position, McArthur suggested that such a Poor Cinema should be supported by an infrastructure that placed an emphasis on ideas and access provided by Scotland's film and video workshops as "enabling houses" offering both production facilities and training.[12] McArthur also argued for the value and promotion of cinematic literacy as a cornerstone of a vibrant Scottish film culture and by extension a Poor Cinema, invoking an integration of theory and practice that harked back to the values and aspirations of the Workshop Movement and to some of the beacons in the history of national film schools, including pioneering establishments in the Soviet Union, Italy, France, and Poland.

While McArthur's ideas generated a level of response and debate, he failed to make any significant impact on wider institutional practice. Indeed, by the end of the 1990s the momentum seemed to be moving in the opposite direction, serving to reify the market-oriented industrial logic McArthur had attacked, with the advent of the "creative industries" agenda. Enthusiastically promoted by the New Labour government elected in 1997, this can be seen as a direct development from the earlier cultural industries discourse that had underpinned the establishment of bodies like the Glasgow Film Fund, but with an enhanced emphasis on markets, entrepreneurialism, and wealth creation.[13] And if the guiding policy of the 1990s had been directed toward the fostering of a Scottish feature film industry—which, despite McArthur's critique, clearly entailed a cultural dimension albeit one that revolved around the narrative feature film—advocates of "creative industries" policy were less interested in products (cultural or otherwise) than in encouraging enterprise and wealth creation, building infrastructure and production capacity, and enhancing skills. Following a review in 2002, the pot of lottery funding available for film development and production was reduced as Scottish Screen became engaged in a wider field of "creative industries," including games and new media production. This downgrading of film as a privileged media form was exacerbated in 2010 when Scottish Screen was absorbed along with the Scottish Arts Council into Creative Scotland, a body responsible for the total range of Arts, Screen, and Creative Industries.

These changes and their underlying industrial logic have also been largely accepted by a filmmaking community that seemed unwilling or unable to articulate a sense of purpose or vision beyond the extension of market mechanisms for the distribution of investment. This had significant consequences, as Robin MacPherson notes:

> By succumbing to the economic doctrine of "Creative Industries" discourse, Scotland's filmmakers and policymakers have exercised a form of self-exclusion which removes social, cultural and political concerns from the arena of "legitimate" film policy discussion. This is to the detriment not just of Scottish cinema, but of our national cultural life as a whole.[14]

Within the wider sphere of UK film policy in the 2000s, the Creative Industries agenda is perhaps most visible in the core objective of the UK Film Council to create a sustainable British film industry by fostering a greater market responsiveness and encouraging inward investment through the promotion of Britain as a high-quality and financially attractive international production hub.[15] This required a new emphasis on training a workforce with the appropriate skills necessary for such an industry and consequently came to inform a national training strategy, "A Bigger Future," developed by Skillset and the UKFC and launched in 2003. Arguing that many existing university courses in film and media were irrelevant to the needs of industry, the strategy set out to remedy this through the creation of a network of Skillset Academies and a system of course approvals to ensure the delivery of the necessary skills.[16] But in spite of the instrumental and reductive logic of the skills-training discourse—within the strategy universities are referred to as "training providers"—"A Bigger Future" was to have a very interesting impact in Scotland, creating the opportunity for a new institution to emerge that would lay claim to being a Scottish Film and Television School.

The First Attempt to Establish a Scottish Film School

The explosion in independent production that followed the arrival of Channel 4 television in 1982 had important benefits for Scotland. Not only did this create the necessary conditions for an increase in feature film production, it also stimulated developments across a range of formats and genres, boosting aspirations for a local film and television industry. The formation of new practitioners became an important consideration, and in 1986 the Scottish Film Council and the Scottish Film Training Trust responded by setting up an inquiry to investigate current provision and future needs of professional film and video training in Scotland. The impetus for this inquiry was the "widely held perception that professional film and video training in Scotland has evolved in an uncoordinated fashion, failing to make the vital connection between training opportunities and the needs of the industry."[17] The subsequent report recommended that a new modular course on film and television production skills be established by a Scottish university or college and that such a course be primarily technical and provide entry-level industry-relevant skills. The report was careful to note that such a course should complement rather than compete with the National Film and Television School, which in relation to "intensive training in Direction, Production and other specialisms . . . would continue to provide an alternative and essential form of training not available in Scotland."[18]

By the mid-1980s there were a number of higher-education institutions in Scotland offering production-oriented courses, although significantly Meech

identified only three that were currently "appropriate to the needs of both broadcasters and/or the independent film and video producers."[19] These were Edinburgh-based Napier Polytechnic's BA in photography, which incorporated 16mm film and hi-band video production in the second and third years; the same institution's BEng sandwich course in Communications and Electronic Engineering; and the PG Diploma in Electronic Imaging offered by Duncan of Jordanstone College of Art and Design (DJCAD) in Dundee.[20] Consequently, after a period of consultation a proposal emerged involving collaboration between Napier and DJCAD. The former had a strong grounding in filmmaking, which by the mid-1980s was run by Jack Shea and Mark Bender; while the latter was one of the first educational institutions in the UK to recognize the potential of video as a creative medium. DJCAD's postgraduate diploma in Electronic Imaging had been set up by filmmaker and video artist Steve Partridge, who had previously worked in the burgeoning London-based facilities sector and spotted an opportunity to provide appropriate professional training for an industry that was growing to meet the new demands of independent production. In 1985 Partridge was joined by Colin MacLeod, who had kept alive his aspirations for educating aspiring film and television practitioners in Scotland. In addition to more than 15 years of teaching experience gained at Edinburgh College of Art, MacLeod, who had worked as a stringer cameraman with the BBC, brought with him important connections to the Scottish broadcasters. The television industry was at that point in time in the process of acquiring new video equipment that required technical staff to be up-skilled. Thus the postgraduate diploma in Electronic Imaging proved a great success in terms of its relevance to a changing television industry. As Partridge puts it:

> There was really no course like it in the UK, and certainly nothing approaching it anywhere else in Scotland. We trained a lot of very highly talented, bright creative people, many of whom then went on into the facilities industry. Some of them went into film-making—people like David Mackenzie. It was a broad church but we didn't really think of it as a film school because it was a very niche thing; we were offering a fast track for artists and designers to go into that side of the industry.[21]

Thus in 1989 a new one-year postgraduate Master of Science program in Film and Television Production was designed, resourced, and validated by the University of Dundee and Napier Polytechnic. Moreover, the venture was also given permission from the then Conservative secretary of state for Scotland Iain Lang to call itself "The Scottish Film and Television School."[22] This proved to be rather controversial, with David Bruce, director of the Scottish Film Council at the time, subsequently noting that "(n)ot everyone was happy that the scheme should promote itself as a Scottish National Film School, at least not until it had earned that status."[23] For his part, Macleod recalls the barely disguised hostility from the SFC, which he believes had been against a venture not located in Glasgow where the bulk of Scottish film and television production had traditionally taken place. But there was also antipathy from other quarters. In a televised debate on the future of a Scottish film industry broadcast in July 1990, Colin Young suggested that the proposed course appeared to be less advanced than would be expected from a postgraduate initiative:

If that remains the case, by the time the thing comes on stream it will be a bit like having a narrow gauge railway down to Hadrian's wall and then the passengers have to get off and get on another train. That would be a real pity because what has to happen is that an infrastructure for any film industry, any television industry, has to be based on training. And if Scotland is going to invest in training in our industry it must get the plan right.[24]

It was against this rather unenthusiastic backdrop that the Scottish Film and Television School admitted its first cohort of students to the new one-year MSc program in the autumn of 1992. The group was split across the two institutions with individual students specializing in either filmmaking at Napier or video production at DJCAD, with a program of shared master classes bringing the two groups together. Unfortunately there were by this time certain internal problems that caused the initiative to be somewhat ill-fated from the very start. In the intervening period between the program being validated and the students coming on board, MacLeod had left Dundee due to a combination of personal factors and professional conflict with his new head of department and had found a position at Napier. This left Partridge to run the DJCA end of the program, but he was far less enthusiastic about the idea of a Scottish film and television school than MacLeod had been and decided after a year to pull out, preferring to concentrate on setting up new undergraduate courses. This left Napier to go it alone for another couple of years before a second problem arose when the finance provided by Lothian Enterprise dried up in 1995, because of a shift in priority from educational to industrial initiatives. This had consequences for the match funding provided by the Scottish Office, leaving Napier with no option but to suspend the course, bringing to an end the first attempt to establish a Scottish film school. However, given the very short period the MSc had been in operation, a number of talented students did emerge from the initiative including writer/director Morag Mackinnon, producer Wendy Griffin, and documentarian Liviu Tupurita.[25]

The suspension of the MSc instigated a period of major institutional change at Napier. Under a new department head, Desmond Bell, a wholesale transformation in staffing within the photography and film department was instituted. Bender and Shea both left and gradually a new teaching team was assembled, with MacLeod providing the only continuity on the film side. Meanwhile, the idea of a Scottish film school was being kept alive. In his inaugural lecture, part of which was subsequently published in *The Herald*, Bell made the case by pointing out the systematic ways in which the issue had been continually ducked by policy-makers and bureaucrats:

> The reluctance to embrace the idea of a film school for Scotland reflects perhaps a more general hostility among policy makers to supporting a distinctive Scottish cinema. Film funding in Scotland is now largely targeted at mainstream commercial producers who seek to ape Hollywood or European art house genres. Screen agencies are now playing an international game with big bucks provided by the National Lottery. Debate about the development of film in Scotland has exclusively centred on commercial and industrial considerations with cultural and public interest questions marginalised.[26]

What Bell implies here is that a film school should provide not only an environment for professional training but also an opportunity for considering how the purpose and value of moving image production within a national context could inform the formation of new generations of film and television practitioners. For Bell, "a properly funded film school" was the only place in which aspiring Scottish filmmakers could "experiment, innovate, learn their craft and develop their professional practice" in a manner that also embraced the new challenges and opportunities posed by the new technological, industrial, and political realities. But others were making a more overtly industrial argument in relation to film training. For example, the 1996 *Scotland on Screen* report that was produced by Hydra Associates for the Scottish Office, which led to the establishment of Scottish Screen the following year, recommended a Screen Industries Business School for training producers with appropriate business and commercial skills.[27] Then in 1999 (as a reminder of the local geographical issues that also continued to impact on policy development) a feasibility study for a Scottish Television and Film School conducted by The Research Centre (TRC)[28] for the Glasgow Development Agency recommended Glasgow as the most likely setting for such a school, with the Royal Scottish Academy of Music and Dance as the most appropriate potential venue.

A New Opportunity within a UK Strategy

The return of a parliament to Edinburgh in 1999 provided a new arena for these issues to be reconsidered. In 2001 a report by SNP MSP (Scottish National Parliament, Member of Scottish Parliament) Michael Russell to the Education, Culture, and Sport Committee advocated that in addition to setting up an enquiry into the development of fiscal and other incentives for film production in Scotland, the committee should also revisit the question of training, including the possible establishment of a Scottish film and television school. This was in opposition to the Scottish Executive's preference for "an inward investment-oriented goal of creating a Scottish film industry"[29] and so unlikely to have much policy traction. Whatever the case, such discussions were overtaken by other developments on the national stage with the launch in September 2003 of "A Bigger Future," Skillset, and the UK Film Council's new education and training strategy for the British film industry. A key part of the strategy concerned the role of universities and colleges in the training and the urgent need for more programs and courses of relevance to the needs of industry, a problem to be addressed via the creation of a small number of Skillset Screen and Media Academies, centers of excellence to provide appropriate industry training. Successful applicants would not only be granted industry approval, they would also be the recipients of serious investment from the Film Skills Fund.

Moreover, while the strategy embraced a number of distinct areas of training, one of the overarching concerns was an acknowledgment of the significance of the "Nations and Regions" as a key part of the institutional framework and implementation of "A Bigger Future." This created a new opportunity for a fresh Scottish initiative and it quickly became clear that among the various universities

and colleges involved in film and media education, Napier continued to have the strongest basis on which to make a bid. The rebuilding that had commenced in the wake of the closure of the MSc in 1996 had transformed the Department of Photography and Film, now part of the School of Arts and Creative Industries. Another crucial factor was the emergence of an appropriate individual to lead a putative Scottish Screen Academy. In 2002 Robin MacPherson had joined Napier University from Scottish Screen, where, as head of Development, he had played a key strategic role in supporting feature production in Scotland.[30] MacPherson was a veteran of the Edinburgh Film Workshop Trust, having produced a number of documentaries and a short drama, *The Butterfly Man* (1996), under its auspices. He also had a proven commitment to and understanding of the cultural and industrial dimensions of the moving image in Scotland, and a long-standing connection to Napier as a visiting lecturer. Indeed, he had recently been involved with them in connection with a European virtual film school project "Journeyman." This initiative provided the idea for a new postgraduate program in project development, which would help speak to MacPherson's conviction that there was a deficit in the necessary skills and experience among would-be producers in Scotland. Thus on arriving at the university, Macpherson initiated a new Masters program in Screen Project Development to provide an all-important bridge between an undergraduate experience and a more professionally oriented experience while giving working producers an opportunity to return to university to develop their skills. The new program was also a way of moving the emphasis of the department toward drama production. As MacPherson notes, the program had several premises including:

> ...a focus on development skills, creative producer skills and it would act as a bridge to industry. So it wouldn't just necessarily recruit people from undergraduate programmes, it would recruit people who wanted the time, space, [and] support to become better skilled at developing projects that had European potential.... We wanted to ensure that it had that intellectual and academic base of understanding the institutional context of film and television programme making. So the meeting point of theory and practice was that producers needed to have a critical understanding of the world in which they operate as professionals, with a set of skills drawn from business and finance and from the ability to work across multiple contexts from independent film-making through to mainstream television.[31]

As such, the program was perfectly in tune with the aspirations for relevant training informing "A Bigger Future."

At the same time, important developments had also been taking place at Edinburgh College of Art, most notably the appointment in 2001 of Noé Mendelle as head of Film and TV.[32] Like Macpherson, Mendelle had come through the workshop sector, in her case the Sheffield-based Steel Bank Film, and had a strong commitment to documentary. This led to the establishment of the Scottish Documentary Institute (SDI) in the following year, a research center within the college engaged with the development of the documentary form in Scotland via training, production, and distribution. Mendelle notes that she wanted the institute to be "a hybrid between industry and academia":

I felt if we had a space where we could still work and criticise industry it would be of benefit to the industry. And if we had a space in which we could work and criticise academia, it would be of benefit to academia. By bringing the two together it would create a different kind of synergy. It seemed to me that Scotland was in the right frame of mind for that to happen, so getting funding from Scottish Screen at the time definitely helped in setting it up and developing relationships with BBC Scotland. But also putting all of this in the context of academia, this created the opportunity for our students to stop thinking of themselves as students and start thinking of themselves as young filmmakers. That was really important in developing the ambition of young people. So the combination of that flexibility and the growing ambition of our students, and then creating a platform [where] they could witness a part of the club—because at the end of the day it is like this in industry—and then see how to be a participant and not just an observer.[33]

Another key player in this was Amy Hardie, filmmaker and creator of DocSpace, a platform for screening and discussing documentary that brought together practitioners and audiences. The SDI subsequently provided the basis for two important initiatives aimed at establishing new documentary filmmakers: Bridging the Gap, a scheme to help filmmakers progress from student to professional work, leading to the production of four 10-minute docs a year; and Interdoc, a scheme to help producers with a feature-length documentary in development to secure finance and access to the international market.

Given the complementary nature of the two institutions, it made sense for Napier and ECA to mount a joint bid to Skillset, and in 2005 the Screen Academy Scotland was inaugurated. But even before the new organization admitted its first students, Colin MacLeod received an invitation from the Student Film Festival in Biarritz to participate along with some students from both Napier and the Edinburgh College of Art, which he considered "a good way of getting the momentum started and getting the nomenclature established—it is there in the festival brochure."[34] Academy status also provided major investment for establishing posts and student bursaries—between 2006 and 2010 Skillset provided grants totaling more than £1.2 million to the academy, plus a further £320,000 to the Scottish Documentary Institute.[35] At Napier the funding provided pump priming for additional new postgraduate programs including an MA in Screenwriting and an MFA in advanced filmmaking practice, while at Edinburgh College of Art an MA/MFA in directing was established, which embraced drama, documentary, and experimental practice. The Skillset investment also provided the basis for match funding to be secured from the Scottish Executive, via Scottish Screen, while encouraging equally vital capital investment from the Scottish Higher Education Funding Council and support from the broadcasters. So from two Masters programs—one at each institution—with a combined intake of around 15 students a year, the Screen Academy Scotland quickly established a portfolio of four programs with double the number of students. Moreover, and perhaps even more importantly, these programs have been designed to foster a particular kind of creative environment. As MacPherson notes:

It is one thing to have all these programmes and students, but it is another thing to have them working together and collaborating across programmes and genuinely

connecting. That takes time. It is like slow cooking. We were very fortunate in that when we added the screenwriting programme to the producers programme at Napier they shared modules—they study business and script development together. Then we brought the filmmaking programme in and there are cross-overs between the directors and the writers. There is also collaboration with students at the Art College so producers might produce a film with students at the Art College. But the first five years has been a gradual process of making that work; it's like an engine running in.[36]

During that period the student body has continued to grow and now there are around 80 students attached to the SAS. Academy status also paved the way for a period of incremental growth and soon the organization added a number of continuing professional development (CPD) courses, an online postgraduate certificate in Screenwriting, and initiated and developed Engage, a pan-European project aimed at fostering international creative collaborations between writers, directors, and producers. The SAS also became a member of CILECT, the international association of film and television schools.

In this way, the Screen Academy Scotland was off to an auspicious start, providing students with the resources to make films that were to win awards at the Celtic Film and Television Festival and BAFTA Scotland in the first year of the program. Since then a number of SAC graduates have started to make a mark. They include Simon Arthur, whose debut feature film *Silver Tongues* (2011) won the audience award at the Slamdance Film Festival in the United States; Anne Milne, whose short documentary *Maria's Way* (2009) won the Best Scottish Short Doc EIFF and BAFTA Scotland New Talent Award in addition to playing at more than 20 international festivals; and Johanna Wagner, who followed her BAFTA award-winning graduation film *The Inner Shape* (2008) with *Peter in Radio Land* (2009), a documentary supported through the Scottish Documentary Institute's "Bridging the Gap" scheme, which won the Best International Short Film award at the Glasgow Short Film Festival and has been screened at around 40 international film festivals. Other notable films made by SAS alumni include a number of recent documentaries: *Caring for Calum* (2011) by Lou McLoughlan, which won BAFTA and Grierson Awards; *Kircaldy Man* (2011) by Julian Schawanitz, which was awarded the Golden Dove at Leipzig Documentary Festival; *Caretaker for the Lord* (2011) by Jane MacAllister; and the short dramas *Little Red Hoodie* (2009), written and directed by Joern Utkilen (MFA Advanced Film Practice), which was commissioned by Channel 4 and the UKFC; *Paris/Sexy* (2010), written and directed by Ruth Paxton; *Down the Rabbit Hole* (2009) by Eva Pervolovici; *I'm in Away from Here* (2008) by Catriona Macinnes; and *Ladies Who Lunch* (2009), written by Laura Anderson and produced by Victoria Thomas.

This rapid process of growth and consolidation helped the Academy weather its first major test. In 2010 there was a considerable reduction in the Film Skills Fund and when Skillset launched "A Bigger Future 2," the number of screen academies was reduced from seven to a new network of three film academies: the National Film and Television School, the London Film School, and the Screen Academy Scotland. But while shrinking resources is a major concern, the fact that the SAS now sits alongside the only two long-established single-discipline film schools

in the UK is a major reaffirmation of the organization's status as a Scottish Film and Television School.[37]

Addressing the Industry/Culture Relationship

But how has the Screen Academy Scotland oriented itself in relation to the problematic relationship between industry and culture? On the one hand, the organization has been very successful in addressing the needs of the industry as both a film and a media academy. While being one of only three academies with a clear remit toward feature film and television drama production (the primary orientation of the traditional film school), the SAS has also engaged with the broader range of skills, disciplines, and practices that constitute the varied sector of television production in Scotland, which, as I have noted, continues to provide local job and career opportunities. For Macpherson, the two areas are complementary:

> So as long as the industry in Scotland aspires to a more diverse, full spectrum of audio-visual production for different markets, the need for a Film and Television School is actually stronger. So if you want to bring together students with high levels of skills in writing, directing, producing, cinematography, editing, music composition, sound design—you need a film school to do that; you need a film school to get the critical mass and levels of engagement.[38]

And in addition to its degree programs, the academy has expanded its role in relation to skills training via the Screen NETS (New Entrants Training Scotland) program that provides on-the-job training in camera, production, art department, animation, and assistant directing in recognition that many production companies and houses in Scotland do not have the resources to invest properly in such training.

On a more strategic level (with potential cultural ramifications), the SAS is also attempting to address the consequences of the deficit in support for film in Scotland following the demise of Scottish Screen. In 2012 a low-budget feature film initiative called Lo-fi was launched, moving the Academy beyond supplying talent and addressing skills needs to play a more active part in creating the opportunities for filmmakers to establish themselves. This will be done through developing feature scripts and creative teams comprising a writer, director, and producer, an echo of development processes that had been run by Scottish Screen and before that the Scottish Film Production Fund and in the European "Engage" project:

> Students have been making shorts which compete shoulder to shoulder with independently produced shorts—they operate on the same terms as Tartan Shorts did ten years ago. What we want to do is [exert] influence at the level of long form filmmaking. In other countries film schools play an important role in nurturing first features. The distinction between film schools and 'the real world' is evaporating. What we are aspiring to is to involve not just our home team but to spin out the ability to work with people who are not necessarily our graduates. This is in tandem with the SDI and their "Bridging the Gap" initiative in nurturing documentaries.[39]

For MacPherson, this will help to ensure that the Screen Academy is relevant to both the industry and the broader culture in Scotland, "sustaining this throughput of graduates but being part of and intervening in and across a broader spectrum. That's what I think the role of a national film school is."[40]

At the same time, the Academy also plays a role in the wider British, European, and even world context. The students come from a variety of countries and will not necessarily have any particular commitment to working in Scotland. Moreover, while those individuals interested in a craft role may have more of an opportunity to stay in Scotland, working in a facilities house or freelancing on corporate productions and promos while trying to get short films made and longer projects developed, others, particularly those ambitious to work in features or television drama as writers, directors, producers, or even as cinematographers and designers, are much more likely to end up in London.

This is an acknowledgment of the continuing lack of a critical mass of production in Scotland, which, following the legacy of a decade of creative industries policy, has left a vacuum in terms of a defined national cultural project. Scotland continues to produce writers of different kinds—novelists, short story writers, poets, and playwrights—whose work singularly and collectively engages in a vital way with the specificity of the place, its people, landscapes, and history. But unfortunately similar claims cannot be made for Scotland's filmmakers who are increasingly guided by the dictates of familiar and accessible genres rather than personal storytelling. And while MacPherson is clearly an advocate of a strong cultural engagement, he admits to a lack of any specifically national project among the SCS students—indeed, the category of Scottish cinema may even be regarded as something to avoid rather than embrace:

> You get the odd filmmaker who comes through who wants to reflect the experience of de-industrialisation in the 1990s and how that is refracted in their growing up. But we don't see the student who is a filmmaker in the first and second decade of the 21st century who grew up in the 1990s in the wake of Thatcherism and whose parents or grandparents saw all of that wanting to deal with that in the way that a novelist might. The Bill Douglas, Terence Davies, or even Bill Forsyth of the 21st Century, they are probably out there somewhere but they are not banging on the door with a kind of manifesto saying 'we are the young Turks of the new Scottish cinema.'[41]

This is confirmed by James Mavor:

> very few of the students want to write about Scotland in what you might think of as a significant or culturally interesting kind of way. Like everyone else they want to write a thriller or a horror (film). I can't think of any students who have had a distinctively 'Scottish' voice.[42]

By way of contrast, Noé Mendelle points out that many of the international students based at the ECA engage with Scotland in some interesting and productive ways:

> Students coming from Europe engage better with the concept of Scotland than they would engage with the concept of the UK. That has been interesting. And when they

finish here they all actually go on working together and collaborating—we have got some amazing collaborations across different countries of former students who set up their network when they are here and go on using it afterwards.[43]

So while certain aspects of cultural identification may have been weakened, political devolution has created opportunities for new kinds of transnational relationships to emerge and develop in Scotland. In this way Edinburgh is able to trade on its reputation as a cosmopolitan center facilitating valuable cultural encounters and exchange. Moreover, this is in line with tendencies in moving image production in the twenty-first century in which small nations have increasingly appreciated the advantages of collaboration within wider transnational networks as an alternative to Hollywood hegemony.[44] Such relationships enhance the significance and even the specificity of the site of particular small national cinemas, moving image industries, or film schools, precisely by presenting opportunities for creative encounters and collaboration across borders. Thus, a space for cultural pluralism and dynamism is preserved, countering the perpetuation of narrow nationalist stereotypes on the one hand and global cultural homogenization on the other.

Whatever the challenges in the cultural sphere, the Screen Academy Scotland (SAS) has at least created the environment within which new ideas can be germinated and which may grow into a shared sense of collective engagement, however that may be defined. One of the most heartening things is that the Academy represents much more than a narrow skills training factory. MacPherson makes an interesting link between workshops and film schools, both of which provided an educational space where ideas and communication were crucial to the forging of a particular purpose and identity. He argues that the most important thing about an institution like SAS is not the facilities or technology but the people: "that is what makes film schools resilient and what makes the institutions of filmmaking enabling—they are conduits and contexts for the exchange of knowledge about practice, experimentation and risk."[45] This is supported by Colin MacLeod, who argues that the success of the Screen Academy Scotland has been in the creation of a community of like-minded people—"a group of people who may not all be Scottish but who find themselves wanting to stay here, which has in fact got a bit more breathing space."[46] And in the final analysis, it is this relationship between proactive agency, effective institutional organization, and enlightened policy that has always underpinned effective moving image education, nationally focused or otherwise.

Notes

1. See Duncan Petrie, *Screening Scotland* (London: BFI, 2000).
2. Jerzy Toeplitz, "The Creative Impulse in Film-Making," (12th Annual Celebrity lecture given at the 19th Edinburgh Film Festival, September 4, 1965). Transcript held at the British Film Institute Library. Interview with Colin MacLeod by the author (Edinburgh, February 22, 2012).

3. Mette Hjort, *Small Nation, Global Cinema: The New Danish Cinema* (Minneapolis, MN: University of Minnesota Press, 2005); Mette Hjort, "Denmark," in *The Cinema of Small Nations*, ed. Mette Hjort and Duncan Petrie (Edinburgh: Edinburgh University Press, 2007), 23–42.
4. Ian Lockerbie, "Pictures in a Small Country: The Scottish Film Production Fund," in *From Limelight to Satellite: A Scottish Film Book*, ed. Eddie Dick (London: SFC/BFI, 1990), 172–173.
5. See Duncan Petrie, "British Film Education and the Career of Colin Young," *Journal of British Cinema and Television* 1.1 (2004): 78–92.
6. Alastair Scott, "What's the Point of Film School, or, What Did Beaconsfield Film Studios Ever Do for Scottish Cinema?" in *Scottish Cinema Now*, ed. Jonathan Murray et al. (Newcastle: Cambridge Scholars Press, 2009). Scottish graduates of the NFTS include Steve Morrison, Michael Radford (who were all part of the first intake of students), Sandy Johnson, Ian Knox, Paul Pender, Dennis Crossan, Ian Sellar, John Kerr, Michael Caton-Jones, Gillies Mackinnon, Amy Hardie, Alex Mackie, Aileen Ritchie, Eirene Houston, Douglas Mackinnon, Paul Murton, and Lynne Ramsay.
7. These three examples all established successful careers as directors but with significant differences. While Caton-Jones quickly gravitated toward mainstream Hollywood production—his only significant Scottish feature being *Rob Roy* (1995)—Gillies Mackinnon found a home in the sphere of low-budget British cinema, contributing directly to the New Scottish cinema with *Conquest of the South Pole* (1990), *Small Faces* (1996), and *Regeneration* (1997), while Douglas Mackinnon has concentrated primarily on television drama, with the exception of the feature film *The Flying Scotsman* (2006).
8. David Bruce, *Scotland the Movie* (Edinburgh: Polygon, 1996), 149.
9. See Robin Macpherson, *Independent Film and Television in Scotland: A Case of Independent Cultural Reproduction?* Unpublished MA Dissertation, University of Stirling, 1991.
10. With STV and British Screen, the SFPF also initiated "Prime Cuts," a scheme aimed at shorter more low-budget productions, and "Gear Ghearr," a Gaelic Language initiative supported by the Gaelic Film and TV Fund and BBC Scotland. In 2000 a digital short film scheme, "Newfoundland" was created by the SMG and Scottish Screen to take advantage of working with new technology. Subsequent developments included "Newfoundland," a digital scheme funded by the Scottish Media Group to produce half-hour dramas for television, and "Cineworks," an entry-level collaboration between Scottish Screen and the Glasgow Film and Video Workshop. For more details see Petrie, *Screening Scotland*, 180–182.
11. Colin McArthur, "In Praise of a Poor Cinema," *Sight and Sound*, 3.8 (1993): 30.
12. Colin McArthur, "The Cultural Necessity of a Poor Celtic Cinema," in *Border Crossing: Film in Ireland, Britain and Europe*, ed. Paul Hainsworth et al. (Belfast: ILS/Queen's University, 1994), 123.
13. See Nick Garnham, "From Cultural to Creative Industries: An Analysis of the Implications of the 'Creative Industries' Approach to Arts and Media Policy Making in the United Kingdom," *International Journal of Cultural Policy* 11.1 (2005): 15–29; Philip Schlesinger, "Creativity: From Discourse to Doctrine," *Screen* 48.3 (2007): 377–387.
14. Robin Macpherson, "Shape Shifters: Independent Producers in Scotland and the Journey from Cultural Entrepreneur to Entrepreneurial Culture," in *Scottish Cinema Now*, ed. Jonathan Murray et al. (Newcastle: Cambridge Scholars Press, 2009), 223.
15. See Margaret Dickinson and Sylvia Hervey, "Film Policy in the United Kingdom: New Labour at the Movies," *The Political Quarterly* 76.3 (2005): 420–429.

16. See Duncan Petrie, "Theory/Practice and the British Film Conservatoire," *Journal of Media Practice* 12.2 (2011): 125–138.

17. Peter Meech, *Professional Film and Video Training in Scotland* (Glasgow: Scottish Film Council, 1987), 2.

18. Ibid., 26.

19. Ibid., 10.

20. Other institutions noted in the report included Edinburgh College of Art, Glasgow School of Art, the Glasgow College of Building and Printing, and the Royal Scottish Academy of Music and Drama in Glasgow.

21. Telephone interview with Steve Partridge by the author, March 6, 2012. This initiative was to grow into the School of Television at DJCA, while Partridge also pioneered other key ventures at the college including the Television Workshop, which provided access and equipment to various artists and filmmakers.

22. Colin MacLeod, e-mail.

23. Bruce, *Scotland the Movie*, 151.

24. Colin Young, *The Scottish Arts Debate: Still Rolling*, STV Txd: July 1990.

25. Alumni from Napier's undergraduate program during the same period include Lynne Ramsay, the TV drama directors Andy Goddard and Fraser Mackenzie, and the cinematographer Simon Dennis.

26. Desmond Bell, "A Hollywood on the Clyde," *The Herald*, May 3, 1997.

27. A separate report by Hydra had led to the setting up of an approved Scottish Vocational Qualifications (SVQ) assessment center in Glasgow for film and television in May 1997.

28. TRC was established in 1998 as a charity concerned with facilitating developing media training and other industry events. It has developed close relationships with Channel 4, the BBC, and various public agencies and currently operates as TRC Media. See http://www.trcmedia.org/trcmedia/.

29. Jonathan Murray, "Devolution in Reverse? The Scottish Executive and Film Policy 1999–2003," *Edinburgh Review* 116 (2006): 62.

30. Significantly both men had reputations as strategic and analytic thinkers. McIntyre had written a number of articles on policy in the 1980s and had been a key advocate of a cultural industries approach for developing the filmmaking potential in Scotland and the English regions, and subsequently played a key role in the process that led to the setting up of Scottish Screen in 1997. MacPherson had written an MPhil dissertation on the development of independent production in Scotland and had a keen understanding of the shifting relationship between industrial and cultural issues within the production community.

31. Interview with Robin MacPherson by the author (Edinburgh, January 14, 2012).

32. Mendelle had previously worked at Napier and when she moved to ECA the vacancy this created was filled by MacPherson.

33. Interview with Noé Mendelle by the author (Edinburgh, May 21, 2012).

34. Interview with Colin MacLeod.

35. These figures are derived from Skillset's annual financial reports. The breakdown per year is as follows:

 2006/7—£500,000 (£60,000 for SDI, £250,000 to Scottish Screen for various new entrants schemes)
 2007/8—£407,912 (£60,000 to SDI, £160,570 to Scottish Screen)
 2008/9—£174,740 (£83,000 to SDI, £263,950 to Scottish Screen)
 2009/10—£172,486 (£120,060 to SDI, £10,699 to Scottish Screen)

36. Interview with Robin MacPherson. The academy also provided opportunities for new teaching talent to emerge, most of whom were also veterans of the short film schemes

established in the 1990s. The screenwriting program was initially run by Mark Grindle, whose industry experience had primarily been as a producer, and then subsequently by James Mavor, an experienced and award-winning writer of television series and feature length dramas. The producing MA was taken over by Oscar Van Heek, who had worked as an executive for the Scottish Film Production Fund in addition to producing a number of short films and the digital feature *Blinded* (2004). Paul Holmes, director of television drama and short films and producer of *A Small Deposit* (2003)—one of the first "Tartan Shorts"—was put in charge of the MFA in Advanced Film-Making. The MA/MFA in Film Directing offered by the ECA is taught by Noé Mendelle and Emma Davie, both experienced documentary filmmakers, alongside Morag Mackinnon and David Cairns, both writers/directors of drama.

37. The Screen Academy Scotland also gained Media Academy Status in 2008, making it one of only two combined institutions alongside the National Film and Television School.
38. Interview with Robin MacPherson.
39. Ibid.
40. Ibid.
41. Ibid.
42. Interview with James Mavor by the author (Edinburgh, May 19, 2012).
43. Interview with Noé Mendelle.
44. See Mette Hjort and Duncan Petrie, eds., *The Cinema of Small Nations* (Edinburgh: Edinburgh University Press, 2007).
45. Interview with Robin MacPherson.
46. Interview with Colin Macleod.

"We Train *Auteurs*": Education, Decentralization, Regional Funding, and Niche Marketing in the New Swedish Cinema

Anna Westerståhl Stenport

New film training programs emerging in the western Gothenburg region of Sweden illustrate assumptions and logics structuring the contemporary Swedish film industry as it operates on regional, national, and international levels. These training programs illustrate a productive tension between market- and economic development-oriented regionalization efforts and a focus on arts/auteur/noncommercial film education. This productive tension has effectively contributed to a vibrant, heterogeneous, and diverse film culture. Building on dozens of interviews with directors, producers, film instructors, educational program coordinators, and film practitioners undertaken during the past two years, as well as on analyses of curricular and policy documentation, this chapter presents a prismatic account of a previously overlooked component of contemporary Swedish film culture and industry. Combining representative practitioner perspectives and analyses of curricular assumptions and practices, the chapter also includes brief case-study career trajectories of some recent film program graduates.

The development of new production centers and film training programs in western Sweden is a departure from the status quo. Swedish film and moving images production and training culture have historically been located in and around Stockholm, included as part of the historic studio systems of Svensk Filmindustri and Europafilm, and public broadcaster Sveriges Television through the mid-1980s, as well as the Swedish Film Institute and its film school. This school, subsequently renamed Dramatiska Institutet and now called the Stockholm Academy of Dramatic Arts, has dominated formal higher education film training in Sweden since its inception in 1963. Stockholm also remains the ostensible

capital of the Swedish film and media establishment. However, since the mid-1990s, the production and funding parameters of the Swedish film industry have changed substantially. Both have become more decentralized, with a number of regional film funding and production centers now located outside of Stockholm, and more internationalized, as part of a general increase in Nordic and European coproductions in the wake of coproduction treaties in the 1990s.

The regionalization of the Swedish film industry during the last two decades has been facilitated by three conjoining developments. First, by national government initiatives seeking to foster dispersed political, economic, cultural, and educational interests that counteract concentration in the capital region; second, by supranational initiatives, including European Union support channeled to stressed economic regions to develop new industry segments, training programs, and employment opportunities; and, third, by local entrepreneurial business, municipal, cultural, and education representatives, who have seized on regionalization efforts from the top to increase civic, cultural, and financial output at home, so to speak.

Film training practices have been transformed as well, with a significant set of film education programs emerging in the greater Gothenburg region and Västra Götaland County during the past dozen years. This set of dynamically interrelated formal education programs established in the greater Gothenburg region since 1997 includes the University of Gothenburg School of Film Directing (Bachelor of Arts), University West's film production program (Bachelor of Arts), and the Trollhättan Vocational College's film professional program. Informal programs include County of Västra Götaland outreach programs for high-school youth and disenfranchised population groups in high-immigrant neighborhoods, the public education mission of the annual Gothenburg International Film Festival and related smaller festivals, and the continuing professional education offered by the region's major annual film industry event, Nordic Film Market.

The Gothenburg region's formal and informal film training initiatives not only benefit directly from but also contribute to the substantial regional film industry established during the past two decades. Contributions include the growth of and public support for the film fund and regional production center Film i Väst (Film in West, or FiV). FiV is based in the small town of Trollhättan, some 70 km (45 miles) northeast of Gothenburg. FiV has skillfully combined local and internationalization approaches, attracting substantial EU support during the period 1997–2005, and today derives the lion's share of its support from tax-generated Västra Götaland county funds. FiV can finance up to 20 percent of a film's budget if it is shot in the Västra Götaland region.[1] Now one of Europe's largest film funds, FiV awards about SEK 100 million (US$ 15 million) per year in coproduction funding.

The development from scratch of a regional film industry, with corresponding education opportunities, bears no precedent in the Nordic context. Since 1997, over 300 feature films, as well as many dozens of documentaries, short films, and TV dramas, have been coproduced by FiV. As a point of comparison, fewer than 30 features per year are generally produced in Sweden; FiV coproductions are thus involved in roughly two-thirds of the national output.[2] Since FiV's inception, its mandate has included the goal of generating a sustainable film production

infrastructure in western Sweden by fostering a culture attractive to locally based A-function practitioners, such as directors, producers, scriptwriters, art directors, and directors of photography, as well as by securing adequate availability of trained B-function professionals whose skills range from location managing and production coordinating to postproduction sound and visuals. This mandate corresponds to the ambition of facilitating the establishment of broad audiovisual commercial activity in the region. The need and opportunity for skilled film practitioners have helped to foster the development of this regional development.

The various models of film training available in the greater Gothenburg region and in the county of Västra Götaland provide an important angle for understanding previously overlooked aspects of regional development in creative industries and cultural arts sectors. These programs may be viewed as spanning tensions between film production as a commercial activity driven by, and in the service of, market forces or as tax-supported arts ventures serving a common and public good. Regional film training programs also illustrate how the contemporary Swedish film industry operates according to a number of constraints, all of which implicitly or explicitly inform training assumptions. This small industry of indigenous film production is characterized by fragmentation, with a number of small production companies that make relatively few films per year, and operates to a significant extent on personal connections.[3] A contemporary Swedish mid-market feature film is generally budgeted at around SEK 20 million (US$ 3 million), with notable exceptions on either end of the spectrum. Public support, from the Swedish Film Institute (SFI) or in the form of regional funding, is necessary for the vast majority of films that are not explicitly commercial genre products. Only relatively few films make a profit.

Cinema distribution options for art film, Swedish or otherwise, can only be described as extremely limited, with few for-profit distributors and only one commercial cinema exhibitor currently in operation, supplemented by a handful of cooperative or nonprofit exhibitors in the larger cities.[4] A majority of films made in Sweden reach audiences through public television broadcaster Sveriges Television (SvT), one of several private film cable channels, DVD sales and rentals, or dispersed video-on-demand services, rather than through cinema exhibition. Small production companies and independent directors often resort to ad-hoc digital distribution with unclear revenue generation venues, such as Vimeo or YouTube. Some directors use this model to generate limited crowd-sourced funding. These factors implicitly or explicitly inform educational assumptions and graduation expectations in all training programs that have developed in the Västra Götaland region, albeit in different and complementary ways.

University of Gothenburg's Film Program: The *Auteur* Model

"We train *auteurs*," affirms University of Gothenburg School of Film Directing (UGSFD) initiator and professor Göran du Rées. A veteran of Swedish film, especially in the independent documentary tradition, du Rées is one of the driving forces behind Sweden's first strictly arts-oriented university film education

program with an emphasis on directing.[5] The UGSFD is distinguished, du Rées continues, in "developing each individual's talent and aptitude for telling stories that matter personally, socially, and politically; we emphasize exploration and experimentation in visual language communication that transcends genre boundaries and we teach our students to take on projects in which they are completely in charge from idea conception to final editing." This formulation of film education is distinctive; it implies an independent, low-budget, and arts-oriented approach to filmmaking for which the individual's personal expression is key.[6] A recent description explicitly includes a social aspect: "Our guiding principle is to depict human experience, global diversity and the complexity of our times." It further affirms a "holistic and comprehensive perspective [. . . encompassing everything] from idea, funding, directing, production and post-production to distribution and screening."[7] UGSFD emphasizes directing, script development, and cinematography, including the fostering of a distinct visual mode of expression. Since the start of the program, students have been furnished with a DV camera and a laptop computer with editing software. This was a novelty when the program originated and continues to structure the curriculum, by emphasizing the significance of students' developing small projects for which they are individually responsible from inception to completion.

The program combines both feature and documentary approaches, and graduates go on to be active in both, and blended, genres. The program also works closely with the main theater actor training program at the University of Gothenburg, by which students and faculty collaborate on projects that emphasize acting and directing for film and moving images. The collaborative connection between directing and acting is immediately initiated in the program. Similarly, the UGSFD has collaborated closely with the fine and visual arts program at the University of Gothenburg, which has also resulted in a joint MA-level program on film curating. These close interdisciplinary collaborations with related fields are unique in Swedish film training programs.[8] Since its start in 1997, the UGSFD has educated 55 students in the Bachelor's program in directing, as well as an additional 50 film professionals in related post-tertiary programs on the Master's or Magister levels.[9] The entering film directing class is small, usually comprising around six students, with admissions every other year.[10]

Du Rées and colleagues at the UGSFD have created a curriculum, organization, and educational ethos at the BA level that are significantly different from the programs offered at the Stockholm Academy of Dramatic Arts (SADA; previously Dramatiska Institutet, or DI). This school, which is significantly larger, is divided into separate tracks (directing, producer, screenwriting, documentary, editing, sound, etc) and operates on a team basis that seeks to emulate film industry working expectations and conditions, as well as honing each individual's distinct set of skills. In the Swedish context, SADA today includes orientation toward training for mid- to large-level budget films, TV drama, and commercial film production and also trains for cross-media proficiency, including in analog film production on 16 and 35 mm.[11] The UGSFD curriculum, divided into about ten major segments over three years, explicitly emphasizes the significance of developing creative processes. Courses are offered at different levels in three

major areas. The first is feature film directing: script development, film theory and history, and actor instruction. The second is documentary directing and the third is called film directing tools – photography, editing, and audiovisual postproduction. Formal course work is integrated with individual student film projects. The major film project is the diploma film at the end of the third year, though students will have produced several short films as part of their education by then.

The UGSFD approach to film education aligns with that of an art school. This includes an orientation toward developing sophisticated visual modes of expression (the program tends not to foreground sound)[12] and a focus on relatively small projects for which an individual student is responsible. This institutional direction has produced a number of students who have been successful in noncommercial and art niches, winning awards for short films (e.g. Mariken Halle, Johannes Nyholm, Elisabeth Cronwall, Fijona Jonuzi) and making recognized feature and documentary films (Ruben Östlund, Gabriela Pichler, Gorki Glaser-Müller, Håkon Liu, Jonas Selberg).[13] It is clear that UGSFD directing alumni are representative of an underground, can-do, indie aesthetic, and that quite a few get their films made, to critical acclaim, and with few resources. Several of these films reach large audiences (even if nonpaying), such as Johannes Nyholm's short film *Las Palmas* (2011), which posted on YouTube with nearly 15 million views in the first year of its release. Proficiency in the producer role, including the capacity to network and make contacts for future projects, involves a different kind of training from that of a director, cinematographer, or script writer. The Swedish Film Institute, which distributes the necessary development and production funding for most films, is known to include in its selection process consideration of the comprehensive team behind a proposal.[14] Yet, it appears from conversations with current and past students that the UGSFD emphasis on creating film art and commitment to an *auteur* concept could benefit from more critical analysis of the industry and framework for which graduates are destined; they may leave the program underprepared effectively to realize all their potential, both as filmmakers and as agents of change in the industry.[15]

A particularly significant aspect of this school is the relatively rapid progression of female film director graduates transitioning from short film to full-length feature or documentary production, with development and production support from the Swedish Film Institute. Examples include Gabriela Pichler and Mariken Halle. The usual trajectory from film school to production has generally tended to be much slower for women than for men, as numerous reports have shown.[16] Indeed, a recent national Film Production and Distribution Treaty (*filmavtal*) in 2006 included an affirmative action clause meant to remedy the relative lack of women practitioners in A-functions: it suggested that at least 40 percent of scriptwriters, producers, and directors who are awarded support from SFI should be women.[17] The 2013 treaty mandates it. SFI advisor Andrea Östlund, who is a UGSFD alumna and has overseen a "Rookie" funding scheme initiative financed by FiV, notably directed its last funding cycle exclusively toward first-time women directors. In a similar vein, current SFI CEO Anna Serner has launched several initiatives to promote further gender equality. Despite advances, the industry remains

divided on the basis of gender, especially in terms of commercial narrative feature productions.

The UGSFD reflects several recent developments in the higher-education sector in Sweden, as well as in the film industry. In recent years, the program has aligned itself with the Bologna protocol of the European Union, which includes emphases on establishing a comprehensive higher-education milieu, with education programs from Bachelor's to PhD levels, curricula that emphasize critical reflection and assessment, and active research projects.[18] Film programs tend to hover uncomfortably between practice and theory; both the UGSFD and SADA have adapted to the Bologna protocol while, as a point of contrast, the National Film School of Denmark has not; it reports to the Ministry of Culture rather than to the Ministry of Education. Swedish universities have also internationalized extensively since the mid-1990s. A significant international component of the UGSFD is an exchange program on the BA level with a small number of students at the Suchitra School of Cinema and Dramatic Arts in Bangalore.[19] The UGSFD also engages with other Nordic film schools, which includes being part of the Nordic Talent film days in Copenhagen in early September each year, with students and instructors from various film schools meeting to attend workshops, to network with invited professionals, and to pitch film ideas to industry representatives. This reflects an increasing Nordic transnationalism in the industry, especially in terms of coproductions and in the international travel of labor.[20] Indeed, FiV emphasizes the incorporation and promotion of international film production as central to its mission.[21] International engagement, especially in terms of students connecting in some depth with film production practices in other countries, may be one of the areas most ripe for expansion at the UGSFD.

Being located in a developing regional film industry, and without the historical assumptions of the Swedish film establishment, the UGSFD has helped to foster what I describe as a distinctive set of Gothenburg directors. The small-scale and *auteur* approach partly aligns with industry logics for art films, which are rarely commercially viable and so depend on an individual's drive and often on personal sacrifice. The emerging Gothenburg model also indicates that support mechanisms are directed toward fostering art and documentary filmmaking in the region without the assumption of a direct return on investment. FiV, for example, sponsors each graduation film with a cash stipend of up to SEK 75,000 (ca. US$ 10,000). Initiated at around the same time, the UGSFD and FiV initiatives were not directly linked, but have clearly benefited from one another.[22] Though regionalization efforts in the audiovisual and creative sectors have often been most closely tied to economic development efforts, interaction between FiV and the UGSFD shows that the two, though seemingly serving different constituents and with different goals, in fact have closely aligned interests. The art orientation of UGSFD has fostered a set of individualistic directors who make recognized and critically acclaimed films, often with coproduction funding from FiV; this in turn helps FiV fulfill its mission to create a viable and differentiated film culture in the region.

UGSFD Graduate Ruben Östlund

Acclaimed director Ruben Östlund's career provides one venue for understanding some characteristics of the specific film milieu of the Gothenburg region, including the significance of the UGSFD. Östlund is the most famous and acclaimed of the program's graduates to date. He credits his experience in the program and interactions with key faculty, including veteran producer and affiliated professor Kalle Bohman, for providing the conceptual, intellectual, and artistic tools needed to refine his filmmaking skills and for enabling him to begin taking storytelling and aesthetic risks that challenge conventional dramaturgy, visual expression, and boundaries between documentary and fiction.[23] Östlund's films have been produced by Erik Hemmersdorf, a UGSFD graduate and producer at Plattform Produktion, which is a key driver in the Gothenburg film milieu. In particular, Östlund indicates that the all-around training delivered by the program, where the practitioner is deeply involved in all aspects of the film—including script development, production funding, directing, filming, and editing—was decisive, in terms of his drive to make independent and individualistic films.

Östlund is one of the few younger-generation contemporary Swedish directors to call himself an *auteur* and to self-identify with that term's historical connotations—as the author of a complete work of art with high artistic and deeply personal aspirations. Östlund is also a self-described political filmmaker who wants to make films of contemporary social significance. Two of his feature films, *De ofrivilliga* (*Involuntary*, 2008) and *Play* (2011), have opened in Cannes, which is no small feat for an emerging and low-budget director; *Play* received the prestigious Nordic Council film prize in 2012. Coproduced by Paris-based Bober Films and distributed internationally, Östlund's film joins a catalog that includes hardly anyone not of European *auteur* rank. Plattform Produktion has nurtured this international collaborative development as a dedicated strategy aimed at building a foundation for serious engagement with art film in the Gothenburg region. Östlund began plans for his first feature, *Gitarrmongot* (*The Guitar Mongoloid*, 2004), soon after graduating. Working with Bohman and Hemmensdorf, Östlund pursued his interest in shooting locally in a blended documentary-fiction film form, an approach dovetailing with the film training at the UGSFD. Rather than pitching a script to the Swedish Film Institute for production support, with an ensuing lag time, Östlund and Plattform undertook the project in installments, shooting and editing consecutive segments of the film before applying for SFI funding, which provided the support needed to finish the film. Film i Väst provided coproduction funding, continuing its practice of supporting filmmakers trained at the UGSFD.

Östlund's most recent film, *Play*, caused intense media debate in Sweden in 2011. Based on real events and with dialogue partly based on court transcriptions, *Play* tells the story of three middle-class Gothenburg school boys who get conned, humiliated, and eventually robbed by five boys of African descent, presumably first- or second-generation immigrants. Östlund deliberately turns the tables on contemporary Swedish politically correct rhetoric that positions non-ethnic or

foreign-born Swedes as victims and their compatriot Swedes as lords-in-charge.[24] In terms of visual aesthetics, especially image composition, Östlund emphasizes geometry. *Play* is visually organized in horizontal, vertical, and diagonal lines—spatially, scenes appear to convey isolation and alienation. Östlund's framing of actors is distinct. Rarely are any of the boys featured on their own in a frame and they are never featured in close-up; a collective, often in movement, is prioritized over a stationary registering of one character's emotions through a close-up. There is not one instance of a traditional shot-reverse shot editing principle, which is the standard film tool to create the illusion of continuous dialogue. There are occasional slow tracking shots but the camera is most often stationary; cinematic movement is created through steady horizontal pans and through zooms, alternately zooming in and out. One of the most distinguishing features of Östlund's cinematic strategies is his emphasis on long takes, with scenes lasting two to five minutes, which situates him squarely in an *auteur* and New Wave tradition. The result is a film expansive in its scenery and temporal construction, yet distilled and uncluttered by images juxtaposed in the editing process, or by disjointed camera movements. The long take is also an apt cinematic strategy for presenting a particularly incisive portrayal of Swedish contemporary society, promoting the notion that the film is somehow *real*. The film is not only based on actual events; its very cinematic strategy fosters this supposition.

The fact that *Play* was shot with a digital video camera recalls the standard practice at the UGSFD and bears testament to Östlund's training in the program. The film is also representative of the transition in film practice during the last 15 years; the Danish Dogma films of the late 1990s brought DV-produced filmmaking in the Nordic countries to the big screen. In effect, Östlund's *Play*, with its references to classical film theory of the long take and *auteur* practices, is also representative of the rapid change in global motion picture distribution and screening practices. Despite the seeming advantages of digital technology for enhancing viewership—such as, being much easier to distribute, less fragile, viewable on multiple platforms, and so on—Östlund's film was exhibited on only a handful of commercial screens in Sweden; it has subsequently made the rounds in Sweden by being screened partly at community centers. This low-key means of exhibition persists despite Östlund's rank in the European film community, with films opening at Cannes, film support from the Swedish Film Institute, *Play* being a European coproduction, and the film's having a topic that created intense debate.

Östlund's career, including his decisions to film locally and be an active participant in Gothenburg film culture, reflects both the practices and the ethos of the UGSFD. These include an emphasis on making socially relevant films based on a clear personal perspective with a distinguishable set of visual aesthetic strategies, experimenting creatively with digital film technology, exploring multiple aspects of the screen-acting process, working with amateur actors, and setting up circumstances of filmmaking in which the director can be in direct control of the entire process. The difficulties in screening *Play*, and having it reach a large audience, also illustrate challenges with which the Swedish, and most smaller film contexts, must contend. Such challenges are, arguably, an aspect of real-world practice that most film training programs do not effectively take into account; in its emphasis

on art film creation for noncommercial venues, the UGSFD trains students for this particular paradigm, but appears to do so effectively.

Theory or Practice? Competing Demands in the Film Production BA at University West

The Bachelor of Arts program at the University of Gothenburg School of Film Directing has trained some of Sweden's most interesting emerging art film and alternative filmmakers. Nearly simultaneous with the start of UGSFD, FiV in collaboration with University West (Högskolan Väst) initiated Sweden's first Bachelor's program in Film Production.[25] Designed to educate film producers, it also provides students with transferable competence for other media industries. Lars Dahlqvist, a veteran Swedish film and TV producer, is one of the originators and a continuing lecturer and advisor in the program. Dahlqvist emphasizes that the curriculum at University West in Trollhättan was designed with complementary as well as seemingly competing aims: first, to tailor a traditional Business Administration curriculum to burgeoning student interest in media industry and policy; second, to offer a critical perspective on media-profession hype; third, to position creative and culture sector practices as integral to traditional industry regeneration; and, fourth, to serve as a supporting mechanism to the evolving film industry in western Sweden.[26] The regional production center Film i Väst was supportive of the education initiative, as University West's campus is located in Trollhättan, in the same town as FiV.[27]

The University West program is partially a response to the industry perception that Sweden lacks sufficiently skilled producers, with the relevant need escalating as film and media contexts become increasingly multifaceted through international coproduction developments and accelerating digital production, distribution, and convergence practices. With the exception of the practically oriented film and television producer track at SADA/DI in Stockholm, there is no other formal educational track for film and media producers in Sweden. The profession is generally characterized by unstructured apprenticeship training, with individuals moving through the ranks from production coordinator to line producer to producer, frequently assuming several of these functions concurrently for different productions.

University West's Film Production program presents itself as preparation for employment in what it calls "creative organisations," including foci in organizational leadership, entrepreneurship, and project management.[28] It emphasizes academic instruction, rather than practical or internship training, although it invites visiting lecturers active in the industry. In the film production context, the education focuses on the preproduction stage, with a significant set of courses offered in Business Administration (*företagsekonomi*), including budgeting, organizational theory, personnel management, marketing, entrepreneurship, and investment and financial analyses. The second major component is a course generically called "film production," which includes production processes and practices, media and film law, industry characteristics, and idea generation and project development, as well as a thesis project oriented toward research methodology. Internships can

be counted as electives in the program, but are not required. Accepting about 30 students per year since 2001, the program reflects competing educational and industry demands.

The BA in Film Production at University West provides a key example of the competing demands of higher education, which, like the competing demands of the film industry, hover between market-oriented and critically reflective and analytical noncommercial orientations (the latter usually being understood as key in a liberal arts curriculum).[29] Students seek out the program because of a perceived close proximity to the film industry in Trollhättan and the Västra Götaland region, even though the curriculum, by and large, is not directed to generating industry contacts, network access, or internships.[30] Some program components involve industry engagements—such as a session on pitching film projects, which can be described as "a fairly concrete example of the market orientation of the learning process"—and reflect industry expectations that students be socialized into industry norms.[31] Yet, Film i Väst's involvement in the educational program has been sparse, limited to organizing supplemental industry workshops about once a year.[32] Thus, the tension between the program's academic/theoretical direction and student interest in practical applicability and industry expectations clearly correlates with changes in a higher-education context over the past 20 years, which has included both a push away from traditional liberal arts curricula toward professional programs and toward establishing new university colleges as part of regional economic and employment development initiatives. University West is one of these new regional universities. This institution has, moreover, sought to differentiate itself as a college dedicated to integrated professional learning pedagogy (*arbetsintegrerat lärande*) and research on affiliated processes.

Though European higher education has internationalized substantially over the last two decades, in part due to the Bologna protocol and increased student mobility through the Erasmus program, relatively little attention in the Film Production BA at University West is oriented toward preparing students for international production and media contexts. Similarly, relatively little effort is spent on critical analysis of or practical preparation for digital convergence paradigms. The program and curriculum have transitioned over the years toward a broader focus on media, culture, and creative sector management. The Swedish film industry cannot absorb 30 film producer graduates per year, especially as students are academically trained for a profession that remains heavily dependent on personal connections and networks, and in which a university degree is not necessarily regarded as an indicator of success. At the same time, the Film Production BA is not oriented toward theoretical or historical analyses of industry, film, and media cultures, with only one short course pertaining to those fields.[33] The Film Production BA at University West thereby provides evidence of the heterogeneous growth and dynamic educational context in the greater Gothenburg region. Having developed largely independently of one another, the varied film education programs in the region by now seem to cover most bases. Together they represent a snapshot of early twenty-first-century film industry assumptions and educational standards.

Creative Ad-hoc Resource Alignment: Producer Erika Malmgren and Director Gorki Glaser-Müller

Gothenburg-based producer and production coordinator Erika Malmgren graduated with a BA in Film Production from University West in 2005. Having studied film history and criticism at Lund University, Sweden, and practical production at the European Film College in Denmark, she is representative of many of the program's students who have had some postsecondary educational or professional film or media experience before entering the program.[34] When Malmgren started at University West in 2002, several of Swedish film's best-known directors of that decade, such as Lukas Moodysson and Josef Fares, were regularly filming in Trollhättan. This was an especially dynamic time for Film i Väst, which was rapidly expanding, attracting international coproductions, and building the international reputation upon which it now relies. Malmgren recalls the University West program marketing itself as being closely aligned with the film industry, including access to industry and business networks, internships, mentors, and practical on-set production experience.[35] Together with several students in her class, she sought to be more actively involved in film producing than what was incorporated within the de facto academic focus of the program. To accomplish this goal, she and fellow student Anna Byvald contacted the University of Gothenburg School of Film Directing to inquire about partnering up with BA directing students for thesis projects; this way, both student producers and directors could develop their professional skillsets under real-world conditions.

Malmgren and Byvald took on and jointly produced UGSFD directing student Gorki Glaser-Müller's award-winning short film *Ägget* (*The Egg*, 2003).[36] By pooling resources from their respective educational programs and applying for supplementary short film production funding from FiV, they pulled off a sophisticated and original film with an astonishingly low budget of about SEK 15,000 (ca. US$ 2000). Malmgren, together with University West Film Production graduate Kristoffer Henell, has subsequently produced all of Glaser-Müller's films, including his first feature *En gång om året* (*Once a Year*, 2011), which screened to significant acclaim at the Gothenburg International Film Festival in 2012, and received cinema distribution in 2013. A low-budget film coproduced by Zentropa International Sweden and Film i Väst, without support from the SFI (something highly unusual in Sweden, especially for an ambitious low-budget first feature), *Once a Year* presents a compellingly directed and acted clandestine love story spanning 30 years, focusing on the once-yearly meetings between lovers Maria (Gunilla Röör) and Mikael (Michalis Koutsogiannakis). The film was shot nearly continuously in a hotel room with very few retakes. Cinematic strategies include long takes, probing close-ups, asynchronous sound and image editing, and a deliberate use of an original and sparsely suggestive soundtrack. The film is also highly unusual in contemporary Swedish film history—it focuses resolutely on a mature romantic relationship and the characters shaped by it.

In conjunction with the film, Malmgren, Henell, and Glaser-Müller also formulated a manifesto; this document reflects the ethos and practices of filmmaker training at the UGSFD, as well as Malmgren's interest in producing quality

films on a limited budget, and her recognition of the constraints she would be operating under as a rookie feature producer. Key components of the manifesto include stipulating that the film be a chamber play, with a maximum production time of two weeks, shot with Glaser-Müller's personal equipment (only sound equipment could be rented), no postsync of dialogue sound, limited scenography, a small team, and no salary paid in advance of supplemental financing.[37]

The ongoing collaboration between producer Erika Malmgren and director Gorki Glaser-Müller reflects their mutual interest in developing a distinct set of film skills in the course of their educations, appropriate for either profession. For Glaser-Müller, the UGSFD directing program's emphasis on the individual being in charge of a complete film process, from idea to final editing, initially presented obstacles to his realizing his full potential in the creative process.[38] Trained as an actor at one of Sweden's competitive university acting programs before his admission to the UGSFD, and with a clear mission to direct feature films in which he could work closely with actors to tell compelling interpersonal stories, he wanted to hone those skills rather than also to assume responsibility in a producer's or production coordinator's role. For Glaser-Müller, the close UGSFD collaboration with the University of Gothenburg's acting program, and especially with professor Gunilla Röör, was formative. Indeed, the concept of *Once a Year* was first developed during one of the program's training sessions in which Röör participated. Malmgren, Henell, and Glaser-Müller have realized a succession of films by adopting a low-budget, can-do attitude quite typical of the film culture emerging through the commitments and activities of practitioners based in the Gothenburg region, including several trained at the UGSFD. With support from FiV and drawing on in-kind contributions from unpaid actors and other professionals, *Once a Year* was realized on a very small budget.

Malmgren indicates that the close collaboration with Glaser-Müller was influential for her as a producer seeking to produce A-list narrative feature films, and that it was during this practical work that she began to formulate her acutely analytical assessments of the industry, including its conservative status quo assumptions.[39] She sees the film sector as fiercely competitive, and often fragmented, and believes that it is very difficult to become established as a producer, even with the kind of academic training, experience, and connections she has acquired.[40] Indeed, to support herself, she works as a freelance unit production manager and coordinator for larger film and TV productions, mostly in the Gothenburg region. Although she regards this work as exciting and stimulating, she also claims that it weakens her interest in producing more feature films. The Swedish film industry remains male dominated and especially so in the feature film producer category; it is not unlikely that Malmgren's professional situation also reflects gender biases. Getting access to and being included within the production network has been the most challenging component of her career, Malmgren asserts. Similarly, Glaser-Müller expresses that he wants to focus on feature film directing, but that the financial outcomes of doing so are unsure at best. Having invested his own time and resources in all previous films without subsequent revenue generation, Glaser-Müller supports himself largely as an instructor of

film, media, and directing at different schools, including at the UGSFD, in the Gothenburg region.

Reflective Skill-set Vocational Training: A New Training Model for Film Practitioners

A third film education program has emerged in western Sweden since the late 1990s, now known as the Film Worker Training Program and offered at the Vocational College in Trollhättan. This two-year program was initiated by Film i Väst in the mid-1990s to ensure adequate availability of supporting functions for film and TV shoots in the region. Functions include production coordinator, location manager, first assistant director, assistant director of photography (B-photo), electrician, mask designer, costume designer, and DIT (digital imaging technician). Recruiting nationally once every two years, the program attracts a large number of applicants and boasts a high employment rate upon graduation. Students admitted generally have some previous experience from film and media areas and train for a technical- and production-team-oriented career, rather than directing or producing.[41]

Program director Charlotte Gimfalk, with experience from Hollywood and the Swedish film industry, designs the makeup of each class in close consultation with the film and TV industry, including a group of producers, FiV representatives, and former students, to ensure that the different educational tracks are targeted to industry needs.[42] This is clearly a professional skillset-oriented program, but also involves a substantial degree of self-reflection and analysis. It thereby challenges customary boundaries between "academic" and "vocational" programs. Each student has an individual education plan, with specific goals and evaluation criteria. Students are responsible for assessing progression toward goals, and their current and expected future skillset level. Student testimonies and learning outcome documents on the program's website attest to the level of process- and critical analysis that these students are trained to engage in, including in ways that articulate sophisticated self-reflection on career assumptions and choices. In contrast to the academic programs presented in this chapter, this professional program incorporates extensive internship components, including in ways that take specific advantage of FiV-funded productions in the Västra Götaland region. These internship components can range in time from a day to many weeks, especially during summer months when production is most intense.

One of the primary aims of the Trollhättan Vocational College program is to give students access to a network of film industry professionals upon graduation; this reflects the informal and network-oriented characteristics of a small industry based in a small region. Moreover, Sweden, in contrast to the United States and the UK, does not have set employment characteristics for professional supporting film production functions. Gimfalk designs the curriculum based on the UK Creative Skillset model to ensure consistency and practical applicability.[43] This helps ensure student employability, but also, she maintains, has the potential to help diminish reliance on informal connections in the industry. The Swedish film industry is fragmented and dominated by a number of small production companies that

rely on their networks and word of mouth to hire professionals for productions, rather than on a set of standardized professional job descriptions for supporting functions. With such descriptions in place, whether based on the Creative Skillset formulations or not, she argues, jobs may be more easily accessed and, perhaps, more fairly awarded, including according to gender, social background, nationality, and ethnicity.

A related and significant educational component of the Trollhättan program emphasizes each student's knowledge of employment regulations, safety protocols, and practical workflow organization. As Gimfalk emphasizes,

> these students will in many cases be working for exceptionally driven and demanding people, directors and producers who may believe, and want to present the case, that this one particular film shoot is the most significant in the history of film, period. Supporting functions need to know safety and employment regulations well to safeguard the quality of a production and the safety of all involved. I see this component as one of the most significant contributions of the program.

Most of the students graduating from the two-year program go on to be freelancers in a competitive industry. As Gimfalk emphasizes, the program thus also needs successfully to train students to manage their careers as freelancers in frequently brutal work settings, as well as to foster a set of reasonable employment expectations, including remuneration, and the need to maintain a healthy lifestyle under what are often physically and mentally demanding conditions.

The Greater Gothenburg Region Film Context

The three complementary film training programs of the greater Gothenburg Region have developed largely independently of one another and with surprisingly little formalized engagement and few interactions between them, though each is supported in different ways by Film i Väst. Despite the relative insularity of each program, these constitute a heterogeneous, dynamic, and productive regional educational ecosystem unique in Sweden and in the Nordic context. Several related film training and educational efforts in the area align with the formal programs both to support and to further what has become a very dynamic film culture in the greater Gothenburg region. Other initiatives in the region also contribute to the dynamic film culture: film festivals here, as in many other parts of the world, serve critical functions both for public and professional education.

The Gothenburg region is indeed home to one of the largest public film festivals in the world. Started in 1977, the Gothenburg International Film Festival (GIFF) is held annually for ten days at the end of January and in early February. Its aim is to screen what it describes as "valuable films from all over the world and to encourage engagement with and conversations about film culture."[44] In addition to a large and varied screening program of hundreds of films, many from regions around the world not otherwise represented in Swedish film culture, the festival awards several distinguished prizes and sponsors the world's largest

program of free public seminars on film policy and culture, as well as master classes, and workshops for professionals. GIFF thereby serves a de facto public education mission, which distinguishes it from many festivals mostly oriented toward screenings. Drawing a significant contingent of the Swedish film industry, including international and domestic directors, key representatives from main production companies, the Swedish Film Institute, regional film funds, professional organizations, and film education programs, GIFF turns Gothenburg into a hub of film connections during a traditional lull in production activity in the winter months. GIFF also sponsors the Nordic Film Market (NFM), which is the Nordic region's largest industry, trade, prescreening/work in progress, and distribution event, attracting industry representatives from Europe, the United States, and other parts of the world.[45] GIFF immediately precedes the Berlin film festival and plays a significant role in preparing deals completed either during NFM or at Berlin. A complementary aim of NFM is to serve as a conduit for continuing education for industry professionals through targeted master classes and seminar presentations. The University of Gothenburg Film Program organizes a seminar and networking event during GIFF for film education students from all over the Nordic region, with FiV organizing a conjoining master class and industry networking event. The recently launched Gothenburg Film Studios, with related film companies located in what is becoming a hub of film and media activity at the rehabbed shipbuilding dock of Liljeholmen, also organize a set of complementary public education and filmmaking exposure events during GIFF.

Although the main festival and marketing events are concentrated in an intense ten-day period, GIFF and NFM serve as a conjoining force for the Gothenburg region film context, not least by employing a year-round staff member who helps to coalesce a number of fragmented practitioners into a film community in the region. GIFF also organizes regular film screening events during the year on a smaller scale, and has recently introduced a children's and youth film festival in mid-January, which includes practical and hands-on film training components. Filmmaking training and film culture exposure for local youth in elementary and secondary schools, as well as for disenfranchised social groups, are components of the Västra Götaland region's cultural and educational aims. The regional office, Kultur i Väst (KiV), channels support for outreach to schools, Bergsjöns Kultur- och Mediaverkstad, the youth film competition program Frame, and the distinguished International Exile Film Festival, held annually in the early fall, which attracts films and filmmakers in exile from around the world to screenings and presentations.[46] The county thereby functions as a cofunder and coordinator of a very wide array of initiatives. A recent project involved a semester-long film and workshop lab for young women, with the explicit aim of increasing the number of women filmmakers in the greater Gothenburg region.[47] Filmmaker education, as well as cofinancing of film production, is publicly supported through a multifaceted and loosely organized system in the Västra Götaland region. This system accommodates a range of expressions and initiatives, is fragmented and eclectic in its composition, and is distinctive of what has become a rich film culture in the greater Gothenburg region during the past decades.

Conclusion

Film industry and education developments in the greater Gothenburg region during the past 15 years are quite remarkable by any standard. The significance of the three formal film education programs and related supplementary outreach, pedagogical, and industry events cannot be underestimated, though their significance has been overlooked in previous scholarship. Publicly supported regional film fund and production center initiatives, in Sweden and in Europe, are often framed as motivated and evaluated by job and revenue generation. These aspects have clearly played an integral part in developments in the greater Gothenburg region. Yet the pedagogical assumptions and underlying logic of the region's complementary and dynamically integrating educational programs testify to film's sustained imbrication in a paradigm that hovers between formulating film and media production as a commercial activity governed by market assumptions and a very clear need for a diverse and differentiated film sector in which art, upmarket, and individualized film production and media generation are equally important for creating a viable film industry culture that transcends its regional and national contexts. Efforts by a diverse set of agents, representing state, regional, municipal, and commercial media interests in the greater Gothenburg region of Västra Götaland have conjoined, not that it appears by deliberate coordination among partners involved, to form what can be described as a productive constellation with significant potential for the future, despite challenges facing graduates and those active in the industry.

One challenge is that film education programs continue to train according to a set of expectations that derive from film policy and production contexts established in the 1960s. Film programs tend to underscore that film is not only a commercial activity but serves a public good, not least by making films set in Sweden, with dialogue in Swedish, relating to contemporary Swedish culture and social practices, and made by a category of professionals assumed to be "Swedish" by virtue of having been trained "at home." Though there are some significant international outreach components, film education programs are generally oriented toward a lingering notion of film and moving image generation as nationally oriented and constituted; though international coproductions are steadily increasing, domestic release mechanisms are thwarted, and digital media convergence generation and distribution paradigms have global potential.

Theoretical and practical engagement with digital distribution and the impact of media convergence practices remain a challenge for educational programs that emphasize process (whether arts oriented or deliberately commercial) and object generating (a finished film, whether digital or analog). Few programs cross over to other digitally networked or imaging content production or to gaming, for example. Practitioners, however, once active in a field characterized by freelance and insecure employment, work in multiple forms of visual media production—commercials, music videos, informational, educational, and project films, and so on. Film training programs clearly grapple with the impact of a digital "transition," especially in terms of financial viability and distribution of films produced, yet they do not explicitly include these aspects as a major part of a curriculum. Graduates prepare generally for small-scale output, small organizations,

and with the expectation of working in a fragmented industry where they will operate largely as freelancers while also drawing public support in different forms. There are few efficiency mechanisms in place in the Swedish film industry, and few film programs appear to train for a change in this area that could conceivably help to further the reach and impact of films made in Sweden by filmmakers trained in the greater Gothenburg programs.

Film training programs are therefore located at the center of contemporary higher-education debates about "globalization" and "strategic" international engagements, and those focusing on digital pedagogy and content delivery. What is more, they reflect assumptions pertaining to the scope and modus operandi of the industry and policy contexts from which they derive and to which they contribute. The dynamic example of film training programs developed in the greater Gothenburg region during the past 15 years provides a particularly productive angle through which to understand this complexity.

Acknowledgments

Travel and other research funding to complete this chapter is gratefully acknowledged from the European Commission, the college of Liberal Arts and Sciences at the University of Illinois, and the Anna Lindh Fellows program of Stanford University.

Notes

1. Film i Väst AB, *Årsredovisning*, 2011, www.fiv.se (accessed May 12, 2012). FiV includes a description of its aims and mission on its website: "Film i Väst has directly contributed to the growth of the industry, the education of film workers, and the development of new talent in the region. Now involved in 30–40 feature film coproductions each year, it is one of the most significant regional film funds in Europe and the most significant source of funding for films in Sweden, after the Swedish Film Institute. It acts as a coproducer, part owner and financier of feature, short and documentary films, drama for TV, and offers many additional resources for film production."
2. Comprehensive information about films produced in Sweden is collected by the Swedish Film Institute, available at *Svensk filmdatabas*, www http://www.sfi.se/en-GB/ Swedish-film-database/.
3. Several recent reports discuss these aspects in more detail. See, for example, Olsberg SPI, *Building Sustainable Film Businesses: The Challenges for Industry and Government* (London: Olsberg SPI, 2012) and Ib Bondebjerg and Eva Novrup Redvall, ed., *A Small Region in a Global World: Patterns in Scandinavian Film and TV Culture* (Copenhagen: Filmthinktank, 2010).
4. Svensk Filmindustri is the only commercial cinema exhibitor in Sweden as of 2011. The nonprofit organization Folkets Bio is represented in larger cities and university towns.
5. Göran du Rées, research interview by the author (Gothenburg, June 13, 2011). Subsequent references to remarks by du Rées refer to this interview, unless otherwise noted.
6. The program on the BA level is called "Konstnärligt kandidatprogram i filmisk gestaltning—regi och produktion, 180 högskolepoäng," translated in English documentation as "BA programme in Independent Filmmaking—Directing and Producing 180 higher education credits [ECTS]."

7. Filmhögskolan, "Our Vision and Strategy," http://www.film.gu.se/english/Our_vision_ and_strategy/. See also "Film at Valand Academy," http://www.film.gu.se/english/? languageId=100001&contentId=-1&disableRedirect=true&returnUrl=http%3A%2F %2Fwww.film.gu.se%2F (accessed May 7, 2012).

8. Indeed, in June 2012, four fine arts departments merged into one academy at the University of Gothenburg, effectively aligning education and research in film, photography, fine arts, and creative writing.

9. In recent years, the UGSFD has branched out in terms of coursework on the post-BA level to include one- or two-year training programs with a focus on entrepreneurship and public distribution of films, film curating, international producer skills, and further development of the artistic processes involved in cinematic representation.

10. Students admitted are relatively equally disbursed according to gender. No information is gathered on ethnicity or immigration status, though students are required to speak and read Swedish; instruction is in Swedish only at the BA level.

11. What is now SADA originated in 1963 as part of a government initiative to support film production, distribution, and culture in Sweden. During the period 1970–2004, the Dramatiska Institutet film program was housed in Peter Celsing's monumental concrete building dedicated to film culture, the Film House, which contained production studios and cinemas, as well as the offices of the Swedish Film Institute, and Stockholm University's Cinema Studies program. Chief architect of Sweden's first public film support program, the Film Production and Distribution Treaty of 1963 (*filmavtalet*), and key driver in establishing the Swedish Film Institute, the Film School, and the Film House was Harry Schein. Schein served as CEO of the Swedish Film Institute (1963–1970 and 1972–1978) and as director of the board (1970–1978). His formidable impact and legacy is described in a recent impressive volume published by the Royal Library: *Citizen Schein*, ed. Lars Ilshammar, Pelle Snickars, and Per Vesterlund (Stockholm, the Royal Library: Mediehistorisktarkiv 14), 2010. As of 2011, the merged National Academy of Dramatic Arts contains three departments: The Department of Performing Arts, the Film and Media Department, and the Department for Acting.

12. Gorki Glaser-Müller, "Blind eller döv?," in *Filmblickar*, ed. Jonas Eskilsson, www. filmblickar.se.

13. A list of graduates is available at: http://www.film.gu.se/ViewPage.action?siteNodeId= 518524&languageId=100000&contentId=-1. A cross-match between these names in *Svensk filmdatabas*, the most comprehensive repository of information on the film industry in Sweden, shows that a majority are active in the field. Graduates have also gone on to significant policy- and film-development or educational positions in Sweden (e.g. Andrea Östlund, Linda Sternö). Many UGSFD graduates remain in Gothenburg and contribute to the strong film culture there, including by setting up small production companies, being active in professional organizations, teaching at local schools, and participating in the Gothenburg International Film Festival, GIFF.

14. Ref Jenny Lantz, *Om kvalitet. Synen på kvalitetsbegreppet inom filmbranschen* (Stockholm: Wift, 2007).

15. Similarly, study of film theory and history, as well as an analytical study of media and technology, is generally underrepresented in film school training; the UGSFD is no exception.

16. Several recent publications and reports have investigated prevailing gender discrepancies in the Swedish film industry, especially in A-functions such as producer and director. These include Svenska Filminstitutet, *00-talets regidebutanter och jämställdheten* (Stockholm: SFI, 2010), http://sfi.se/sv/om-svenska-filminstitutet/ Publikationer/Omvarldsanalys-och-uppfoljning/ (accessed May 7, 2012); Karin

Högberg, "Kvinnor som producenter," in *Att göras till filmarbetare*, ed. Margareta Herrman (Stockholm: Nya Doxa, 2011), 142–172; Jenny Lantz, *The Fast Track: Om vägar till jamstalldhet i filmbranschen* (Stockholm: Wift, 2011) and *Om kvalitet*; and Svenska Filminstitutet, *Hur svårt kan det vara? Filmbranschen, jämställdheten och demokratin* (Stockholm: SFI, 2004). See also, Annika Wik, *Inför nästa tagning: kontaktytor för unga filmskapare* (Stockholm: Svenska Filminstitutet, 2012).

17. *2006 års filmavtal*, p. 2, http://www.regeringen.se/sb/d/5975/a/50827.
18. Du Rées and others involved in the UGSFD have indeed launched artistic research programs. See, for example, a substantial joint journal publication by a number of scholars and practitioners active at the University of Gothenburg college of fine arts entitled "'Passionen för det reala': nya rum," *Art Monitor* 9 (2010) [no named editor]; Göran du Rées, *The Gunshots at Vasaplatsen*, DVD (Gothenburg: University of Gothenburg, 2010), http://www.film.gu.se/Forskning/Forskningsprojekt/the-gunshots-at-vasaplatsen—skotten-pa-vasaplatsen/; and, Jonas Eskilsson, ed., *Filmblickar*, Göteborgs universitet filmhögskolan, 2012, www.filmblickar.se (accessed May 7, 2012).
19. The exchange is focused on student–student individual film laboratory projects, in which students spend a few weeks of intense collaboration with one another at each location, focusing on the development of a joint short film. This exchange is part of a Västra Götaland region's greater cultural exchange agreement with Bangalore, in place since 2008.
20. For accounts of these developments, from multiple perspectives, see articles in *Transnational Cinema in a Global North: Nordic Cinema in Transition*, ed. Andrew Nestingen and Trevor Elkington (Detroit: Wayne State UP, 2002).
21. Film i Väst AB, *Årsredovisning 2011* (Trollhättan: Film i Väst, 2012). http://www.filmivast.se/finans.
22. For example, FiV outreach and education coordinator Louise Martin helps organize professionalization workshops and meetings with FiV's film commissioner and other advisors.
23. Research interview with Ruben Östlund, by the author (Gothenburg, June 13, 2011). Subsequent references to Östlund's remarks derive from this interview, unless otherwise noted.
24. Swedish culture and public discourse exhibit a high level of anxiety with respect to non-Western immigration, with people of African and Middle-Eastern descent, or who are Muslim, being the object of anxiety. Sweden's population of first- and second-generation immigrants has risen steadily over the last decades, with 15 percent of the current population born abroad, as reported by Statistics Sweden http://www.scb.se/Pages/PressRelease_305658.aspx.
25. Degree of Bachelor of Arts with a major in Film Production. Information on this educational program is available at http://www.hv.se/extra/pod/?action= pod_show& module_instance=2&id=538&page=hv_prog.php&study_plan_id=521&show_prog =visaprog&fullwidth=true&webid=HV-91278.
26. Lars Dahlquist, research interview by the author (Gothenburg, June 10, 2011). All subsequent references to Dahlquist are from this interview.
27. Louise Martin, research interview by the author (Trollhättan, January 31, 2012).
28. See course presentation and student testimonies at http://www.hv.se/extra/pod/?action=pod_show&module_instance=2&id=538&page=hv_prog.php&study_plan_id=521&show_prog=visaprog&fullwidth=true&webid=HV-91278.
29. A recent collaborative research project has analyzed some of these competing demands, including student learning outcomes, industry engagement expectations, and underlying assumptions of a professionally oriented academic university education

that also should include, as per higher-education standards in Sweden and the European Union, emphasis on critical reflection, impartial research inquiry and methodology, and analyses of context assumptions. Herrman's and colleagues' findings are collected in the informative volume *Att göras till filmarbetare*, ed. Margaretha Herrman (Nora: Bokförlaget Nya Doxa, 2011). See especially Margareta Herrman and Carina Kullgren, "Studentpitchen: iscensatta normer," 233–253, and Maj Asplund Carlsson et al., "Att göras till filmarbetare i den nya kulturekonomin," 280–291.

30. Dahlqvist, research interview; Erika Malmgren, research interview by the author (Gothenburg, May 17, 2012). Subsequent references to Malmgren pertain to this interview.
31. Herrman and Kullgren, "Studentpitchen," 252. Functional translation by author.
32. Martin, research interview.
33. The program does not maintain alumni statistics.
34. Dahlquist, research interview.
35. Malmgren, research interview.
36. Anna Byvald has upon graduating from the Film Production program at University West in 2005 become one of Sweden's more recognized documentary producers, including winning awards for films such as *Maggie vaknar på balkongen* (*Maggie in Wonderland*, 2008) and *Jakten på Bernhard* (*Traces of Bernhard*, 2010), both coproduced by Lukas Moodysson, and receiving production funding from SFI and several regional film centers, including Film i Väst.
37. Gorki Glaser-Müller, et al., "Manifesto för vår film." Formulated February 2009. Submitted via e-mail to chapter author on May 9, 2012.
38. Gorki Glaser-Müller, research interview by the author (Gothenburg, May 22, 2012). Subsequent references to Glaser-Müller pertain to this interview.
39. Ref accounts in Högberg, "Kvinnor som producenter;" Lantz, *The Fast Track*; Svenska Filminstitutet, *Hur svårt kan det vara?*
40. Malmgren has also worked as deputy commissioner for short films at Film i Väst and was selected on the recommendation of FiV to participate in a targeted trainee program offered by the employment office in Trollhättan, serving to connect film practitioners with industry professionals.
41. See http://www.filmarbetarutbildningen.se/. This website contains quite detailed information on the program, curriculum, alumni tracks, and student self-reflections and statements.
42. Charlotte Gimfalk, research interview by the author (Trollhättan, 10 May 2012). All subsequent references to Gimfalk pertain to this interview.
43. http://www.creativeskillset.org/standards/standards/Production/. Student accounts of their education and learning trajectory, included at http://www.filmarbetarutbildnin gen.se/, show evidence of the significance of the Creative Skillset rubrics and set of professional definitions.
44. Paula Wahlbom, research interview by the author (Gothenburg, May 17, 2012). See also Gothenburg International Film Festival, *Statistik, Publik och Media* (Gothenburg: GIFF, 2012) and Eva Novrup Redvall, "More than films and dragon awards: The Göteborg International Film Festival as a meeting place," in *Journal of Scandinavian Cinema* 2.2 (2012): 135–142.
45. Cecilia Edström, research interview by the author (Gothenburg, August 4, 2011). NFM sponsored the author's accreditation to GIFF and NFM in 2012.
46. Pia-Maria Wehrling, research interview by the author (May 16, 2012).
47. Kultur i Väst, *Fokus: Filmteknik för tjejer. Rapport från ett genusprojekt*, Skriftserie 2012: 1. Västra Götalandsregionen.

Divided *Dirigisme*: Nationalism, Regionalism, and Reform in the German Film Academies

Barton Byg and Evan Torner

The post–Second World War history of German film academies, and even their history since German unification in 1990, is one of politics and paradoxes. As such, it reflects the deep contradictions inherent in Germany's film and media industry, educational institutions, and administration of culture. Some of the consistent contradictions can be found neither at the level of aesthetics nor at the level of pedagogy, but at the level of policy and diplomacy. They are between centralized, top-down administration and regionalist and/or grass-roots decentralization; between art and commerce; between present-oriented production and an engagement with history (either of German cinema or of an individual film school); between institutional support for national legitimacy and resistance or alternatives to these institutions; between nationalism and internationalism, either on bilateral terms with a superpower such as the United States or Soviet Russia or globally, as in the present day; and between specialized training of personnel and general education, or *Bildung*.[1]

Here are a few blunt but plausible theses. There would be no German cinema without subsidy. There would also be no German film schools without subsidy—even the nominally "private" ones.[2] And whether in the former West or East, film education in Germany still bears the mark of the German philosophy of education since the nineteenth century.[3] These theses highlight the contradictions regarding the relationship between art, the state, and commerce, and between national interests and international reputation.

Our term for the deep structural logic of German national cinema and its effect on film education is *"dirigisme"*—a term from political science used to describe an economy in which a government wields significant, active power over its operations. Though US government policies have helped Hollywood maintain its position in world cinema,[4] Germany follows closely behind in terms of money invested toward specifically German film. These investments are ostensibly to maintain its status as a country capable of sustaining a major national cinema.

Yet the *dirigiste* agendas behind support for film education and young German cinema—especially with regard to language and aesthetic conventions for national consumption—may have actually inhibited this cinema's export abroad. Quite simply, Germany has made it clear that it does not necessarily need the rest of the world for its vital film culture.[5] This chapter will trace the parallel history of the film schools in East and West Germany, particularly the struggles to replace a centralized, top-down, and rigorously specialized structure with more open forms of organization that would presumably produce more innovative media and/or more commercially viable jobs in the media industry.

Prussia, *Bildung*, and the German Film School

The centralization and top-down organization of German education have persisted to a great degree since the Prussian education reforms of the nineteenth century. These products of that century's German Unification (i.e. 1870, not 1989) were modernizing moves that brought about rapid changes throughout all German institutions, accompanying unprecedented—and in many ways unparalleled—urbanization and industrialization. As Malte Ludin put it in the German Film and Television Academy Berlin (dffb) retrospective catalog from Oberhausen, " 'The times are driving a car,' says [Eric] Kästner. One might add that film is coming along for the ride."[6]

The "modernity" of the present day, however, remains distant from the coherence of the nineteenth century. It is a dramatically decentralized—centrifugal—phenomenon. The current tensions over the euro and the European economy are only the most recent example, as the Federal Republic of Germany itself has always had a decentralized logic with regard to actual governance and regional economic affairs. To distinguish itself from the Nazi state, it has significantly decentralized many economic and educational institutions, and declared categorically that culture is a matter for the states (*Kultur obliegt der Hoheit der Länder*). There is, for example, no single federal ministry of culture as there was, by contrast, in the more centralized East Germany.

The federal and decentralized philosophy was also encouraged by the US influence in the post–Second World War era, which extended a long-standing connection between the United States and German education systems. In both nations, modern structures arose from a reform period and the postwar (1864 or 1870) consolidation of their respective nations. The nineteenth-century growth and development of US higher education owes a great debt to the German university model, and much interchange in philosophy and method goes back to that period.[7]

Centralization and the Formation of the First German Film School

The state's intervention to modernize society in the late nineteenth century, with a resulting modernization of the economy, was joined with military and nationalist concerns in the huge push to develop the German film industry during the

First World War era. Here, with figures such as General Erich Ludendorff and the industrialist Alfred Hugenberg in key roles, Germany responded to the "film crisis" of the First World War—a lack of access to imports compared to prewar times—with massive state intervention (including financial support of direct and indirect kinds) and modernizing centralization. The latter resulted in the Universum Film AG (UFA) studios of legend.[8]

At the same time that Germany was developing one of the few film industries to hope to rival Hollywood (in the 1920s, at least), the need to look across borders rather than concentrate on national interests also became clear. Film as a cultural commodity did its most successful work on behalf of the German nation, after all, when it was also the most cosmopolitan—as in the Expressionist era.[9] During that brief period, the film topics ranged from around the world, and the style emphasized the dark side of fairy tales and the unconscious and not a classical nationalism. Artistic influences came from far and wide—Scandinavia, Asia, Africa, and the South Pacific.

It was in this period that first discussions of a German film academy occurred—with attention paid to the models of both the All-Union State Institute of Cinematography (VGIK) in the Soviet Union and Columbia University in New York.[10] The Soviet model, as we will see later on, was actually quite harmonious with the Prussian tendency toward centralized organization and a "Royal Academy" structure. The Academy's approach to "master classes" was also consistent with German tradition, and remained the standard to which the GDR aspired with its 1950s institutions as well. But the American perspective—that art, education, and commerce were not contradictory, nor were art and practice—slowly but surely gained traction as well. But Germany employed a more *dirigiste* method toward film education and subsidy than the United States ever would, creating a long-term source of tension in the German media industry up to this day.

Before 1954 every time Germany tried to establish a film school, the climate did not permit it to take root. In 1919, debates around the establishment of something similar to the VGIK in Germany unearthed strong doubts about whether or not one could or even should teach film craft beyond a straight master–apprentice, guild-like approach. In 1928, after the worldwide success of German cinema and its subsequent crisis around the sound film, plans to roll out a film school were drafted but failed to go beyond the planning stage due to the lack of time among the few successful German film professionals like Guido Seeber to train students.[11] The year 1931 saw an earnest commitment among policymakers toward the creation of a film school, but the Great Depression had sapped state coffers to the point where even obtaining quality sound film stock for the film students was prohibitive.[12]

A similar failed attempt at establishing a German film academy, now in the shadow of not only the VGIK and Columbia but also the University of California Los Angeles (UCLA) in the USA and the Centro Sperimentale di Cinematografia (CSC) in Mussolini's Italy, was made during the Nazi era under Josef Goebbels in 1938. As a result, the Deutsche Filmakademie Babelsberg was born. Although Peter C. Slansky cites the impending war as one reason among many for the school's failure within two years, we stress that its founding—as in the other cases of film

schools' creation—could be seen as a response to a "film crisis."[13] This crisis was one of the Nazis' own making, with increased persecution of Jews pushing out the country's top film talent and the progressive *Gleichschaltung* ("bringing into line") of all social institutions, including film production and finance, under their own direction. The talent base for German cinema had quickly evaporated, and replacement staff would be needed. Although founded by the Nazi party, however, the film school was an entirely private institution. Tuition for the course of study was 2,600 Reichsmarks, meaning that film education was only available to the rich.[14] The idea, of course, was to cultivate a new generation of Aryan *auteur* filmmakers on the model of Fritz Lang, and UFA directors such as Wolfgang Liebeneiner gave a few seminars on the approaches to successful filmmaking.[15] But the new film academy could not succeed, because of its expense and its short duration of significance before the war. Like the attention the Germans paid to the US model ten years earlier, Nazi film policy overall was to a great extent an attempt to replace the Hollywood cinema, which they thoroughly demonized, while going to great lengths to imitate it. Here, as with the post–Second World War situation, the German view of the United States as a rival, model, or sometime partner in media matters has a persistent influence.

East Germany—Continuities in Centralization

In the case of German film education, the Second World War does provide a break in German history, at least for a time, but also only to a degree. The rivalry with and dependency on the United States and its media are a consistent characteristic of West German institutions, and German ones since 1990. On the other hand, the GDR's creation of the Hochschule für Film und Fernsehen (HFF) Potsdam-Babelsberg in the 1950s connects both to the earlier modern innovations of the Soviet film industry and the VGIK, as well as with the traditions of Prussian academies and centralized administration. Education and the arts—and by extension, also to a degree, industrial development including that of the entertainment industry—were and are all concerns of the state. The structure and functions of educational and media institutions correspond to overt *dirigiste* politics, notably in the GDR and West Germany/FRG during the Cold War over the cultural legacies of National Socialism.

If West German film schools were created in response to "film crises" (as we will discuss later on), the crisis to which the GDR responded in the 1950s was more internal. After the brief period of "national front" openness to filmmakers of all political persuasions after 1945 (outright Nazis excluded, naturally), the GDR in the 1950s was faced with the need to create a "national" culture within a separate portion of Germany—albeit with many Prussian institutions in its territory and under a Stalinist model of one-party control. As with other "film crises" in the West as well, one issue here was the education and training of a creative and capable younger generation of film professionals. *Nachwuchs* is the German agricultural metaphor used to describe new growth. Central planning and organization proved the method of choice here, first with the creation of mentoring

and apprenticeship structures in the state-run DEFA Studios[16] themselves, not unlike the Goebbels academy, which had been in a building subsequently incorporated into the studios, today known as "Building 3." This was the *Nachwuchsstudio* model to which GDR artists of the younger generation would longingly appeal until the GDR's demise in 1989–1990.

The groundwork for the HFF "Konrad Wolf" Potsdam-Babelsberg, postwar Germany's first and renowned site of film education, was established in March 1948 with the establishment of a DEFA-*Nachwuchs* education site for actors in Berlin at Unter den Linden 11, right next to Humboldt University. A course of study for directors shortly followed. Space considerations forced the school to move its location to Potsdam-Babelsberg in 1950.[17] This studio academy closed shortly thereafter, in 1951, and transformed into the German University for Film Art (*Deutsche Hochschule für Filmkunst*, DHF) in November 1954.[18] Students there found themselves under the chief dramaturgs of the feature film department, and apprenticed under directors who embodied both the old German left and the Soviet system, specifically Kurt Maetzig, Slatan Dudow, and Ilya Trauberg. Important DEFA directors such as Konrad Wolf and Frank Beyer even received their film education directly from the VGIK and FAMU (in Prague), respectively. The DHF's curriculum involved learning a specific trade such as editing, acting, or cinematography from the remaining, and newly hired Babelsberg personnel, many of whom were informed by UFA techniques from the Weimar or Nazi eras. Slansky elaborates as follows:

> The mediation of high-quality craftsmanship was very significant as a basis from the very beginning. The division of labor among the film team, especially with regard to their functions in the film studio, was implemented virtually on a 1:1 basis in the structure of the film school as a set of specializations, which still exist today in their expanded form.[19]

As was repeated at each crucial stage of the academy's history, film praxis as craft clearly stood out as the top priority, rather than a critical intervention in society. Maetzig and Dudow in particular were soon at odds about the *agency* to be fostered in East German film students: Maetzig wanted strong directors and an obedient, skilled crew that would follow them in the tradition of the VGIK,[20] whereas Dudow wanted capable men and women with general knowledge who could handle any specific filmmaking task.[21] On the one hand, film education was to be about art's critical relationship to society (Dudow), while on other hand, the Party viewed society as already perfected so there was not any "real" way of interrogating it, especially given the proposed role of mass media under socialism (Maetzig).[22] Maetzig won in the end, but not in the least because the instructors concentrated on their specific area of filmmaking and were not encouraged to engage with the sweep of German and European film history.[23]

Under such a planned economy structure, no more filmmakers were trained than were "needed," and candidates for positions first had to be hired in film (and later television), then "delegated" for further formal training. With enough established film directors on salary at the DEFA studios to satisfy the

production quotas, it eventually became the rule that an up-and-coming direc-
tor (*Nachwuchsregisseur*) would be over 40 years old before taking on a feature
film. With this structure in place, the planned economy in many ways indicated
its structural and fatal flaws in responding to, let alone producing, international
"youth culture." In addition, although the discourse of film as art (*Filmkunst*)
dominated both East and West Germany, it was only in the East that film could
also be viewed as a *science*, a team effort derived from collective, scholarly interest
in the world. It was an artistic exercise in scientific exactitude to put Germany's
intellectual prowess on display. As HFF Potsdam-Babelsberg rector Peter Ulbrich
put it, "our cyclotrons are the editing tables, the tracking carts, the portable sound
cameras—all of those devices which, to maintain our metaphor, also become
the tools to unleash enormous amounts of energy, driving forward the world-
changing ideas of our worldview.[24]" This scientific view of filmmaking naturally
also corresponds with its stolid nature under the GDR.

Each time there were successes in the direction of producing a young and more
dynamic cinema, such as in the early 1960s,[25] they were criticized by cautious or
outright Stalinist officials, and—in the "scorched earth assault" (*Kahlschlag*) of
1965/66—harshly put down by the state.[26] In this case, not only did directors lose
their jobs at the studios, but Maetzig, who also had a film banned that year, had
to resign as rector of the DHF, despite his pivotal role in founding the institution.
Both the reforms that led to "team-based" production in the studios (*Künstlerische
Arbeitsgruppen*) and the opening of the practices at the DHF to formal influ-
ences from new waves were innovations from Eastern Europe, which Maetzig felt
compelled to renounce.[27]

The political ramifications of the "master class" structure played a role here,
since the views of such opinionated film artists as Dudow or Martin Hellberg in
the 1950s were anything but compatible with the smoothly organized academic
model the party might have found comfortable. Moreover, the demands on an
active film director's time in order to teach at a film school were also a problem in
the early days of the HFF, as had been the case during the Weimar era. Since the
1970s and increasingly since German unification, however, there are too few major
productions to occupy the number of qualified directors, so teaching is now a way
of maintaining them and keeping them connected to the next generation of film
artists—whose job chances are similarly in doubt.

The ongoing contradictions of DEFA and the DHF/HFF in the GDR are thus
endemic to socialism, but also not totally foreign to the dilemmas of Germany
today. On the one hand, the system was and remains rather inflexible and only
rarely open to new personnel or even new ideas and approaches. Subsidy pro-
vides stability, and filmmakers had very stable or at least predictable production
conditions. Technical support and budgets were set in advance, and this was true
for operations at the film academy as well. On the other hand, anything new,
unplanned, or experimental—whether politically or simply innovative—could
encounter deadly bureaucratic roadblocks.

In a way, what Slansky blames on the Nazis—an imposed mediocrity not over-
come to his day[28]—is endemic to any system. How could a system be designed

to produce what is exceptional? Even if a system were reliably to produce exceptions, then these are eyed with suspicion during their present moment, as if they prove that the system is flawed, not that it works. Or worse, the exceptional is seen as foreign and threatening—or simply ignored, because it is exceptional. There are many such examples: Hollywood exile Marlene Dietrich was rejected by postwar West Germany,[29] GDR exile Thomas Brasch is working in West German theater after causing trouble at the HFF around the 1968 Prague Spring, Werner Herzog moved to Los Angeles for three decades, and so forth. Uwe Boll, a successful working director who shoots genre films in Canada, is almost universally reviled despite his having made over 22 feature films without any German TV subsidies.[30] Even if a film academy alumnus is extremely successful outside Germany, this is also not necessarily celebrated as it would be by most institutions of higher education in the United States and elsewhere, since it suggests a *failure* of a sort—the inadequacy of the domestic industry, which is, after all, to be the aspiration of the graduates and the legitimization of the school.

Put in a less negative way, if the goal of the subsidy system is to be sure that quality media products are produced to satisfy the domestic market (and to protect it from being dominated by imports), there is no inherent motivation to seek international connections. The systemic aspiration is not for German filmmakers to emigrate, nor is it the aspiration of the film schools to train students from other countries to become leading filmmakers. Such an outcome is welcome when it occurs, but it is not trumpeted or particularly prominent in the schools' profiles or self-images.

West Germany—Regional Competition

In the West, unlike the GDR, culture and education were explicitly decentralized—a matter for the states, not the federal government. Film education creation and subsequent reforms were impelled by competing media imports from overtly capitalist media markets such as the United States, as well as by generational conflict found in international youth culture and the movements understood under the label "1968." Film schools were part of general media industry reforms directed at adding diversity to the traditional patterns of training, which were otherwise entrenched in purely private-sector film-industry operations like Artur Brauner's Berlin-based CCC or Horst Wendlandt's Rialto Film.[31] Though there are 14 film schools that might be discussed in the West German context, only two besides the HFF Potsdam-Babelsberg really matter for the purposes of the trends we describe: the dffb and the HFF Munich. Each of these, one should note, is located in a city that qualifies as a "capital city," in a way. Despite the significance of other media and trade centers such as Hamburg and Cologne—both with significant media production—or the influence of Ulm in the era of Edgar Reitz and Alexander Kluge, or Ludwigsburg in today's high-tech landscape, the political and historical weight are entirely on the side of Berlin and Munich. And the rivalries between

the two very often refer to the third rival always looming, namely Hollywood and the hegemonic US presence in international media.

Despite a shared set of challenges—working with new technologies, fostering innovation, responding to local industrial, political, and economic pressures, expressing national interests or a sense of ethical, cultural responsibility via global interchange—the contemporary landscape of film schools in Germany is still surprisingly regionalized. The HFF Potsdam-Babelsberg remains the principal film and television training institution in the five new states (i.e. the former GDR), while the former West perpetuates the regional patterns that held since 1949. In each area, the character of the respective film schools reflects regional understandings of film history, other media, and cultural and political constellations. The West German story can shed light on these trends.

In the early 1960s, West German cinema fell into its current state of perpetual crisis, to which the regional film schools were intended to be the national solution. No German national film prize was awarded in 1961, since there appeared to be not a single eligible film from the industry that year. Whereas in the 1950s over 100 West German films were produced per year and usually broke even, by 1962 the number of films per year had dwindled to 61—closer to the number produced by East Germany—and these remaining films were far from surefire means to profit.[32]

But while East Germany had the DHF as a film school to represent their interests at international congresses like CILECT (International Association of Film and Television Schools), West Germany had no such equivalent. To keep pace with their rival in the Cold War, a West German film school had to be bolstered. The institution for the job appeared to be the German Institute for Film and Television Studies in Munich (DIFF), a provisional school for film studies created in 1954 as an extension of the University of Munich. The institute was able to take advantage of Munich as a long-established film location, with companies such as Bavaria Film operating full-fledged studios out of nearby Geiselgasteig since 1919. But students at the DIFF eventually radicalized around the idea of incorporating more praxis into their education after the early films of the French *nouvelle vague* were screened in Germany. Several of them under the name of DOC 59, including film lecturer Harro Senft, helped organize the Oberhausen Manifesto signed at the International Short Film Festival on February 28, 1962. The Oberhausen Manifesto, which declared the death of the uninspired and conservative "Daddy's cinema" in Germany (*Papas Kino ist tot!*), gave birth to the so-called "Young German Cinema" movement. This was closely followed by the institutionalization of the regional film subsidy system in 1965, without which there would have been no New German Cinema and no *auteur* films by Werner Herzog, Wim Wenders, or Rainer Werner Fassbinder for international audiences to celebrate in the 1970s. The Oberhausen International Short Film Festival even became integrated into the very film education wave it sparked, holding film school retrospectives of the HFF Potsdam-Babelsberg in 1974 and the dffb in 1989. One might see Oberhausen as a youthful revolt later subsidized (and thus co-opted) by the government. But it also gave reason to institute praxis-based film education throughout West Germany in locations that otherwise did not have film industry activity already in those areas, specifically in Ulm and Cologne.[33] The postwar republic would now have

its regional locales of film education and innovation, as well as regional film and television funds to finance them.

To give one a sense of the institutionalized federal competition around the national goal of a better German cinema, we shall examine each of the major West German schools in brief. Our purpose here is not to tell each institution's full story, as Slansky and other scholars have already contributed studies in this regard, but to serve as outside observers of what appear to be generalizable trends in German film education. No school, it turns out, stands above struggles over decentralization/centralization, art/commerce, internationalism/nationalism, and generalization/specialization.

The University of Television and Film Munich (HFF Munich) is a natural starting point. Founded in 1966 on the bones of the DIFF, the film school had the advantage of being in one of the richest federated states (*Bundesländer*) and having immediate connections to Hollywood via Bavaria Film, the studio site of films such as *Sound of Music* (dir. Robert Wise, 1965) and *Willy Wonka & the Chocolate Factory* (dir. Mel Stuart, 1971). Yet to label the school as a mere extension of Hollywood with its Bavarian "neo-romantic sensibility," as Wolf Donner once framed the cliché,[34] is misleading. On the contrary, it was conceived of as a site of German *Bildung* that would then discipline the coming generation of film *auteurs*. The school's founder, Professor Dr. Otto Roegele, was a polymath journalist with degrees in philosophy, history, and medicine, and his pedagogical strategy was to give young, free-thinking, and artistic German filmmakers freedom to experiment before pushing them out into the media industry.[35] This liberal arts generalist model, which could also be found at the dffb, educates a remarkably small number of students in all aspects of film theory and filmmaking. The school's alumni directors include many of the German film industry and Hollywood elite: Wim Wenders (*Der Himmel über Berlin/Wings of Desire*, 1987), Florian Henckel von Donnersmarck (*Das Leben der Anderen/The Lives of Others*, 2006), Doris Dörrie (*Männer ... /Men ...*, 1985), Bernd Eichinger (*Die unendliche Geschichte/Neverending Story*, 1984; *Der Untergang/Downfall*, 2004), Roland Emmerich (*2012*, 2009), and Caroline Link (*Nirgendwo in Afrika/Nowhere in Africa*, 2001). During the Cold War, the HFF Munich was perceived as the *de facto* top film school in West Germany, followed closely by the dffb.

The dffb has, in contrast with HFF Munich, profiled itself as a site of experimental, leftist filmmaking since its inception the same year as the other school. Also focused on general film education over specialization, the dffb cliché resides in the image of a small, dogmatic faction that revolted against the school's leadership in 1967/1968. This cadre included among others later *auteur* filmmakers Helke Sander (*Die Allseitig reduzierte Persönlichkeit: REDUPERS/The All-round Reduced Personality*, 1977), Helga Reidemeister (*Von wegen Schicksal?/Who's to Say It's Fate?*, 1979), Wolfgang Petersen (*Das Boot*, 1981), Hartmut Bitomsky (*Reichsautobahn*, 1985), and Harun Farocki (*Bilder der Welt und Inschrift des Krieges/Images of the World and the Inscription of War*, 1988). While their protests were imbricated with the *Zeitgeist* of 1968 Europe, the films the group produced demonstrated an enviable amount of passion and political motivation not seen in the German film schools since. These students—particularly Bitomsky and Farocki—would

later become the film school's establishment, and would cultivate the sensibili-
ties of the so-called "Berlin School," a pan-German group of filmmakers active
from the 1990s on. Including such filmmakers as Christian Petzold and Thomas
Arslan, the Berlin School's work is characterized by politically critical narratives,
aesthetic minimalism, and unadorned long takes.[36] Films by the dffb students are
stereotyped as overtly alternative, destined for art-house cinemas and art galleries.
Nevertheless, the school's former location in the Deutschland-Haus at Theodor-
Heuß-Platz and current location in the Sony Center at Potsdamer Platz indicate
how close this school remains to the center of the German film establishment.
Historically, there are likely far more similarities between the dffb and the HFF
Munich than either school would care to admit.

The above three national-level schools can be profitably compared with their
numerous much younger competitors throughout Germany: the Film Academy
Baden-Württemberg (Ludwigsburg), the film department at the Ulm School of
Design, the Academy of Media Arts Cologne (KHM), the International Film
School Cologne (IFC), the Hamburg Media School (HMS), and the Macromedia
Hochschule für Medien und Kommunikation (MHMK), which joined CILECT
in May 2012. The Ludwigsburg film school, for example, has skyrocketed to the
top of German rankings since its founding in 1991,[37] largely based on its top-
notch equipment and focus on computer animation and digital postproduction.[38]
Its early institutional focus on animation and the genres of advertising, fairytales,
and science fiction has given it an edge in the current media environment, while
still maintaining a "specialist" orientation similar to that of the HFF Potsdam-
Babelsberg. The film department at the Ulm School of Design meanwhile was
created in the combined spirit of Bauhaus and Oberhausen and, under the influ-
ence of Oberhausen signatories Alexander Kluge and Edgar Reitz, produced the
filmmaking-at-art-school model still employed by many art schools throughout
Germany.[39] The HMS in Hamburg orients students toward practical applications
in the industry, and is comparable to a trade-school film education rather than
an "elite" film school education. Lastly, the MHMK is almost explicitly corpo-
rate, with majors in fields such as "media and communication management" and
new emphases on games and digital media. The KHM, IFC, HMS, and MHMK all
distinguish their locales as major television and European media outlets. These
are semiprivate or even private film schools that produce many of the work-
ing television personnel in Germany and take pride in their integration of their
relatively small numbers of students into the professional (subsidized) media
workforce.

Weighing the Benefits

Like the United States, however, the German film system functions to some degree
as a star system. Director Robert Thalheim, a 2003 graduate of the HFF Potsdam-
Babelsberg, reported at a recent seminar at Dartmouth College[40] that there are
only a handful of German directors who can actually make a living solely from
making feature films. Examples include Christian Petzold (educated at the dffb),

Andreas Dresen (HFF Potsdam-Babelsberg), Fatih Akin (Academy for Visual Arts Hamburg), Hans-Christian Schmid (HFF Munich), and Leander Haußmann (Bochum Theater). Each of these directors is profiled as an *auteur* with a distinct style, but none can presumably write their own ticket on the international film circuit like Wenders or Herzog. Thalheim further elaborated on the elusive quality of a stable career in film directing with an informal analysis of his own class at the HFF Potsdam-Babelsberg. Of his cohort, 50 percent of the graduates got to direct one feature film, 33 percent managed to make two, and only Thalheim himself had yet made a third. The fact remains that the subsidy system has a short memory and needs to support the next generation of young filmmakers coming through the system.

On the other hand, Germany has had a remarkable track record among its peer countries in promoting women's filmmaking. Stephen Brockmann recently called it "a country that enjoys one of the most active feminist film scenes in the world."[41] It is a feat that scarcely would have been possible if it were not for state intervention. Though not a single woman's name stood on the Oberhausen Manifesto, by the early 1970s German film academies had incorporated a substantial female presence, and women film directors brought their unique visions to the silver screen: Helke Sander and Helga Reidemeister emerged from the dffb, Caroline Link from the HFF Munich, and Ingrid Reschke (*Kennen Sie Urban?/Do You Know Urban?*, 1971), Iris Gusner (*Die Taube auf dem Dach/The Dove on the Roof*, 1973), Evelyn Schmidt (*Das Fahrrad/The Bicycle*, 1982), and Helke Misselwitz (*Winter adé*, 1989) emerged as DEFA directors from the HFF Potsdam-Babelsberg. Even the two most acclaimed women directors, Margaretha von Trotta (*Die bleierne Zeit/Marianne and Juliane*, 1981) and Ulrike Ottinger (*Madame X: Eine absolute Herrscherin/Madame X: An Absolute Ruler*, 1978), found that despite their Parisian training, they could rely on a better funding environment in Germany over France once they had proven their talents. The West Berlin–based dffb in particular found itself under intense feminist pressure once the male-dominated student movement had made its impact. The dffb later became the genesis of experimental documentaries such as Sander's *The All-round Reduced Personality* and Cristina Perincioli's *Die Macht der Männer ist die Geduld der Frauen* (*The Power of Men Is the Patience of Women*, 1978), both of which represent female agency in a male-dominated professional and domestic world through alienating and jarring techniques. Many of these women's diploma films were fully funded and broadcast by the ZDF or WDR television stations. Such avenues had certainly not been available under the strictures of "the market" during the 1950s and 60s, which had survived partly on the basis of German soft-core pornography and exploitation films. After the educational and subsidy reforms of the 1960s, women could then use their cameras to turn the gaze back on these men and their genres.

What also contributes to the German film schools' cultural heft is their location. Throughout his study, Slansky repeatedly applies the Latin saying *genius loci*—the "spirit of place"—to the various media sites. The proximity of both the GDR's HFF and the FRG's HFF Munich to major film studios is certainly significant in multiple ways, as it is significant that both Babelsberg and Geiselgasteig have photogenic landscapes within one kilometer of the film school. The location of the old dffb

(before it relocated to Potsdamer Platz) is more subtly evocative, however. Its proximity to the 1920s Radio Tower (*Funkturm*) and the Nazi-era buildings around it, such as the Deutschlandhaus of 1937, which housed a TV station—the nearby "Broadcasting House" (*Haus des Rundfunks*) of 1930 in Masurenallee—provided subtle connections to the media modernity of Weimar-era Berlin and its Nazi successors. Certainly the collective New German Cinema filmmakers saw themselves as the heirs to the Weimar art film tradition, and Berlin's persistence as an endlessly inspiring locale to film. The Nazi-era Olympic Stadium is just two subway stops further out Heerstrasse from Theodor-Heuss-Platz, the dffb's address, and also that of the British NAAFI club and movie theater, which showed popular English-language fare during the 1970s and 1980s. Theodor-Heuss-Platz itself was named after the Federal Republic's first president shortly after his death in 1963. Previously it had been called "Reichskanzlerplatz" after the office held by Hindenburg, and renamed Adolf-Hitler-Platz during the Third Reich. In the dffb era, it featured an eternal flame in memory of German refugees and displaced persons (from Eastern territories of the former Reich), erected in 1955.[42]

The location of the HFF Potsdam-Babelsberg until it moved to the new building on the studio grounds is similarly evocative. Originally, the film school was in a palace (Schloss Babelsberg), recently vacated by the Soviet occupation. Then it moved to a series of villas on the nearby picturesque lake (*Griebnitzsee*), some of them originally belonging to Jews dispossessed by the Nazis, and later housing Stalin and Truman as they met for the Potsdam talks. The cross-street Karl-Marx-Straße was also a border zone or *Grenzgebiet*, so special ID papers were needed even to enter the school, which looked out over a body of water and into West Berlin.[43] The modern *Glashaus*, constructed in 1999, with its five buildings linked together with greenhouse-like glass, recalls the earliest days of the studios at Babelsberg when Guido Seeber shot Asta Nielsen films in a studio made of glass for maximum exploitation of daylight. The film school sits across the lot from both Studio Babelsberg and the Filmpark Babelsberg, that is, an active film production milieu as well as a tourist trap that helps pay the bills. GDR history is present in this landscape as well, although often under threat: Heiner-Carow-Straße on the studio lot was renamed Quentin-Tarantino-Straße (for reasons mentioned below). But efforts to remove the name of Konrad Wolf from the Academy in recent years were turned back. In short, film history and German history intertwine at the nexus of sites where students learn to shape audiovisual material about the world around them. The private capital, historical legacies,[44] and state interests are right there beside them.

Post-Wende Rupture and Stasis

Since the fall of the Berlin Wall (*Wende*), the schizophrenic character of film education in Germany has increased, as shifts in both the film subsidy and higher education systems of Europe have deeply enmeshed the German states in an intensified conflation of transnational and national cultural stakes. Both international and regional film subsidies matter because not even the most mainstream

of German filmmakers—such as noted producer Bernd Eichinger—have gotten along without them. The European higher-education systems matter, as the Bologna Accord since 1999 has exerted an outside pressure on film students to finish their degrees, and has led to the reduction of faculty appointments to five-year cycles. This forces film instructors to maneuver their careers rather than cultivate a culture at a specific film school, while students have less time to devote to perfecting a craft. In the context of these changes, film board subsidies have an increasing impact on what German film education looks like.

German cinema's viability as a national cinema has been called into question many times over the years, especially since the 1960s.[45] The shakiness of film institutions since unification reveals the extent to which support for film production and education in Germany up until 1990 was motivated by Cold War politics.[46] During the Cold War, both West and East Germany wagered millions of German marks on the production of films for both television and movie theaters that would establish either side as the torchbearers of the "real" German culture, as humanists who had overcome their Nazi past and who would also master the forces of American capitalism as well. They also spent this real money on producing generation after generation of sufficiently trained German filmmakers so that both Germanies could consider themselves important *loci* in international film circulation (rather than colonies of Hollywood).

In the contemporary context, however, German national cinema cannot be distinguished from a rhizomatic ecology of film, television, and even video game projects[47] produced in English, German, and French for a multitude of outlets: gallery, festival, straight-to-DVD, television, and/or mainstream cinema markets. The ostensible purpose for federal support for German film is to "implement improvements in the structure of the German film business,"[48] but today's German Federal Film Board appears to fund projects with the express purposes of (1) attracting taxable film dollars to relevant regions of Germany,[49] (2) providing work for German media professionals who also happen to constitute the bulk of the country's film infrastructure, and (3) making a national and even international impact via talented filmmakers whom the country can then "own" as part of a national film tradition.[50]

Yet Randall Halle among others[51] has made a strong case for looking at the diverse body of German moving images resulting from these film subsidies not only as national products but also as sites of transnational flows:

> No audiovisual object is now produced outside of global systems, and by this I mean big-budget mega-blockbusters as well as film-school debuts, from the work of the most dogmatic art-house independent director to the amateur wielding his or her first discount digi-cam, indeed all forms of audiovisual production. Film is globalized.[52]

In Halle's terms, the flows of global cinema are unpredictable and impact all aspects of cultural production, from the twinkle in the eye of a young German film student to the pirated Blu-ray of the final film downloaded by an indifferent Russian consumer. Film scholars must account for the full lifecycle of a

film, and that can only happen if one considers the transnational context found at each stage of the cycle. By the same token, however, Dudley Andrew is correct when he says that "cinema . . . is constitutionally out-of-phase with itself"[53]—that is, cinema practices change neither uniformly nor coherently, but based on loaded historical precedents and uneasy future premises. Older forms of film conception, production, and distribution, many of which still inhabit German film schools, have slowly assumed the mantle of "national" traditions of filmmaking, with enduring geographical and historical ties. The film-finance structures in place to support professional German filmmakers are in some ways a bulwark against the changing times. The battle lines appear not to be drawn between commerce and art—film subsidies will clearly support either—but between past traditions and present conundra.

A quick comparison of two recent successful German coproductions, Fatih Akin's *Auf der anderen Seite* (*The Edge of Heaven*, 2007) and Quentin Tarantino's *Inglourious Basterds* (2009), reveals the impact of regionalized film finance and education models—as well as the international collusion between art and commerce—on the lives of film school students once their professional careers are in motion. *The Edge of Heaven* in this context represents a classic, festival-ready European *auteur* film, *Inglourious Basterds* a quirky Hollywood blockbuster. Akin's film was conceived as a Turkish/German/Italian coproduction: most of the film's financing came from Germany, whereas Akin's international crew constituted the film's personnel. That meant that virtually no one on this prestige film was educated at a German film school, but the film was nevertheless championed as a masterwork of German national cinema in dialog with Turkey, and with its own prestigious national film history in the form of the New German Cinema (embodied in the presence of star Hanna Schygulla). *The Edge of Heaven* could be seen as a product of the *auteurist* model promoted at the HFF Munich, on the model of Rainer Werner Fassbinder in the 1970s: genius filmmaker Akin has assembled a small loyal production team with whom he can make his German film art.

On the other hand, *Inglourious Basterds* was an enormous Hollywood production on the Studio Babelsberg lot, and its high personnel demands were met by dozens of highly qualified German film technicians, who were on hand, thanks to the 6.8 million euros in subsidies from the film commission and the presence of a world-class film school just a few meters away from the production. The production employed a host of young filmmakers from Potsdam and throughout Germany, many of whom later felt loyalty toward and pride about the resultant film.[54] Tarantino was able to harvest German film school talent, and the states of Berlin and Brandenburg in turn harvested the Hollywood money spent on their soil, while the regional film industry gained international prestige.

Both films were internationally successful—thus the exception, not the rule—but neither provides a clear picture of what a film school student is to do upon graduation. Akin has been elevated to star status, meaning easy access to film subsidies and the German national *auteur* label for the "next Fatih Akin film" without having necessarily to turn toward fellow German talent in order to pull it off. This is thus an unlikely scenario for most film school students. Similarly, large external projects like *Inglourious Basterds* are actually what are needed to employ sufficient

numbers of film school graduates, but despite the subsidies, such films are nei-
ther accepted as German nor do they open up a discussion of what they mean
in the context of transnational media production.[55] Thus the long-term career of
any German film school student now takes place in a kind of limbo, somewhere
between Germany, Europe, and the rest of the world.

Looking at the HFF Potsdam-Babelsberg as a site of shifts in media education
over time, dramaturg Roland Neumann saw this limited slate of outcomes for film
school graduates as particularly bleak. After all, he had been educated at Potsdam-
Babelsberg during the 1970s and 1980s, where under socialism "there was strong
state support and regimentation of film and television production."[56] In his report
for the *Journal of Film and Video*, Neumann describes how new funding for film
education after German unification was not forthcoming, which meant that the
film school had to further professionalize its students either as specialists serving
under West German *auteurs* or as *auteur*-generalists in their own right (a task the
HFF was not able to accomplish, according to him).[57] The film school found itself
pleading for hardware and technology upgrades from the federal government, as
the nearby DEFA Studios were being cleared out and renovated in terms of their
outdated technology and, more cynically, their outdated personnel. The remain-
ing lecturers now had to examine closely the network of private film companies
already established in West Germany in order to push their students into produc-
tion queues and shift the discourse surrounding their work to one of "quality,"
where TV production heads and private investors rather than political officials
judged the merit of one's film work.

As the Babelsberg studios were purged of many of the DEFA filmmakers who
had borne a tradition harkening back to the Weimar era, the HFF Potsdam-
Babelsberg saw itself threatened by an alien media environment that, even after
the completion of a new school with an all-new building in 1999,[58] jeopardized
the sustained ability for working German film professionals to pass on their craft
to the next generation. Robert Thalheim's observation that about two-thirds of
his fellow HFF film direction students never got beyond their first feature film
reflects a certain anemic quality of both the artistic and commercial aspects of
German film education. Of those remaining HFF Potsdam-Babelsberg graduates
who go into the media, about 80 percent of them will wind up in public or private
television.[59]

The cinema will likely haunt a film student's existence as he or she moves along
a career path dominated by advertising, TV series development, and now video
games and new media. But these realities have also prompted the students and fac-
ulty at the HFF Potsdam-Babelsberg to look at emerging trends with a keen and
creative eye. An initiative to bring the film schools into the era of 3D prompted the
creation of the student action feature *Topper gibt nicht auf* (*Topper Never Gives Up!*,
2010), a production that tapped into the spirit of collective work at the film school
in that it involved over a quarter of its student body and faculty in some capacity.
In addition, media studies professor Lothar Mikos sensed the intense interest at the
film school for the new "quality television" from the United States, seen in the form
of HBO shows *The Wire* and *A Game of Thrones* or the Swedish TV adaptation
of Stieg Larsson's *Millennium* trilogy. He recently initiated a "Drama Series Lab"

to find the proper financing and film institutional model to make internationally marketable German television series, which would then employ the next generation of film school graduates.[60] Meanwhile, Klaus-Dieter Müller's *Media EXIST* project views the film school students as *entrepreneurs* whose innovations in the problem solving for their own films can be patented and monetized as part of a wider program for Berlin and Brandenburg to assist the networking of media professionals into financial independence. Certainly the Brandenburg region has invested a substantial sum in its film education programs, and one might see such programs as means of justifying the investment in something beyond a regional identity as a "Filmland" (a region central to film production and culture).

By contrast, there is, of course, Werner Herzog's Rogue Film School, an *auteur*-centered international film seminar that teaches anyone willing to read the required texts Herzog assigns and to pay US$1500 for access to the director's personal insights. Herzog wishes in some ways to replicate the high artistic ideals of the dffb or the HFF Munich without involving German film subsidies. "Follow your vision," he writes on his website. "Form secretive Rogue Cells everywhere. At the same time, be not afraid of solitude."[61] His reasoning is simple: more quirky artists working within both independent and commercial venues (such as the Discovery Channel, for which Herzog is shooting a "better" US crime television series) will improve the medium overall and reject the hold of special interests on its language. It is hard to determine if these seminars are producing the kind of filmmaker welcome in either the German or the international system, but Herzog benefits from both.

In the end, regardless of the ramifications of German film subsidy and education, the hearts and minds of the individual film students are where this conflict plays out. In his 2011 directing thesis, "The Young Film Scene and the Old HFF,"[62] Axel Ranisch rubs against the grain of the team-oriented HFF Potsdam-Babelsberg. He stresses the development of authorship and an individual signature (the private sector *auteur* model) while being supported with state funds, rather than dwelling in the endless realm of internships and technical apprenticeships. Inspired by Rosa von Praunheim's HFF seminars given out of his home between 2001 and 2006, Ranisch asserts that "without personal ambition, film school gets you absolutely nothing."[63] He sees the two roles of a film school as (1) providing competence in media production and (2) giving the filmmakers experiences of success to bolster their self-worth.[64] His preferences are for a film school to legitimate, subsidize, and provide the budding filmmaker with networks, or otherwise step aside.[65] Yet the anxiety about his own individual initiative in this education process and his eventual career prospects becomes evident when he comments that his entry into the HFF meant that "now I was one of these snot-nosed brats who, protected by large institutions and pampered and subsidized by taxpayers, had come to snatch the Young Talent Awards away from all those other broke young filmmakers."[66] This bitter statement emotionally summarizes many of the points underlying the film student experience. A student is sponsored by the system, but the system cannot provide work without reaffirming their dependency on it. Egos are bolstered, only to be shattered in the working world with episodes of *Tatort* or shampoo commercials. Regional film funds try to maintain support for film

education and young filmmaking in the spirit of Oberhausen, but the truth of the matter is that 16 decision-makers sitting in German television management decide what feature films are produced for the whole country. Those outside of this bureaucratic clique are left high and dry after they distribute their first feature films. The German Film Boards desire innovation and spend 130 million euros a year to subsidize such critical favorites as the *Berliner Schule* or a more sensational Tom Tykwer film, but it also means funding the mediocre programming that keeps talented film students in some state of employment. Therefore, a productive German film education in Ranisch's mind is apparently received only by those who are either so skilled in their fields that they receive steady work or who rise to the status of an independent genius performing all filmmaking tasks in order to realize his or her artistic vision. Yet most filmmakers in Germany do not exist in this binary, not even the star directors. Based on our study, the *Bildung* that can be found at the German film schools has always qualified as something more elusive, with a liberal arts and political agenda inscribed in their pedagogies. This is an agenda that somehow longs for a Germany as an enlightened media power, capable of opening up dialog between Germans, Europe, and the globe, while still bringing in enough box office revenue to keep all the film artisans behind it afloat with some measure of dignity. In GDR film director Slatan Dudow's fitting words from 1951, "[it's] about helping birth a new German intelligence working hand in hand with the progressive forces of the older generation on the development of a new German film, on the creation of a new German culture."[67]

Acknowledgments

The authors would like to thank Mette Hjort, Meaghan Morris, and all their colleagues at Lingnan University for their generosity in hosting the conference where this work was first presented, as well as Felix Tsang and all the other conference coordinators for their assistance. We would also like to acknowledge the Smith College Libraries and the W.E.B. DuBois Library of the University of Massachusetts and thank the DEFA-Stiftung (Berlin) for providing research funding. Thanks, finally, to the following colleagues as well, who provided information and support: Chrissie Bell, Benita Blessing, and Tobias Ebbrecht.

Notes

1. *Bildung* is a distinctive German term for education, which implies cultural sensitivity and cultivation in addition to knowledge; it remains quite distinct from practical training. Hence the terms *Bildungsroman*—for a coming-of-age novel (a novel of personal development)—and *Bildungsbürgertum*—the bourgeoisie whose status rests in part on education. It is telling that film academies are not treated at all in the respective chapters of the "Historical Handbook of German Education [*Bildung*]." In the chapter on West Germany, Knut Hickethier stresses mainly how education in the sense of *Bildung* was long seen as a bulwark against the influence of media such as film—a pernicious threat to German high culture from the US. Knut Hickethier, "Medien," in *Handbuch der deutschen Bildungsgeschichte, Band VI, 1945 bis zur Gegenwart, Zweiter Teilband,*

Deutsche Demokratische Republik und neue Bundesländer, ed. Christoph Führ and Carl-Ludwig Furck (Munich: C.H. Beck, 1998), 585–630. For the GDR, according to Hannes Schwenger, the media, including film, were themselves seen as an educational tool, to mold the "socialist personality" and anchor the cultural legitimacy of the state. Media policy as cultural policy is thus the focus, not the education of the filmmaker. Hannes Schwenger, "Medien," in *Handbuch der deutschen Bildungsgeschichte*, 341–358.

2. "DFFB Satzung und Statut," in *Deutsche Film- und Fernsehakademie Berlin (dffb). Eine Retrospektive 1966—1986*, ed. Frank Arnold (Oberhausen: Westdeutsche Kurzfilmtage, 1989), 36 and 40, respectively.

3. Michael Geisler's forthcoming monograph *Setting the Agenda for Democracy: Television and Public Discourse in (West) Germany, from 1952 to 1989.*

4. Toby Miller, "Hollywood, Cultural Policy Citadel," in *Understanding Film: Marxist Perspectives*, ed. Mike Wayne (Ann Arbor: Pluto Press, 2005), 182–183.

5. The German language may have served as a barrier to education and exchange with the Global South (though not with Eastern Europe). English- and French-language films subsidized by Germany simply reach a wider global audience, but are then not necessarily recognized as German, thus hampering the inherent goal of the subsidies.

6. "'Die Zeit fährt Auto,' sagt Kästner. Der Film fährt mit, könnte man ergänzen," in Arnold, *Deutsche Film- und Fernsehakademie Berlin (dffb)*, 26.

7. Prussian reforms of state and military institutions as well as education date from the late eighteenth and early nineteenth century, motivated both in a positive sense by the model of the French Royal Academy and in a negative sense by the humiliation of defeat by Napoleon. One of the most influential reformers where *Bildung* is concerned, Johann Gottlieb Fichte, even argued for "an early variant of *dirigiste* socialism." Gregory Moore, "Introduction," in *Fichte: Addresses to the German Nation*, ed. Gregory Moore (Cambridge: Cambridge University Press, 2008), xix. It would be instructive, but goes beyond the scope of this chapter, to trace the origins of film education to nineteenth-century dilemmas. For instance, John v. Maciuika, *Before the Bauhaus: Architecture, Politics and the German State, 1890–1920* (Cambridge: Cambridge University Press, 2005); James C. Albisetti, *Secondary School Reform in Imperial Germany* (Princeton: Princeton University Press, 1983); or Detlef K. Müller, Fritz K. Ringer and Brian Simon, *The Rise of the Modern Educational System: Structural Change and Social Reproduction, 1870–1920* (Cambridge/New York: Cambridge University Press, 1987). D.L. Moody and the American evangelical education reform movement were also much in discussion within the German context.

8. Klaus Kreimeier, *The UFA Story*, translated by Robert and Rita Kimber (Berkeley: University of California Press, 1999), 29–33.

9. It is worth noting that the Expressionist cycle can largely be attributed to the conscious efforts of producer Erich Pommer at Decla-Bioscop, later UFA, to create a total art form out of art and business—effectively creating blockbuster art pictures through *The Cabinet of Dr. Caligari* (1919) or *Destiny* (1921). It is fair to say that his ambitions remain part of the unconscious of the German film industry to this day. Hans Michael Bock, "Erich Pommer," in *The Oxford History of World Cinema*, ed. Geoffrey Nowell-Smith (Oxford, UK: Oxford University Press, 1997), 256.

10. Peter C. Slansky, *Filmhochschulen in Deutschland: Geschichte Typologie Architektur* (Munich: edition text + kritik, 2011), 55.

11. Ibid., 79.

12. Ibid., 94–95.

13. Peter Gallasch, "Filmhochschulen in Deutschland," in *Filmhochschulen in Deutschland*, ed. Peter Gallsch (Cologne: Katholisches Institut für Medieninformation, 1982), 1.

14. Ibid., 4.

15. Ibid., 5.

16. DEFA stands for *"Deutsche Film-Aktiengesellschaft"*—literally "German Film Company."

17. Günter Schulz, *Die DEFA (Deutsche Film-Aktiengesellschaft) 1946–1990: Fakten und Daten* (Berlin: DEFA-Stiftung, 2002), http://www.defa.de/cms/DesktopDefault.aspx? TabID=981 (accessed November 11, 2012).

18. The DHF would become the *Hochschule für Film und Fernsehen der DDR* in 1969, and the *Hochschule für Film und Fernsehen "Konrad Wolf"* in 1985, named after one of the GDR's most influential film directors. Slansky, *Filmhochschulen in Deutschland*, 224.

19. Ibid., 194.

20. Tobias Ebbrecht, "Nonkonformismus und Anpassung: Überlegungen zur Rolle und Funktion der Hochschule für Film und Fernsehen in der DDR von 1954 bis 1989," in *Unter Hammer und Zirkel: Repression, Opposition und Widerstand an den Hochschulen der SBZ/DDR*, ed. Benjamin Schröder and Jochen Staadt (Frankfurt am Main: Peter Lang, 2011), 278.

21. Günter Agde, "Die Anfänge der Filmhochschule Potsdam-Babelsberg und ihr Gründungsrektor Kurt Maetzig: Skizzen zu einer Rekonstruktion," in *Jahrgänge: 40 Jahre HFF Konrad Wolf*, ed. Egbert Lipowski and Dieter Wiedemann (Berlin: VISTAS, 1995), 17.

22. Ebbrecht, "Nonkonformismus und Anpassung," 279.

23. Ibid., 17.

24. Klaus Rümmler, *Hochschule für Film und Fernsehen der Deutschen Demokratischen Republik 1954–1979: Materialien* (Oberhausen: Karl Maria Laufen Verlag, 1979), 10.

25. Henning Wrage, *Die Zeit der Kunst: Literatur, Film und Fernsehen in der DDR der 1960er Jahre: Eine Kulturgeschichte in Beispielen* (Heidelberg: Universitätsverlag Winter, 2008).

26. Ebbrecht stresses that a history of the HFF would need to stress the long succession of banned films and expulsion of students, which adds to the institutional legacy won for the academy as its students filmed—for the first time without restrictions—the events of 1989 that led to the fall of the Berlin Wall. Jürgen Böttcher, Thomas Heise, Lars Barthel, Chetna Vora, and others had films banned; Thomas Brasch was expelled in 1968.

27. Slansky, *Filmhochschulen in Deutschland*, 196. For instance, in the faculty of "Dramaturgie und Film- und Fernsehwissenschaft," those in charge before 1965 had mostly been studio "Chefdramaturgs" but after the 11th Plenum's intervention, more theoretical and younger scholars took up this position (Gerbing, Wuss, Haucke). Also, as a side-effect of the *Kahlschlag* (the banning of numerous works in 1965/66 and a general crackdown across the spectrum of cultural activity) few German directing students were trained in the mid-1960s, but rather a good number of foreigners. The influence of Jerzy Toeplitz, a link to CILECT, FIAF, the Łódź Film School, and international film relations in many countries, would reward further study of this period and other formative stages of the development of HFF.

28. Ibid., 171.

29. Since German unification in 1990, Dietrich has since risen to become the absolute icon of the German film industry. Hers was the first star laid on the Walk of Stars at Potsdamer Platz in 2010.

30. Evan Torner, "Transnational System Schlock: The Case of Uwe Boll," *kunsttexte* 2 (2010), http://edoc.hu-berlin.de/kunsttexte/2010-2/torner-evan-2/PDF/torner. pdf (accessed July 31, 2012).

31. Tim Bergfelder, *International Adventures: German Popular Cinema and European Co-Productions in the 1960s* (New York: Berghahn, 2005), 105–108.

32. Slansky, *Filmhochschulen in Deutschland*, 263.
33. Ibid., 26.
34. Ibid., 412, originally in Wolf Donner, "Profis ohne Profession. Zwei Hochschulen und wenig Gemeinsamkeiten," *dffb: 10 Jahre Deutsche Film- und Fernsehakademie Berlin* (Berlin: dffb, 1976), 101.
35. *25 Jahre HFF München* (Bayerische Staatsbibliothek München, 1992), 67–92.
36. David Clarke, "Capitalism Has No More Natural Enemies," in *A Companion to German Cinema*, ed. Terri Ginsberg and Andreas Mensch (Walden, MA: Blackwell, 2012), 134–154.
37. According to a recent ranking in the magazine *FOCUS* 22 (2006), the Film Academy Baden-Württemberg is the current top film school in Germany based on its reputation, support for students, technical equipment, and awards won.
38. Slansky, *Filmhochschulen in Deutschland*, 648.
39. The Ulm School of Design itself closed in 1968.
40. The seminar, hosted by the German department, was held on April 23, 2012.
41. Stephen Brockmann, *A Critical History of German Film* (New York: Camden House, 2010), 394.
42. On the monument, these words were inscribed: "This flame reminds us—never again expulsion!" (*Diese Flamme mahnt, nie wieder Vertreibung*). See: http://www.berlin.de/ba-charlottenburg-wilmersdorf/bezirk/kultur/ewigeflamme.html.
43. Slansky, *Filmhochschulen in Deutschland*, 191. In a provocative and ruminative scene in Lars Barthel's *My Death Is Not Yours* (2006), Barthel himself as well as Dieter Schoenemann, two graduates of the HFF, swim in the lake after 1990 and talk about the filmmaker and cinematographer's respective "place" in personal biography and geography.
44. GDR history is present in completely disparate films, with distinct film school histories. On the one hand, Florian Henckel von Donnersmark's *Lives of Others* fits well with the Munich film school's more commercial and decidedly Western approach. Yet even he could not do without actors and designers from the former GDR to lend substance to his film. At the other end of the spectrum is the "hand-made" film work of Thomas Heise and his students from the Karlsruhe Academy of Arts, exhibited in Berlin in 2011 at the Pony Pedro gallery. Reviewing the show, Matthias Dell wrote that films developed in a bucket exhibit "not a nostalgic animosity toward technology, but rather an aesthetically conceived material consciousness. [...] This is shown in Serpel Turhan's film *Mr. Berner and the Wolokolamsker Avenue* (*Herr Berner und die Wolokolamsker Chaussee*). In the film, an old man uses a huge magnifying glass to read a text by Heiner Mueller, in which he recognizes his own memories of the war, by way of the life of an average SS-man untouched by regret. And the grainy, imperfect celluloid film becomes a last invaluable witness of how near to today is the past that was thought so distant." Matthias Dell, "Die Kraft des Ungenauen," *Die Tageszeitung*, April 24, 2011.
45. Barton Byg, "German Unification and the Cinema of the Former German Democratic Republic," in *Gegenwartsbewältigung: The GDR after the Wende*, Special Issue of *Michigan Germanic Studies*, guest ed. Patricia A. Simpson, 21.1/2 Spring/Fall (1995): 150–168.
46. Bergfelder, *International Adventures*, 246.
47. With regard to video games, there is even a 300,000 euro award for video game production that has been recently instituted as part of the German film subsidy package. Yet young game developers naturally consider film to be a privileged medium with regard to funding (some 300 million euros annually).
48. Filmförderungsanstalt, http://www.ffa.de (accessed May 7, 2012).

49. Randall Halle, *German Film after Germany: Toward a Transnational Aesthetic* (Urbana, IL: University of Illinois Press, 2008), 3.

50. Christian Jansen discovered, for example, that reliably talented German filmmakers could substantially affect the financial performance of any given film, e.g. those educated individuals who were "closely related to business management and film project development and realization seem to play a role in film performance." Christian Jansen, "The Performance of German Motion Pictures, Profits and Subsidies: Some Empirical Evidence," *Journal of Cultural Economics* 29 (2005): 201.

51. See also Bergfelder, *International Adventures*, 247.

52. Halle, *German Film after Germany*, 4.

53. Dudley Andrew, "Time Zones and Jetlag: The Flows and Phases of World Cinema," in *World Cinemas, Transnational Perspectives*, ed. Nataša Durovicová and Kathleen Newman (New York: Routledge, 2010), 60.

54. Paul Hockenos, "Germans' surprising reaction to *Inglourious Basterds*," (May 30, 2010), http://www.globalpost.com/dispatch/germany/090903/inglourious-basterds (accessed May 15, 2012).

55. A similar conundrum dominates recent films *Hanna* (2010), *Unknown* (2011), and *The Debt* (2010), where Germans are portrayed often in ambivalent, genre-typical roles.

56. Roland Neumann, "Hochschule für Film und Fernsehen (Babelsberg)," *Journal of Film and Video* 44.1–2 (1992): 97.

57. Ibid., 101.

58. Incidentally, the new HFF Potsdam-Babelsberg building was the first brand new film school building in Germany that was both conceived and actually built. Slansky, *Filmhochschulen in Deutschland*, 536.

59. Cited by Klaus-Dieter Müller, "*Media EXIST*," (presentation given at the HFF Potsdam-Babelsberg, October 5, 2009).

60. Interview with Lothar Mikos, "Warum sind deutsche Serien so mies?" *Spiegel Online*, http://www.spiegel.de/kultur/tv/mad-men-borgia-millennium-tv-serien-weltweit-a-822803.html (accessed May 7, 2012).

61. Werner Herzog, "About Rogue Film School," http://www.roguefilmschool.com/about.asp (accessed May 10, 2012).

62. Axel Ranisch, *Die junge Filmszene und die alte HFF*, advisor Prof. Helke Misselwitz (Diplomarbeit, Studiengang: Film- und Fernsehregie, 2011).

63. Ibid., 18.

64. Ibid., 9–10.

65. Ibid., 18.

66. Ibid., 3.

67. Slatan Dudow, "Die Frage des künstlerischen Nachwuchses," in *Auf neuen Wegen. 5 Jahre Fortschrittlicher deutscher Film*, ed. Günter Agde (Berlin, 1977), 74.

6

Sites of Initiation: Film Training Programs at Film Festivals

Marijke de Valck

Film Festivals and the Turn to Training

The movie business is a fast-moving world, in which new technologies can turn existing practices upside down and where everybody is looking for ways to "make it." It is an extraordinary business that defies regular approaches to education and career development. It seems, then, that the education of the filmmaker does not stop once training in a well-established film school has been completed. Instead the initiation of young talent into key practices merely begins at this point, as does the major process of sifting out the lucky few, who succeed, from those who will continue to struggle throughout their professional careers. In this chapter I will look at the role film festivals play in the development of emerging filmmakers. My focus will be on the European continent. At the start of the new millennium, a series of training initiatives developed by European film festivals quickly gained popularity and acquired significant influence in the industry. Dieter Kosslick, director of the Berlin International Film Festival, took the tenth anniversary of the hugely successful Berlinale Talent Campus as an occasion to reflect back on the ambitious undertaking in question:

> When we prepared the first edition of the Berlinale Talent Campus in 2003 this idea sounded wonderful, desirable and forward-looking on the one hand—and totally crazy on the other. How could the complex system of one of the world's leading film festivals stand another 350 accredited guests, and how would all this be financed? Today, as we celebrate the 10th edition, we can easily say: The Berlinale Talent Campus is one of the best things that has ever happened to the Berlinale! The Festival and the Campus interact efficiently on many levels. While the Talents profit from the input of distinguished Berlinale guests, the Festival itself is refreshed by mingling in young filmmakers from all over the world.[1]

Film festivals' turn to training is part of a larger trend in which festivals expand their activities beyond the classic core task of programming. This trend began

modestly in the 1980s with the creation of the first coproduction market, CineMart, and the first festival fund, the Hubert Bals Fund, both initiated by the International Film Festival Rotterdam, and came into full swing in the late 1990s, with other festivals following with their own funding schemes and coproduction markets.[2] On the one hand, the decision to intensify relations with the industry was motivated by ideological reasons. Festival professionals observed how difficult it had become for the cinema they cherished—art cinema and films from developing countries—to find financing, and so they responded to the challenges with programs that aimed to support the realization of projects close to their festival heart. On the other hand, the various funds and coproduction markets that emerged mixed a cinephilic passion with a pragmatic feel for the changing climate in the cultural sector. On the wings of neoliberalism, cultural policies in Europe converted to the ideal of cultural entrepreneurship, and subsequently, the lavish budgets previously available for cultural subsidy throughout the EU were more and more subjected to additional economic requirements. By repositioning themselves as factors of significant weight in the industry, film festivals also strove to safeguard their future. With regard to the investment in training programs specifically, the underlying motivation stems from a genuine commitment to foster and support young talent. At the same time, investment of this sort also matches a European ambition to be the most competitive knowledge economy in the near future. It can thus be seen as linked to the designation of the creative industries as one of several European priority areas, and to an understanding of the relevant sector as potentially well placed to advance the ambition in question.

As noted, this chapter deals exclusively with film festivals and their training initiatives in Europe. Although film festivals are constituted as particularly powerful nodes in the often floundering European film industries and scrutiny of their recent turn to training is indeed instructive, I should emphasize the obvious, namely that our contemporary media industries are thoroughly globalized and that the international film festival circuit too is characterized by complex intertwinements of national, transnational, and international dimensions. Indeed, one of my arguments will be that festivals' contemporary commitment to educate filmmakers often transcends national borders, and festivals' training programs can be understood foremost as a global and cosmopolitan affair. Much can be said about the spatial configuration of the festival circuit and the power relations between different agents, cities, and nations involved,[3] and I shall take up some of the most pressing concerns related to geopolitics and postcolonial relations in my discussion of the festival model for training in Europe in the final part of this chapter. Here, by way of introduction, a brief historical contextualization of the issues is in order.

It is important to realize that the phenomenon of film festivals originated in Europe and was designed to meet the particular interests of European film industries and European nations: promotion of national cinemas at a time when Hollywood was exerting global domination, support for struggling national industries and tourism, and the recognition of cinema as an art form and as a vehicle for the expression of cultural identity.[4] In Europe, film festivals brought revitalization to the film cultures in crisis, and, in doing so, claimed a powerful position for

themselves. If America had Hollywood as its bustling film capital to which young filmmakers and aspiring talent gravitated, Europe got Cannes, Venice, and Berlin, the hotspots on the emerging film festival circuit. An ingenious invention for a continent that has difficulty trading national sovereignty for global power, these festivals offer a calendar of events that allows the international film elite to reconvene at different locations. Whereas in America, film schools and postgraduate training naturally concentrate around Hollywood and New York, the birthplace of American film culture, Europe lacks a similar *permanent* site. Each nation clings to its own industry and many cities rival each other for the position of capital. Paris, Berlin, London, Moscow, St. Petersburg, and Rome—each is important, but neither qualifies as the European equivalent of Hollywood. Film festivals, I argue, function as a substitute for the European film capital that is missing.

The Landscape of Training at European Film Festivals

Looking at the European landscape of training initiatives offered by or in collaboration with film festivals, one sees a rich and dynamic patchwork of both recurring and single events, elaborated programs as well as small workshops, and creative training (such as scriptwriting) alongside seminars on industry knowledge and skills (like pitching). In this section I introduce the leading training programs and discuss several upcoming events. My sketch of the landscape is not exhaustive, but aims to give a good taste for the variety and relations among training initiatives. As this is a young and rapidly developing business, any overview risks becoming quickly outdated. The main objective of this introduction, beyond giving an impression of the landscape, is therefore to establish the empirical base from which generalizations and critical approaches to festival film training can be drawn. Most importantly, the descriptions will inform my discussion in the next section of five parameters that allow for meaningful distinctions to be drawn between various festival-based training programs. These parameters allow for a better understanding of the ways in which programs utilize their affiliation with festivals. They also facilitate discussion of such key issues as cultural legitimization, prestige, festivals' internal competition, and the networked relations between festivals in general.

In Europe three big players dominate the map: Cinéfondation, the Berlinale Talent Campus (BTC), and TorinoFilmLab. Cinéfondation is an association created by the Festival de Cannes in 1998. Gilles Jacob, elected general delegate in 1978, wanted to "inspire and support the next generation of international filmmakers" and envisioned Cinéfondation: The Selection as a way to achieve this aim.[5] Since 1998, the festival has selected 15 to 20 short- to medium-length films from film schools around the world to be screened as a parallel section of the Official Selection. In 2000 Cinéfondation was extended with a training program: The Residence. This program gives 12 young directors the opportunity to live in a Parisian residence for four-and-a-half months to work on a first or second film. In 2005 The Atelier followed, a program that selects 15 feature film projects and invites the filmmakers to the festival, where they are supported in establishing contacts with the industry, finding international financing, and speeding up the process of

production.[6] Cinéfondation is supported by the CNC (National Cinema Centre) and the City of Paris, and sponsored by large corporate companies.

The BTC began in 2003, initiated by the Berlin International Film Festival with the Filmboard Berlin-Brandenburg and UK Film Council as cofounders. The BTC was designed as a winter academy for up-and-coming filmmakers taking place at the same time as the film festival.[7] The inaugural campus ran over five days and welcomed 500 filmmakers, most of whom were directors, to participate in the workshops, screenings, discussions, and sessions led by industry professionals.[8] Today, the campus lasts six days, is limited to 350 filmmakers, and features different programs for actors, directors, cinematographers, distributors, editors, film critics, producers, production designers, screenwriters, sound designers, and composers.[9] Admission to the hands-on training programs is on the basis of additional selection. Presently, the federal government's Commissioner for Culture and the Media funds the BTC, in cooperation with the training program of MEDIA, the Medienboard Berlin-Brandenburg, and the Robert Bosch Stiftung.[10]

TorinoFilmLab began in 2008. It is organized as a year-round "international laboratory that supports emerging talents from all over the world working on their first and second feature films."[11] The lab is closely connected with the Torino Film Festival and promoted by the major film institutions in Turin and Piedmont, the Museo Nazionale del Cinema, and the Film Commission Torino Piemonte. It develops activities in three fields: training, development, and funding. Training initiatives are Script&Pitch (20 participants), Audience Design (three participants), Writer's Room (up to five participants), and AdaptLab (eight European participants), which run parallel to each other during the year. FrameWork focuses on development (up to 12 participants, of which six are chosen from the Script&Pitch program). The training and development programs are explicitly connected to the festival. The organization emphasizes this point:

> all [programs] reach their conclusive moment at the TorinoFilmLab Final Meeting Event in November during the Torino Film Festival when projects are presented to a selected group of producers, sales agents, distributors and other professionals from all over the world working in independent filmmaking.[12]

During the Final Film meeting at the festival several awards and prizes are granted that provide funding for further development, production, or postproduction. A separate program is designed to foster cooperation between European and Arab filmmakers. Known as Interchange (23 participants), this program includes workshops in Turin and Dubai. TorinoFilmLab receives funding from the Ministry of Heritage and Culture, the Piedmont Region, and the City of Turin, and is in addition supported by the EU (MEDIA, MEDIA Mundus, and CineEurope).[13]

Next to programs offered by the three leading organizations stand a handful of noteworthy new initiatives that are jumping into the emerging market for training at film festivals, sometimes in collaboration with film festivals. There is FEST—Training Ground in Portugal, a training week for new and upcoming filmmakers from around the world that takes place at the start of the summer (early July) in Espinho, a small tourist beach town close to Porto, Portugal's second-largest city, when the town is also host to FEST—International Youth Film Festival. The

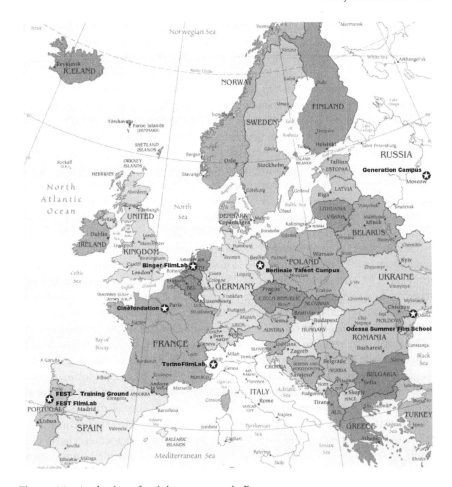

Figure 6.1 A selection of training programs in Europe

festival was founded in 2007 and Training Ground kicked off two years later. FEST differs from Cinéfondation, the BTC, and the TorinoFilmLab significantly, in that participation is not based on a selection process. Training Ground is open to everybody and barriers to participation are deliberately kept low.[14] For example, FEST offers a range of affordable packages that include accommodation and access to the training events and festival screenings while emphasizing the appeal of its settings—"one of the summer hotspots of Portugal"—and promising a unique social and cultural experience.[15] By the third edition in 2011 the Training Ground had attracted more than 500 participants from over 25 countries.[16] The organization has ambitions to grow even further and feels confident the program can accommodate up to 1000 filmmakers.[17] In October 2011 FEST launched Filmlab, an institution for year-round professional filmmaking workshops.[18]

The equally ambitious Odessa International Film Festival (OIFF) included a Summer Film School right from its inception in 2010. The festival takes place over a period of nine days in mid-July in the city of Odessa, Ukraine's third-largest city, a seaport with a population of just over 1 million. The OIFF, which is supported

by the state film agency, Odessa Regional State Administration and Odessa City Council, strives to become the main film event in the Ukraine.[19] The first Summer Film School invited "the students of film schools and the students of any other universities who is [sic] interested in movies together with all the funs of cinema to become the participant of this project."[20] Like FEST, Odessa sets low entry barriers and aims at a large number of participants: everybody can participate by buying a Summer Film School pass and making use of a cheap camping option.[21] In 2011 two selective programs (20 participants) were added to the festival, one for film critics and one for scriptwriters. Both are limited to people of Ukrainian nationality. In addition to workshops and master classes taught by industry professionals and festival guests, the event's main appeal is its open-air screenings, in particular the annual outdoor screening of a silent classic with live musical accompaniment on the famous Potemkin stairs.[22] The number of participants in the Summer Film School can be estimated at approximately 700.[23]

Taking place in neighboring Russia is Generation Campus, "an international program of creative and professional development for young and talented filmmakers."[24] The campus began in 2008 as a modest initiative (with ten participants) and expanded over the years using the BTC as inspiration (growing to 64 participants in 2011). Since its inception Generation Campus has partnered with different young film festivals, synching the campus to the selected festival. In 2011 it began collaborating with the newly founded 2-in-1 Film Festival in Moscow, while also offering a trip to St. Petersburg as part of the program. The program comprises one week (eight days) of intensive workshops, lectures, seminars, round tables, master classes, and coaching. The contours of the program are still in constant development and overall Generation Campus appears to be less successful than FEST or the Odessa Summer Film School. In 2012 people had a choice between attending the overall program, for which they could cherry-pick events, or individual labs, which were very intensive and demanded commitment. Five labs were offered: Directors Lab, Script Lab, Producers Lab, DOPs Lab, and Actors Lab. Access to the labs was by selection. Generation Campus does not charge a fee.[25]

Although not many film festivals go so far as to organize a fully fledged campus or to construct a temporary camping site, a lot of them do offer occasional workshops or seminars that aim to educate local filmmakers and film students, nurture new talent, and/or promote the up-and-coming to the industry. These objectives are, moreover, partially shared by the extensive network of student film festivals. The International Student Film Organization lists no fewer than 150 student film festivals and this number is likely to grow as more organizations and initiatives discover this young network and register with its database.[26] Moreover, there are training programs that resemble the film festival initiatives in design and content, but are not directly affiliated with a film festival. One well-known example is the Binger FilmLab in the Netherlands, founded in 1996. The center offers coaching to writers, directors, and producers of both documentary and feature film projects in intensive programs lasting four months (for twelve to 20 participants). The Binger FilmLab competes most directly with the TorinoFilmLab in terms of target group. In spite of enjoying a good reputation globally, the financial

position of Binger FilmLab is currently precarious, as support by the Ministry of Education, Culture and Science and the City of Amsterdam will cease in 2013 due to general policies aimed at cutting down on subsidies for arts and culture at a time of financial crisis.

It is important to emphasize that film festivals play an equally significant role in independent training programs like the Binger FilmLab. Binger intersects with the festival circuit in several ways. For example, a trip to CineMart at the International Film Festival Rotterdam is an integral part of the autumn/winter labs, and participants in spring/summer labs travel to Cannes, where Binger hosts events and brings participants into contact with the industry. Moreover, Binger is represented at several training events offered by film festivals throughout the year. They organize pitch workshops and script consultancy for the BTC, Meetings on the Bridge in Istanbul, Cinelink at Sarajevo Film Festival, Film Bazaar at the Goa International Film Festival, and Buenos Aires Lab at the Buenos Aires Festival Internacional de Cinema Independiente (BAFICI).[27] Why exactly film festivals constitute such beloved sites for offering training and what this means for the education of the filmmaker in a larger perspective is something I will begin to tackle by suggesting five parameters to assess the recent surge in training initiatives offered by or in collaboration with film festivals.

Parameters for Comparison and Distinction

Film training at festivals can be set apart from other types of training, such as the conservatoire-style model of traditional film schools (Byg and Torner, this volume), the process-oriented approach of modern college programs (Moinak Biswas in this volume), and branch-campus initiatives of Ivy League universities (Hamid Naficy in volume two). Film training at festivals is positioned outside the formal educational system. The programs are significantly shorter and do not culminate in a diploma or degree. The vocabulary used to describe and promote the training initiatives at film festivals underlines their ambiguous relation to "proper" education. On the one hand, terms like "campus," "school," and "academy" are freely borrowed from the educational system, while, on the other, there is a reluctance to speak of "students" and instead "participants" is preferred. That training at film festivals can be considered a relatively recent, distinct phenomenon within film education does not mean all festival film training is alike. There are significant differences between the various training programs. I distinguish five key parameters: access, size, duration, training, and costs. In figure 6.2 below the parameters are applied to the training programs from the previous section.

Access

The first parameter, "access," differentiates between training programs that select participants and those that administer an open participation policy. The two variants represent opposing strategies for utilization of the intersections with the world of film festivals. By opting for selection, the training programs tap into film festivals' position as cultural gatekeepers. Several scholars have argued that

	Access	Size	Duration	Training	Costs
Berlin Talent Campus	Selection	350 incl. small labs 3–20	6 days	Creative industry general interest	No fee, partial reimbursement of travel and accommodation
Cinéfondation	Selection	42–47			
The Selection		*15–20*	Cannes	No training component	Covers subtitles, transport, storage & insurance
The Residence		*12*	4-5 months	Creative	Accommodation + €800 grant + trips to festivals
The Atelier		*15*	Cannes	Industry	Invited to Cannes
TorrinoFilmLab	Selection	62–71			Covers for each program accommodation + subsistence, not travel
Script & Pitch		20	11 months	Focus on creative	€2000
Audience Design		3	6 months	Industry	No fee
AdaptLab		8	9 months	Creative+ Industry	No fee
Writer's Room		<5	9 months	Creative	€2000
Framework		<12	8 months	Industry	No fee
Interchange		23	2 × 5 days Torino & Dubai	Creative+ Industry	No fee
FEST— Training Ground	Open	500 and growing	7 days FEST	Creative Industry General interest	From €59 or from €89 incl. camping
FEST FilmLab	Open	30	2 days year-round	Creative	€269–450
Odessa Summer Film School	Open	700 and growing	9 days Odessa	Creative Industry General interest	From €29 or from €48 incl. camping
Generation Campus	Selection	64 and growing	8 days 2-in-1 festival	Creative Industry General interest	No fee
Binger FilmLab	Selection	12–20 per Lab	4 months	Focus on creative	€3500 + €6250 application fee

Figure 6.2 Comparing European training programs linked to film festivals on five parameters

one of the main functions of film festivals is to act as sites of cultural legitimization: they sift through the world's annual film production and select the best or most interesting films of a given year.[28] In a similar vein, festivals can add value by programming tributes around filmmakers, or rescue old films from oblivion by organizing a thematic retrospective.[29] In the festival circuit a limited number of film festivals hold the most influential positions—like Cannes, Venice, and Berlin in Europe—and filmmakers gain the most prestige by participating in these festivals. The more prestigious a festival is, the more likely this quality is to rub off on affiliated new initiatives. This means that among the discussed training initiatives Cinéfondation: The Residence is most prestigious due to its patronage by the Cannes Film Festival. That the training program is not situated on the Riviera is not relevant. On the contrary, for the Cannes organization and offices are also to be found in Paris, with staff traveling south only during the festival. TorinoFilmLab also uses a "prestige" strategy, but in a slightly different way. The Torino Film Festival is a respected institution with a history of nurturing young cinema since 1982, but its position on the festival circuit is not as solid as Cannes' or Berlin's. The Piedmont region, however, is wealthy, both industrially and agriculturally, and the festival reaps the benefits from the region's willingness to invest in culture. As a result, TorinoFilmLab has not only been able to develop a quality training program, but is also in a position to be generous toward its selected participants, who, for example, receive full accommodation and board during the on-site workshops in Turin. The program has become very popular very fast and its prestige grew as it became more difficult to pass selection.

For festivals that have little influence in the festival circuit and lack funding, the "prestige" strategy (see figure 6.3) is less obvious. Both FEST and Odessa realize it is not prestige that will be the main appeal of their event, but the classic combination of cinema, sun, and fun. FEST—Training Ground and Odessa Summer Film School are conceived as cinephilic holiday packages for the young and young at heart: FEST has the beach as an additional selling point; Odessa plays on its cinematic heritage with the attraction of open-air screenings on the stairs where Sergei Eisenstein shot his famous scene from *The Battleship Potemkin* (1925). Instead of emphasizing selection, FEST and Odessa have opted for an

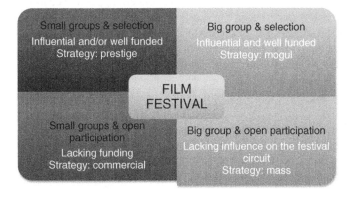

Figure 6.3 Access/size—Four different strategies

open participation policy. In doing so, they highlight festivals' contribution to the democratization of film culture, rather than their role as cultural gatekeepers.[30] Traditionally, film festivals promote the cinemas that fall outside regular commercial distribution and program many films that will not be screened elsewhere. In doing so, festivals make a diverse palette of films available to a broad and global audience. FEST and Odessa have extended this attraction to training: now anyone with an interest in cinema can work on their skills and knowledge by participating in these training events, conveniently hosted during the summer holiday season.

Size

The open participation policy that FEST and Odessa adhere to has generated large numbers of participants. Both seem eager to grow even further. Mass is important for them as it testifies to the success of the event: the more people attend, the more appealing the training programs become for future participants. If FEST and/or Odessa succeed in consolidating the size of their programs, they can improve their position on the competitive festival circuit and might qualify for funding from the equally competitive MEDIA program, which then could enable the development of selective strands within the open program without the need to demand higher fees. In addition to the "mass" strategy behind FEST—Training Ground, FEST has recently developed a "commercial" branch (see figure 6.3). In 2011 it began FEST FilmLab, a separate year-round institution that offers quite expensive two-day professional workshops. This new venture, however, appears not to have taken off yet.

Although it seems logical that the parameter of size is linked to access—with more prestige reserved for small, selective groups—the example of the BTC shows that this is not always the case. The BTC combines selection with a large size. Each year 350 talents are selected for the campus. More than 4000 filmmakers applied for the 10th edition of the campus in 2012.[31] Why did the Berlinale, already a prestigious institution, decide to accommodate a big group? Berlin's choice of scale should be understood in light of the interfestival competition with Cannes and Venice. The festival explicitly uses the talent program to connect filmmakers to the Berlinale family, and, by fostering loyalty, ultimately, hopes to feed its flagship program. Dieter Kosslick writes, "But most of all we enjoy seeing Talents return. Every year the Official Selection of the Berlin International Film Festival is enriched by films made by Campus alumni."[32] With a larger group of Campus alumni, the odds are enhanced of some of its members being attached to top productions in the future. The hope, then, is that such filmmakers will be willing to repay Berlin for supporting them in the early stages of their career, by opting for a premiere in Berlin over Cannes or Venice. With a competition that has been insistently less strong than the official selections in Cannes and Venice, the investment is welcome. For although Berlin is widely regarded as one of the most prestigious film events, the expectations and hopes for artistic revelations among attending film critics are modest. Reporting on the 2012 edition the well-known film critic Jonathan Romey writes as follows:

In Berlin, you learn not to expect the bombshells that Cannes has made its selling point. There, every film is a potential game-changer, or so you've been conditioned to hope. Here, you just pray that the choices will be watchable.[33]

What I call Berlin's "mogul" strategy is based on power and consolidating influence through expansion. This is also quite literally what the BTC has done. Since 2008, the BTC has branched out internationally to Talent Campuses in Buenos Aires, Argentina (2006),[34] Sarajevo, Bosnia, and Herzegovina (2007),[35] Guadalajara, Mexico (2008),[36] Durban, South Africa (2008),[37] and Tokyo, Japan (2012).[38] The international campuses are limited to regional filmmakers (respectively South America, South-Eastern Europe, Central America & the Caribbean, Africa, and East & Southeast Asia) and therefore pose no threat to the mother Campus in Berlin.[39]

Duration

A third parameter for distinction is the duration of training programs. The training programs affiliated with film festivals are relatively short compared to the educational programs offered at film schools. While some only comprise a couple of days—being limited to (part of) the duration of the film festival—others extend over a period of four to 11 months. All big-size initiatives use the short variant: approximately one week of training organized during and in collaboration with a film festival. It is this coupling that brings significant logistical and financial advantages to the complex production of large training events. Filmmakers, industry professionals, and other experts attending the festival constitute a rich pool of potential speakers, moderators, workshop leaders, and roundtable participants. Disadvantages, on the other hand, are the fragmentation of the program into short and ultra-short sessions and the limited time available to practice new skills or to engage in an educational process. Clearly, the longer training programs offer far greater opportunities systematically to develop competencies and to apply these to individual projects. Part of the strength of both the Residence and Binger FilmLab, moreover, is the physical dislocation of selected participants to an environment where they can dedicate themselves completely to the development of personal skills and/or individual projects. TorinoFilmLab works slightly differently, offering longer programs that consist of long-distance coaching as well as on-site learning. The labs typically include several one-week residential workshops, online meetings, and the Final Meeting event during the festival.

Training

The duration and design of training programs have a significant effect on training, the fourth parameter. One can roughly divide all training into three types: creative, industry, and general interest. Creative training, such as scriptwriting, transmedial storytelling, adaptation, sound design, acting, and directing, is best conceived in small groups with individual coaching. Having realized this, the BTC's mogul

strategy includes offering small group, hands-on training programs that require an additional application and for which the selection is highly competitive.[40] While much can be achieved in intensive workshops, the added value of longer programs in which participants can develop a project is obvious. Here, Cinéfondation, TorinoFilmLab, and Binger FilmLab have a clear competitive advantage over the BTC.

Industry training, on the other hand, might be more easily fitted into several short formats, such as lectures, roundtables, and pitching workshops. The quality of industry training depends on the training program's ability to collaborate with key industry professionals. Rather than benefiting from extended trajectories and space for reflection, industry training fits the intensity of the festival event like a glove. Participants can hear about the latest trends and observe practices or perform their skills in precisely one of those sites where a lot of the international film business takes place: at film festivals. In some programs the line between industry training and support becomes blurred. For example, the TorinoFilmLab boasts that all labs culminate at the Final Meeting event during the festival when projects are pitched to industry professionals, such as producers and sales agents. At this point the TorinoFilmLab morphs from training into a variant on the coproduction market where selected filmmakers are supported in establishing contact with the international film industry for the purposes of securing financing.

Finally, there is training that falls into the category of general interest. Examples include lectures on the social power of the image or the role of fiction in documentary, Q&As with famous actors, and discussions with filmmakers about the aesthetics and success of a recent new wave. General interest dominates the open training programs of FEST and Odessa.

Costs

The final parameter is costs. What do the various training programs cost the participants? On one side of the spectrum, participation in a training program costs nothing or very little. The most prestigious programs belong to this side of the spectrum. Programs are offered for free, and selected participants are reimbursed for accommodation, subsistence, and/or travel. Two mid-range options are no fee is demanded for participation in the training, but participants have to cover all other expenses; and the program requires a modest fee but provides cheap options for accommodation (as is the case for FEST and Odessa). On the other end of the spectrum, we find the more expensive training programs. The new workshops organized by FEST FilmLab, for example, are on the market for commercial prices. The Binger FilmLab, which used to receive funding but is currently in a financially precarious situation, charges 3500 euro. The TorinoFilmLab, enjoying rich support, still charges 2000 euro for some of its most intensive labs. However, with regard to both Binger and Torino it is not clear how many of these fees actually come out of participants' own pockets. The organizations underline the availability of (national) funds, stipends, and scholarships. Moreover, considering the duration of the programs in Turin and Amsterdam, as well as the luxury of long-term individual coaching, the fees can be considered modest to fair.

Cinéfondation: The Residence occupies an exemplary position in the comparison of costs. It offers free accommodation in the heart of Paris (at a "Villa Médicis"), an 800 euro grant, free French-language lessons, the possibility to attend film festivals, personal coaching in scriptwriting, and a collective program of forums with industry professionals. Multiple big sponsors and partners who are pleased to affiliate their names with the Cannes super brand make the program's extreme generosity possible.[41]

Assessing Film Festivals' Commitment to Training and Talent Development

The landscape of European training initiatives at film festivals is burgeoning. In the past decade several new and ambitious programs have been initiated. Young and aspiring filmmakers have flocked to these events to immerse themselves in a week- or several months-long training/development experience that also promises the possibility of boosting one's career. These training initiatives constitute a young and dynamic field, one where the institutional players appear to be monitoring competition and new developments closely. Successful formats and familiar terminology are freely copied, and as a result, the contours of three to four steady variants of a film festival-training model are emerging. Influential festivals and those with ample funding are in the comfortable position to develop what I called a "prestige" strategy: by using strict selection criteria and admitting only a small number of filmmakers, these training programs add maximum value and prestige for the lucky few who are selected. It should be noted, though, that as the field for festival training grows, it will become less easy for newcomers to adopt this strategy, even in the event of funding. Prestige is by definition a scarce good, and if more players enter the field, prestige can only be redistributed, not multiplied. Alternatively, festivals that lack funding or prestige have developed a strategy based on acquiring the critical mass needed to exert influence. These programs are not typically meant to cater to up-and-coming filmmakers who are looking to launch their careers. Instead they are aimed at students of film and at young cinephiles who are lured by the idea of spending a summer holiday sharing their passion for film with a young, like-minded international crowd, while learning more about film and filmmaking. Success with the "mass" strategy variant is dependent on the initiatives' capacity to consolidate the requisite scale, a precondition for applying for attractive (EU) funding schemes. The other option available to less influential and less wealthy festivals is to offer commercial training programs. This variant has not been sufficiently explored as of yet, and its efficacy thus cannot be assessed. Finally, there is the theoretically unlikely "mogul" strategy that lies at the base of the hugely successful BTC, where it is a matter of combining prestige with mass. What appears to be especially relevant here is the underlying motivation to create a broad alumni network, which can then feed back into the festival program. I have argued that this variant should be understood in light of the competition between the A festivals in Berlin, Cannes, and Venice. The BTC makes use of an amended version of the cultural gatekeeping philosophy, focusing on a larger pool of up-and-coming filmmakers who together increase the odds of affiliating future talent with Berlin.

The example of the BTC and the comparison of festival training programs through the parameters of access, size, duration, training, and costs generally make clear that these programs are not constituted as single, separate entities, but as part of the larger network of film festivals and media industries. For the assessment of film festivals' commitment to training and talent development, it is therefore necessary to consider some key implications of these networked relations. Geographical demarcations are of limited value as the network is profoundly globalized. This chapter's limited focus on European initiatives is largely artificial and for a full comprehension of the recent European boom, it is necessary briefly to touch on the mother of all festival training programs: Sundance. Long before European film festivals started to develop structural training programs, Sundance had an elaborated program in place. Founded in 1981 by Robert Redford to foster independent American cinema, Sundance began as a Filmmakers'/Directors' Lab, where a small group of talented young filmmakers worked together with seasoned filmmakers to develop their projects. Following the success of this event, more labs were added.[42] The new European festival initiatives of the 2000s picked up different elements that had been introduced and made successful by Sundance, such as the coupling of (small) groups of emerging talent with experts and professionals working in the film world, the cross-fertilization between training events and the film festival, the idea of training as a laboratory, and indeed the term "Lab" itself. While Sundance was originally envisioned as a means of offering independent *American* filmmakers a sanctuary away from the pressures of the marketplace—and one can argue the American scene continues to be the main interest group until today—the European initiatives have been more cosmopolitan from their inception. For example, each year the BTC press releases make explicit mention of the broad range of nationalities among its participants. Not only do they disclose the number of different nationalities in any campus edition (99 in 2012) but attention is also drawn to the even larger number of different nationalities among applicants (137 nationalities in 2012). Considering there are 196 countries in the world today, this is an impressive number. The rich experience of cultural encounters is promoted as an additional attraction to potential participants. Clearly, the initiatives do not want to be considered "European," let alone to be limited to Germany, Italy, or France. Instead, they reach out to the world in their commitment to foster young filmmakers. This means that, ideologically, they treat training as something essentially universal, as something that can transcend national borders.

Returning to the parameters of training, this implicit ideological claim can be assessed. First, with regard to creative training, it ought to be noted that the understanding of art that informs talent development at film festivals is not value free. The more prestigious training programs all emphasize individual coaching, often exemplified by a preference for the term "lab." The laboratory as ideal teaching environment implies a belief in "individuality," "originality," and, by extension, "authorship," which is a very Western conception of artistic practice. Instead of educating filmmakers in a given tradition or teaching them set skills, the emphasis is on the personal process, on discovering one's own voice and signature. In addition to many programs, like Cinéfondation, that are aimed at directors—the creative genius in European auteur theory—others, like the BTC, have opened

themselves up to multiple filmmaking professions, and by doing so they can be seen as contributing to the correction of a persistent false belief in the director as *the* author of a film, both in the contemporary art cinema scene and some film theory.

Second, the industry training provided at festival training programs is oriented toward the international film industries. Festival training programs draw upon the industry professionals who are visiting the festival or its market to recruit mentors, coaches, and teachers for their talent development activities. This means that people who are at home in the international scene dominate the industry sessions. So, while in Berlin, for example, the German and federal film industry will be well represented, it is less likely that Indian talents will learn about Bollywood and the particular demands of that national industry. Above all they are initiated into the circle of international cinema and its industries, and thus become well acquainted with the current market prerogative that film projects must appeal to global audiences.

One could argue that for film festival training programs the ties to the industries are both their greatest strength and chief weakness. For participants the connection to film festivals has clear advantages. By entering a talent development program, they are initiated into the cosmopolitan world of international filmmaking. The opportunity to connect with industry professionals, to learn from them, and, moreover, to establish one's own international network of peers is as valuable as the creative training. A filmmaker who is selected by one of the prestigious festival training programs on the basis of his or her CV has a distinct advantage over his or her peers. In a profession where formal education has an ambiguous status, and work experience, industry knowledge, and networking are essential, film festival training constitutes a valuable experience. If film festivals previously already acted as cultural gatekeepers for finished film products—elsewhere I called them sites of discovery[43]—they should now, I believe, be seen as also functioning as sites of initiation, on account of the turn to training: if you want to "make it" as a filmmaker in the contemporary international film industry, particularly in the sphere of global art cinema and world cinema, you need to begin by gaining access to the "postgraduate" level of festival talent development, to the "prestige" or "mogul" training programs. As my use of the term "postgraduate" suggests, this typically happens once aspiring filmmakers have completed some form of formal training, often in the context of a conservatoire-style film school.

The interrelations with the industries, however, also have disadvantages. Being affiliated with the cosmopolitan world of international film industries and enabled by the liminal state of the festival event,[44] film festival training programs are not usually rooted in a local or national context, but occupy a transnational space. Participants are above all prepared for global careers, learning universal—or what will count as universal—skills, establishing international networks of peers, and engaging with global industry representatives. One could argue that the cosmopolitan flavor of festival training is detrimental to the future of filmmaking as a form of cultural expression for national or regional identity. In particular when young filmmakers are guided by the industry penchant for viability in the marketplace,

the diverging tastes of regional audiences will be hard pressed by the particular aesthetics and topics of the genre of global art cinema that travels well.[45] In this regard it is problematic that the international network of global cinema industries and the international film festival circuit are characterized by uneven power relations between various agents, and that a gap exists between wealthy countries that are able to finance film production and poorer countries, where such funding is unavailable. One could, however, also evoke Homi Bhabha's more hopeful concept of a third space. Writing on (former) colonial territories, Bhabha contends that the construction of culture and identity is hybrid and emerges from the interweaving of elements of the colonizer and the colonized. Here he draws on cultural theory that argues against essentialist understandings of identity. Bhabha's concept of a third space refers to the liminal space, "the cutting edge," where these elements are negotiated and translated.[46] Applying the notion of a third space to film festivals, it becomes possible to see them as sites that generate possibilities for productive articulations of new cultural identities, something different from the isolated local or regional experience, but not necessarily oppressed by dominant powers in the globalized area either; rather a site for collaboration and contestation.

As Dieter Kosslick, quoted at the beginning of this chapter, underlined, training programs and film festivals cross-fertilize each other. Talent development is particularly valuable for festivals as they depend on a constant supply of new films, new trends, and new talent. The movie world is a fast world and international film festivals play to the beat of the same drum. With the global spread of film festivals in the 1980s, the need for film festivals to be distinctive and competitive has intensified. For a long period of time, film festivals concentrated on programming, acting as sites of discovery. Since the 1990s, European festivals have extended their activities, adding training and talent development to funding and coproduction markets in the new millennium. The benefits for festivals are clear: by investing in young talent early on, they improve the quality of future film production, on which they depend for their core business of programming, while nurturing a relation to the stars of tomorrow. For young filmmakers, the leading initiatives among the many existing film festival training programs have clearly developed into sites of initiation. These filmmakers are eager to participate in the programs, as they are seen as offering a passageway between education and an established professional career. Paradoxically, however, the burgeoning field of festival training has also given rise to another variant of the festival training model, which may threaten the "conventional" education model that is based on selection and track records. Some of the new training initiatives are open to everyone with an interest in cinema and a week to spare in the summer. The popularity of these events reveals a massive body of film students and amateurs who are committed to investing in their own personal development. Considering the ambivalent status of education in the film world—a professional sector in which diplomas and credentials seem to offer fewer chances at future employment and success than anywhere else, while people wholeheartedly embrace Romanticist stories of self-made (wo)men and accidental discoveries of world-famous stars—it is not unthinkable that such commitment in individual cases may produce even more competition for the up-and-coming film talents of today.

Notes

1. Dieter Kosslick, "Editorial: Let the campus change your perspective," *Berlinale Talent Campus #10 Magazine*, February 2012, 6, http://www.berlinale-talentcampus.de/story/65/3965.html (accessed May 12, 2012).
2. For an elaborated overview of the rise of coproduction markets, see Marijke de Valck, "Filmfestivals, coproductiemarkten en de internationale kunstcinema: het CineMart model van matchmaker onder de loep," *Tijdschrift voor Mediageschiedenis* 13.2 (2010): 144–156.
3. Read more on this topic in Julian Stringer, "Global Cities and International Film Festival Economy," *Cinema and the City: Film and Urban Societies in a Global Context*, ed. Mark Shiel, and Tony Fitzmaurice (Oxford, UK: Blackwell, 2001), 134–144; and Marijke de Valck, "Berlin and the Spatial Reconfiguration of Film Festivals," in *Film Festivals: From European Geopolitics to Global Cinephilia* (Amsterdam: Amsterdam University Press, 2007), 45–82.
4. de Valck, Ibid.
5. Festival de Cannes, "Cinéfondation," http://www.festival-cannes.fr/en/cinefondation.html (accessed May 9, 2012).
6. Festival de Cannes, "Atelier," http://www.festival-cannes.fr/en/cinefondation/the Atelier.html (accessed May 9, 2012).
7. "First BERLINALE TALENT CAMPUS unites 500 filmmakers from all around the world – Industry and public invited to screenings and discussions with international filmmakers," *Berlinale Talent Campus press release #4*, January 21(2003), 1, http://www.berlinale.de/media/pdf_word/pm_1/53_berlinale_en/15_PressReleaseCampus_01_21_2003.pdf (accessed May 9, 2012).
8. Ibid.
9. Berlinale Talent Campus, "General information," 4 April 2012, http://www.berlinale-talentcampus.de/story/62/1862.html (accessed May 9, 2012).
10. "The Berlinale Talent Campus is an initiative of the Berlin International Film Festival, a business division of the Kulturveranstaltungen des Bundes in Berlin GmbH, funded by the Federal Government Commissioner for Culture and the Media upon a decision of the German Bundestag, in cooperation with MEDIA - Training programme of the European Union, Medienboard Berlin-Brandenburg, and the Robert Bosch Stiftung." Disclaimer on all *Berlinale Talent Campus #10* press releases, e.g. http://www.berlinale-talentcampus.de/story/73/3773.html (accessed 27 February 2013).
11. TorinoFilmLab, "About us," http://www.torinofilmlab.it/about.php (accessed May 9, 2012).
12. Ibid.
13. TorinoFilmLab, "Disclaimer," http://www.torinofilmlab.it/about.php (accessed May 14, 2012).
14. On the flyer promoting FEST 2012 Training Ground the question "Who can attend?" is answered as "Everyone with a genuine interest in Film and audiovisual production."
15. Prices for FEST 2012 are: €59 for access to Training Ground and Festival, €89 for access plus camping accommodation, and €129 for a bed in the local youth hostel. More luxurious options are available on request. FEST 2012, "What is Training Ground?", http://fest.pt/?page_id= 1501&lang= en (accessed May 9,2012). The promotional flyer lists five reasons why one should go to FEST—Training Ground. The fifth reason states "Because it is impossible to say no to a few days of films. Learning about Production and the Industry. Beach and Party."
16. FEST 2012, "History," http://fest.pt/?page_id= 1527&lang= en (accessed May 9, 2012).

17. Personal conversation with Fernando Vasquez, festival producer for FEST, during the Berlin International Film Festival 2012.
18. The past and upcoming events workshops listed thus far are two-day workshops, two organized in Portugal and one in Norway. Prices ranged from €269 to €450. Group size is limited to 30 participants. See FEST FilmLab, "Home," http://filmlab.fest.pt/?lang=en (accessed May 14, 2012).
19. Vladimir Koslov, "Odessa Film Festival to Kick Off with New Format," *The Hollywood Reporter*, July 14, 2011, http://www.hollywoodreporter.com/news/odessa-film-festival-kick-new-211265 (accessed May 9, 2012).
20. "Summer Film School," Odessa International Film Festival 2012, http://2010.oiff.com.ua/school.en.html (accessed May 9, 2012).
21. Also like FEST, the Odessa Summer Film School offers a package that includes a pass for access to workshops and screenings as well as accommodation in the Festival Tent Camp, put up in the city center. Prices rise as the festival opening is approaching. For 2012, prices are 300, 500 and 800 UAH (approx. 29, 48 and 77 euro) for the pass if bought before March, between April and May, or after June, and an extra 200, 300, and 400 UAH (approx. 19, 29, and 38 euro) for a camping place on the territory of the Odessa Film Studio. Odessa International Film Festival 2012, http://2011.oiff.com.ua/en/zriteljam/kupit_abonement_1305029571/abonement_letnjaja_kinoshkola.htm (accessed May 9, 2012).
22. During the first festival Sergei Eisenstein's *Battleship Potemkin* was screened with live music performed by a full symphonic orchestra. The second festival edition featured Fritz Lang's *Metropolis*.
23. Personal conversation with Fernando Vasquez. The OIFF states that their camping site offers accommodation to 500 people. In addition, a range of hotel options is offered to buyers of a Summer Film School pass.
24. Generation Campus 2011, http://www.generationcampus.ru/en/info (accessed May 10, 2010).
25. Ibid. Also see NISI MASA, "Russia—Generation Campus," European Network of Young Cinema, http://www.nisimasa.com/?q= node/438 (accessed May 10, 2012).
26. International Student Film Organization, "Members area," http://futureinfilm.com (accessed May 10, 2012).
27. Binger FilmLab, "Industry," http://www.binger.nl/industry (accessed May 10, 2012).
28. Thomas Elsaesser, "Film Festival Networks: The New Topographies of Cinema in Europe," in *European Cinema: Face to Face with Hollywood* (Amsterdam: Amsterdam University Press, 2005), 96.
29. Julian Stringer, "Raiding the Archive: Film Festivals and the Revival of Classic Hollywood," in *Memory and Popular Film*, ed. Paul Grainge (Manchester: Manchester University Press, 2003), 81–96.
30. For an elaborated version of this argument see Marijke de Valck, "De rol van filmfestivals in het YouTube-tijdperk," *Boekman* 83 (2010): 54–60.
31. "More than 4000 filmmakers from 137 countries apply for the Berlinale Talent Campus #10/Ryūichi Sakamoto to mentor the Score Competition/First-ever Talent Campus Tokyo in November 2011," *Berlinale Talent Campus press release #2*, November 2, 2011 (accessed May 11, 2012).
32. Dieter Kosslick, "Editorial," *Berlinale Talent Campus #7 Magazine*, 9, http://berlinale.top-ix.org/audio/website/btc_magazine_09.pdf (accessed May 11, 2012).
33. Jonathan Romney, "At the Berlinale," *Londen Review of Books blog*, February 17, 2012, http://www.lrb.co.uk/blog/2012/02/17/jonathan-romney/at-the-berlinale/ (accessed October 29, 2012).

34. The Talent Campus Buenos Aires is an initiative of the Universidad del Cine in cooperation with the Berlinale Talent Campus, the Buenos Aires International Independent Film Festival (BAFICI) and the Goethe-Institut Buenos Aires. *Website Berlin Talent Campus,* http://www.berlinale-talentcampus.de/channel/119.html (accessed May 12, 2012).

35. The Sarajevo Talent Campus is an initiative of the Sarajevo Film Festival in cooperation with the Berlinale Talent Campus. *Website Berlin Talent Campus,* http://www.berlinale-talentcampus.de/channel/122.html (accessed May 12, 2012).

36. The Talent Campus Guadalajara is an initiative of the Guadalajara International Film Festival in cooperation with the Berlinale Talent Campus and the Goethe-Institut Mexico. *Website Berlin Talent Campus,* http://www.berlinale-talentcampus.de/channel/258.html (accessed May 12, 2012).

37. The Talent Campus Durban is an initiative of the Durban International Film Festival in cooperation with the Berlinale Talent Campus. *Website Berlin Talent Campus,* http://www.berlinale-talentcampus.de/channel/120.html (accessed May 12, 2012).

38. The Talent Campus Tokyo is organized in cooperation with Berlinale Talent Campus and Goethe-Institut Tokyo. *Website Berlin Talent Campus,* http://www.berlinale-talentcampus.de/channel/540.html (accessed May 12, 2012).

39. Generation Campus in Russia is also modeled on the BTC and even uses the trademark "campus" in its title in a clear attempt to trigger positive connotations, but is not officially cooperating with the BTC.

40. In these hands-on training programs there is, for example, space for ten to 12 screenwriters, ten to 12 documentary makers, three composers, eight film critics, and 20 actors.

41. Founding sponsors are L'Oréal, Néstle France, and Warner Bros. "The Cinéfondation partners," http://www.festival-cannes.fr/en/cinefondation/partenairesCinefondation.html (accessed May 13, 2012).

42. In 1985 the Sundance institute (headed by Sterling van Wagenen) took over the management of the US film festival (founded by Sterling van Wagenen in 1978, previously head of Westwood, Robert Redford's production company). The festival had already moved from its original Salt Lake city location to Park City in Utah in 1981, and was renamed Sundance by the new management.

43. Marijke de Valck, *Film Festivals: From European Geopolitics to Global Cinephilia* (Amsterdam: Amsterdam University Press), 174–177.

44. Ibid., 37.

45. For a similar argument concerning the influence of festival funds on Latin American cinema see Tamara Falicov, "Migrating from South to North: The Role of Film Festivals in Funding and Shaping Global South Film and Video," in *Locating Migrating Media,* ed. Greg Elmer et al. (Lanham, MD: Lexington Books, 2010), 3–21, 25. Also see Miriam Ross, "The Film Festival as Producer: Latin American Films and Rotterdam's Hubert Bals Fund," *Screen* 52.2 (2011): 261–267.

46. Homi K. Bhabha, *The Location of Culture* (New York, NY: Routledge, 1994), 36.

Part II

Australia and Asia

Beyond the Modular Film School: Australian Film and Television Schools and their Digital Transitions

Ben Goldsmith and Tom O'Regan

Over the last 15 years or so, the number and variety of film education institutions in Australia has grown with many private providers now operating courses in parallel with those offered by "traditional" film schools, public universities, and vocational education colleges. Some Australian private providers have developed significant international operations. This recent growth in the number and variety of institutions has been accompanied by changes to the kinds of programs of study on offer. A greater variety of audiovisual training is now being offered in part as a direct consequence of the digital transition and attendant new technologies, practices, and skill-sets, which in turn present new opportunities and challenges for entry-level practitioners. The traditional, conservatoire-style film schools have been transformed with the transition to digital and the convergence of media forms.

In this chapter we will describe the contemporary variety of practice-oriented training institutions in Australia. We will examine the different ways in which public and private providers are managing the challenges of digitization and convergence. We will consider the logics governing film education, which this mix of providers pulls into focus, and we will outline some of the challenges the providers face in educating, (re)training, and preparing their graduates for life and work beyond the film school. These challenges highlight questions about the accountabilities and responsibilities of practice-oriented film education institutions.

This chapter begins with an introductory section that outlines these logics and questions. It explores some of the tensions and dynamics within the spectrum of issues through which we can understand film schools. The chapter then

goes on briefly to describe the multifaceted training landscape in Australia, before profiling the leading public provider, the Australian Film, Television and Radio School (AFTRS), as well as the other leading public providers, the Victorian College of the Arts and the Griffith Film School. It concludes with a short section on film education in primary and secondary schools as the education sector prepares for the implementation of a national curriculum in which "media arts" has a new centrality.

Logics Governing the Formation of Film Training

There are two distinct but overlapping pressures or logics governing film training in Australia, as elsewhere in the world. The first is exogenous, and relates to broader changes in the structure, makeup, and needs of the professional production industry. These broader changes are important to educational institutions because of their implications for graduate employment and for the opportunities they offer for professional development and retraining courses for those already working in the industry. The second pressure or logic governing film training is principally endogenous, and relates to the organization of training programs themselves, including their funding formulas and the institutional and political contexts in which they operate, all of which inevitably structure the provision of practice-oriented film training. These logics are by no means new; Annette Blonski introduced her 1992 report for the AFTRS on film and broadcasting training in Australia up to 1990 with the following observation:

> Training and education is intimately connected to the structure of the industry, the scope and diversity of its production, and its size. What and how we teach plays a role in the kind of film and broadcasting culture we teach (as well as the reverse—the culture influences the nature of the training and education provided), both in terms of what is produced and the work relations that inform the process of production.[1]

The structure of the professional production industry, its makeup, and its training- and skills-development needs can be affected by a variety of external factors. First, digital technologies have, albeit in different ways and to different degrees, affected work practices and workflows across the value chain of film, from production and postproduction to distribution and exhibition. Education programs in turn are impacted both generally, in terms of new ways of thinking about the creative possibilities opened up by new technologies and practices, and specifically, in terms of the need for students to be trained to use new technologies such as high-definition digital cameras and nonlinear editing programs.

Second, the introduction of new national and subnational media regulations and policies, or the amendment of existing measures such as production subsidies, content quotas, and tax incentives, can affect the type and style of production work. This in turn may affect the demand for employment and training in particular roles and areas; for example, the introduction or increase of an incentive for interactive media content or a tax offset for postproduction work can

increase demand for training in animation, motion graphics, or sound editing and recording.

Third, shifts in the corporate strategies of local and international media companies can influence production industry dynamics and, consequently, approaches to training. For example, Australian distributor and exhibitor Village Roadshow's partnership with the Hollywood studio Warner Bros to operate a new film studio complex in Queensland in the late 1980s had the ultimate effects of increasing the number of international productions made in Australia, and establishing a new production base.[2] This in turn created demand for a range of local film services, and stimulated the establishment of a variety of training programs and entities. A parallel move by Rupert Murdoch's News Corporation to establish the Fox Studios Sydney complex in the mid-1990s had similar effects, with a new production cluster growing up around the studio including, from 2008, the newly relocated national film school.[3]

Fourth, changes in audience taste, manifested in the popularity or otherwise of films and other content, can affect production activity and training needs. For example, the heightened popularity of animated feature films with animal characters in the 2000s spurred demand for a range of animation and digital media skills and expertise, in particular software programs that in turn influenced the offerings of film schools and colleges.

Fifth, the demand for content beyond mainstream film and television projects can shape the production industry and training requirements. The professional production industry covers computer games, corporate video/communications, online content, visualization work such as animation in real estate and industry prototyping, exhibits and guides for museums and galleries, educational content, community work, and fine art and performance art work. The industry both provides graduate destinations and supplies many of the dramatis personae for film training and education in the form of teaching and support staff at training institutions.

Training always has a quasi-autonomous character. It does not (or not only) directly reflect industry requirements but is also a creature of the frameworks and institutions within which training is provided. So industry needs are translated through, refract, and respond to wider training logics. These logics and frameworks are not so much driven by the film industry, but are rather defined by larger training or education agendas and structures. In Australia, the federal education department (currently the Department of Education, Employment and Workplace Relations) is responsible for the recurrent funding of universities and tertiary and further education colleges in the vocational education sector, which gives the department and its minister considerable power to influence the structures, policies, and orientations of educational institutions.

Many film schools are part of larger, multifaceted educational institutions, such as universities. Established film schools in Australia have historically taken a number of distinct institutional forms, although many either began life as part of a university or further education institution or, where they have been independent, have been absorbed into a university, usually for financial reasons. In comprehensive arts colleges, practice-oriented film education forms part of a portfolio of

creative offerings. For the older conservatoire-style arts colleges, which date back to the 1860s, practice-oriented film education became a natural extension of their arts curricula in the later decades of the twentieth century. The film and television programs at the Victorian College of the Arts (VCA) and the Griffith Film School, which are each parts of two of the largest and most comprehensive art colleges in Australia, both offer practice-oriented film education alongside fine art, photography, ceramics, and, in the VCA's case, the performing arts. Formerly independent arts colleges, both the VCA and the Queensland College of Art (QCA)are now parts of larger universities; the VCA formally became part of the University of Melbourne in 2007, while the QCA became part of Griffith University in 1991.[4]

In the new universities established in Australia in the late 1960s and 1970s (La Trobe in Victoria, Murdoch in Western Australia, Griffith in Queensland, and Flinders in South Australia) and in the institutes of technology that later became universities of technology after 1988 (University of Technology Sydney, Curtin, Queensland University of Technology, and University of South Australia) film production training generally formed part of broader communication, film, and media studies degrees. These institutions and some colleges of advanced education (CAEs) like Darling Downs, later to become the University of Southern Queensland, and Lismore, later to become Southern Cross University, tended to be more academically focused than the practice-oriented AFTRS or VCA. The new universities also often employed experimental filmmakers who gave an avant-garde and gallery-oriented approach to the form.

As these examples show, the location of training matters. The Australian Film, Television and Radio School (AFTRS), for example, is funded under a cultural policy rubric and has a direct federal budget allocation. It is, therefore, related quite directly to the cultural and industry development priorities of government. Consequently, aspects of its training and mission can be shaped by the priorities of the government of the day. By contrast in the comprehensive arts college environment, such as at the Victorian College of the Arts, the Griffith Film School in Brisbane, and the College of Fine Arts (COFA) in Sydney at the University of New South Wales, screen training programs need to fit with the mission and agenda of the larger Art College, which in turn must fit with the mission and agenda of the parent university.

What Are the Accountabilities and Responsibilities of Film Education Institutions?

Film schools and other practice-oriented educational institutions are accountable to multiple stakeholders and interests, all of which can shape the range, style, and orientation of training that they provide. They are all audited, reviewed, and assessed on a semiregular and occasional basis, sometimes on their own and sometimes as part of larger processes. These institutions can be directly accountable to government when, as in the case of the AFTRS and some other national film schools, direct funding from government situates them as both an instrument and an institution of cultural policy. Where training is provided within the context of a

larger educational institution, film schools are accountable to college or university governors and policies, and by extension to government higher education policies and priorities. So the film and television program at the VCA formally becoming a school within the University of Melbourne matters in terms of line management. Practice-oriented programs are accountable to the subsection of the university of which they are a part and to its mission and priorities. They are also accountable to their students, and their alumni. In addition, private providers are accountable to their owners, investors, and shareholders. And, of course, all are accountable, to greater or lesser degrees, to the industry they serve. In recognition of this, most film training entities have some kind of formal links or liaison functions with industry and other stakeholders beyond the educational sector.

What are film schools responsible for? That is, what ends and purposes are served by film education? Most film schools, because they are educational institutions, answer these questions in terms of broad prosocial educational objectives, such as producing critical thinkers, socially and ethically responsible, well-rounded persons, and people able to work and express themselves collaboratively. They may also answer these questions in terms of the opportunities they provide for students to experiment, as well as to be "industry ready" not just for jobs now but also for the jobs of the future. They differ in relative emphases by what is around them or what else they need to do. While there is a larger stabilization at the edges there are differences depending on educational missions, the trajectories of institutions, and the like. Amidst this diversity a film school conducted in conjunction with a cultural and media studies program might be seen as something of a norm although it does not quite hold for the art schools. It is to this variety that we shall now turn.

The Spectrum of Film Schools

One of the ways in which we can differentiate between film schools, and understand their similarities, is to try to position them on the spectrum of issues that they face. Do they offer a general "all-rounder" training program, or do they offer specialist training in particular arts, crafts, and skills? Are their curricula traditional, based on long-established principles and understandings of what film training and education should comprise, or are they intended to be at the cutting edge of the discipline, informed by, responsive to, or even leading the latest developments in pedagogical practice and technological innovation? Are they oriented to the needs of the production industry, or is their focus on film-as-art? Do they emphasize the final product—the finished film—or do they privilege the process of production itself? Do they consider themselves educational or (re)training institutions? Do they offer entry-level programs, or are they pitched at graduates and industry professionals? How do they balance the practical and theoretical components of film education? How do they understand and convey the contribution of craft to creativity, and creativity to craft? How do they assess and manage the multiple and occasionally conflicting needs of individual students and the group work demanded by the collaborative act of filmmaking? How do they connect the

individual and the collective—the networks of alumni and industry? Do they serve a local constituency, or do they have an international orientation? We will explore just some of these questions in more detail.

Generalist/Specialist

The generalist–specialist divide in Australia was for many years one of the main distinctions between the Swinburne Film School (later VCA) and the AFTRS. To some extent this divide came down to funding and infrastructure; with its substantial government appropriation AFTRS was from the outset able to offer specialist training courses, while the relative lack of funding and infrastructure at Swinburne/VCA led to the preference for generalist courses. Until 2012, VCA offered a three-year Bachelor of Fine Arts (Film and Television), in which students learnt to become writers, directors, and editors, as well as crewing productions. Today it offers this as one specialization alongside Animation and Scriptwriting. It also offers a year-long part-time nonaward generalist foundations program. At graduate level, students can specialize in documentary, narrative, producing, and screenwriting. Most other university courses are generalist, with emphasis placed on "multi-skilling" students by requiring them to learn and take on a variety of creative roles in the various productions they make during their period of enrolment. The AFTRS, on the other hand, has had a long-term commitment to specialist education through full-time postgraduate programs offered to limited numbers of students in directing, producing, screenwriting, cinematography, screen music, production design, documentary, sound recording, sound postproduction, and editing. It no longer offers full-time programs in television production or digital media. Changes in the audiovisual industries and within the educational institutions themselves are leading to a reassertion of both "generalist" and "specialist" programs in practice-oriented film education. The AFTRS, for example, has since 2009 offered a general "Foundation Diploma" for students with no prior experience, as well as developing part-time postgraduate specialist courses in areas including screen business, 3D animation, and visual effects. The Griffith Film School is starting to draw a sharp distinction between its "generalist" education at an undergraduate level and its specialist education at a postgraduate level.

Traditional/Modern

The lines between what might be considered "traditional" and "modern" in film education are somewhat blurred. Most education providers offer aspects of both approaches. In broad terms, in Australia the "traditional" approach is best represented by the early AFTRS under Jerzy Toeplitz, and by the film programs within art colleges like the VCA and Griffith: European-style academies oriented to art-house, auteurist, and alternative production, emphasizing experimentation (within some limits), as well as theory and study of the history of the medium. The "modern" approach is exemplified by the AFTRS since the mid-1980s, and by the contemporary private providers such as SAE Institute and the Sydney International Film School: vocationally oriented, industry-focused

production houses, emphasizing the development of technical skills, and commercial, collaborative and mainstream approaches to production. In the modern approach, practice tends to be privileged over theory. Having said this, though, Ruth Saunders, who began working at the AFTRS in 1978, first as film librarian and for the last 25 years as film distribution manager, made an observation in 1998 that arguably remains true to this day: "we've [i.e. AFTRS] never been sure of our role; we've never known whether we are a vocational institute or a university or a production house. We're a bit of everything."[5]

Industry/Art, Product/Process

The industry/art spectrum, which we might also characterize as an opposition between mainstream/alternative, and between product/process, is navigated by different institutions in different ways. Institutions like the AFTRS struggle to negotiate it all the time. Critics of the AFTRS sometimes point to the contrast between it and the VCA. The VCA is seen as a school that has consistently produced films and filmmakers with great ideas and vision—the home of auteur writer-directors in a more European kind of film school—while the AFTRS is seen as producing films with great production values but less well-developed ideas. This is unfair to both, given the number and variety of films produced at each institution over the last 40 years.

Craft/Creativity

Craft/creativity relates closely to the preceding categories. At the AFTRS, the directing, producing, and screenwriting departments were collectively described in internal discussions as the "creative" departments, while the others— cinematography, editing, sound recording, digital media, costume design, and production design—were "craft" departments. While this reflected long-standing attitudes within the industry—see, for example, the title of the Australian UNESCO seminar of 1968 that contributed to the founding of the national film school[6] (Australian National Advisory Committee for UNESCO 1969)—the artificial division between "creative" and "craft" roles unfairly downplays the creative input of the latter groups of practitioners to the film process. But it is to make the point that part of the role of film schools is to teach technique, with the question of how they understand technique and technical training as a form of creativity or as a kind of training in creativity perhaps marking differences between institutions.

Individual/Collective

We can readily point to the importance of particular individuals to the direction and orientation of these institutions. The head, dean, director, or CEO of a film school can make a significant mark on the institution he or she leads. Swinburne/VCA Film School's long-term directors—Brian Robinson (1966–1988) and Jenny Sabine (1988–2005)—provided a consistent vision for the school,

steering it through dramatic transformations in the tertiary education sector, the film training landscape, and the film and TV production sector for close to 40 years.[7] The AFTRS heads have similarly left their mark: this was certainly the case for the AFTRS in the person of foundation director Jerzy Toeplitz, but the same could be said of most of the heads of most schools. It is true of Toeplitz's successors, one of whom—Anne Deveson, director from 1985 to 1988—observed, "Any director [of a film school] who comes in, the first thing they do is revise the curriculum. And they restructure."[8] Deveson initiated a review of the School upon her appointment that resulted, among other things, in a heightened emphasis on advanced training for industry professionals. The individual/collective spectrum also reflects a school's approach to education, which is often oriented toward the individual, even though filmmaking is a collaborative or collective act. This is about the relation of the individual student to the school or the head of that school to the students, staff, alumni, and wider industry. It is also about the process of individual assessment, and the teaching of teamwork. The relationship between the individual and the collective also highlights perhaps the primary motivation for many individuals to attend film schools: the connections it offers to networks of alumni and industry practitioners. As Jerzy Toeplitz remarked in 1978, "The School, in my opinion, has a duty to sponsor, encourage and take patronage of [contacts with the outside world]."[9] A recent survey of AFTRS graduates since 1972 found that: "With very few exceptions, networking was identified in the qualitative research as the single most important factor in career progression. AFTRS was also mentioned in this context, largely as an effective place to begin building such networks."[10]

National/International

There is a particular tension experienced by institutions like the AFTRS that are designated "national film schools." These institutions are typically specifically tasked with promoting or developing national culture, identity, and expression, but are also often heavily influenced by their international counterparts and by international consultants. The AFTRS, for example, had its origins in part in a 1968 UNESCO Seminar on Professional Training of Film and Television Scriptwriters, Producers and Directors, for which the President of the Writers Guild of Great Britain and a well-known playwright and writer for film and television, Lord Willis, was invited to Australia to act as a consultant.[11] The following year, a committee established by the prime minister visited about 20 film schools around the world before submitting their report. Jerzy Toeplitz, who had been head of the Lodz Film School until he was forced to step down in 1968 owing to his political interrogation by governmental officials, was brought to Australia to advise on the establishment of the new school, and went on to become its founding director. While the AFTRS has restricted entry to its full-time programs to Australian citizens and permanent residents, it has, like a number of other institutions, developed exchange programs with international schools, including the New York University Tisch School of the Arts, Il Centro Sperimentale di Cinematografia in Rome, Fondation Européenne pour les Métiers de l'Image et du Son (FEMIS) in Paris, and the National Film and Television School in the UK.

There are different kinds of internationalization in the film industry and in film training. Some private education providers in Australia such as the SAE Institute and the New York Film Academy operate in many countries. Some university-based Australian training institutions have sought connections with international providers as part of a broader institutional push to internationalize their own curriculum and student experience and to attract international students. Those schools that are members of the association of the world's major film and television schools, CILECT[12]—namely, the AFTRS, the VCA, and Griffith Film School—have seen international links through CILECT as a way of furthering ties within the organization.

As the Australian production industry has become more internationalized with the building of several large studio complexes and the growth in international location production since the early 1990s, local schools have begun to internationalize their own offerings. Through efforts to attract international students, employ international faculty, invite visiting filmmakers to address students or teach short courses, and seek student internships on international projects, Australian providers have sought to respond to the growing links between the Australian and international industries.

A Multifaceted Training Landscape

As the preceding discussion has indicated, film education is offered across the tertiary education sector. Elements of film education are also taught in secondary schools and, as we will discuss later, will be introduced in 2014 in primary schools as well. In addition to the formal education sector, film education and training is offered by a variety of other media and cultural organizations.

At the top of the training pyramid are the three Australian CILECT members, the AFTRS, the VCA School of Film and Television, and the Griffith Film School. We will profile each of these schools below. Production courses are offered at many of Australia's universities, often as part of media studies degrees. The major Technical and Further Education (TAFE) colleges such as North Sydney TAFE have offered technical training programs for many years, while the state-based screen development centers like QPIX in Brisbane, Metro Screen in Sydney, Open Channel in Melbourne, the Media Resource Centre in Adelaide, Wide Angle in Hobart, and the Film and Television Institute in Perth offer a variety of short courses and certificate courses. Aboriginal Media Associations have also been important providers of training to indigenous people in remote communities. Perhaps the highest profile has been the Central Australian Aboriginal Media Association (CAAMA), which began offering training in radio broadcasting in 1980, and video production in 1984. In 1986, CAAMA was granted a regional television license, and in 1988 it began operating a commercial television service, Imparja, that now broadcasts to almost half of the Australian continent. The most prominent private provider in Australia is SAE Institute, which began life in 1976 as the School of Audio Engineering in Sydney, and which now operates over 50 training facilities in more than 20 countries. SAE also owns the former cooperative multimedia center

QANTM, based in Brisbane, which now offers a variety of digital media courses in Australia as well as in six countries around the world. Cooperative multimedia centers were established in each state in the aftermath of the 1994 national cultural policy statement, "Creative Nation." They were intended to kick-start digital media education outside the university sector. QANTM is the only surviving center. Other major stand-alone providers include the Sydney Film School, formed in 2005 by a group of lecturers and filmmakers from the former Sydney University UBS Film School, and the International Film School Sydney, which is operated by a subsidiary of the University of Wollongong.

Practical Education Pre-1966

Prior to 1966, film and television training was almost entirely a product of industry training, alternative filmmaking collectives, and amateur networks. The respective missions of the organizations shaped the kind of training provided. The major in-house industry training was provided by three organizations: the Australian Broadcasting Commission (now the Australian Broadcasting Corporation ABC), the large independent TV producer, Crawford Productions, and the national government documentary film agency, the Commonwealth Film Unit (later renamed Film Australia). Further on-the-job training was provided by the advertising industry and other TV broadcasters. In each, trainees were attached to particular craft specialists or producers from whom they learnt their trade.

The ABC—the national public broadcaster and the only TV network initially set up to operate at a national scale—maintained the most extensive and organized training system. Its training regime was modeled on the BBC's and combined formal training elements with on-the-job training. ABC training programs operated across television drama, documentary (including wildlife documentary), news and current affairs, and variety and infotainment. ABC staff went on to significant careers in the industry, in production companies, and as independent filmmakers. The ABC remained central to the formal training mix until well into the 1990s. However, reduced funding levels beginning in the latter half of the 1970s, growing amounts of work allocated to independent producers, and the increasingly multifaceted character of the filmmaker education being provided by tertiary institutions cut into the logics behind its training provision.

The independent production house Crawfords Productions played a significant training role from the 1950s to the 1980s. Crawfords occupies a special place in Australian television for the role it played in developing the television drama production industry, drama formats, and production methods. Crawfords had well-established training pathways with trainees starting as young as 14 and 15 doing routine clerical work such as making stencils of scripts. They then worked their way up the organization, learning the business through attachments to producers, camera operators, sound-recordists, and so on. Many of the major producers, directors, and writers from the 1970s to the 1990s came through the Crawfords system.

The Commonwealth Film Unit (CFU)—renamed Film Australia in 1973—played the most important role in providing specifically "film-based" training

from the mid-1950s onwards. The CFU was modeled along the lines John Grierson had promoted for documentary production units throughout the British Commonwealth. The CFU mostly produced documentaries, although from time to time it branched out into drama and feature length productions as with the feature film *Three to Go* in 1971, which was codirected by Peter Weir. From the early 1960s the CFU came to be regarded as Australia's film school, particularly in Sydney. It afforded aspirant filmmakers the opportunity consistently to work wholly on film—from inception to final product—in a variety of contexts and locations. With its purpose-built studio, editing and postproduction facilities, and screening spaces in Sydney, it also provided its filmmakers with the largest state-of-the-art film production studios available in the country in the 1960s and 1970s. The CFU provided a multifaceted training ground for future feature and documentary filmmakers. Its role in craft training proved to be especially important for the revival of the feature film industry from the 1970s; key directors such as Donald Crombie and cinematographers including Dean Semler learned their craft at the CFU.

The last piece of the industry part of the training landscape in this period was the advertising industry, through the demand for high-quality television advertisements produced on film. Advertising continuously renovated the higher end of film production equipment and infrastructure available in Australia and provided filmmakers with the opportunity to work with the same high-end equipment and production values that would be required in feature filmmaking. As the highest cost-per-second television programming, advertising had consistently higher production values than other Australian-produced programs. In some crafts like cinematography and animation, working in advertising meant working at the highest available levels in the country. The experience of working in advertising proved formative for a number of filmmakers, including director Fred Schepisi—who sank a lot of his own money made in advertising through his production house into his landmark Australian feature film *The Chant of Jimmie Blacksmith* (1978).

The final piece in this training landscape was outside the industry. It was provided through alternative and self-funded film production collectives and networks. The personal cinema espoused by those associated with Ubu films and the experimental cinema promoted by Arthur and Corinne Cantrill both generated their own alternative filmmaking scenes, which were part of wider artistic movements. The Ubu founders were integrally involved in the development of the Sydney Film Makers Cooperative. This provided a context for an emerging group of filmmakers to learn their craft, engage in film discussions, experiment, and directly shape the emergence from the 1970s of more organized film and video resource centers, which became today's screen development agencies.[13]

Each of these different "bodies" provided different sorts of pathways into and training contexts for filmmakers. But each form of training related to an aspect of production. There was no overall approach to production training and there was no training program specifically designed for feature film and shorter forms, closed-ended rather than open-ended TV fiction series and serials. This created gaps that the more formalized training at Swinburne would start to fill from 1966

onwards. As film training became more formalized, production became more outsourced, and media corporations including TV networks became more streamlined, the importance of this on-the-job training for getting a leg into and being prepared for the industry diminished.

Swinburne/VCA

The contemporary history of practice-oriented film education in Australia begins in the late 1960s and early 1970s. Not coincidentally, these were the years of struggle to reestablish Australian cinema as an issue for governmental concern, and also the years in which new tertiary institutions—institutes of technology, colleges of advanced education, and universities—were founded with distinctive missions, complementary to but also different from the older, established universities. At this point and ever since, there have been different kinds of film training providers operating in Australia.

The Swinburne Film School was established in 1966 as part of the then Swinburne Institute of Technology in Melbourne. The Swinburne model set a trend for stand-alone film programs often disconnected from acting and theater training. Swinburne's success ensured that it would be emulated to a greater or lesser extent over the coming years. The "film school" model was later taken up with the establishment of the (then) Australian Film and Television School in the early 1970s. Swinburne's first director, or head of school, Brian Robinson had lobbied strongly for the long-awaited national film school to be based in Melbourne. Even though he was unsuccessful in these efforts, Robinson was appointed to the governing body of the Australian Film and Television School, known as the Council, in 1973, and served as a member until the AFTS (now AFTRS) gained a permanent home in Sydney in 1975.[14]

The idea of establishing a technical college/institute of technology like Swinburne, and later a university embracing film and television production, fit long-standing emphases on vocational and professional pathways. In particular the transition from technical training to professional academic training and the awarding of diplomas and degrees marked the transition first to institutes of technology and later to university of technology status. The idea of a film production program situated in the context of other liberal arts teaching that could bring credit to the institution was also rolled out elsewhere. Finally, the program's radical intent to stage an enlarged conversation, about what film and television production might become, licensed various kinds of experimental, avant-garde, alternative, and political filmmaking programs.

In 1992, the Swinburne School of Film and Television, under the guidance of its second director, Jennifer Sabine, who had succeeded Robinson in 1988, migrated to the Victorian College of the Arts in central Melbourne. At that time the VCA, which had begun life as the National Gallery of Victoria Art School in 1867, was still an independent institution albeit with a close association with the University of Melbourne. The VCA maintained Swinburne's emphasis on training writer-directors, with a producing course only introduced in 2004.[15] Before that

date, anyone wishing to study producing had to go to the AFTRS in Sydney. The VCA School of Film and Television remained at Hawthorn until the completion of its dedicated federally funded Film and Television building on the VCA Southbank campus in July 1994. It was now in a multi-art-form environment. Different tensions over funding (now between different art forms), priorities, and identity inevitably ensued.

The perception of Swinburne/VCA as the "poor cousin" of the AFTRS is borne out by the vastly different financial situations of the two schools.[16] Annette Blonski estimated that Swinburne's operating budget in 1990 (excluding salaries) was around AU$180,000, while the AFTRS's total operating revenue for 1989–1990 was AU$10.5 million.[17] By 1998, several years after the move to the VCA, the relative funding gap closed somewhat, although the VCA then boasted a budget of AU$1.35 million, while the AFTRS's annual funding had risen to $14 million.[18] As one commentator described it, "[f]inancially, the competition between the VCA and Sydney's well-funded Australian Film, Television and Radio School is more like an arm wrestle between Lurch and Thing in *The Addams Family*."[19] To a great extent, the difference in funding levels between the two schools has been due to the AFTRS receiving funding directly through the federal Department of the Arts, while Swinburne/VCA has always principally been funded through the federal Department of Education. The latter has then felt more keenly the effects of changes to the federal government's tertiary funding arrangements, as in the mid-2000s when a broad-ranging revision of tertiary education funding included a 30 percent cut to the VCA's income from the federal government. This reduction in its budget led directly to the VCA's merger with the University of Melbourne in 2007.

This amalgamation brought the VCA into alignment with other large art colleges, namely COFA, QCA, and Sydney College of the Arts. Now under the purview of a tertiary institution for which the VCA was just another division, the VCA School of Film and Television became hostage to transformations within its larger parent institution. Its third film school director, Ian Lang (2006–2011), was appointed for his management experience in such contexts at the Griffith Film School and was expected to manage the VCA film program's integration into the broader Melbourne University context while retaining its independent filmmaking ethos. The introduction of the so-called "Melbourne Model," under which all of Melbourne University's undergraduate programs were replaced with six general degrees, coupled with the "shotgun wedding" of the VCA's and the university's music programs, and new accounting procedures resulting from the merger provoked a storm of protest.[20] The requirement under the Melbourne Model that students take on "breadth subjects" beyond their chosen specialization was considered damaging to the VCA's practice-oriented approach. Following an external review,[21] the dean of the Victorian College of the Arts and Music resigned. Those music programs that had traditionally been part of the University were hived off to the Melbourne Conservatorium of Music, and the VCA returned to being a distinct college of art, including the performing arts, film, and television.[22] In late 2010, the Labor federal government committed recurrent funding, matched by the University, which returned the VCA to its funding levels before the 30 percent

cut imposed by the previous Coalition federal government. The following year, the Victorian State government announced an AU$24 million commitment to the VCA over four years to fund new scholarships and regional training.[23] The VCA School of Film and Television continues to deliver both undergraduate and postgraduate programs based, to a great extent, on those developed during its formative years at Swinburne. Its new head David Price (2011–) has had an explicit priority to restore the School's integrity and grow it within the parameters of its longstanding educational settings. He has introduced both scriptwriting and animation as specializations and a number of elective courses aimed at students inside and outside the VCA.

What is particularly notable about Swinburne-VCA is the consistency of its approach to film training. Although initially established to meet the needs of the advertising and television industries (it grew out of its Diploma of Advertising Art[24]), it quickly became a vehicle for film training and filmmaking aspirations. In many ways, it was an extension of the larger conversation about the cinema and what it might become associated with, the film society movement, the Melbourne Film Festival, and other cineaste perspectives. Its students and their interests shaped this direction. In its first period it was a change agent promoting the possibility, and providing for the reality of film production. With the emergence of a feature film industry and the explosion of television drama production in the 1970s, it became an integral part of and shaper of these industries. Its "path dependency" in the auteur film discussions and milieu of the mid-1960s in Melbourne has shaped a subsequent trajectory committed to film's expressive possibilities and the nurturing of individual creativity in a collective context that has persisted through major industry and technological change and a revolution in higher education. Throughout its history, Swinburne-VCA has maintained its strong identity as Australia's European-style film school nurturing auteur writers/directors.

AFTRS

There can be no doubt about the centrality of the AFTRS to film training and the performance of film training in the Australian context. By and large, it sets the agenda that others follow. The AFTRS was established in Sydney in 1973 as a key component of the federal government's efforts to revive the Australian film industry. It has its own Act of Parliament, and unlike other publicly funded educational institutions, it is funded directly from the federal Department of the Arts (currently part of the Department of Regional Australia, Local Government, Arts and Sport) rather than from the Education portfolio. The AFTRS does not have to compete with other tertiary and TAFE providers for funding or resources, and is able to organize its offerings without the same kind of external pressures that characterize the broader educational sector. This key difference between the AFTRS and its counterparts, including the VCA, had significant consequences for each institution's development in the 2000s. At the same time that VCA suffered a 30 percent cut in its income in 2005, the AFTRS managed to secure an additional $9 million in funding from the federal government over three years to finance the extension of its digital media programs, and the establishment within the School

of the Centre for Screen Business. In 2007, these additional funds were rolled into the school's annual appropriation of $22 million.[25]

The then director of the school, Malcolm Long, sought this extra funding because of his belief that a key part of the school's role was to assess the gaps and weaknesses in the industry, and address them.[26] That is, Long believed that the school should not just *serve* the industry, but *anticipate* its needs, and lead the way in responding to them. The school had begun its digital transition in 1995, initially with MA-level short courses in Microsoft Softimage and Silicon Graphics Alias. These courses were intended to alleviate skills shortages in the production industry. A digital media department was created in 1997, offering full-time courses in computer-generated animation, motion graphics, and visual effects. In the same year, the head of Digital Media, John Colette, and the then director of the AFTRS, Rod Bishop, made a presentation at the CILECT conference on the AFTRS's digital program. Colette later recalled that "other schools felt that we were at least a year ahead of anything in America and two years ahead of facilities in Europe."[27] So by 2005, as Long put it, digital was "in the DNA" of the school. But the contribution that digital media students could make to AFTRS films was not yet fully appreciated by the other teaching departments. This position mirrored that in the industry in the mid-2000s; as Long put it, it was as if they were "speaking different languages." The funding for digital was intended to serve three purposes: first, to reinforce internal production excellence, by ensuring that digital media students could work with the latest gear and to make digital production pedagogy as contemporary and technologically high end as possible; second, to infect the rest of the school, to stimulate the "digital way of thinking" in more traditional departments, and encourage them to better incorporate digital media in their curricula; and third, to create a center of expertise and learning for the working industry, a place where the industry could come to "catch up." This last purpose was a key point, as Long believed that the school's role in reskilling or updating practitioners' skills and knowledge was as important as training new people. One key initiative toward this goal was the visionary Laboratory for Advanced Media Production, or LAMP.

LAMP was set up in 2005 by the AFTRS head of Digital Media, Peter Giles, and the School's lecturer in Interactive Media, Gary Hayes, who had previously been head of Interactive at the BBC. Teams comprising a producer, an editor, and a designer were invited to pitch multiplatform projects to a group of local and international mentors. The selected teams, from both within the School and from the wider industry, then attended a week-long intensive residential workshop comprising practical, production, and market-focused seminars, and an immersive rapid prototyping process leading to industry-focused product development. For Hayes, LAMP was less about the project and "more about the transformation of people—sowing the seeds, setting them on the road" to cross-platform content development.[28] The LAMP model was subsequently taken up by the principal federal film agency, Screen Australia, under the Digital Ignition program.[29]

Long's desire to "embed the School in the industry," in his words, was also the motivation behind the School's move from North Ryde—the "edge of the known world" as the campus was known—to Moore Park in the center of Sydney, directly adjacent to Fox Studios Australia. Such a move had been recommended from the very beginning of the School's life. In 1969, the committee that convinced Prime

Minister John Gorton to initiate the process of setting up a national film school had proposed a central venue, as one of the members, Phillip Adams, recalled in 1998:

> We wanted a school right in the middle of the city so it was surrounded by the rough and tumble of stimulus and interaction. We didn't want a school on a distant and lofty university campus. In other words, we didn't want a school where it is now [i.e. in North Ryde].[30]

During its first intake of 12 students under the Interim Training Scheme, the School was based in temporary premises in Chatswood, on the north shore of Sydney Harbour, quite distant from the center of the city. By the time of the first full-time student intake in 1975, the School had moved to a disused factory close by, with the intention of moving to purpose-built premises on land owned by the Commonwealth next to Macquarie University in North Ryde. In the end, the School did not make this move until 1988. The then director Anne Deveson had once again tried to convince the government to move the School to the center of Sydney, but was told by the minister for the Arts, Barry Cohen, "You stay where you are or you'll lose the lot."[31]

Eventually in the mid-2000s, the AFTRS secured substantial additional funding from the federal government to build new premises in the center of Sydney, but in giving up its campus at North Ryde for a new base in the city, the school's annual rent increased dramatically. In part as a result of this new financial impost, the school revised its curricula and closed down (temporarily in some cases) a number of courses in digital media, and even several departments including Production Design, Documentary, and Television on the grounds that they were either too costly or drew insufficient numbers of applications. The change in the school's financial position also initiated a move back into the highly competitive school-leaver market with the establishment of the Foundation Program in 2009. This move parallels that of the Queensland College of Art (QCA), parent institution of the Griffith Film School, which has turned its undergraduate degree into a more general offering, reserving specialization for postgraduate programs.

For over a decade from 1997, the AFTRS had only offered full-time postgraduate degrees alongside a national program of short courses. The so-called "4x4" model, under which each of the School's departments, with the exception of Television and Radio, trained only four full-time students in both first- (Graduate Diploma) and second-year (Master of Arts) programs, was largely dismantled. A variety of new full- and part-time Graduate Certificate courses were introduced, which, along with the Foundation Program, dramatically increased the School's student intake. At the same time, the national program of short courses that the School is required under its Act to offer was curtailed, and the School's offices in each of the six states were closed. All of these changes—the expansion (and subsequent contraction) of the digital media program, the establishment of the Centre for Screen Business, the move to Moore Park, the overhaul of the curriculum—were initiatives of the School's former director Malcolm Long and his successor (now CEO) Sandra Levy. They are indicative of both the privileged position of the School in relation to its counterparts elsewhere in Australia, and of the enormous power and influence that the head of the School holds.

Griffith Film School

The Griffith Film School was formed in 2004 with the bringing together of Griffith University's three distinct and long-standing training programs in Animation (established in 1977), Film and TV Production (established in 1974, both part of QCA), and Digital Media and Screen Production (established in 1975, as part of the University's School of Film, Media and Cultural Studies). With new premises (officially opened in 2007)[32] and a new identity, the Griffith Film School could proclaim itself Australia's third film school after the AFTRS and the VCA, and the largest provider of screen production training by enrolment in the country.[33] The Griffith Film School divides its film training into three subprograms in film and TV production, animation, and games development offered at both undergraduate and graduate levels.

The School's establishment not only put some distance between itself and its competitor programs in Brisbane and elsewhere in Australia but it was also important for the standing of film training within the University more broadly. It resolved the sometimes destructive competition for students and resources within the University by consolidating screen practice training into a single high-profile entity. It ensured film training had importance and visibility within the university and externally. It proved attractive to international students, particularly from the Asia-Pacific region. Like its Sydney and Melbourne counterparts, the Griffith Film School moved into iconic premises, in this case on South Bank, and these gave it the creative location, scale, and scope to host seminars and workshops, to attract visiting artists in residence, and to position itself as a key player in the field of production training.

The School's inaugural head, Ian Lang (2003–2006), drawn from the staff of the QCA production program, saw an international focus as being critical to securing the new School's national and international visibility with his first task to secure CILECT recognition of the school with full institutional membership.[34] Not since Jerzy Toeplitz's appointment in the 1970s has a major film school in Australia so explicitly sought its reference point from international film training educational norms. The next two heads, Craig Caldwell (2007–2009) and Herman van Eyken (2010), were both international appointments with considerable production and training experience in, respectively, the United States and Europe and Asia.

Prior to coming to the Griffith Film School, Caldwell had been director of Media Arts at the University of Arizona, where he had established the University's Visualization Lab and New Media Center, after a career in Disney as a specialist in artist development for its feature animation division. Caldwell's appointment reflected the increasing importance of digital production to the future shape of the film school. It also signaled the importance of making connections with the international production services industry that had developed in Queensland in the wake of the establishment of the Gold Coast film studios in the late 1980s, the importance of its animation program to its identity, and the growing importance of the games industry, which had grown rapidly in Brisbane and the Gold Coast over the 2000s. (Indeed by 2006 the Brisbane-Gold Coast games industry vied with Melbourne for national leadership in the games industry, with these cities accounting for the lion's share of the national games industry).[35]

Herman van Eyken came to Griffith from Singapore where he had founded the Puttnam School of Film at Lasalle College of the Arts in 2005. A graduate of RITS national film school in Brussels and the universities of Bologna and Rome, van Eyken had previously worked at RITS as professor in Film Directing after a 15-year film industry career working across a variety of film forms from commercials to documentaries to feature filmmaking. With the downturn in international production and service industry work and the contraction of the local games industry, van Eyken was in the 2010s working to a different and more straitened local production industry context than his predecessors. He signaled Griffith's ambition not only to prepare students to work in the Australian film industry but also to work in international contexts and with international partners.[36] In this he looked to innovations from among CILECT members, particularly Korean and Japanese experiments in long form film training, and European members' established international student exchange programs. He also sourced European training expertise on a short-term basis to address what he saw as storytelling and performance deficits in student filmmaking.

While both the AFTRS and the VCA had developed similar kinds of international connections, what is new about today's Griffith Film School experiment was how much these connections had become a matter of routine across the curriculum, operations, and student experiences. Van Eyken is seeking a film education regime in which students gain experience in working in various cross-cultural contexts and become familiar with Asia-Pacific films and filmmakers. While little of this was new in the European context, where the European Union and the close proximity of countries to each other have ensured strong filmmaking networks and close associations among CILECT members, it was new in an Australian context where Australia's distance from other countries has tended to make such ordinary international exchanges more difficult to achieve and costly to undertake.

While it would be tempting to characterize the change from Caldwell to van Eyken as one from a North American to a European and Asian model and focus, the change is perhaps better described as one of moving from being responsive and reactive to the training needs of the games, international production services, and Australian film and television industries toward a new and more visionary agenda for filmmaking. The School is making a transition at undergraduate level to more generalist production training to be followed by more specialist postgraduate training working on long-form production.

The Griffith Film School combines over its life several of the trajectories within the Australian tertiary film training environment. Its production and animation programs were established within an art college environment that had been historically shaped by an applied arts and fine arts focus in which the applied arts were clearly ascendant.[37] This made it akin to the early Swinburne. And like the original Swinburne program, its production programs were established while QCA was a vocational education provider. But like the VCA and COFA, production training took place in a comprehensive art college environment; and like these independent colleges, QCA became part of a larger university in 1991. For its part Griffith University's production program was established with the first intake of undergraduate students in 1975. In a pattern similar to that in a number of other

universities and institutes (Murdoch, La Trobe, Flinders, UTS, Curtin, University of South Australia), its production program grew alongside and in close relationship to the development of screen, media, and cultural studies as areas of inquiry. Like the many other film training programs in the university sector, the Griffith Film School has provided continuing and stable employment for skilled creatives and contributed to the stabilization of such expertise across the country. The creation of the Griffith Film School gave it the kind of lead provider status in its state that the AFTRS has for Australia and NSW and the VCA for Victoria. Like other university training programs, broader research quality assessment and the advent of "practice-oriented research" also created a teaching staff cohort who now need to find ways to continue their credits and industry currency, accommodate new ways of teaching appropriate to the new screen environments, and to acquire new qualifications, particularly Masters and PhD qualifications, needed to teach at a graduate level.[38] Film teaching is now not only about training students it is also about continuing to be a filmmaker in new ways.

Film Education in Australian Schools

In considering the question of when film education begins, it is useful to end this chapter by looking briefly at the teaching of film in schools. The Australian government is currently in the process of implementing a national curriculum that will replace the long-standing state-based education system. Under the previous system, film education differed depending on where in Australia a student attended school. In New South Wales, film education has formed part of the secondary school English curriculum, while in Victoria and Queensland, media studies have been taught as a separate subject area for some years. A few primary schools have taught film education, but for the most part it has been confined to secondary schools. Under the national curriculum, beginning in 2014, this will change. From 2014, all primary schools across the country will teach "media arts" as part of the arts component of the national curriculum. The required component is only a minimum of 20 hours over a two-year period, but this is still a substantial change in approach. Media studies will be an elective subject at secondary level. This will bring with it the need for certain forms of film production training up to a basic level to become integral to teacher education and this will have flow on effects on tertiary training, creating an increased demand for lower levels of film production training as a basic "literacy." This is likely further to distribute film production expertise nationally just as it is likely to lead to further differentiation in training and to exercise new pressures upon forms of generalist training.

Notes

1. Annette Blonski, *Film and Broadcasting Training in Australia* (North Ryde: AFTRS, 1992), 4.
2. Ben Goldsmith, et al., *Local Hollywood: Global Film Production and the Gold Coast* (St Lucia, Qld: University of Queensland Press, 2010).

3. Ben Goldsmith and Tom O'Regan, *The Film Studio: Film Production in a Global Economy* (Lanham, MD: Rowman & Littlefield, 2005); Rod Jensen, "Sydney Media on the Move," *Cityscape Creative Cities* 40 (2010): 8; Oli Mould, "Mission Impossible? Reconsidering the Research into Sydney's Film Industry," *Studies in Australasian Cinema* 1.1 (2007): 47–60.
4. Alan Seibert, "The Queensland College of Art, Griffith University 1881/1996: Past, Present and Future," *Australian Art Education* 19.2 (1996): 23.
5. Meredith Quinn and Andrew Urban, eds., *Edge of the Known World: The Australian Film, Television and Radio School—Impressions of the First 25 Years* (North Ryde: AFTRS, 1998), 161.
6. Australian National Advisory Committee for UNESCO, *Professional Training of Film and Television Scriptwriters, Producers and Directors* (Sydney: University of New South Wales, 1969).
7. Barbara Paterson, *Renegades: Australia's First Film School from Swinburne to VCA* (Ivanhoe East, Vic: The Helicon Press, 1996).
8. Quinn and Urban, *Edge of the Known World*, 64–65.
9. Ibid., 46.
10. IPSOS SRI, "AFTRS Alumni Survey: Research Findings from IPSOS SRI," *Lumina* 10 (2012): 64.
11. Australian National Advisory Committee, *Professional Training*.
12. CILECT stands for the Centre International de Liaison des Ecoles de Cinéma et de Télévision. The body was formed in 1955 in Cannes with the intention of stimulating an international dialogue among the major film schools. See http://cilect.org
13. Peter Mudie, *Ubu Films: Sydney Underground Movies 1965–1970* (Sydney: UNSW Press, 1997).
14. See Paterson, *Renegades*.
15. Sian Prior, "Producer School Gives 'Play Lunch' New Meaning," *Sunday Age* [Melbourne], February 1, 2004, 4.
16. Mark Poole, "This Year's Model: Saving the VCA," *Metro Magazine* 162 (2009): 130.
17. Blonski, *Film and Broadcasting Training*, 16.
18. Chris Boyd, "School's In and Still a Class Act," *Herald-Sun* [Melbourne], August 24, 1998, 97.
19. Ibid.
20. Fiona Mackrell, "The VCA's Sense of Renewal," *Arts Hub*, December 8, 2011, http://www.artshub.com.au/au/news-article/opinions/arts/the-vcas-sense-of-renewal-186732 (accessed July 27, 2012); Poole, "This Year's Model."
21. University of Melbourne, *The Future of Visual and Performing Arts at The University of Melbourne: A Response to the Review Committee Report on the Faculty of the VCA and Music July 2010* (Melbourne: University of Melbourne, 2010).
22. Michelle Griffin, "VCA Chief Quits Amid Overhaul," *The Age* [Melbourne], July 23, 2010, 3.
23. Mackrell, "The VCA's Sense".
24. Paterson, *Renegades*, 4.
25. With this substantial funding base the AFTRS is the film counterpart to similarly subvented national programs such as the Australian Institute of Sport and the National Institute of Dramatic Art.
26. All quotations in this section, unless otherwise stated, are from a telephone interview with Malcolm Long by Ben Goldsmith on May 17, 2012.
27. Quinn and Urban, *Edge of the Known World*, 194.
28. Interview with Gary Hayes by Ben Goldsmith, Sydney, June 5, 2012.

29. See http://www.screenaustralia.gov.au/funding/allmedia/ignition.aspx.
30. Quinn and Urban, *Edge of the Known World*, 15.
31. Ibid., 66.
32. The Qld Government contributed AU$5m to its refurbishment with Griffith University documentation putting the cost of the new facility at AU$14million. See Griffith University, *A New Era in Global Partnerships: Griffith University Capability Statement* (Gold Coast: Griffith University, 2010), 20.
33. Griffith University (and QCA) has long had a reputation as Australia's third "film training space," but because its programs were distributed into different programs on different campuses in different organizational entities it lacked a stable public identity.
34. Telephone interview Ian Lang with Tom O'Regan, August 3, 2012.
35. Ian Lang claims that this Brisbane-Gold Coast leadership was significantly enabled by QCA's animation program. Telephone interview with Ian Lang by Tom O'Regan, August 3, 2012.
36. Interview with Herman van Eyken by Tom O'Regan, Brisbane, May 10, 2012.
37. Seibert, "The Queensland College of Art," 21–23.
38. See Tina Kaufman, "Artists [as] Educators: Film—The Balancing Act of Teaching and Making Film," *Realtime* 74 (2006): 17–18; Josko Petkovic, *Assessing Graduate Screen Production Outputs in Nineteen Australian Film Schools, Final Report* (Canberra: Australian Learning and Teaching Council, 2011); Ian Lang, "Film Schools in a Post-Industrial Era," (paper presented at IM 7: Diegetic Life Forms II—Creative Arts Practice and New Media Scholarship Conference, Perth, September 3–5, 2010).

8

Dynamics of the Cultures of Discontent: How Is Globalization Transforming the Training of Filmmakers in Japan?

Yoshiharu Tezuka

Japanese cinema established its artistic reputation in the West, and enjoyed its golden days, in the 1950s. It then went into a sharp decline during the 1960s and 1970s: Japanese film studios reduced the number of productions radically, and by the end of the 1970s ceased all recruiting and training efforts aimed at bringing new blood into the film industry.[1] The decline of the "classic" film industry based on mass production was a worldwide phenomenon. The major film-producing countries in the West responded to this drastic decline by setting up film schools to deal with the problem caused by a lack of opportunities and training grounds for the next generation of filmmakers. However, in Japan this did not happen for a very long time.

Throughout postwar Japanese history, policymakers paid hardly any attention to "culture," and had little interest in popular cultural productions and industries. The economic plight of the Japanese film industry was entirely ignored. Furthermore, Japanese cultural policy was historically elitist and generally only supported traditional high cultures. Public support for the cinematic arts through production funding was nominal.

As a result, experienced filmmakers were economically marginalized while the main sites for relevant training were moved out of the film industry as such and into adjacent industries and alternative cultural spaces—into soft-porn production and *jishu-eiga* (self-financed nonprofessional filmmaking), as well as the TV advertising industry. Filmmaking itself and the training of filmmakers in Japan were kept alive and invigorated mainly by those who formed informal communities and developed what could be called "cultures of discontent" opposed to the mainstream media industry and its culture.

Following the decade of economic stagnation in the 1990s, this total neglect of the culture industries in Japan finally changed and a new policy was established. Seeing the new challenges brought about by globalization, the neoliberalist Koizumi administration adopted a strategy aimed at rebuilding Japan's national economy through the production of media "contents" coupled with the control of intellectual property rights. The administration spotted the media and culture industries as an area with major potential for growth and enacted a series of laws such as the "Art and Culture Promotion Law" (2001), the "Basic Intellectual Property Law" (2002), and the "Contents Promotion Law" (2004), all of them with an eye to bolstering the production and export of Japanese media of various sorts: manga, anime, film, TV drama, and music.[2]

As a consequence of this political maneuver, what is now called the "Contents Industry" was built up as the industry that could give hope to Japan's future. Encouraged by these political discourses and measures, many universities set up new courses to train "contents producers" and "contents creators" of various kinds.[3] Among these initiatives the most significant development was the establishment of the Graduate School of Film and New Media at Tokyo University of the Arts (Tokyo Geijutsu Daigaku Daigakuin Eizo Kenkyu-ka) in 2005. This university is Japan's most prestigious national institution for art and music. The school was set up to train the next generation of film professionals and it was intended to match the world's elite film schools where the cream of a given nation's students are taught and mentored by the country's top working filmmakers: the FEMIS (Fondation Européenne pour les Métiers de l'Image et du Son, Paris, France), the NFTS (National Film and Television School, Beaconsfield, UK), the AFI (American Film Institute, Los Angeles, USA), and the KAFA (Korean Academy of Film Arts, Seoul, Korea).

In order to cast light on the dynamics that kept the practice of filmmaking alive within the Japanese filmmaking community, this chapter first looks at how the post-studio generation of Japanese filmmakers trained themselves and found pathways into professional filmmaking. As television took over the mantle of the national media from cinema, filmmakers were relegated to the margins of the mainstream media industry. The film industry became fully specialized and was the first industry to provide flexible working arrangements in Japan, and by the mid-1980s the majority of film workers had become freelancers. It was in this context that the practice of *jishu-eiga*[4] filmmaking emerged as a form of professional training for the young generation of filmmakers.

Second, this chapter examines the institutional changes that the new cultural policies later effected in relation to the education of filmmakers. The policy discourses instituted in the early part of the twenty-first century highlighted the popularity of Japanese media—such as anime, manga, and various games—overseas, where they were identified as "Cool Japan."[5] Successive governments urged the Japanese people to use this as a springboard for economic recovery and to forge Japan into a "Contents Nation."[6] My focus of interest is, however, not to measure how (un)successful these policies were, in terms of increased industrial output and exports. Rather, I shall examine how those communities of filmmakers that emerged from the culture of discontent took advantage of the socioeconomic climate engendered by the new political discourse, and negotiated in such a way

as to carve out niche spaces by which different and diverse kinds of film education, production, and consumption could be encouraged within mainstream institutions.

Two different groups associated with the culture of discontent that kept Japanese filmmaking alive and kicking during the 1970s to 1990s when the film industry was at its lowest ebb are identified in this chapter. I call the first group "traditionalist" and the second "modernist." In spirit, these two groups are connected through a common sense of resistance, for they both defined themselves against the culture of the mainstream media industry when the old film industry was absorbed by TV and the advertising agencies. Many individual filmmakers emerged from the *jishu-eiga* scene.

The difference between the traditionalist and modernist groups has to do with the different genealogies with which the filmmakers see themselves as connected, and with the filmmaking cultures by which they profess a sense of belonging. The traditionalist filmmakers see themselves as situated in the lineage of the good old days of Japanese cinema and the tradition of studio filmmaking, while the main sources of influence for the modernist filmmakers are Euro-American filmmakers and aesthetics. Those standing at the margins of the mainstream national culture—forming a communal bond with either the "tradition" of the national past or with a "modernity" derived from the Euro-American context— often used a strategy of affiliation to entrench their communities. And their struggle against the mainstream culture was seen as potentially leading to a wider cultural transformation. This grouping is by no means exhaustive, nor can every dissident/critical filmmaker in Japan be said to fall into one or the other category.

In the rest of this chapter, I will discuss the emergence of *jishu-eiga*, and then provide case studies of film schools to illustrate how these two cultures of discontent, encompassing traditionalist and modernist filmmakers, developed maneuvers by which to build up their institutions so as to train the next generation of filmmakers. The first case study looks at the Japan Academy of Moving Images (Nihon Eiga Gakkou) as an example of the traditionalist school, and the second and third case studies consider the Film School of Tokyo (Eiga Bi-Gakkou) and the Graduate School of Film and Media Arts at the Tokyo University of the Arts, as examples of modernist schools.

Emergence of *Jishu-eiga*—Independent Filmmaking as Training Ground

Two decades after the golden age of Japanese cinema, two student filmmakers, Kazuki Omori (1952) and Sogo Ishii (1957), neither of whom had any professional filmmaking experience, were picked out (on two separate occasions in 1978) by the two major film studios, Shochiku and Nikkatsu, to direct theatrical feature films. Omori was a cinephilic medical student, who had made a number of super 8 and 16mm films. His film script "Orange Road Express"("Orenge Road Kyukou") won a prestigious script contest, and the aspiring director then negotiated with Shochiku, which was hosting the contest, in order to be allowed to direct the script himself. At that time, Shochiku was keen to get in touch with young talent because the studio had not recruited any new directors into their production system for

many years; so the company made a brave decision to let this amateur filmmaker direct his first big commercial film.

Sogo Ishii made a short film in super 8 called *Panic in High School* (*Koukou Dai Panic*, 1976). This hellish parable is set in the Japanese education system and tells a story about how the suicide of a classmate prompts a frustrated high school student to steal a shotgun, shoot an insensitive maths teacher, and then hold some classmates hostage. The film was picked up by Nikkatsu for theatrical remaking. Ishii, who was a film student at Nihon University College of Art (Nihon Daigaku Geijutsu Gakubu) at the time, insisted that he would direct the Nikkatsu version himself, and he managed to get himself hired as codirector to work with the company's director, Yoshihiro Sawada. Ishii later stated that his relationship with the Nikkatsu film crew was awkward, and it appears that as the codirector he didn't often get his own way. *Panic in High School* (1978) was Nikkatsu's first nonpornographic film for many years[7]—the company had specialized in low-budget soft-core sex films since 1971 as a temporary measure to overcome financial difficulties—and it was widely publicized in the media as a film that was made by, and reflected the sensibility of, the youth of the day.

Before Omori and Ishii made these films, the only way to become a film director was first to gain employment as an assistant director, and then to go through usually more than ten years of apprenticeship training within the studio production system. Being shaped and learning through a maestro–apprentice relationship within the system was an essential process for newcomers to earn trust and be accepted in the professional filmmaking community. It was unthinkable, and actually impossible, for a young person without on-the-job training in the system to direct a theatrical feature film. In a way, Omori and Ishii's cases demonstrated both the willingness of the indigent film industry to exploit young talents and a major cultural shift in the approach to independent filmmaking. A well-respected avant-garde poet, playwright, and filmmaker, Shuji Terayama (1935–1983) articulated the meaning of this shift as follows:

> Japanese independent cinema was in its infancy in the 1960s . . . [It] meshed with the "counter culture" of that time, and a lot of films got made.
>
> But independent cinema came to mean something different in the 1970s, after the May '68 revolution and the defeat of the antiestablishment movement. From then on, independent films were either private introspections, almost completely disengaged from the world around them, or films made as stepping-stones by directors who want[ed] to break into the film industry.[8]

At the tail end of the economic high-growth era, many young Japanese found themselves wealthy enough to afford to buy a super 8 camera and were allowed a kind of moratorium on growing up when they attended university before being swallowed up by Japanese corporate culture. Radical politics and student activism became increasingly unfashionable as a result of the failures of the early 1970s. But, not everybody was yet ready to swear by the consumerist liberation of the 1980s: *jishu-eiga* caught the imagination of the generation that had been brought up in a

political vacuum but still felt uncomfortable with what life had become after the end of politics.

A city information magazine called *Pia* played a crucial role in the development of *jishu-eiga* culture and filmmaking especially following the establishment of their Pia Film Festival (PFF). *Pia* magazine was started by a group of student entrepreneurs in 1974 and the magazine included listings of various film screenings taking place outside of the conventional spaces. *Jishu-eiga* films were often screened in universities, public meeting rooms, and cafes, with screenings organized as difficult-to-find, irregular events, and thus *Pia* magazine provided an essential communication tool for *jishu-eiga* audiences and filmmakers before the advent of the Internet.

The Pia Film Festival started in 1977 with a mission to introduce *jishu-eiga* to the wider public. The first festival screened, among other films, Kazuki Omori's earlier film called *Cannot Wait for It to Get Dark!* (*Kuraku narumade matenai!*, 1975), and Sogo Ishii's super 8 feature film, *Charge! Hakata Gangs* (*Totsugeki! Hakata gurentai*, 1978), was shown during the second edition. Then from 1984, PFF started the PFF Scholarship Scheme, the stated intention of which was to "discover new cinematic talent and provide training."[9] Filmmakers who won an award at the PFF festival were granted a right to apply for the scholarship with a proposal for their next project. If a given project was chosen, full financial and professional support was provided to enable the filmmaker to develop, produce, and distribute a 16mm feature length film. The scholarship was set up as a joint venture involving film, TV, and DVD companies, so as to facilitate the commercial exploitation of the completed films.

Since then the PFF has provided one scholarship each year for nearly 30 years, up to the present day, and it is considered to offer a singularly important gateway to success for new film directors. PFF award–winning directors who are now known on the international film festival circuit include Sogo Ishii (1978), Isshin Inudo (1979), Kiyoshi Kurosawa (1981), Akira Ogata (1981), Jouji Matsuoka (1981/1984), Tetsuya Nakajima (1982), Akihiko Shioda (1984), Nobuhiko Suwa (1985), Sion Sono (1986/1987), Ryosuke Hashiguchi (1986/1989), Shinya Tsukamoto, (1988), Daisuke Tengen (1990), Shinobu Yaguchi (1990), Naoko Ogiue (2001), and Yuya Ishii (2007). And this list is by no means exhaustive.[10]

Following the introduction of a new cultural policy in the early 2000s, Japan's Agency for Cultural Affairs, which is part of the Ministry of Education, Culture, Sports, Science and Technology, launched a publicly sponsored training program for young film directors in 2006. Called *New Directions in Japanese Cinema* (NDJC) the program's aims are similar to those of the PFF: to "discover young filmmakers who do not have sufficient resources and [to] provide training for them."[11] The program provides financial and professional support for about five young filmmakers each year to make short 25–30-minute films in 35mm, and is still in existence at the time of writing.

Over the years making *jishu-eiga* became established as an alternative to undergoing an apprenticeship in the industry and today it is not unusual for a young amateur to direct a commercial feature film without having working experience as an assistant director or equivalent on-the-job training. To put it differently,

through the process of flexible specialization of the film labor market in the 1980s, *jishu-eiga*, on the one hand, emerged as a stepping-stone for young amateur filmmakers to become professional and, on the other hand, provided a large low-cost talent pool for the industry. Many dissident filmmakers who exhibit either traditionalist or modernist characteristics came out of *jishu-eiga*.

The Traditionalist School: Japan Academy of Moving Images

Tadao Sato[12] is a well-respected Japanese film historian and the chancellor of Japan Institute of Moving Images (Nihon Eiga Daigaku)—a new university that was developed out of a reputable vocational college called Japan Academy of Moving Images (Nihon Eiga Gakkou) in 2011. According to Sato, before the 1930s entering into the film industry was strictly through personal connections.[13] In 1935, a Japanese film studio called PLC recruited ten new assistant directors from the general public for the first time in history. Of those ten, nine were graduates from Japan's top universities but included as an exception one applicant who had only a junior high school education at the time. The applicant's knowledge and enthusiasm for the visual arts, especially painting, made a great impression on the examiner. Cutting a long story short, this was how Akira Kurosawa managed to find a job in the film industry, and out of these ten recruits he was the only one to succeed, and thus make a name as a film director.

As the film industry prospered and became socially respectable from the 1930s onwards, the film studios became increasingly elitist and recruited only from among the top university graduates. However, Sato points out that the majority of well-known Japanese film directors who worked in the golden days of the studio era did not have high, if any, academic qualifications.[14] For example, Kenji Mizoguchi, Mikio Naruse, Teinosuke Kinugasa, and Kaneto Shindo all had only primary school education; Daisuke Ito, Mansaku Itami, Yasujiro Ozu, Masahiro Manino, Sadao Yamanaka, Yasujiro Shimazu, Keisuke Kinosita, Kozaburo Yoshimura, and Shiro Toyoda were graduates of junior high schools. From this, Sato argues that "it is certainly true that the fact that many directors were not part of academic elites was an important underlying factor for the popularity of cinema"[15] at that time.

According to Sato, the family values and morality that the films of both Ozu and Kurosawa had at their core were something that common Japanese people could easily identify with and share. Neither Ozu nor Kurosawa was interested in dealing with issues of modernity and individualism in abstract terms, issues with which the Japanese intellectual class was generally concerned. The same can be said of Kenji Mizoguchi, who developed his art of mise-en-scène from traditional popular cultural forms—Kabuki and Shinpa-geki—with which he was very familiar from his upbringing. It is important to note that these master filmmakers were capable of capturing the hearts of a wide popular audience because they were themselves not from the elite and were in touch with a popular sensibility. But, of course, Sato continues, the fact that they were not from the elite does not in itself explain why and how they were able to achieve such artistic quality in their work.[16] It was the

Japanese studio production system that nurtured and educated those men from common backgrounds into master filmmakers:

> Film studios did not just train simple craftsmen for the entertainment industry. The film studio was a place where they could develop into cultural giants. It was a better school than the university, laboratory and workshop combined together, a place that was open to somebody without academic qualifications and where people could educate themselves to the highest degree. As Japan increasingly became a society based on academic qualifications in the 1930s, this also affected the film industry. However stronger academic backgrounds did not necessarily make better filmmakers. It can even be observed that those old masters who had no academic qualifications left greater cinematic works. One thing we must acknowledge here is that the Japanese film studios of the time had an amazing capacity to help those without formal educations to grow into world class artists.[17]

According to Sato, it was the Japan Academy of Moving Images and its successor, the Japan Institute of Moving Images, that inherited the spirit of the studio production system as an educational institution. After the demise of the studio production system, the Academy was set up by the enterprising film director and educator Shohei Imamura, in order to restore one of the film industry's earlier functions: training a new generation of filmmakers.[18]

Imamura[19] had established the predecessor of the Academy, the Yokohama Academy of Film and Broadcasting (Yokohama Housou Eiga Senmon Gakuin), in 1975. At that time, two of the six major Japanese film studios went bankrupt and another decided to specialize in soft-core sex films in order to survive financially, while the remaining three laid off the majority of their workforces. As the labor market for film workers was being rapidly specialized with an emphasis on flexibility, many experienced film directors and technicians became unemployed. Meanwhile, Japanese society in general was at the tail end of the economic high-growth era—before the bubble economy—and becoming very rich. The so-called "middle class society," with which more than 90 percent of the population identified themselves, was dominant. The cost of achieving such a high level of economic growth, and so rapidly, was, however, also very high. It manifested itself as a highly homogeneous, strongly group-oriented and regimented society where individuals were rigorously classified according to the universities from which they graduated and the companies to which they belonged. The young generation was under tremendous pressure to study hard to survive the "examination hell" and to be good "corporate soldiers (slaves)," in order to spend their lives as "ordinary" Japanese "middle-class" people. But inevitably, there were substantial numbers of young people who could not adjust to such pressure and rejected, or simply dropped out of, the mainstream, and sought alternative life courses.

Imamura's idea was to bring together two marginalized groups of people— experienced filmmakers who were disillusioned with the condition of the Japanese film industry of the time and young people who could not envisage having bright futures within the oppressive Japanese education system and corporate culture— to create a film school based on the spirit of the old film studios. Although Imamura was born in an upper-middle-class doctor's family in Tokyo, during his

youth he was involved with various street life activities, selling cigarettes and liquor on the black market, after the war when Japan was generally economically devastated and in a state of social chaos. His interest in indigenous cultures and the lower strata of Japanese society, and in their will to survive, was said to be a reflection of his early experiences. Imamura's philosophy and the founding sprit of this school were expressed well in a famous advertisement aimed at student recruitment: "If you fail university entrance exams, come to Yokohama Academy of Film and Broadcasting."

The school changed its name to Japan Academy of Moving Images in 1985 and moved to its present site in Kawasaki city, a satellite town of the Tokyo megalopolis, where the academy has run three-year filmmaking courses for 160 students and a two-year acting course for 40 students each year. Upon graduation significant numbers of students are successful in finding assistant-level jobs within the film and TV industries every year, and there are even cases of graduates going on to direct a debut feature film within a few years of graduation, like that of Sang-il Lee, who directed the award-winning film *Hula Girls* (2006).

Over the years, the Academy has supplied the Japanese film and TV industry with a large number of workers and with numerous film directors, writers, technicians, and actors. One of the most celebrated and sought-after film directors in the contemporary Japanese film industry, Takashi Miike, looks back on his young days in a message given to his juniors. He says he was just an aimless youth who did not like studying for university and was not ready for adulthood and working. Thus he decided to

> go to a film school to buy some time . . . But why a film school? . . . Well, I thought the name of the school sounded nice; and more than anything, I did not have to take an entrance exam to get a place . . . I just wanted to get away from my hometown and escape from the pressure to be a grown up, knowing that making a clear run from adulthood was not a possibility . . . "Did you like films that much?" somebody asked me. No, . . . I liked watching films, but never thought of making films before. I just wanted an escape.
>
> 34 years have passed since then, and I couldn't escape from the passing of time as I'd expected. I became fifty years old in the blink of an eye. But, somehow, I became a film director, and I don't feel bad about being one; because this is a job that allows me to remain a non-grown up. It is a good job and now I am planning to keep at it till I die
>
> Well, my point . . . is that of course it is the audience to which cinema primarily gives something. It gives laughter and tears, even a will to survive and courage to live sometimes. Some filmmakers say they make films because film has such power over audiences. However, I would say that they are telling only half of the story. The real blessing of cinema is upon those who make films. Cinema actually gives far more to filmmakers than audiences. Cinema nurtures and loves filmmakers unconditionally like mothers do.
>
> This is true and I know that from the bottom of my heart, because cinema gave me, who was really good for nothing but making films, a space to stay alive in this world.[20]

Despite his humble background as a streetwise kid with no intellectual inclination, Miike is now one of the internationally best-known Japanese film directors. His

earlier films, such as *Audition* (1999), made his name synonymous with what became known as "Asian Extreme."[21] As well as being the "busiest director on hire" in the Japanese film industry, he now regularly attends major international film festivals. In a way, his ascendance shows the degree of success that the Japan Academy of Moving Images has achieved as the heir to the studio tradition of training and nurturing. Like the old Japanese film studios in the golden days, it produced filmmakers with a popular sensibility; and helped "those without formal educations to grow into world class artists."[22]

Another important contribution made by the Academy to Japanese film culture was that it promoted multiculturalism and provided a space for a form of "globalization from below."[23] Imamura and the academy supported filmmaking by, and about, ethnic minorities in Japan and hosted numerous foreign students, mostly from other Asian countries. For example, Kim Sugiru (1961), a Korean resident in Japan, wrote an original script *Yun's Town* (1988) and directed a theatrical feature film *Did You See the Bare Foot God* (1986), which was the Academy's ten-year anniversary production. More recent graduates among Korean residents in Japan were directors Lee Sang-il (1974) and Tetsuaki Matsue (1977). Lee's *Hula Girls* (2006) won all the major Japanese film awards and Matsue is a very prolific documentary filmmaker who made *Annyon Kimuchi* (1999), which humorously explored his Korean family identity.

The Academy started taking in foreign students in 1984, and by now about 200 students from Hong Kong, Taiwan, China, Korea, Indonesia, Bangladesh, Myanmar, Germany, Italy, and Belarus have studied at the academy.[24] In 2011, the Academy became a fully fledged four-year university and changed its name to the Japan Institute of Moving Images. In an official document titled "The Effects of the Establishment of the University and the Reasons Why This is Necessary,"[25] the aim to increase the number of foreign students was cited as one of the most important reasons for the institutional upgrading; this is because it is difficult to obtain foreign government financial assistance without having university status, which in turn makes it difficult to attract more foreign students. The document also states that Imamura had a grand vision to make his school a hub of cinematic education in Asia. It also stated that at least a third of the students studying at the Academy should be from other Asian countries in the future.

Backed not only by the prevailing politico-economic discourse of building a "Contents Nation," which would guide and encourage Japanese universities to take on the training of the producers and creators of media content, but also by the "Foreign Students Three Hundred Thousand Plan,"[26] Imamura's school has embarked on a journey for institutional survival in the increasingly competitive environment that private universities inhabit due to decades of low birth rates.[27] This film school, originally set up as an alternative to university education by a charismatic individual, is now in the process of reestablishing itself as a university in its own right.

The Modernist School: The Film School of Tokyo

The Film School of Tokyo (Eiga Bigakkou) is a part-time adult education school, which has classes mostly at night and over the weekends. The school runs basic-

and advanced-level filmmaking courses of one year each both in fiction and documentary filmmaking, as well as a one-year scriptwriting and acting course. The school was established by two prominent film distributors/exhibiters of European art films, Kenzo Horikoshi[28] (1945) and Masamichi Matsumoto (1950), in 1997. Both these figures continue to be actively involved in running the film school to this day.

Horikoshi started a cinema club in 1977 and introduced the New German Cinema to Japanese audiences; then he opened a small art-house cinema called Euro Space in Shibuya, which became a forerunner of the mini theater (a kind of boutique cinema)[29] movement in 1982. Matsumoto has been in charge of a cinematheque—the Athénée Français Cultural Center—since 1977. From the background of the founders/organizers, one might assume the school to have a certain inclination toward European art cinemas. However, the aesthetics that underlie teaching there is complex and bears a certain historic contingency peculiar to the ways Japanese intellectuals imported Euro/American ideas.

Two tutors who have a strong influence over the teaching at the Film School of Tokyo are film director Kiyoshi Kurosawa (1955) and scriptwriter Hiroshi Takahashi (1959), who have been teaching at the school since its beginning. Kurosawa is regarded as a central figure in the so-called "Hasumi School" of Japanese filmmakers, who were once students of the French literature scholar Shigehiko Hasumi.[30] During the 1970s and 1980s, Professor Hasumi taught a "Cinematic Expressions" course at Rikkyo (St Paul) University where *jishu-eiga* filmmaking by students was very active. His seminar inspired a great many students and a significant number of them went on to become successful filmmakers later in life. The Hasumi school of filmmakers includes Kiyoshi Kurosawa, Masayuki Suo (1956), Shinji Aoyama (1964), Akihiko Shioda (1961), Makoto Shinozaki (1963), and Kunitoshi Manda (1956). Many of them teach at the Film School of Tokyo, and they provide an aesthetic backbone to the teaching there.

In his legendary seminar on "Cinematic Expressions" (Eiga hyougen ron), Hasumi, the scholar of French literature who professes to dislike French high culture and has a strong admiration for French anti-establishment filmmakers like Godard,[31] taught a class based on the Nouvelle Vague's way of looking at American popular cinema. The idea was to use the Nouvelle Vague as a stick with which to beat a drum that would help to subvert the authority of old cultural establishments.[32] Although Hasumi did not teach practical filmmaking, his teaching cultivated in the students not only a certain cinematic taste and value judgments but also a certain attitude toward mainstream national and commercial culture. Moreover, he taught a generation of *jishu-eiga* filmmakers—all of them born too late to benefit from training within the studio production system—a method of learning filmmaking by looking at certain films very closely and analytically.

Like Kurosawa, the scriptwriter Takahashi[33] started his career as a *jishu-eiga* filmmaker while he was a university student. In a co-authored book titled *Cinema's Lessons: From Class Rooms of the Film School of Tokyo* (Eiga no jugyou: Eiga Bigakkou no kyoushitu kara), which was intended to provide a record of lectures and to take the form of a text book, Kurosawa and Takahashi state the following: "We don't intend to teach how to make just any films. What we aim for is to

nurture *jishu-eiga* or independent filmmakers of the most powerful kind."[34] They mean that the original intention of the school was not at all to train students for the existing film industry but to support students to make their own *jishu-eiga* films outside of the existing film industry.[35] Although a number of graduates have made successful commercial films—for example, Takashi Shimizu (1972), who directed *Juon* (2003) and the Hollywood remake of the same film, *The Grudge* (2004)—the film school uniquely positions itself as being at the vanguard of Japanese independent filmmaking and film culture along with other organizations through which Horikoshi and Matsumoto operate.

In 2011, the school relocated its premises to occupy part of a cinema multiplex building called KINO HOUSE in Shibuya—a central entertainment district in Tokyo. The rest of the building is occupied by a mini-theater, Euro Space, a repertory cinema Cinemavera,[36] and the head office of the Community Cinema Centre,[37] which is an organization devoted to promoting film culture through the noncommercial community-based film exhibition activities that Horikoshi and Matsumoto also established and operate. This alternative version of a cinema complex building—KINOHOUSE—is a response from the two founders of the school, who have made a stand for Tokyo's inner-city-art-house cinema culture, to the increasingly difficult financial and cultural environment created by the booming of large suburban cinema complexes and the domineering popularity of TV-based spin-off films turned out by horizontally integrated teams linked to the major corporations within which TV broadcasters and the old studio majors play key roles.

From the 1980s to the mid-1990s, mini-theaters flourished in Japan's urban landscapes as an unexpected side-effect of free-trade economic globalization. The Japanese government of the time adopted a policy of *internationalization* (*kokusaika*) to ease trade conflicts with the USA. Part of this effort involved deploying various measures to persuade the Japanese to consume more foreign goods and symbols in order to increase imports. The number of imported foreign films jumped from 250 a year to over 500 in 1989 at its peak.[38] Backed by this politico-economic trend, numerous independent film distributors started importing various European art films, world cinemas, and some quality independent American films. An amazing variety of films suddenly became available and created a demand for more screen spaces. Mini-theaters boomed. Contrary to the conventional wisdom of cultural imperialism, American pressure for free trade ironically helped to diversify Japanese film culture and for a while invigorated local independent filmmaking.[39]

However, the advent of cinema complexes and the reorganization of the Japanese media industry in the 2000s—that is, the vertical reintegration of the cinema exhibition sector by the major media companies and the informal horizontal integration of the major media companies across the different business fields (TV, film, music, publishing, radio, games, advertising etc)—and the resultant so-called "revival of Japanese cinema"[40] put an end to the heyday of mini-theaters. In 2012, Japanese box-office taking was dominated by a small number of films produced and distributed by consortia of TV broadcasters and the old studio majors. Many mini-theaters have closed down in the last few years despite the "revival" of the

film industry in general and it is said that mini-theaters and art-house cinema culture are facing a "fateful crisis."[41]

According to Matsumoto, relocating the film school serves two ends: contributing to the education of students, and revitalizing urban film culture.[42] Shibuya is a focal point not only for mini-theaters but for creative business more generally. Thus it provides easy access to a variety of cinema experiences for students as well as opportunities to mix with creative workers/students from other fields. And having the sites of film education, production, and consumption within one and the same building encourages the students to see the kinds of films they would not otherwise see, and may encourage film audiences who never thought of making films to take classes at the film school.

Japanese art-house cinema culture may be in a "fateful crisis" as it is in many other countries. However, the legacy established by the modernist school has provided an active force in the field of film training and is certainly here to stay. As I have already mentioned, the most significant development that followed the new cultural policy was the establishment of a national institution for training filmmakers: The Graduate School of Film and New Media. And it is one of the founders/organizers of the Film School of Tokyo, Kenzo Horikoshi, who has led the designing and running of this new institution.

The Graduate School of Film and New Media at Tokyo University of the Arts

Tokyo University of the Arts had intended for a very long time to open a film school. In fact, the Ministry of Education had once granted authorization for this in 1949, but it never materialized for various reasons. It was the radical turn in cultural policy in 2002, placing the spotlight on audiovisual content production as a key site for Japan's economic future, which obliged the Ministry of Education finally to make a move. Kenzo Horikoshi, who had been campaigning for more public support for filmmaking and culture, saw this as an opportunity.

Horikoshi was involved with the advisory committee of the graduate school when Tokyo University of the Arts finally decided that the time had come to establish its long overdue film school. He organized a study tour for the advisory committee to visit film schools in Europe including FEMIS (Paris, France) and the NFTS (Beaconsfield, UK), and he became a central figure in the committee that drew up a blueprint for the film school.[43]

The School opened departments of film production in 2005, new media in 2006, and animation in 2008. Horikoshi was appointed as professor of film production in 2005, and was then appointed as the director of the Graduate School in 2011. Other prominent Japanese filmmakers who have held professorships in the school include the film directors Takeshi Kitano, Kiyoshi Kurosawa, and the American-trained cinematographer Toyomichi Kurita. Horikoshi played a key role in selecting faculty members and setting up programs. One thing that is noteworthy about the way in which the graduate school is set up is that none of these original faculty members had conventional training within the Japanese film industry. They are a set of independent filmmakers with unique backgrounds who work mostly on films for art-house cinemas.

The establishment of this national institution is significant for the future of Japanese cinema for at least three reasons. First, it shows the nation's commitment to nurture and train the next generations of filmmakers. Second, it provides financial security and some respectability for practice-oriented film education within the Japanese education system. Third, it provides a point of contact with international networks of film schools of a similar standard and creates a greater traffic of students and opportunities for creative cross-fertilization.

When reading the Japanese government's cultural policy documents, it is hard to deny that there was a form of nationalist desire and a sense of narcissism—what Iwabuchi called "soft nationalism and narcissism"[44]—operating in the background when the graduate school was established. It was said that the school's mission was to strengthen "soft power" in order to enhance Japan's national brand so that the whole of the national economy would benefit from it. Yet, there are key questions: How has this "soft nationalist" cultural policy been understood? And how has it actually played out on the ground? What have its implications been, at the level of practice, for various individuals, such as Horikoshi and his colleagues and students? And how is the next generation of Japanese filmmakers positioning itself within a new constellation of powers engendered by globalization?

The department of film production offers 16 places for producers, directors, and scriptwriters, and another 16 places for cinematographers, sound recordists, art directors, and editors each year. According to Horikoshi, who is in charge of the program for producers, the school places particular emphasis on the importance of their film production students' learning filmmaking in the international context, and on their development of trans-cultural skills. This is because the school sees that the training of a new generation of film producers who are capable of selling ideas and talents internationally, and of setting up frameworks for transnational collaborations, is essential for the entire Japanese filmmaking community.

Each year, about five students enroll in the producers' program. Over a period of two years, students participate in two international coproduction workshops, one of which is organized with the French film school FEMIS and the other with the Korean film school KAFA. All of the students travel to France to learn about the possibilities of coproducing films not simply with France but also with other European countries, and about how to circulate their films through European film festivals. In return, French students are invited to Japan and are encouraged to develop film scripts together with Japanese students. The coproduction workshop organized with the Korean film school KAFA involves actually producing short films. Students travel to Korea, Korean students visit Japan regularly, and the interchange between the two schools is active. Korean and Japanese students develop coproduction ideas and scripts together and shoot their scripts in either country with mixed crews and casts.

The fact that these workshops are organized with the French and Korean film schools reflects, on the one hand, the Graduate School's vision for the future, and, on the other hand, the particular economic and geopolitical reality in which Japan is positioned within the global power structure. Horikoshi said he originally wanted to set up similar workshops with Chinese and American film schools as well. However, things did not work out. In the case of China he started negotiations

with the Beijing Film Academy a number of times, but each time he wore himself out and nothing materialized. With regard to the USA, several American universities have approached the Graduate School in order to form an affiliation, but the American Film Institute, which Horikoshi considers as the best suitor for the school, has never shown any interest.

Production links with Hollywood and access to Chinese (mainland and diaspora) markets are said to be the two most important keys to globally successful commercial films, and this was a kind of filmmaking the Japanese government officials most likely had in mind when they spoke of building a "Contents Nation" with the "soft power" needed to contribute to future economic well-being. However, after years of ground-level experience as an independent film producer, Horikoshi says that it is neither a realistic nor an interesting option for Japanese filmmakers. Instead, he sees two ways that Japanese filmmakers can make their mark internationally. The first consists of conventional routes through European film festivals—Cannes, Berlin, Venice, and so on. Almost all of the international Japanese filmmakers of the past—such as Akira Kurosawa, Nagisa Oshima, and Takeshi Kitano—took this route. Through successful European art-house distribution and DVD circulation, their films sometimes achieved American art-house distribution and have occasionally been remade by Hollywood.

The second way is to take an active role in the process of Asian regionalization. The popularity of Japanese media content in the urban areas of East Asia during the 1990s has been well documented, and the recent international success of the Korean film and TV industry—the so-called "Korean wave"—was a key factor in persuading the Japanese government to renew its cultural policy so as to provide more support for its own media industry. Now, Japanese and Korean filmmakers and companies are building closer creative and business relationships. While ethnic Chinese filmmakers are working closely beyond national borders under the aegis of Pan-Asian Cinema, there is a strong possibility that a closer Japanese–Korean partnership will provide another drive for the regionalization of the Asian media industry. According to Horikoshi, the joint coproduction workshops with French and Korean film schools are there to equip his students for these two realistic options, so that the next generation of Japanese filmmakers has greater possibilities to explore.

Conclusion

For a long time cinema in Japan, unlike other major film-producing countries, has not been central to mainstream popular culture and the film industry was not regarded as significant for the national economy. Instead, manga, animations, TV dramas, and J-pop music occupied the central stage of Japan's media culture and industry. In the absence of public support, the training of filmmakers in Japan was kept alive and invigorated by those dissident filmmakers who were not content with the mainstream media culture; I called one of the groups traditionalists, and the other modernists. For minority activists/artists in a non-Western nation like Japan, which is in the process of performing a mental de-colonization/de-imperialization, the "tradition" of their own historic past and the "modernism" of

the powerful Western Other provide material they can use to make their critical voices heard.

The policy discourses developed in the new century have, however, created an environment that makes it easier for these critical forces to occupy central sites within the mainstream commercial and national cultures. As a consequence, the traditionalist school, the Japan Academy of Moving Images, has now become a full-blown university in its own right, and the Film School of Tokyo has been able to extend its influence, and to form a strong tie with the most prestigious national university in Japan.

Understandably there are many concerns being articulated by people who are closely associated with both schools. For example, the Japan Academy of Moving Images may be getting out of touch with its founding spirit and becoming institutionalized; or the Film School of Tokyo may be becoming a sort of prep-school for elite education. However, it is obviously too early to make an assessment or to predict the future of these two successful film schools, which have both developed strong and distinctive profiles.

Notes

1. Only one Japanese studio major—Nikkatsu—continued regular production by specializing in soft-core porn films, and continued to recruit newcomers during the 1980s.
2. It was said that this move by the Japanese government was strongly inspired by the successes of Korea's cultural policy and film and TV industry.
3. Mitsuteru Takahashi, *Contents Kyouiku no Tanjou to Mirai* (*The Birth of Contents Education and its Future*) (Tokyo: Born Digital, 2010).
4. When film companies stopped recruiting new blood into the industry in the 1970s, many wannabe young filmmakers and students started making no/low-budget films on super 8 and 16mm with their own financing; such films are called *jishu-eiga*. See Yoshiharu Tezuka, *Japanese Cinema Goes Global: Filmworkers' Journeys* (Hong Kong: Hong Kong University Press, 2011).
5. METI (Ministry of Economy, Trade and Industry; Division of Creative Industry) *Cool Japan Senryaku—Cool Japan Strategy*, http://www.meti.go.jp/policy/mono_info_service/mono/creative/index.htm (accessed February 20, 2012).
6. Prime Minister of Japan and his Cabinet (Chizai Senryaku Honbu), *Chiteki Zaisan Suishin Keikaku 2011*, http://www.kantei.go.jp/jp/singi/titeki2/kettei/chizaikeikaku2011_gaiyou.pdf (accessed February 20, 2012).
7. The film did not do well enough for the company, so Nikkatsu kept producing *Roman Porno* films until 1988.
8. Terayama, cited in Tony Rayns, *Eiga: 25 Years of Japanese Cinema* (Edinburgh: Edinburgh International Film Festival, 1984), 16.
9. See PFF website, http://pff.jp/jp/whats/index.html (accessed March 10, 2012).
10. Ibid.
11. See NDJC website, http://www.vipo-ndjc.jp/top.html (accessed March 10, 2012).
12. Tadao Sato (1930) is a film critic and an Asian cinema researcher, and he has been the director of Japan Academy of Moving Images since 1996.
13. Shohei Imamura and Tadao Sato, *The Educator Shohei Imamura* (*Kyouikusha Imamura Shohei*) (Tokyo: Kinema Junposha, 2010), 14.

14. Ibid., 15–17.
15. Ibid., 18.
16. Ibid., 18–19.
17. Ibid.
18. Besides vocational schools like the Japan Academy of Moving Images, two universities offered courses in practice-oriented film education in the 1970s to 1990s: Nihon University College of Art and Osaka University of Arts.
19. Shohei Imamura (1926–2006) was the first Japanese director to win the Palme d'Or at the Cannes Film Festival twice, first for *The Ballard of Narayama* (1983), then for *The Eel* (1997). He started his life as assistant director at Shochiku studios in 1951 for the director Yasujiro Ozu, and then moved to the Nikkatsu studio in 1954.
20. Takashi Miike, *A Message from the Director Miike: Japan Institute of Moving Images—Nihon Eiga Daigaku: Miike Kantoku Message*, 2011, http://k-builder.com/d/eiga/index.php?p=f_1/sub_0 (accessed March 1, 2012, my translation).
21. Jinhee Choi and Wada-Marciano Mitsuyo, "Introduction," in *Horror to the Extreme: Changing Boundaries in Asian Cinema*, ed. Jinhee Choi and Mitsuyo Wada-Marciano (Hong Kong: Hong Kong University Press, 2009), 1.
22. Imamura and Sato, *The Educator Shohei Imamura*, 18–19.
23. Arjun Appadurai, "Deep Democracy: Urban Governmentality and the Horizon of Politics," *Environment and Urbanization* 13.2 (2001): 23–43.
24. Mitsuru Igarashi, "Mitsuru Igarashi's Let me speak (Igarashi Mitsuru no ore kara mo hitokoto)," *Cinema Nest Japan OB Bokujo* (2005), http://www.cinemanest.com/OBbokujo/25th.html (accessed March 4, 2012).
25. Kanagawa Eizo Gakuen, "Daigaku no secchi no shushi oypbi tokuni secchi wo hitsuyou tosuru riyuu wo kisaisita shorui," (Document that states the purposes and special reasons for the necessity of establishing the university), 2010, http://www.dsecchi.mext.go.jp/d_1010n/pdf/nihoneiga_1010nsecchi_syushi1.pdf (accessed May 10, 2012).
26. Ministry of Education, "About the framework of 'Foreign Students Three Hundred Thousand Plan'" ('ryugakusei 30 man nin keikaku's kosshi no sakutei ni tuite), 2008, http://www.mext.go.jp/b_menu/houdou/20/07/08080109.htm (accessed March 6, 2012). In 2008, the Japanese government drew up the plan to increase the number of foreign students studying in Japan from 120,000 to 300,000 by 2020 as part of their strategic response to globalization.
27. The Japanese birth rate has been falling continuously since 1973. As a result, there have been more university places available than the total number of applicants since 2007. Competition among private universities to recruit quality students, it is said, will be more and more fierce in future.
28. Horikoshi coproduced/cofinanced films by Leos Carax, Daniel Schmid, and François Ozon, etc., and produced many films for Japanese directors in conjunction with his activity in the film school.
29. In Japanese, "mini-theater" is a general term for small art-house cinemas with independent programming, which flourished in urban areas in the 1980s to 1990s. However, most mini-theaters are now in financial difficulties since the advent of large-scale multiplex cinemas. See Tezuka, *Japanese Cinema Goes Global*, 80–89.
30. Shigehiko Hasumi, (1936) is professor emeritus of French literature at the University of Tokyo, but he is better known as a film critic and for his love of classic American films in the golden days.
31. Shinji Aoyama et al., *Eiga naga hanashi* (Cinema long talks), (Tokyo: Little More, 2011), 86–106.
32. Kiyoshi Kurosawa, *Eiga no kowai hanasi: Kurosawa Kiyoshi taidan shu* (Scary Stories of Cinema: Talks with Kiyoshi Kurosawa), (Tokyo: Seidosha, 2007), 72.

33. The script tutor of the school, Hiroshi Takahashi is known as an originator of J-Horror. He wrote the script for *Ringu* (1998) and supervised *Juon: The Grudge* (2003).
34. Kiyoshi Kurosawa, et al., *Eiga no jugyou: eiga bigakko no kyoushitsu kara* (Cinema's Lessons: From Classrooms of the Film School of Tokyo), (Tokyo: Seidosha, 2004): 7.
35. Kiyoshi Kurosawa, *Eiga no kowai hanasi: Kurosawa Kiyoshi taidan shu* (Scary Stories of Cinema: Talks with Kiyoshi Kurosawa), 117–120.
36. Cinemavera shows mainly old Japanese cinema and is owned by the cinephile entertainment lawyer Atsushi Naito. He is a close associate of Horikoshi.
37. See their website, http://jc3.jp/english/index.html (accessed May 10, 2012).
38. Motion Picture Producers Association of Japan (MPAJ) website, http://www.eiren.org/statistics_e/index.html (accessed May 10, 2012).
39. Tezuka, *Japanese Cinema Goes Global*, Chapter 3.
40. TV broadcasters and the old studio majors teamed up to win back Japanese audiences with films based on popular TV series, such as *Bayside Shakedown* (2003). In 2006, Japanese films took more than 50 percent of the domestic box office for the first time in over 20 years. Phrases like "the revival of Japanese cinema" spread through business journals. However, these films were not exported and "the revival" remained a peculiarly domestic affair.
41. For example, Soichiro Matsutani, "Kyuukan aitsugu mini-theatre wa honnto ni sonnbou no kiki nanoka?" (Mini-theaters Continue to Close Down. Is this Really a Fatal Crisis?), February 10, 2011, http://trendy.nikkeibp.co.jp/article/pickup/20110207/103
4423/?ST=life&P=1) (accessed May 10, 2012).
42. "Jinzai ikusei kiiman ni kiku! Eiga bi gakkou daihyou riji Matsumoto Masamichi" (Listen to the Key Person in Human Resource Training! The President of the Film School of Tokyo, Masamichi Matsumoto), April 7, 2011, http://www.bunkatsushin.com/varieties/article.aspx?bc=1&id=1005 (accessed May 10, 2012).
43. Kenzo Horikoshi was interviewed by Yoshiharu Tezuka on May 15, and June 20, 2012, in Tokyo.
44. Koichi Iwabuchi, " 'Soft' Nationalism and Narcissism: Japanese Popular Culture Goes Global," *Asian Studies Review* 26.4 (2002): 447–469.

Learning with Images in the Digital Age

Moinak Biswas

I would like to speak from my experience of working with the Media Lab project at Jadavpur University, Kolkata, where we have been trying to explore methods of training and research in new image forms. As teachers in the Department of Film Studies at Jadavpur, the first department of its kind in South Asia, we had to design the early curricula for a subject that scarcely had academic practitioners in India. The periodic updating of syllabi followed the logic of incorporating new scholarship. The exercise proved to be a challenge, however, with the radical transformation of the very material and social character of the image brought on by the digital. The Media Lab was launched in 2008 as a space where the logic of the transition itself could be addressed before one could arrive at modules of finished material to be taken to the classroom. The Lab hosts digital databases, which involve the practice of documentation and linkage, image production and interpretation. Workshop-based training, organized alongside all this, has been working together with possible interventions in the radically expanding spaces of image production.

Films Studies is lodged with some degree of unease within the humanities, primarily because of the uncertain terms of cohabitation of art, discourse, and technology in the object with which it is concerned. Film has always seemed a slippery object—even before the new historical reflections uncovered the rules of object constitution for the disciplines—since technology, on the one hand, and economics, on the other, play a direct role in shaping its very material and modes of existence. The other well-known problem, that is, film having a codified but uncodifiable language, also made it difficult to work with the methods developed under the sign of linguistics in the late decades of the last century. I would like to make a few observations about the current challenge visiting film pedagogy from the technological transformation signaled here by the term "digital," keeping in view the new entanglement into which all these factors—technology, economy, and language—have entered.

Let me begin by revisiting a classical account of self-development—a lecture that the director Satyajit Ray gave in 1982 in Calcutta. It came out in the *New Left Review* under the title "Education of a Filmmaker," which is appropriate for our context.[1] Ray recounts his experience of learning his craft from sources as diverse as lessons in oriental styles of painting at Tagore's university in Santiniketan, Western classical music, modern Bengali novels, and Italian cinema. Those were pre-film-school days in India (1940s), where the model of education Ray suggests, resonating with the history of cultural resurgence in nineteenth- and early twentieth-century Bengal, would constitute the paradigm for the filmmaker trying to find a place in the industry. Ray also tells us about the more conventional method of "learning on the job" within the industry, which almost all filmmakers of the time would consider the only way of learning, even though some of his contemporaries from the 1950s who had come out of the studio system (e.g. New Theatres, Bombay Talkies, or Prabhat Film Co.) had passed through in-house studio apprenticeship, a form of institutional learning. Ray speaks of a humanist education, but it is non- or even anti-institutional as far as film is concerned. To quote him,

> Even on films I am not particularly well read. When I got interested enough in films to start reading about them, there were hardly a dozen books in English on the subject. By the time I finished them, I was already at work on my first film. One day's work with camera and actors taught me more than all the dozen books had done.[2]

He speaks of Tagore's university in Santiniketan and his formal education there with a degree of irreverence, laced with characteristic humor. He left his fine arts course unfinished soon upon Tagore's death in 1941. Even as he acknowledges his debt to the masters there[3] he seems to value the hybrid, informal nature of his learning, as if that is what someone who, like him, is looking for a career in advertising and films should seek. And there is something else, which paradoxically conforms to Tagore's idea of education more closely. Even as the would-be filmmaker pined for a life in the city, he discovered a world apart:

> It was a world of vast open spaces, vaulted over with a dustless sky that on a clear night showed the constellations as no city sky could ever do. The same sky, on a clear day, could summon up in moments an awesome invasion of billowing darkness that seemed to engulf the entire universe. And there was the *Khoai*, rimmed with serried ranks of taal trees, and the *Kopai*, snaking its way through its rough-hewn undulations. If Santiniketan did nothing else, it induced contemplation, and a sense of wonder, in the most prosaic and earthbound of minds.[4]

This seems to complete the picture of a humanist education in its indeterminate relationship with institutions. I would like to underline the nature of this relationship since film education has, in some sense, come back to rest on similar grounds in our times.

The film society movement, pioneered by Ray and his friends in 1947,[5] came to form a significant new arena of learning as it gathered momentum in the 1960s and 1970s. The first film school (Film and Television Institute of India) was set up in Pune in 1960, following recommendations of the Film Enquiry Committee

(1951) instituted immediately after independence by Prime Minister Nehru.[6] Its intellectual and aesthetic orientation largely overlapped with the critical standards developing in the film society movement. As was evident from the characteristic output of the school's graduates in the 1970s and 1980s, training in the intellectual sense meant primarily training in alternative practices, the shorthand for which was "experimentation." Beginning sometime in the late 1980s the orientation changed. The school focused on supplying skilled technicians to the industries in Bombay, Madras, and elsewhere, resulting in a widespread inculcation of global norms of filming. This turn coincided with the demise of the Indian New Wave and state sponsorship for alternative cinema, the latter signaling radical shifts in cultural policies that were to come about after the Indian state adopted measures of economic liberalization in 1991.

The situation has close resemblance to developments across the world. With the fading of a critical divide between the alternative and mass cinema, the standards of training could no longer be grounded in a project of aesthetic resistance. Film schools in India turned to a model of skill development in cinematography, editing, and sound engineering that has achieved an oppressive global uniformity from the United States to Hong Kong, from Mexico to South Korea. A consensus developed around the competent image, and more instinctively around editing styles and sound design. The standards in question were no longer specific to film or necessarily developed within film practice, but were extended across image-sites, saturating late twentieth-century social life.

The interesting point about the Indian situation is that all this was happening at a time when Film Studies was being introduced in the university.[7] I want to keep that conjuncture in focus. While academic discourse on film in India veered away from auteurism and aesthetic concerns to analyses of discourses, and debunked the privilege of art in favor of the study of culture, the alternative cinema, sponsored largely by the state, lost not only its economic but also its cultural support. The developments in the industry, in the film school, and in the university were, at the moment of a triumphant neoliberalism, tied in an unexpected alliance: all were concerned with a cinematic object that could only be defined in terms of dominant industrial codes.

Cultural Studies in India grew in conjunction with a strong tradition of critique of the modernizing state, which was doubled in a criticism of state-aided modernism in the arts (including the project of aesthetic reform supported by the state academies). There is no reason one should necessarily follow the other, but that was how it happened. An outcome of all that has been a certain populism, a fundamentally uncritical attitude that we often find in the literature on Bollywood cinema, and the complementary syndrome of widespread skepticism about projects of artistic intervention. The latter is tacitly or openly equated with elitism.

I would like to see this conjuncture as a point of crisis. There was very little institutional space left for critical training to take place, a training that equips the learner to form opinions and exercise political or artistic choices in relation to the practice of cinema. We are concerned here also with the problem of separation between scholarship and practice, a premise on which Film Studies has largely grown internationally, but these secret affinities between the two areas, where

developments in the academic discourse synchronize with legitimacies gained in the domain of industrial production, remain to be put in perspective.

I would like to suggest that the digital came as a vector, among other things, of two major shifts in this scenario: first, the opportunity that now presents itself, and therefore demands to be put to use, of bridging the divide between practice and research, between working with and on image and sound; and second, the revival of commitment to the idea of the alternative. I shall briefly touch upon two closely related formations, two areas of practice we should call them, that are relevant to these developments and have enormous import for not only film pedagogy but more generally for the humanities at the moment, namely, the "Commons" and the "Database."

One began to sense the impact of the technological shift (digital tools plus the Internet) in the classroom in the middle of the last decade, when we started receiving students who were bringing new knowledge about films to the class, knowledge that did not, therefore, need to be taught in the classroom anymore, but needed to be addressed by the curriculum. This was the beginning of the digital commons as an articulate movement, coinciding with the moment (around 2005) of what is sometimes called Web 2.0 (the typical example of this is Wikipedia and Youtube, where, unlike the earlier version of the Internet, the user/receiver can contribute in the form of original posts, broadcasts, commentaries, editorial inputs, etc.).

The digital commons owes its existence to copy culture, including piracy, hacking, and free sharing. "Commons," a notion derived the history of the European enclosure movement (stretching between the fifteenth and nineteenth centuries), is revived as a positive myth for what the legal scholar James Boyle and his colleagues call the intangible commons of the mind.[8] Social historians have also returned to the idea in the wake of this development.[9] A commons initiative such as Wikipedia depends on collective contribution, scrutiny, and free access. A major development in the area is the free and open source software initiatives.

The common availability of digital tools obviously has played a role in these developments, but there are larger logics of production and governance to consider. The most radical cultural fallout of the latter is the closing of the gap between economic and aesthetic/cultural processes. The logic of informatized production, for instance, requires information to be produced through collaboration. In the service sector, for example, in the case of immaterial labor, information has to be shared and collectively developed, not only exchanged for money. This is a kind of dialectical fallout of what the Italian critics call the informatization of economies.[10] McKenzie Wark, the author of *A Hacker Manifesto* (2004), has recently sought to characterize the period as one of the triumph of "telesthesia," perception at a distance, where the vectors of flow, speed, or processing become a determining force in economy, culture, and social and political action.[11] While the reduction of every bit of symbolic exchange into flows of information invokes ominous specters of exploitation and control, the same processes also end up creating spaces where information gains a morphological license, so to speak. Images, music, and texts are created with handy tools by people who have so far been only receivers (even to participate in electronic forms of governance one ends up working with new media forms). The extension of the image into everyday practices has created a situation where formalization of its principles has become increasingly difficult from the

pedagogical point of view. Sharing, the digital commons in its idealized form, has, on the other hand, begun to create real scopes of collective self-education. Almost every user of a cell phone or a computer now makes and transforms images, sometimes without noticing it; and there is an increasing number of users who improve their skills and their knowledge of image worlds like the cinema through downloads and sharing.

A look at conventional filmmaking today will reveal the extent of unmooring that image and editing have undergone from the principles on which they have been practiced and taught since the first textbooks were conceived. Think, for instance, of the "breathing shot," a handheld camera effect that all sorts of films now use—from serious European films to commercial films in India or Hong Kong. It is a shooting style where the frame seems to be constantly hovering over the object, re-adjusting itself, never settling into a stable composition. It all began with the simulation of the amateur video (in *Dogme*, Wong Kar-wai, or Mira Nair) but has now become a standard convention. This throws an entire body of work dealing with the properties of the shot into crisis. The very limits of the frame, the relationship between on-screen and off-screen spaces, and the ideals of composition that textbooks have inculcated over centuries of image culture are at stake here. The deeper source of this seems to be not so much the home video but the very process of spilling over of images from discrete frames into a continuous social space. What humanities tools could do justice to such processes?

Colleagues from film schools report experiences that are similar to ours in Film Studies departments. They complain that the students do not attend film screenings, and, more important, that they are losing interest in film history lessons, which I suppose points to the question of where to start with digitally self-educated learners. Habits of viewing on computer screens and the large private collections built through sharing are bound to free resources from scarcity and scheduling. The problem with history lessons has troubling implications, but it should also point to a crisis in the film history curricula, which have failed to reflect the mode of access and recall that digital circulation and collections have created. The thoroughly changed status of the contemporary is perhaps reflected in image cultures more concretely than elsewhere. Film history itself, for example, has undergone a thorough reorganization in terms of access and recall, on the one hand, and DVD and Internet-based curatorial intervention, on the other, both of which are based on forms of hyperlinking and lateral connections. The teaching of film history has probably not begun to take this into account. Not just new teaching tools, one should think in terms of the boundary of the institution itself, which is becoming genuinely porous. In this particular sense, the spontaneous self-education of the image practitioner has moved back closer to the quasi-institutional processes that Ray's essay tells us about.

The more critical issue at hand is the increasingly unproductive distance between scholarship and practice in a context where film, in its expanded sense, has become an ordinary language of sorts. Scholarship cannot remain content with diagnoses of film culture without participating in the process of making actual choices and, therefore, in the processes of evaluation that Film Studies, especially in India, has largely set aside. Evaluation, even partisanship in choices, constitutes the first line of contact between film criticism and film practice. One

area where these two have instinctively come together is in what Thomas Elsaesser calls "cinephilia take 2,"[12] a reincarnated cinephilia after the film societies went into decline in the 1980s. The cinephilia of the age of copying and sharing involves widely distributed collective practices of publication (primarily online), small, curated screenings, and constant updating of information. It shows a discord with academic Film Studies, at least that of the South Asian variety, in the sense that it is largely focused on film art, and takes a stand rather than merely producing accounts of cultural dynamics. What is more, it is a discourse created by aspirant filmmakers, many of whom have some hands-on experience with home equipment.

The other formation I mentioned, the "Database," is an organized form of the spontaneous archives that the digital environment constantly produces. It should be understood in relation to an interesting contradiction: while the very basis of the referent becomes indeterminate, loses its body, in digitally produced images because of the new powers of simulation/manipulation, there is a pervasive new investment in the everyday and the ephemeral in the spontaneous documentation in which we all participate now. It looks almost like a new practice of belief in the world. One could reinvoke Satyajit Ray here. Ray wrote one of his earliest essays on film in 1949, for the daily newspaper *The Statesman*. Entitled "National Styles in Cinema," it recalled his experience of traveling with Jean Renoir on the latter's location hunt for his film *The River*.

> "Look at the flowers", said Jean Renoir one day while on a search for suitable locales in a suburb of Calcutta for his film *The River*, "Look at the flowers" he said, "They are very beautiful Look at that clump of bananas, and the green pond at its foot. You don't get that in California. That is Bengal and that is [. . .] fantastic.[13]

"Fantastic" was an adjective frequently used by Renoir, Ray tells us. He finishes the essay by suggesting the following:

> So let us start by looking for that clump of bananas, that boat in the river and that temple on the bank. The results [. . .] may be fantastic.[14]

For Ray and his colleagues in the new cinema movement, the project of capturing the ephemeral and the ordinary, of creating an archive of everyday life, was a means of breaking through dead and oppressive conventions. Let us remember that even though Ray's signal contribution has been recognized in terms of realism, the naturalism that he points to here, an engagement with the effervescent reality of everyday life free from the constraints of narration, played a profoundly liberating role in his early films.[15] It would be useful to recall this in the present context when naturalism has returned to audiovisual forms in a significant way, owing to the compulsion to record the everyday without necessary regard for familiar formal totalities (the return of phenomenology in recent film scholarship could be seen as the obverse of this). The new "form" that corresponds to the fluid archives is the Database, defined not only technically but aesthetically by linkage, montage, and analytical correspondences.[16]

The university has responded to the new conversation between the practical and the analytical in the form of Digital Humanities. The latter is characterized by

practices of the commons and the database as both resource and method. If Film Studies is to stay on as a useful humanities pursuit, this is where the new directions currently seem to lie for it. The more interesting instances of Digital Humanities projects step beyond archive building and concentrate on creating archives as "open content," to be used for creative work as well as research.

I would like to end with an example from something I have been involved with at the Media Lab, a laboratory launched in 2008 to address some of these questions at Jadavpur University, Calcutta. The Lab undertook a project in 2009, moving sideways, as it were, from its usual activities, to document a neighborhood factory. It is one of those numerous factories that have closed down in and around the city, but it held a special interest for us as it used to produce cameras and other sophisticated optical instruments, and also happened to have a long history exemplifying typical Indian industrialism. Having started in 1830, it went through various incarnations before becoming National Instruments Limited (NIL) in 1957.[17] The factory declined in the late 1980s, and shed its workforce steadily until production stopped in 2003. However, NIL did not meet the fate of closed industrial units all over West Bengal, which tend to metamorphose into lucrative real estate. Jadavpur University took over the premises in 2009 to build a new campus.

When we entered the premises we saw not only an industrial ruin but a landscape profoundly imbued with gestating images, not least because strewn all over the place were lenses, binoculars, cameras, sensors, and so on. It was a teeming desolation where machines, tools, clocks, punch cards, workers' overalls, furniture, and files lay everywhere, struck as if by an emergency evacuation. The place seemed to cast a gaze into space, inviting a visual response.[18] We found this to be an opportunity to extend our work into a domain marked by the dynamics of visual production, poised between the old industrial mode (which also gave us the cinema) and the new dispensation where the images are placed seamlessly among everyday objects.

We invited nine photographers/cinematographers and a sound engineer to work on the premises for six months in 2009, capturing the place as fully as possible.[19] The huge collection of stills, video, and sound (including former workers' interviews) was then stored as open content in the Lab for students and independent practitioners to work upon, who have created five films, exhibitions, a blog, and a sound installation so far.[20] The spectrum of the work ranges from documentation of a neighborhood, of a historical episode of labor and manufacture, to a technological history of the photographic image in India, to creative compositions of images and sounds gathered from a history on the verge of erasure. It is difficult to present the scope and nature of the work in print, but I would like to invite the readers to visit the Media Lab website www.medialabju.org for a more comprehensive picture.

The idea of working on a common pool of documents, to arrive from the open-ended protean "shape" of accumulating records to "forms" of work, is what seems to be the shape of practice adequate to the extended cinematic reality in the age of everyday digital image making. The lessons learnt in the Media Lab seem to point to what scholars and practitioners are discovering in many parts of the world: that it is necessary and possible to rethink film education from the premise of the dissolving limits of the cinematic.

Presented below (in figures 9.1–9.18) is a sample of the work of Avik Mukhopadhyay, a well-known cinematographer who participated in the factory project. He shot the images below in an analog format, with a Mamiya 645 camera, using an 80 mm lens and Fuji Neopan 400 ASA film.

Figure 9.1–9.18 A sample of the work of Avik Mukhopadhyay

Figure 9.2

Figure 9.3

Figure 9.4

Figure 9.5

Figure 9.6

Figure 9.7

Figure 9.8

Figure 9.9

Figure 9.10

Figure 9.11

Figure 9.12

Figure 9.13

Figure 9.14

Figure 9.15

Figure 9.16

Figure 9.17

Figure 9.18

Notes

1. Satyajit Ray, "Education of a Filmmaker," *New Left Review*, 1/141, September–October 1983.
2. Ibid.
3. Among whom were Nandalal Bose and Binodebehari Mukherjee, stalwarts of twentieth-century Indian art. Ray made a documentary on the latter, *The Inner Eye* (1972).
4. Ibid.
5. This movement was closely linked to the Calcutta Film Society. Two film clubs were started in Bombay in 1939 and 1942, but the Calcutta society is generally recognized for playing a pioneering role in what was later called the "film society movement," a major force behind the emergence of new Indian cinema heralded by Ray, Ritwik Ghatak et al. For recent accounts of the movement see Rochona Majumdar, "Debating Radical Cinema: A History of the Film Society Movement in India," *Modern Asian Studies* 46.3 (2012); and H. N. Narahari Rao, ed., *The Film Society Movement in India* (Mumbai: The Asian Film Foundation, 2009).
6. Another major film school on the same model came up in Kolkata (Calcutta), the Satyajit Ray Film and Television Institute (1995). These remain the most well funded and prominent among state film schools, offering diploma and certificate courses in direction, cinematography, editing, and sound engineering, sometimes also in acting, and more recently in electronic image production, and production management and design. Among other things, the graduates of these schools have been instrumental in the technical make-over of Indian commercial cinema in the 1990s. Numerous other schools exist, among which are Adyar Film Institute and L.V. Prasad Film and TV academy in Chennai (Madras) and the Whistling Woods International in Mumbai (Bombay). The proliferation of private schools in every part of India has generally meant the development of an exclusive focus on technical education rather than on film history or aesthetics.
7. The Department of Film Studies was established in Jadavpur in 1993. Since then University of Calcutta, Jawaharlal Nehru University in Delhi, Ambedkar University Delhi (AUD), and the English and Foreign Language University in Hyderabad have introduced similar courses, mostly at the postgraduate level. Elements of the discipline have found their way into numerous courses in media and communication.
8. See James Boyle, *The Public Domain, Enclosing the Commons of the Mind* (New Haven and London: Yale University Press, 2008).
9. See, for example, Peter Linebaugh, *The Magna Carta Manifesto, Liberties and Commons for All* (Berkeley, Los Angeles, London: University of California Press, 2008).
10. See Michael Hardt and Antonio Negri, *Empire* (Cambridge, Massachusetts: Harvard University Press, 2000), esp. "Part 3"; and Maurizio Lazzarato, "Immaterial Labour," trans. Paul Colilli and Ed Emery, in *Radical Thought in Italy: A Potential Politics*, ed. Paolo Virno and Michael Hardt (Minneapolis: University of Minnesota Press, 1996).
11. McKenzie Wark, *Telesthesia, Communication, Culture and Class* (Cambridge: Polity Press, 2012).
12. Thomas Elsaesser, "Cinephilia, or the Uses of Disenchantment," in *Cinephilia, Movies, Love and Memory*, ed. Marijke de Valck and Malte Hagener (Amsterdam: Amsterdam University Press, 2005).
13. Satyajit Ray, "National Styles in Cinema," in *Deep Focus, Reflections on Cinema*, ed. Sandip Ray (New Delhi: Harper Collins Publishers India, 2011).

14. Ibid.
15. For a detailed discussion of this, see Moinak Biswas, "Early Films: Novels and other Horizons," in *Apu and After, Revisiting Ray's Cinema*, ed. Moinak Biswas (London and Calcutta: Seagull Books, 2006), 36–79.
16. The most well-known treatment of database as form is to be found in Lev Manovich, *The Language of New Media* (Cambridge, Massachusetts: The MIT Press, 2001), 212–237. See also the essays collected in Victoria Vesna, ed., *Database Aesthetics, Art in the Age of Information Overflow* (Minneapolis: University of Minnesota Press, 2007).
17. The surveyor general of India, George Everest (after whom the Himalayan peak is named), launched the parent unit in 1830 as "Mathematical Instrument Maker" to serve the Great Trigonometric Survey of India. It was christened "Mathematical Instruments Office" and then "National Instrument" before becoming a public sector unit in 1957.
18. For an insightful reading of both the factory and the documentation project see Anustup Basu, "A Memorialization without Destinying: A Revisitation of JU Media Lab's National Instruments Archive Project," *Journal of the Moving Image* 10 (2011), available online at http://jmionline.org/film_journal/jmi_10/article_09.php (accessed November 11, 2012).
19. The names are Nikhil Arolkar, Manas Bhattacharya, Sanjit Chowdhury, Ankur Das, Subhadeep Ghosh, Bhagirath Halder, Sukanta Majumdar, Madhuban Mitra, Avik Mukherjee, and Sourav Sarangi. Some of them are professionals with experience, others independent practitioners at an early stage of their careers.
20. For example, the postgraduate students of Film Studies at Jadavpur were given the scope of exploring the factory premises with their personal cameras for an initial study in 2010. They were then invited to work on the video footage originally collected in the project to make a film for their semester examinations (the 2-year MA program requires a short practical exercise in video production). The outcome is *Under the Skies of Rust*, which can be accessed on www. jadavpur.edu.

Film Schools in the PRC: Professionalization and its Discontents

Yomi Braester

Practical film education in the People's Republic of China (PRC) is growing fast and has reached, by some indications, a moment of crisis as well as of great potential for development and transformation. In fact, the large number of institutions offering practical training, their rich history, and their diverging approaches cannot be fully covered in a single chapter. Speaking of members of the International Association of Film and Television Schools (CILECT) alone, there are four members in the PRC (not including Hong Kong). An ever-increasing number of universities and schools at the national and provincial levels teach some version of media production, hopping on a bandwagon of student demand, fueled by the explosion of visual media venues.[1]

The surging market places the PRC in a situation markedly different from that in other countries discussed in this book. Following an ominous slump in the late 1990s, Chinese film has made a spectacular comeback and has become commercially viable, following the Hollywood blockbuster model. More importantly, TV has grown exponentially, reaching more than 3000 nationwide and provincial channels. As a result, training in film is a coveted commodity and graduates are practically assured of employment. At the same time, however, film and TV are strictly controlled by the government. Students dissatisfied with making eye candy have few options, with notable exceptions of independently funded filmmakers who rely on the international film festival and art-house scene. Film schools concentrate on technical skills at the expense of creativity.

Film educators in the PRC are, for the most part, aware of the pitfalls and try to provide solutions. In this chapter I describe how the pedagogical and institutional challenges have been taken up, both within the state-approved system and outside it. I focus on the two institutions that represent the edges of the spectrum. On the one hand, the Beijing Film Academy (BFA) is acknowledged by the government and by the film industry as the prime training ground in the PRC. On the

other hand, Wu Wenguang's Caochangdi Station and Li Xianting's Film School (henceforth LXFS) are unaccredited institutions and have repeatedly incurred the authorities' disapproval. The juxtaposition of these extremes is not intended to condemn one or to show the weaknesses of the other, but rather to foreground the unique set of constraints within which each operates.

It is especially noteworthy that the BFA—the official flagship—and the maverick schools under Wu Wenguang's and Li Xianting's auspices share fundamental concerns. All three have been trying to balance technological knowledge with a deeper understanding of the wherefore of filmmaking. The BFA is requiring students to ground their skills in humanistic knowledge of literature and philosophy; Wu Wenguang's studio and the LXFS emphasize observation of daily life and choice of subject matter in the belief that camera savvy will likely follow, and in any case is secondary to the subject matter. The perceived need for urgent reform and opening up new paths for practical film education is indicative not only of current social trends in the PRC but also of changing approaches to filmmaking worldwide.

The Beijing Film Academy: The Price of Success

The sense of crisis is better understood against the background of the BFA's reputation for its graduates' success and unrivalled status until the early years of the twenty-first century. The BFA is now a world leader in film education. It is the largest film school in Asia, with more than 4000 students and 280 faculty members. It admits 700 to 800 students a year out of more than 20,000 applicants and is considered among the most prestigious universities in China.

The BFA now comprises specialized departments and schools for directing, cinematography, photography, sound recording, acting, fine arts (set design), animation, film and TV technology (digital media), management, teacher training, and literature (scriptwriting and film theory). About 1500 students are enrolled in these programs, in addition to those in the divisions of vocational studies (ca. 550 students), graduate studies (MA and PhD—ca. 350 and 35 students respectively), continuing education (ca. 60 students), and the international school for foreign students (ca. 60 students). Many of these schools offer multiple disciplines and tracks. The BFA has placed itself as the national center for research in animation, video, and children's film, and it publishes a number of journals. The BFA maintains close relations with other top institutions of higher learning in the PRC and abroad. In particular, it has recently enhanced its international profile by strengthening its position in CILECT. The BFA has been a member of CILECT since 1984 and has chaired since 2002 the Asian Pacific group of CILECT. Since 2001, the BFA has held the International Student Film & Video Festival (ISFF), which came under the aegis of CILECT in 2006.[2]

The BFA's centrality to PRC higher education is better understood in historical context. In the 1950s, soon after the founding of the PRC, the Film Bureau of the Ministry of Culture founded the Performance Art Institute, which after several name changes was inaugurated as the Beijing Film Academy in 1956.

At first, higher education in the PRC took after the centralized system in the Soviet Union, and the BFA was modeled after the Gerasimov Institute of Cinematography (VGIK). In this capacity, the BFA has been the one-stop provider of all film training in the PRC. Over 90 percent of the professionals in the Chinese film industry are BFA graduates, and the BFA enjoys the aura rooted in its historical role in training many of China's most famous filmmakers.[3]

The BFA is often associated with the reputation and success of the class of 1982, better known as the Fifth Generation. The spectacular ascendance of the Fifth Generation is the stuff of legends. They were the first to be admitted into the BFA after the long and bleak lull of the Cultural Revolution, during which the academy practically ceased all activities. When it reopened in 1977, the BFA underwent a thorough curricular revamping. It departed from the Soviet model of specialization, requiring instead a basic curriculum for all students and emphasizing cross-disciplinary training. The immediate beneficiaries were the students, who included many future leading film professionals, among them about a dozen prominent directors such as Zhang Yimou, Chen Kaige, Tian Zhuangzhuang, Li Shaohong, and Gu Changwei. Their education is detailed in Ni Zhen's translated autobiographical account *Memoirs from the Beijing Film Academy*. Ni describes a unique combination of rigorous formal studies, inspiring extracurricular education, and fortuitous on-the-job training. The highly motivated young students shared with their teachers a perception of newfound freedom and a mission to transform Chinese film. They worked in an environment that encouraged close collaboration. Provincial studios were eager to use their talent and gave them the opportunity to make their own films soon after graduation. The Fifth Generation is credited with the renaissance of Chinese cinema and its worldwide renown.[4]

The heady 1980s came to an abrupt end in June 1989, after which the PRC education system underwent a transformation characterized by closer political monitoring, sweetened by abundant government funding. The BFA has been supported generously and offers students the chance to work with up-to-date, industry-standard equipment. For example, the cinematography department alone received in the 2009–2011 biennium 17 million yuan. In addition to a large number of 16mm and 35mm ARRI cameras, the department owns professional SONY HD and other cutting-edge digital cameras, such as Red One. Likewise, students of animation and special effects avail themselves of advanced labs.

The BFA continued to offer rigorous and highly professional training. With time, the academy added training for TV and commercials, as well as majors in related topics such as still photography, theory, and management. Students go through an intensive curriculum, comprising many more contact hours than at institutions such as UCLA and NYU. Students must take all required courses on time, and no extensions are granted. As a result, students graduate in exactly four years, ready to go on the job market. To a large extent, the academy fulfills the mission statement in the BFA handbook: graduates "should have the knowledge and capability in comprehension of literature, art theories and history; good taste in aesthetics and art appreciation; systematic knowledge of the basic rules of film and television directing; [and] video and audio expressive skills."[5] Walking through

the BFA campus today, one can feel the vibrancy of a well-managed institution attended by motivated and gifted students.

Challenges from within the BFA

The BFA, however, is suffering from the shortcomings of the PRC higher-education system. A public controversy, centered on reform at Peking University in 2003, exposed the tension between more conservative, humanities-oriented faculty and a foreign-educated cadre focused on efficiency.[6] As a vocational school, the BFA is even more vulnerable to the clash between cultural edification and commercial professionalization. The BFA has adapted well to the contemporary commercial media environment, at the risk of becoming a victim of its own success.

Those who associate the BFA with its historical role—including many of its veteran teachers who graduated in the 1980—may find themselves estranged in the academy's current state. The giddy sensation of reinventing film education that accompanied the academy's re-opening in 1977 has given way to streamlined professionalism. The Fifth Generation has come to represent the BFA's spirit. But the Fifth Generation also benefited from unique conditions. The intimate study environment of the charismatic stage resembles little the large school of today, which relies on standardized exams, nurtures industry connections, and toes the party line.

The challenges start already at the stage of student admission, given prospective students' backgrounds and expectations and the tools available to the BFA for assessing applicants' qualifications. Like all PRC colleges, the major criterion for admission is the score in the National Higher Education Entrance Examination, known in Chinese as the *gaokao*. This standardized test is often blamed for maintaining a rigid high school curriculum geared toward quantifiable results. High scorers choose top universities not only for their academic environment but also because their diplomas offer entry to the technocratic elite. As a top-tier school, the BFA is assailed by overachievers. These students elect to graduate in film, not necessarily because they are interested in cinema, but rather because they perceive graduation from the BFA as a sure ticket to a lucrative career. For brand-conscious urbanites, the BFA has become primarily a seal of prestige. Young filmmakers outside the BFA often speak dismissively of the academy's students, for whom school is "just a fashion show. They have no true interest in art."[7]

Teachers and administrators at the BFA, as in other institutions of higher education, strive to minimize the systemic problems. They try to balance the standardized admission process by also introducing criteria measuring aptitude for filmmaking. Yet the BFA administrators have found out that testing for prior knowledge and skills may not be effective in predicting creativity. The system used to be very elaborate—applicants to the cinematography department in 1977, for example, were required to undergo 14 BFA-specific exams. The process has now been simplified, and the admission exam focuses on basic observation and expression skills. The most dreaded of these is an essay based on viewing a Chinese

film, causing so much anxiety that its contents have sometimes leaked in advance; the film to be screened is now a well-guarded secret.

Once students are admitted, the curriculum must compensate for their handicap of having gone through the standardized high school preparation. The younger generation is at ease with wired media but its knowledge is otherwise limited to the materials covered by the *gaokao*. They are exposed to only a few literary works and regurgitated Marxism-Leninism for philosophy, and they lack the humanistic background that the BFA deems necessary. In response, the BFA has introduced since 2010 mandatory courses in Chinese literature, Western philosophy, world religions, and composition—even for photography majors. This constitutes a major shift for a school that has long emphasized hands-on experience and marginalized the literature department for being too theoretical.

Film history classes have also been revamped. Instead of dry survey courses, they now often focus on themes, comparing, for example, last-minute-rescue sequences from various films. Given the political atmosphere, students' thought is not likely to be radically challenged, but by graduation they are pushed toward formal innovation and an understanding of broader contexts. The core of the BFA's curriculum and its pride has remained highly professionalized technical skills— yet that, too, calls for compromises due to the structure of the media market. The BFA's major success in recent years may be its ability to prepare students through hands-on training, to the point where they are qualified upon graduation to undertake any job in their profession. A cinematography graduate, for example, is in theory ready to function right away as a film's director of photography. Such positions, however, are rare. The independent industry is at an incipient stage; state-owned film studios employ mostly in-house teams and are very territorial. Entry-level jobs are far less glamorous, and most graduates end up on the sets of TV series or commercials. Teachers have recognized the issue—in fact, since they can hardly live off their salaries, about 80 percent of the faculty also engage in making films and commercials. They openly tell their students, "you may not become a great director, but at least you'll have your bowl of rice [to eat]." It seems that the rapid commercialization of the film and television industries has placed artistic vision and technical skills at two opposing rather than complementary ends of film pedagogy at the BFA.[8]

The challenges posed by the score-driven education system and a changing mediascape are compounded by tightening political control. Many barriers are erected through self-censorship, since the administrators are loath to go outside the government's comfort zone and to risk the generous cash flow. In addition, institutions of higher education have experienced in the recent decade growing intervention by the party apparatus. The few outspoken teachers at the BFA have been marginalized and even forced out. Cui Zi'en, the dean of queer film in China, collects his paycheck from the BFA but has been barred from teaching; Cui Weiping, a prominent film critic and a signee of the human rights manifesto known as Charter 08, was increasingly sequestered until her retirement in 2011. Zhang Xianmin, one of the most active proponents of independent cinema, has kept his position as a screenwriting teacher by carefully avoiding sensitive subjects. A firewall has been effectively set up between the BFA and the vibrant independent film scene.

Practical Film Education at Other Accredited Institutions

The BFA's primacy notwithstanding, other institutions have also played an important role in training personnel for the film industry. Since the turn of the twenty-first century this trend has grown to the point of challenging the BFA's leadership and even taking over in specific areas, in particular TV studies.

A symbolic indication of the BFA's waning position may be found in the tenuous affiliation of China's current leading directors with the academy. Whereas in the 1980s the BFA graduates took the country by storm, popular directors now come from other backgrounds. Jiang Wen, a contemporary of the Fifth Generation, was not admitted to the BFA and graduated from the Central Academy of Drama (CAD), as did Zhang Yang; Feng Xiaogang started his career in TV productions. Of the less commercial but critically acclaimed directors, Jia Zhangke studied at the BFA, but not as a regular college student. Instead, he came to the BFA for an MA in screenwriting. Liu Jiayin, who now teaches at the BFA, also studied in the relatively marginalized literature (screenwriting and theory) department; Zhao Liang graduated from the CAD, and Ying Liang from the Chongqing Film Academy. The BFA may have been the "cradle of Chinese film," but it is no longer the only option for those who wish to receive practical film education in the PRC.

The first wave of competing institutions came soon after post-Maoist reforms were launched. Zhejiang University of Media and Communications (ZUMC), established in 1984, has a wider mandate than film education. In addition to the School of Film & Television Art, it now includes the schools of Journalism & Cultural Communications, Media Management, International Cultures & Communications, Electronics & Information Engineering, Music & Dance, Media Arts & Design, Social Sciences & Humanities, and Chinese Announcing & Anchoring. It has over 700 staff and 9000 full-time students. Like the BFA, ZUMC is a full member of CILECT.[9]

In 1995, Shanghai University established its School of Film and Television Technology, helmed by the veteran director Xie Jin. The school's website makes clear its ambitions to offer a full curriculum:

> The School of Film and Television Technology has been dedicated to cultivating inter-disciplinary talents working in trades like film and television editing and directing, production of films and television programs, audiovisual technology, media communications and advertisements for enterprises and government agencies in Shanghai and other provinces or cities. In addition to a workshop for television production, the School is currently composed of four departments, namely Film and Television Art, Film and Television Technology, Media Communications and Advertising and offers three doctoral programs in Filmology, Communications and Technology and Application of Digital Media, seven master programs in Radio and TV Art, Communications, Filmology, Journalism, Arts, Drama, and Technology and Application of Digital Media, and five bachelor programs and three specialties in Radio and TV Editing and Directing, Radio and TV Journalism, Art and Technology of Film and Television, Art and Technology of Film and Television (specializing in animation), Advertising, Art and Technology of Exposition Industry, Exposition Planning and Managing, and Art Design (specializing in ad originality).[10]

The long-standing rivalry between Beijing and Shanghai seems to be playing out in film education as well. Whereas the BFA enjoys the aura of a more scholarly establishment with a national mission, Shanghai University presents itself as more dynamic and tied to the local media industry. It boasts close collaboration with the Shanghai Media & Entertainment Group (SMEG), which has, in turn, placed itself as a more autonomous alternative to Central Chinese Television (CCTV).

The BFA's status has been changing more dramatically since the early 2000s. In 2000, a second academy, the Meishi Film Academy, was founded as a school of Chongqing University. It is sponsored by the Hong Kong-based Meishi Electric Power Group. Its structure is similar to that of the BFA, but its scale is much smaller. At present it employs some 70 full-time lecturers and enrolls 1000 full-time undergraduate students and 80 MA students.[11] Perhaps the most indicative of the changing relationship between mass media and higher education in film is the success of the School of Television and Film Art at the Communication University of China (CUC), established in 2002 and a full member of CILECT. The CUC now has over 1000 BA students, 170 MA students, and 120 PhD students. It has over 160 faculty members and is considered the leading school for Radio and TV studies. Like the BFA, it has a complete and integrated curriculum, including Literature and Art, Radio and Television Literature, Directing and Performance, Photography, Fine Arts, Music, and Recording, in addition to a large school of animation. The attractiveness of the CUC program is largely due to its focus on television.[12]

Institutions offering practical film education are proliferating. A partial list includes Tongji University in Shanghai, which opened its film school in 2003; the Shanghai Institute of Visual Art (SIVA) and its College of Media Art, which have been operating since 2005; as well as provincial TV schools operating in Hangzhou, Taiyuan, and Guangzhou. Existing art academies have also branched into film education. The Central Academy of Drama (CAD) is a full member of CILECT; the China Academy of Art (CAA) in Hangzhou inaugurated a department of New Media Art in 2003; and the China Central Academy of Fine Arts (CAFA) in Beijing started an experimental video program in 2005.[13]

Insofar as it is possible to assess the impact of these recent developments, they seem to create a benign form of competition. Indeed, the BFA's current growth may be understood partly as a response to the challenge posed by other institutions. Yet the various film education schools face similar programs. Their curricula are geared to produce highly skilled but not necessarily inspired graduates, whose goal is immediately to enter the lucrative media market.

Film Education outside the State-Run System

While the state-run schools have put together efficient programs for professional training, the institutional shortcomings have been noted by students and filmmakers with less of an inclination to conform. The emphasis on technical skills; the requirement to pass the uniform college exams; the intensive four-year curricula; and the political surveillance in state schools are deterring factors for many aspiring filmmakers who do not wish to, or cannot, comport with the

streamlined PRC education system. Some lack funding, others have already grad-
uated from college and found work, and some have an attitude that does not fit
the official school system. At the same time that the BFA, the CUC, and their
likes established their reputation and curricula, demand also grew for alternative
training venues.

Two independent venues stand out: Wu Wenguang's Caochangdi Station and
the Li Xianting Film School. These two operate along very different lines, but they
share a radical rethinking of how filmmaking is taught and for what purpose. Their
existence demonstrates a perceived need for nonacademic approaches to film edu-
cation. Furthermore, their business model—that is, not-for-profit, supporting ad-
hoc projects, sustained by donations from international foundations and wealthy
artists, and encouraging aspiring noncommercial filmmakers—underlines a
strong commitment for a community sustaining alternative independent cinema.

The Caochangdi Station does not even describe itself as a film training pro-
gram as such. Located in the northwestern Beijing suburb of Caochangdi, it hosts
a number of nonprofit projects, most notably the China Independent Documen-
tary Film Archives (CIDFA)—a platform for collecting, screening and discussing,
distributing, researching, and funding Chinese independent documentary films—
and the China Folk Memory Image Archives (CFMIA), discussed below. The man
who envisioned, launched, and managed these projects is Wu Wenguang. Wu has
little formal training in filmmaking—he worked as a TV reporter in the 1980s and
started his career in film by documenting the avant-garde art community in East
Village in the 1980s. His groundbreaking documentaries have won him interna-
tional recognition, and his artist friends, some of whom are now very wealthy,
support Caochangdi Station.

In 2005, with funding from the EU-China Training Programme on Village Gov-
ernance, Wu launched the Villagers' Documentary Project. Villagers of all ages
and backgrounds were encouraged to apply. The ten chosen participants were
given a short training program lasting about a week and focusing on how to use
camcorders, which were then lent to them. The participants returned to their
home villages and recorded the incipient initiatives for local elections and self-
governance. The project, first designed for a single year and geared toward a single
film, is still continuing—some villagers have kept making films, with advice, tech-
nical support, and editorial guidance from Wu's studio. In 2010, Wu Wenguang
launched a separate undertaking, titled the Folk Memory Documentary Project.
In its current form, the project focuses on providing an oral history of the Great
Famine of 1958–1960. Wu has enlisted 12 young people from all over China to
record testimonies about the famine, resulting in about half a dozen films so far.
The projects are process- and result-driven, rather than general training courses.
They emphasize the importance of creating an archive of visual and oral histo-
ries that parallels, and often counters, official accounts. Many of the participants,
especially the younger ones, now express an interest in continuing to make films,
and CIDFA may facilitate their future projects. Yet the Caochangdi Station does
not presume to provide a rounded film education. Filmmaking is only a means
for creating a visual archive to preserve collective memory, and film training is the
by-product of Wu's community-building efforts.[14]

Like Caochangdi Station, the Li Xianting Film School has its roots in the avant-garde community of the 1980s. It grew out of a film screening venue located in Songzhuang, a town 20 km east of Beijing that has attracted artists since 1994, when the artist communities at East Village and Yuanmingyuan were evicted. Li Xianting, the school's founder, is a leading art critic who was among the first supporters of Songzhuang's artist community. His connections with artists who have struck it rich allowed him to raise funding for his nonprofit initiatives, resulting in the Li Xianting Fund. Li first envisioned establishing an alternative arts school, but failing to do so, he turned to independent filmmaking in 2004. Li recognized in the independent film movement of the 1990s the same elements that made the plastic arts in the 1980s so vibrant. China's independent filmmakers work against all odds, with no commercial incentive but, instead, with constant harassment from the authorities.

Given that experienced teachers are all affiliated with professional academies, Li took advantage of the growing community of filmmakers in Songzhuang, which gathered around the China Documentary Film Festival (DOChina), founded and organized by Zhu Rikun. Li joined forces with Zhu. When the Li Xianting Fund was established in 2006, Zhu became its manager and launched an array of activities, including the Beijing Independent Film Festival (BIFF) and a comprehensive archive of PRC independent films. Zhu was also responsible for putting together the Fanhall Films Arts Center (Xianxiang yishu zhongxin) in Songzhuang, which includes a workshop, a film theater, a café, and a website (the latter has been shut down by the authorities). LXFS was the latest, though long-planned, stage in the fund's multifaceted activities.

Parenthetically, notwithstanding Li's support, funding remains a constant concern. The Li Xianting Fund paid for the first seminar, but it has since relied mainly on student fees, set at 5000 for the full 40-day series of classes and prorated for shorter periods. Some students bring their own equipment; more cameras, donated by the Li Xianting Fund and by independent directors, are available for loan. The Li Xianting Fund has focused on helping those who have already graduated from LXFS to make their films.

Li's experimental film school rose out of the perception that the state-run academies of art and film were centered on technique rather than on expressing ideas. Whereas the BFA and other vocational schools prepare their students for filmmaking as a profitable line of work, the LXFS regards filmmaking as a tool for conveying a message. Setting out from a topic to explore, students find out how to film it during the process of shooting. LXFS emphasizes what it calls "a spirit of independent creative production" (duli chuangzuo jingshen).[15] Ying Liang, a filmmaker and an instructor at LXFS, bluntly states that filming technique is not difficult and can be acquired while making films. Filmmaking, according to Ying, can be grasped by people from all walks of life. What LXFS wants its students to receive—"receive, not study," he emphasizes—is how to express one's feelings. "That part cannot be broken down to directing, editing, cinematography and sound recording; it must begin with life experience, through exploration, using one's own eyes and ears." Ying adds: "In this learning system, addressing film [technique] isn't as important. What's more important is life at large. I have to face my

inner soul."[16] Diao Dingcheng, an LXFS graduate and now its program coordinator, sums up his experience in the school: "It taught me how to make judgments, increased my social awareness, and taught me how to address larger questions."[17]

Wang Wo, an experimental video artist who has taken part in leading the LXFS, is especially outspoken on many social issues, including film's role in challenging conventional wisdom and accepted values. This is what he says:

> As far as independent thinking is concerned, I feel that everyone has a natural ability to think for oneself. While it may at times be restricted or suppressed, this ability still exists. All we need to do is create a space for this type of thinking and expression and it will naturally emerge We're not going to tell you what "independent thinking" is, or that you have to think more independently; we simply offer a place for students to explore, and then see how they respond to the opportunities that this environment creates.[18]

In an educational environment that stresses teachers' guidance, Wang's emphasis on gaining independence is a powerful statement.

The LXFS is a miniscule guerilla operation in comparison with the state-run academies. And yet its visibility has increased dramatically in recent years, as domestic blogs and foreign media have reported on it as a vibrant nonacademic alternative. Whatever its future holds, its success at present demonstrates a new conception of film education in the PRC.

An Alternative Curriculum: The LXFS

The LXFS presents an alternative to the state-run academies, through radically different recruiting practices, course structure, and extracurricular activities. To achieve its pedagogical goals, the LXFS instructors have experimented with and developed the curriculum through the years. The "training classes" (*peixun ban*), as they are called, consist of intensive seminars, 30 to 40 days long. The current mix of courses combines basic skills training and courses encouraging individual expression. Students receive instruction in photography, sound, and editing. In addition, Li Xianting has taught major movements in twentieth-century Chinese art; Zhang Xianmin lectures on the past decade in Chinese independent cinema; Beijing-based independent filmmakers, including Feng Yan, Liu Yonghong, and Cui Zi'en, have given classes; Wang Hongwei, who starred in Jia Zhangke's early films, leads an acting and performance workshop. Zhu Rikun has addressed the political aspect of filmmaking in China.

At the core of the curriculum is a series of assignments that calls for the students to go out on the streets of Songzhuang, engage with the community of villagers and artists, and pick out objects for shooting. The resulting films—observing, for example, a local school or a vegetable seller—are screened for classmates and teachers to comment on. In an atmosphere radically different from the state-run, hierarchy-based academies, students and instructors sit together in class after hours and discuss the films as equals. (The students live in dorms on site, and the

leading instructors reside in Songzhuang.) A capstone project is comprised of a short film in any genre—documentary, narrative, or experimental.

The structured core curriculum serves, however, only as a template. Formal studies are pursued only when deemed most beneficial. The teachers take pride in pointing out the program's flexibility: in some cases, they encourage students to stop attending classes and to immerse themselves in filming their chosen subject in Songzhuang. Even though LXFS is an around-the-clock experience, it differs from academic curricula that include intensive projects requiring students sometimes to stay in their labs for weeks on end. Instead, the students in Songzhuang are encouraged to pause and define their goals.

The unorthodox pedagogy has attracted a steady number of students. The first class started on August 7, 2009. Three more classes were offered that year and a further three in the following year. Seminars planned for winter and spring 2011 were canceled for financial and political reasons. (The period 2010–2011 witnessed tightened political control, leading to Zhu Rikun's withdrawal from the Li Xianting Fund.) At the time I last visited LXFS in July 2011, the seventh LXFS class was underway. The first seminars were 30 days long; they were later extended to 40 days. The teachers openly acknowledge that the course is too concentrated, without ample time for absorbing and processing the lessons. However, an attempt to offer a two-month course did not draw enough students (the number of participants in a class has ranged between nine and 30).

Given the small niche carved out by the LXFS, it is of special interest to understand the makeup of the student body. The LXFS does not publicize its activities widely—it is neither equipped for large classes nor allowed by the authorities to operate freely. The LXFS appears in no government publication, of course. Its only way to recruit students is by word of mouth, through people who frequent Fanhall film screenings. The organizers have also placed flyers in art spaces and inside the DVDs sold under the quasi-underground Fanhall label. Anyone willing to pay the tuition fees (at 5000 yuan, affordable for middle-class urbanites) is welcome to join.

The LXFS grants no formal degree or official diploma. Unlike the state-run academies, the Li Xianting Film School does not provide its graduates with inroads to the film industry. The participants are aware that they will make independent—and likely unprofitable—films. And yet, students from 20 to 60 years old, of various educational and social backgrounds, have attended.

The July 2011 class may be taken for a representative sample. Of the 24 students I have interviewed, about a third had no practical film experience but were drawn to the LXFS for its connection to independent film. One student said, "I heard that in this school people dare to do anything, so I came over." Most of them had gone to college or were still completing their formal studies in various fields, including accounting, linguistics, literature, and fine arts. The rest of the class already had considerable experience in relevant fields—a 3D designer, for whom it was the third seminar at the LXFS; students and practitioners of experimental video and performance art; a journalism major; two activists from Pink Space—an LGBT rights NGO—who were preparing to use video to promote the cause of Pink Space; a graduate from the Photography Department of the BFA; a photography

teacher who graduated in Communications from the Zhejiang Academy of Fine Arts; and three Film and TV Studies majors from the Hong Kong Academy for Performing Arts (APA), on a four-month exchange program with the LXFS. The school is proud of the students' diverse backgrounds. All students expressed an interest in becoming independent filmmakers. When I mentioned that a BFA professor admitted that the BFA's goal is to prepare students who can "have a bowl of rice," Ying Liang said, "the students here don't have rice to eat, or don't need to eat."[19]

The LXFS is still under threat. Zhu Rikun, who supported independent films highly critical of the government such as *Karamay* (Xu Xin, 2010), was compelled to leave in 2011. The school was then run by Ying Liang and Wang Wo. Yet Ying, while teaching at the APA in Hong Kong in 2012, received threats to himself and his family over his last film, *When Night Falls* (2012).[20] He is likely to stay outside the PRC for a while.

Even as the PRC enjoys a thriving media market and abundant funding for state-run schools, there are striking similarities with other countries surveyed in this book. Students' eagerness to make films must be balanced by acquainting them with milestones in film and by instilling in them a film-historical awareness. In significant ways, film education is becoming easier, as digitization has made film copies and filming equipment affordable. Yet students may also be misled by the accessibility of materials, seeking immediate entry into the niche market requiring high-end technical skills. The main task of educators is to help students to put a foot in the door of a competitive film and TV industry and at the same time stem their eagerness for mindless professionalization.

Any educational institution should, of course, set up a supporting network, one that extends after graduation and beyond any specific cohort. Such networks operate not only at established schools but also, perhaps even more markedly, at places like Caochangdi Station and the LXFS. Mutual help among independent filmmakers is vital for their survival, and, as is emphasized, a pedagogical tool. Independent filmmakers and film educators alike leverage the scarcity of means to forge a distinct style and a counterhegemonic aura—akin to the strategies of what Mette Hjort has called "minor cinemas."[21] The need to collaborate and improvise in the face of limited human and financial resources generates a support group that is invaluable for the PRC's beleaguered independent film circles.

Notes

1. For comprehensive surveys of film education in the PRC, see Ji Zhiwei, et al., eds., *Zhongguo dianying zhuanye shi yanjiu: Dianying jiaoyu juan* [Historical Studies in the Chinese Film profession: Volume on Film Education] (Beijing: Zhongguo dianying chubanshe, 2011); Zhang Huijun, et al., eds., *Chuancheng yu shuli: Gaodeng dianying hiaoyu yanjiu* [Transmission and Grooming: Studies in Higher Education in Film] (Beijing: Zhongguo dianying chubanshe, 2006).
2. Zhong Dafeng, ed., *The Status Quo and Trends in International Film Education: Beijing 2008 Interviews on CILECT Film Education* (Beijing: BFA internal publication, n.d.); BFA official website, http://www.bfa.edu.cn (accessed August 1, 2011).

3. On BFA, see Stéphane Bergouhnioux and Jean-Marie Nizan, *A l'intérieur du cinéma chinois* (TV documentary, Cinétévé, 2008); Lu Hua, ed., *Dianying ren de chengzhang: Beijing dianying xueyuan bodaoxi zhuren zhi xueyuren tan* [Growing to Be Filmmakers: Talks with BFA Department Heads and Pedagogs] (Beijing: Zhongguo dianying chubanshe, 2007); Lu Meng, *Beijing Dianying xueyuan zhi* [BFA Gazette] (Beijing: Beijing dianying xueyuan, 2000); Sun Xin and Gao Yu, eds., *Shi shuo: Beijing dianying xueyuan boshisheng daoshi fangtan lu* [Teachers Speak: Interviews with Ph.D. Advisors at BFA] (Beijing: Zhongguo dianying chubanshe, 2010); Zhang Huijun, et al., eds., *Dianying Yaolan: Beijing dianying xueyuan de xiandai tonghua* [The Cradle of Cinema: The Modern Fable of BFA] (Beijing: Zhongguo qingnian chubanshe, 2010).

4. Ni Zhen, *Memoirs from the Beijing Film Academy: The Genesis of China's Fifth Generation*, trans. Chris Berry (Durham and London: Duke University Press, 2002). See also Paul Clark, *Reinventing China: A Generation and Its Films* (Hong Kong: The Chinese University of Hong Kong, 2005).

5. Maya E. Rudolph, "Chinese Cinema's Future Faces: The Power of the Old School," http://dgeneratefilms.com/critical-essays/chinese-cinemas-future-faces-the-power-of-the-old-school/#more-7169 (accessed August 1, 2011).

6. Jianying Zha, *Tide Players: The Movers and Shakers of a Rising China* (New York, NY: New Press, 2011), 97–137.

7. Rudolph, "Chinese Cinema's Future Faces."

8. I thank BFA faculty for informal discussions on these issues.

9. See the Zhejiang University of Media and Communications (ZUMC) official website, http://218.75.124.141:8090/zjcm_eng.

10. "Brief Introduction" to the Shanghai University School of Film and Television, http://www.shu.edu.cn/Default.aspx?tabid=8950 (accessed May 20, 2012).

11. See the official website of Meishi Film Academy of Chongqing University, http://www.msfilm.cqu.edu.cn/xygk/aboutus.html (accessed May 20, 2012).

12. See the official CUC website, http://www.cuc.edu.cn (accessed May 20, 2012).

13. See the official websites for SIVA, http://www.siva.edu.cn; CAD, http://web.zhongxi.cn/xjj2/cjyxe/5588.htm; CAA, http://eng.caa.edu.cn; CAFA, http://www.cafa.edu.cn (accessed May 20, 2012).

14. I thank the Caochangdi Station project participants for their open discussion with me and my students on July 14, 2011. See also the CIDFA website, http://www.cidfa.com/archives (accessed May 20, 2012).

15. Benny Shaffer, "Philosophies of Independence: The Li Xianting Film School," *Leap* 8 (April 28, 2011), http://leapleapleap.com/2011/04/philosophies-of-independence (accessed May 20, 2012).

16. Ying Liang, in a discussion among LXFS teachers and students with the author, July 26, 2011. All the following unreferenced details on LXFS are based on this and other more informal discussions with the school's teachers and students, to whom I offer my sincere thanks.

17. Shaffer, "Philosophies of Independence."

18. Ibid.

19. Ying Liang, discussion with the author, July 26, 2011.

20. Ying Liang, "Nothing about Cinema, Everything about Freedom," http://dgeneratefilms.com/china-today/nothing-about-cinema-everything-about-freedom-by-ying-liang/#more-9872 (accessed May 20, 2012).

21. Mette Hjort, "Dogma 95: A Small Nation's Response to Globalisation," in *Purity and Provocation: Dogma 95*, ed. Mette Hjort and Scott MacKenzie (London: British Film Institute, 2003), 31.

Film Education in Hong Kong: New Challenges and Opportunities

Stephen Chan

For close to 30 years since the late 1960s, the company known as Television Broadcasts Limited (TVB) offered the best training ground for a diverse range of talented film practitioners, who in turn worked creatively and independently, enabling Hong Kong cinema to leave its marks on global cinema. For example, the famous in-house screenplay workshop at TVB was first taught in 1971 by Michael Hui, the comedian-turned-filmmaker. After completion of the training course, many participants stayed on to become creative directors at TVB in subsequent years. Some of the most talented graduates were Ng Yu, Wai Ka-fai, and Wong Jing, to name just a few. Turning out talents and professionals for the film industry, with stars ranging from Chow Yun-fat to Johnnie To, TVB demonstrated a unique institutional capacity to develop a creative space and, almost programmatically, to nurture the distinctive practices of filmmaking required for the art and business of cinema to grow during the 1970s and 1980s. Various filmmakers who would become household names of the Hong Kong cinema during the 1990s—that is, celebrities such as Kam Kwok-leung, Clifton Ko, Johnny Mak, Wong Kar-wai, and Raymong Wong Bak-ming—spent some of their early professional years at TVB. In 1985, it was reported that the amount of investment TVB put into training was on average HK$1.2 m (US$ 154,000) per year, generating a total of 20,000 hours of in-house instruction in TV/film practice. According to the study of Po-yin Chung, the percentage of TV-trained professionals (1970–1984) who grew into film prac- titioners in the industry increased from 0.85 percent in 1970 (1 out of 118 films made), to 10.52 percent in 1976 (10 out of 95 films made), to 30.2 percent in 1984 (32 out of 106 films made).[1] This powerful, if unintended, institutional role of TVB as a pedagogic agency faded since the late 1980s, despite the fact that, along with a couple of other local entertainment companies, TVB continued to conduct in- house training for targeted human resources deemed essential to ongoing business needs.

In the meantime, public policies for cultural development and education have made limited progress in Hong Kong, regardless of the historical transition of the territory from British colonial rule to Chinese sovereignty as a Special Administrative Region (SAR) since 1997. It has now become clear that the impacts of globalization, and the opening up of the market on the Chinese mainland (with a resulting influx of capital), have brought new questions and implications for the SAR's postcolonial fantasy to be "the world city" of not just China but Asia. Given these changes, the Hong Kong film industry has encountered deep-rooted problems and undergone significant adjustments since the 1990s, prompting initial discussions of a film policy. In the last decade, critics and community leaders in the cultural sector began to call on the SAR government to prepare its people for the new challenges of the twenty-first century by means of a long-term cultural plan. Some have advocated support for creating a social environment in Hong Kong that would be more generally conducive to creativity. Others, possibly with a less optimistic vision, have advocated a "back to basics" approach that emphasizes the need to nurture humanistic values in pedagogy alongside the recognition of contemporary social needs, for the teaching and learning of a modern-day cultural literacy in the "dying" city.

Against this background, in this chapter I shall examine the opportunities for film education in Hong Kong by looking at some of the factors and constraints pertaining to existing school practices. Using this perspective, the aim is to explore the way in which sustainable changes focusing on the development of Hong Kong's film culture may be achieved through education. The case in point is the recently established Jockey Club Cine Academy (JCCA), a new three-year initiative set up by the Hong Kong International Film Festival (HKIFF) Society with a private donation. The JCCA focuses on the provision of film-related educational experiences through semistructured programs and workshops aimed at secondary school students, via the mediation of teachers and peers drawn to the HKIFF activities.

Three to four decades ago, TVB was able to attract a flow of overseas-trained young film practitioners who returned to Hong Kong looking for work opportunities at a time when there were few formal educational opportunities at local institutions. TVB's strategy was to set up its own training program—in screenplay writing, directing, acting, creative direction, martial arts, dance, and art and design—thereby creating opportunities for young people wanting to join the industry. The station was hard-pressed back then to provide training to its own program and creative staff, including directors and scriptwriters, as well as other creative people in areas ranging from martial arts to dance. In 1985, for instance, the annual budget spent on training by TVB was HK$1.2 million, with a yearly total of 20,000 hours covered.[2] Yet, the continuous supply of quality personnel did have a direct impact on cost (saving). With the flow of the workforce being consolidated at TVB, quality was maintained to a reliable extent in its own productions. For the next two decades, this strategy served to solve the problem of human resources both for TVB and for the industry.

Looking at this development retrospectively, we recognize that for a range of practitioners in various disciplines the growing television business in Hong Kong

created job opportunities, with TVB effectively becoming a training house for many newcomers to the filmmaking circle and entertainment business. For instance, at a time when the television business was involved in an initial period of growth and consolidation, the 16 mm film section in the drama production team at TVB offered an invaluable training ground and learning space for emergent filmmakers to experiment with creative projects they were keen to pursue. The circumstances were such that they would have been able to choose their own scripts, actors, and camera crew with relative autonomy. Both time and funding were limited, but the cluster of young professionals had all the incentives they needed to plunge themselves into the process of collective creative practice. As is well known, the New Wave in Hong Kong cinema was soon to emerge at the forefront of Hong Kong film culture.[3] Alongside significant growth in the areas of critical print culture, television production was instrumental and became a means of transitioning to the film industry for young people at the time. And it is undeniable that the film department at TVB played a significant role in providing opportunities for disciplinary training as well as creative project learning. But when the television business gradually came to a standstill throughout and since the 1990s, and as the external environment became more competitive for Hong Kong, even the existing programs of formal and professional training would reveal their fundamental limitations. Today film education in Hong Kong is still relatively underdeveloped from the perspective of anyone advocating a general critical culture, despite the fact that film degree programs in the tertiary sector have grown in number.[4]

The drastic change in cultural climate has since created the need for an alternative educational practice.

> While [the] moving image is an essential and widely accessible form of art today, there is no film or media program in our existing [primary and secondary] education curriculum to teach our younger generation how to watch and understand moving images.[5]

With an aim to foster film literacy among the youth in Hong Kong, the Hong Kong International Film Festival (HKIFF) Society has established a three-year film education program (2011–2013) called the Jockey Club Cine Academy (JCCA), with funding from the Hong Kong Jockey Club Charities Trust. Its mission statement clearly states that its aspiration is "to teach the youth to critically understand film as an independent art form and medium" and "to encourage the youth to create and innovate through the practice of filmmaking."[6] Although not exactly advocates of an education for filmmakers or of professional training for industry practitioners, the JCCA proponents are committed to the basic stance that film education is an important part of media literacy in the twenty-first century. Here, film literacy is understood as "the ability to access, understand, appreciate, and to critically evaluate different aspects of the medium and its content, thus enabling us to navigate and communicate in a variety of contexts and other related media." Firmly standing by this value, the JCCA has attempted to offer a variety of opportunities for young students to have access to film as an art form, and intends its program of activities to make film "an integral part of young people's lives in

Hong Kong." In line with the growing recognition of and concerns for the value of liberal arts education, its educational objective is not technical literacy, but to inspire "life-long learning capabilities and cultural literacy through the creation, understanding, and enjoyment of moving images."[7]

In short, the JCCA program advocates "[g]oing back to the basics." To promote and enhance participation, all activities were provided free of charge during the last two years. "It is important to encourage young people to be critical consumers [of popular culture]."[8] In 2012 the program was presented in association with the 36th HKIFF (held from 21 March to 5 April 2012), the largest cultural event of the year in Hong Kong. Holding the belief that "literacy in moving images has become an integral part of a wider literacy," project director Li Cheuk-to works to bring film education to school students and teachers, and to drive creativity, independent thinking, and lifelong learning capabilities through the enjoyment and understanding of moving images.[9] Highlights of the 2012 program were organized as an associate program of the HKIFF. These included a Master Class with Jia Zhangke in 2011 (which drew 433 applications) and one with Keanu Reeves in 2012 (with 901 applications); and the meet-the-filmmaker "Face to Face" sessions with director Wai Ka-fai in 2011 (with 741 applications) and Peter Chan in 2012 (with 1063 applications). The majority of these activities, organized around and for young people (of age 12 or above), were all conducted in Cantonese or with simultaneous interpretation in Cantonese and Putonghua if necessary.

Accompanying these activities are the Festival Tours, which are provided free of cost to registered participants. Guided by veteran film critics and filmmakers, Festival Tours are for film buffs who want to learn more about contemporary world cinema by navigating through the annual HKIFF film program.[10] In addition, the Youth Volunteers Program trained young volunteers during the HKIFF in "transferable skills" and they were subsequently rewarded with "a wealth of film knowledge" through placement in the festival's key areas of work, in marketing, operations, and programming.[11] Service Learning was also provided in conjunction with some universities. The average number of volunteer hours for each person was about 40. Parallel to this is the Joint Universities Program, "a unique platform for student films from Hong Kong's universities to be shown beyond their academic settings, and to the audiences at the annual HKIFF."[12] Again, all screenings were provided free of charge to the public, and two Audience Choice Awards were given to enhance users' participation. Screenings of films from five local universities were arranged at the Science Museum Lecture Hall, where directors and/or actors were invited to meet the audience for Q&A sessions after the screenings.

The Short Film Competition offers a more challenging platform for young creative talents, although the thinking behind it is quite straightforward: "film is a powerful educational tool; an ability to appreciate and analyze film is an empowering skill that is increasingly important for young people." Around 20 films of various genres are selected for screening at the annual HKIFF, and three prizes are awarded, including a new Special Prize for Hong Kong films, selected by a jury of three renowned personalities in 2012. In 2011, 604 submissions were received and 21 finalists selected, with their films being shown in four screenings during the

HKIFF. In 2012 a total of 666 submissions were received and 20 finalists selected, whose films were featured in four screenings. In short, the organizers put together a program they considered essential to film education aimed at young people today. The approach is liberal arts oriented, emphasizing the cultivation of media literacy and critical film culture.

Programs like these provide a global stage for local students to showcase their best work and further encourage interested young local people to attend screenings by providing free tickets to secondary and tertiary students upon request. Promotion of film literacy and culture is taken seriously here, as they are believed to be essential to the education of a young generation. As youth become the potential agents in filmmaking, the JCCA sets out to promote film as both an art and a contemporary cultural practice. These two threads are linked fruitfully through educational work. Young people recruited as volunteers for the film festivals are trained to serve film-related intellectual and artistic programs, and hence introduced to the work of film curatorship. While the strategy is outreach, conventional formats such as the Master Class continue to play a part in the pedagogy. Ideally, the approach would be holistic, articulating the various program activities to overall educational goals, all for the cultivation of capacities to create, understand, and enjoy moving images. For practical reasons, unfortunately, insufficient efforts have been put into integrating the various components of the program into a coherent whole. Yet, the model driving the JCCA's approach is promising, as a brief consideration of the wider context of film training in Hong Kong makes clear.

Shu Kei (pen name for Kenneth Ip, head of the Film Department at the Hong Kong Academy for Performing Arts [HKAPA]) has been a vocal critic of the local conservatoire-style film institution and of the cultural landscape within which it operates. In his view, the industry expects the film school to train young "professionals" while the government that funds it has similar expectations. This synergy between industry and government perspectives has implications for the school's own film culture, leading to the uncritical tendency to see film education as focusing only on the study of the craft. As a result the school's pedagogical targets concentrate on the proficiency of students' technical capabilities. With the advent of digital cameras, filmmaking is no longer expensive and exclusive. Thus, the majority of students who enroll in a film school today have attitudes shaped by a perception that filmmaking is easy, and the situation in Hong Kong is no exception. At the same time, these film school students tend to be illiterate when it comes to film history, incapable, that is, of differentiating the results of good artistic practices from commonplace commodities.[13] Shu Kei's take on the challenges involved in delivering practice-based film education at the tertiary level, and in the context of a performing arts academy, suggests that initiatives such as those of the JCCA have a role to play in the education of the filmmaker. Immersion in the JCCA's programs counters the very attitudes that Shu Kei sees as characteristic of aspiring filmmakers at the HKAPA, and may in the long run produce a quite different kind of film school applicant in the Hong Kong context.

Since youth is placed at the heart of the JCCA's program, specific targets have been strategically chosen with the aim of filling certain gaps in film education and of helping to lay a foundation for the development of film literacy. It is

hoped that the literacy in question will reach school students not only directly but also indirectly through their teachers, as well as cultural managers at all ranks and in different domains of the business too. Designed to provide the layman with a foundational education in film history, film art, and film language, the JCCA's introductory Educators' Workshop has been advertised as "Hong Kong's first series of workshops for educators to learn the basics of film literacy."[14] Consisting of 12 four-hour lectures spread over a period of six months, the workshop is the only structured educational program offered by the JCCA. Provided twice a year for two different groups of school teachers, workshop sessions are conducted on a bi-weekly basis and given free of charge to the registered participants. Teaching venues are conveniently located, including the Jockey Club Creative Arts Centre (in Shek Kip Mei), the Hong Kong Baptist University Academy of Film (in Kowloon Tong), and the Hong Kong Film Archive (in Sai Wan Ho). Each meeting consists of a 90-minute lecture, the screening of a full feature, and a structured discussion session led by a guest speaker, who is usually a film critic, film scholar, or someone with relevant expertise. Course designer and coordinator Wong Ainling, a film scholar and researcher long associated with the HKIFF, also stresses the significance of media literacy. In an interview, she reiterated how important it is for the workshop to "provide an opportunity for teachers to learn the basics of film literacy and to use moving images as teaching tools in schools." She indicated that she strongly believes that film provides an important entry point to understanding the complex cultural changes of the twenty-first century. "It is important to encourage young people to be critical consumers of what they see."[15] A systematic general film education is therefore crucial, Wong insisted, and should start as early as possible for the young people of today. The JCCA Workshop is a small step taken in the direction of meeting the needs of local teachers with an interest in film. It is noted, however, that in the case of the two classes offered so far—Class A from January to June in 2011 and Class B from July to December in 2011—only about 50 selected students ended up participating and thus being able to benefit from the relevant film education initiative.

Given its limited resources and its belief in the merits of small-class teaching, the Educators' Workshop can only accommodate a small number of participants (15–18) in each class. Selected participants were teachers active in organizing film activities in the schools. While some were film buffs, many had been encouraged to join the program by their schools. The proponents of the workshop are well aware of the limited scale of the project. Nonetheless they are fully convinced of the need, even urgency, to push ahead with it. In the light of the educational reform currently affecting all curricula under the Hong Kong government's new so-called "3-3-4" academic structure (3 years of junior secondary school, 3 years of senior secondary school, and 4 years of university), schools are now more open than before to new subjects and learning experiences. As a result, teachers now find it possible and appropriate to adopt film as a teaching tool or medium. This trend is new and unusual, given the generally conservative environment in local schools. Elements of film have been introduced in recent years into the secondary curricula (in Chinese, English, and Liberal Studies) by language teachers who would prefer to have students participate in social and cultural life through the use

and comprehension of moving images. Outside of the formal curriculum, some schools hold special film events or organize occasional class visits to the local cinemas. Though these are not yet common practices, they may well become popular when students and teachers begin to find them enjoyable and come to see them as enhancing the experience of both teaching and learning.[16]

In the new curriculum, film is still not a unified or required subject, and as an optional module it has taken on various forms. It must be acknowledged that teachers are generally not confident about handling the subject matter of film in class. As of now, teachers have introduced film as follows: in the category of language classes, in English as an elective (e.g. Learning English through Popular Culture, Literature in English), and in Chinese as an elective (e.g. Masterworks and Audio-Visual Appreciation); in the category of Liberal Studies, in one of the subject's six modules (Personal Development & Interpersonal Relationships, Hong Kong Today, Modern China, Globalization, Public Health, Energy Technology & the Environment). Moreover, film can also be included as a component of Visual Art, for it can serve "as a dynamic platform that comprises various art forms," thus giving students insight into the visual culture as a whole.[17] At the same time film may also be adopted as a topic for "Independent Enquiry Study" under the suggested themes of Media and Art. Since 2010, senior secondary students may also elect to take film courses as Applied Learning (for a total of 180 class hours). Under the new curricular provision, it is possible for film-related learning to be included under the "Media and Communication" strand of Applied Learning. Schools may choose to offer such courses in partnership with, or through "out-sourcing" to, film institutions. In this connection, classes in multimedia art, film, and video have been offered by the Vocational Training Council and by practitioners associated with the Hong Kong College of Technology (previously an evening school in downtown Kowloon, established in 1957) teaching the production of infotainment programs. Finally, schools may also invite external bodies and organizations to help provide Other Learning Experience to their students, thus introducing to the curriculum film-related contents, such as animation or other elements from the creative industries.

Many new opportunities are there for film educators if they are prepared to take the initiative. Thus, in asking the question "To what extent has the workshop been effective?" let me share the results from the focus group and interviews I did with the teacher-participants from the JCCA Workshop, both of which were organized for the purpose of the present study. With an age range between 22 and 62, the participants all had stories of teaching to tell.[18] First, a senior English teacher (a mature film buff and senior teacher) who taught in a Band-2 (above average) level school had been working with film in her English language classes. Experienced and resourceful in pedagogy, she believed that acquiring knowledge in film art would further enhance her expertise and confidence in making use of film as a resource and as a platform for her class. Two Chinese teachers (one very senior, one junior), both fully dedicated to Chinese culture and history, were somewhat more conservative in their pedagogies. But they also saw film as a useful medium and as allowing them more effectively to handle the subject matters of Chinese culture and history. The senior teacher soon became deeply enamored of films through

her participation in the workshop; and she has since come to believe in film as a core value and as an essential part of a humanistic education. Indeed teachers were often pragmatic in their attempt to absorb new elements into their curricula. In this regard, we were all impressed by the innovative attempts made by one Visual Arts teacher, an energetic young teacher who drew on what he learnt from the workshop for his junior class. He redesigned his assignments so that students' grades would be based equally on media literacy (50 percent) and filmmaking practice (50 percent). Having taught the class and conducted a critical review of it, he further adjusted the grade proportion to 66 percent and 33 percent respectively. His example indicates how participants have been able to take proactive steps to foster creativity in their own classrooms through use of the film/video medium.[19]

There is no doubt that in Hong Kong the overall environment and general condition in schools are not helpful to cultural educators. For this reason, the JCCA Workshop was especially welcome. Not only were the workshop participants active in identifying pedagogic innovations, they also helped to create synergy between classroom work and film cultural activities, thus linking school education to the cultural field at large. The empirical data collected through the focus group and interviews suggest that the possibilities are endless: there was the case, for example, of the school counselor working with gifted students, who treasured the affective education the program provides; that of the teacher in a Band-3 school who tried to motivate students to learn English; and also the Visual Arts teacher who shared his pedagogic practice with others through activities and opportunities mediated by the JCCA. With such mediation more teachers were able to make use of the school-based components in the curriculum, and to turn film into a platform for pedagogical changes in classroom practice. Knowledge in film literacy helped them to identify productive intervention, whether this relates to teaching film literacy and/or enhancing learning in other subjects. All participants valued the cultural space opened up by the workshop, a space for critical thinking through media work in creativity and interpretation.

Often, technical education is readily available, but not critical cultural education. Moreover, most teachers would agree that for school students today mainstream film (and movie watching) is less and less engaging.[20] This poses a big problem and provides a strong justification for the kind of pedagogical program initiated by the JCCA project. The Form 4 (Grade 10) students taught by some of the workshop participants appear to know very little about cinema, including local movies. Film art education involving a mix of film as art and film as craft is therefore especially relevant and useful. Pedagogy will have to be explored, along with more consolidated efforts to develop film culture around the established school curriculum (via film clubs, activities, visits, and short courses). In this sense, the situation is a good reflection of the society at large in Hong Kong. Although there are traces here of the beginning of a filmmaker's education, the JCCA initiative has not been undertaken as a part of any long-term cultural planning. What it offers, rather, is a flexible form of pedagogy, a kind of critical intervention, with film enhancing the students' experience of art and culture. Ultimately, though, it is up to the individual schools to decide whether the pedagogy on offer merits being adopted. Indeed, such a decision is made by individual teachers.

Given the funding from the Hong Kong Jockey Club, teachers admitted to the Educators' Workshop pay no tuition fees. They are expected to pay a deposit of HK$2000 (about US$258), but this is refunded to individual participants upon completion of 80 percent of the class. The selection process at the JCCA has to date focused on identifying those with a real interest in film or with strong pedagogical needs. Unfortunately, the absence of any kind of macro-perspective at the level of planning makes it difficult to predict the workshop's future. There is no clear vision for the further development of this valuable pilot program beyond the initial three-year period, and its fate is thus unknown at the time of writing.

It is regrettable that relevant policy questions, such as those given below, have not been asked and appropriate strategic steps not taken by policymakers: Is there a need to introduce film education to primary and secondary school curricula? Should youth creativity in school be a policy priority as Hong Kong pursues its ambition to become a cultural and creative hub in the region? For sure, there is no shortage of critical concerns in the community regarding the failings of the Hong Kong educational system. At the same time, it is important to recognize that no consensus about possible solutions and necessary policies exists among the parties concerned. Film critic Ka-ming Fung (who teaches film at the Hong Kong Academy for Performing Arts) reminded us of students' lack of film knowledge and the general absence of film education in the Hong Kong system. But he added that there is no trust whatsoever in the wider educational system and that many of those who know how education works in Hong Kong would hate to see film turned into yet another apparatus for the brainless training of young people in schools. Another criticism concerns film electives in the Language classes. In practice, film-related classes focusing on literature tend to treat film as a complementary text rather than an art form. Worse, casual treatment of moving images in a school setting might lead to the wrong impression that film is "easier to digest" than most other subjects, which would in turn compromise the integrity of film and turn it into a "fast-consumable substitute for literature."[21] Standardization and drilling for instrumental learning are the notorious features of Hong Kong's examination-driven education system. What is feared, following the line of thought outlined here, is the most dreadful scenario of all: made part of the school curriculum following vigorous efforts on the part of those who see film as key, the new subject of film art and history, rather than enhancing media literacy, merely ends up perpetuating the uncritical delivery of subject contents.

Critical concerns about film education in schools have to do with the way teachers might handle film literacy (with a pedagogic emphasis on film form and aesthetics), and the extent to which they would actually be prepared to demonstrate in class how an audiovisual text can be read. There has been little discussion of what the priorities are if indeed film education is to be popularized in schools, and thus there is certainly no consensus on this matter. What does seem to be obvious is that there is room for further work, including the preparation of young students in the practice of film- or video-making, and this through mediated exercises focusing on the audiovisual production of narratives, particularly self-narratives. Partly in response to such needs and concerns, an advanced course has been developed by the JCCA to provide more in-depth treatment of the film

text, and to allow more time for students to be engaged closely with the "reading" of films. Targeted at those who had taken the introductory class, the first Educators' Advanced Workshop was provided to 11 participants (in six weekend sessions, each lasting four and a half hours) in 2012. The theme chosen was the filmic adaptation of literature, for it was believed that such an emphasis would link well to both the school curriculum and setting and hence trigger discussions in class. The films selected for in-depth study in the spring of 2012 included: *The Story of Qiu Ju* (dir. Zhang Yimou, 1992), *Rouge* (dir. Stanley Kwan, 1988), *2001 Space Odyssey* (dir. Stanley Kubrick, 1968), *The Departed* (dir. Martin Scorsese, 2006), *The Way We Are* (dir. Ann Hui, 2008), and different adaptations of the Chinese classic "紅樓夢" (*Dream of the Red Chamber*), based on two television series directed by Wang Fulin (1987) and Li Shaohong (2010), and two films by Bu Wancang (1944) and Shen Fan (1962). The workshop instructors discussed appropriate topics pertaining to teachers' use and application of film in the classroom as an artistic, cultural, and pedagogical resource.

In a session that I visited in May 2012, participants in the Advanced Workshop were deeply engaged in a discussion about the issue of a pedagogic space for film education in the secondary curriculum. The teachers who were there were highly concerned about freedom of expression in the Hong Kong context and the issue of self-censorship in schools. It appears that cultural space outside the classroom has been diminishing; and many workshop participants expressed concerns about creating an open platform for critical discourse through school-based film activities. References were made to the film *Tiananmen: The Gate of Heavenly Peace* (dir. Richard Gordon and Carma Hinton, 1995), which had triggered discussion in one school about the use and value of documentary films in education. References were also made to national education and the threatening trend toward brainwashing, caused in some cases by directives from schools' administrators.[22] The workshop discussion took place well before the public debates about and opposition to the Education Bureau's plan to introduce National Education to the school system. That plan, it is worth recalling, resulted in massive protests and demonstrations outside the government's offices during the summer of 2012, leaving the authorities with little choice but to withdraw the much criticized curricular guidelines at the beginning of the school year in September. At the same time, it seems clear that the new core subject Liberal Studies has opened up opportunities for educators to explore film's role within a critical cultural education. The Advanced Workshop, which targets teachers working within the government's system, is useful in a variety of respects. Among other things, it makes course materials available to all teachers through open-access online channels. These materials help to ensure that film, when introduced to various school-based pedagogies, is treated as a critical platform, and not as a mere content or skill to be mechanically learnt and tested.

Every now and then there has been the suggestion that film education in Hong Kong should aim to raise the overall level of appreciation of the art and cultural form of cinema among the younger generations. There are critics who do not want to see film become yet another academic subject open to quick appropriation, if not corruption, by the public examination system. With an apparent lack of confidence in the system, renowned director and chairman of the Film and Media

Arts subcommittee of the Hong Kong Arts Development Council Johnnie To has said, repeatedly, that only the skills of filmmaking can be taught, but not its art. To's stance is obviously aligned with that of those working closely with filmmaking as an art who must also meet the challenges of the film industry. Speaking from another perspective, however, Shu Kei has been openly critical of the idea that the role of a film school should be confined to training in the craft of filmmaking and to the goal of ensuring that students are cinematically proficient, in the sense of having clearly defined technical capabilities.[23]

In the new senior secondary curriculum, school-based assessment has been introduced as a new model, which, to a certain extent, releases schools from common curricular guidelines. That is, schools have the authority to introduce new learning and assessment designs as a means of handling subjects according to the specific needs they identify for their students. Intended to allow learning to be based in a school culture rather than driven by public examination, school-based assessment has, no doubt, created opportunities for film education, even though resources are limited. Relevant shortages are especially serious in the area of personnel, including teachers, educators, educational programmers, and policymakers with educational vision. And it is this kind of shortage that provides a context for initiatives such as the JCCA project, and, indeed, for the wish list that drives it. That wish list includes: cultural literacy; a passion for film among teachers and students; film knowledge geared to secondary school classrooms; and the building of teachers' confidence, so as to enhance the teaching of film or use of moving images in teaching.

If these are the opportunities in the short term, what are the challenges for a long-term policy? Unfortunately, with the budget for the Hong Kong International Film Festival basically kept largely unchanged in the last decade, the HKIFF Society has had to resort to other channels in recent years to step up its outreach work.[24] As the JCCA workshops are the only outcome of such recent attempts, there is reason to worry that the three-year project ultimately will amount merely to the launch of a pilot scheme with a total funding of about HK$5 million (about US$640,000) from the Hong Kong Jockey Club. That is, further support, whether from the side of government or business, can by no means be taken for granted. The larger environment in Hong Kong is definitely not culture-friendly, and as a result the prospect for a certain kind of education is unclear. In the words of Shu Kei, "The decidedly 'commercial' nature of Hong Kong cinema [...] deters producers (businessmen) from investing too much in newcomers. As such the industry remains highly sceptical of what a film school [or film education] does and can do."[25]

In considering issues having to do with the development of a sustainable environment for film in Hong Kong today, it may be helpful to recall the possibilities associated with a film culture that has roots in the civil society of Hong Kong in the 1980s. Hong Kong's New Wave Cinema brought new energies to the local film culture and industry, through figures such as Allen Fong, Yim Ho, Ann Hui, Tsui Hark, Cheuk Pak-tong, Clifford Choi, and Kirk Wong. The TVB training program that was so crucial for Hong Kong's New Wave has long ceased to exist, and other courses focusing on film outside of the formal academic framework are limited

in scope or function.[26] While the New Wave generation was often closely involved in the promotion of film culture since the 1980s, the relatively free social environment during the last couple of decades under British colonial rule was not an insignificant factor.[27] The critic Law Kar has reminded us of the pioneering work of a variety of film clubs and societies active since at least the 1970s.[28] In the 1980s, the Hong Kong Film Culture Centre engaged in sustained efforts to promote the culture of the art house and independent cinema among the common people, with key figures such as Clifford Choi, Ng Ho, Allen Fong, Tsui Hark, Stephen Shin, Lau Shing-hon, Law Kar, Koo Siu-fung, and Cheuk Pak-tong among its members. Many of the students who emerged from their classes have since joined the film industry, including, notably, Fruit Chan (independent filmmaker), Julia Chu (producer, production manager), Lorraine Ho (producer, production manager), Neco Lo (independent filmmaker, animation director), O Sing-pui (director, cinematographer, actor), Lam Wah-chuen (director, cinematographer, film score composer), and Keeto Lam (screenwriter, animator).

Mentorship during the 1980s enabled these young apprentices to join the profession, and some have subsequently made successful careers in the entertainment business or in the independent cinema sector. These early developments in our film culture paved the way for the growth of independent filmmaking in the 1990s and helped to develop a local community of film lovers. Prior to any work by the former Hong Kong Urban Council (subsequently dissolved) and the Hong Kong Arts Development Council (which was once the funding agency of HKIFF), initiatives such as the JCCA project described here were driven completely by passionate individuals and nonprofit groups within civil society. The possibilities may at this point be considerably changed. In an increasingly competitive commercial society such as Hong Kong, public cultural institutions like these have over the years provided certain resources, but they have done so through a bureaucratic system that channels the efforts of newcomers to the discipline and business of film in very specific ways. The result has been one of containing or marginalizing the creative energy and intellectual vitality of the local culture. Hence, it would seem that film cultural and educational activities previously run outside of the established institutional framework and led by advocates who based their work totally in the community ought to be revived today.

What is clear is that, when compared with the situation some 30 years ago, Hong Kongers' access to film as culture is now far more restricted. What the present study suggests is that aside from the various festival-related activities, the most distinctive program with critical functions to have emerged from the three-year JCCA project is the Educators' Workshop. There are some reservations about reproducing the scheme on a massive scale after the initial phase, the insistence on the small-class format being recognizable as a "quiet" intervention backed up by a crucial pedagogical argument for film as liberal arts education. At the same time, the JCCA does make reference to policy developments of the kind that envisage a larger scale of intervention. As the JCCA's *Fostering Film Literacy in Hong Kong* puts it:

> Many countries in the world have been paying attention to film literacy, some within the context of formal education in primary and secondary schools, providing

a structured and systematic opportunity to watch, understand and even to make films... Others are beginning to advocate and introduce film education as part of their arts and culture education policy.[29]

Film critics have pointed to the refusal by the government to recognize film as culture, and to develop a clear film cultural policy. Another critical factor hampering the development of a sustainable film environment in the Special Administrative Region is that Hong Kong people have been trained to live with cynicism and according to the status quo fixed by an elitist technocratic system of governance.[30] As Li Cheuk-to and Wong Ainling repeatedly stressed during interviews, compared to the situation in the 1980s and 1990s, there is now an alarming shortage of cultural and media literacy in Hong Kong. Hence, in their assessment, film education ought to take root outside of the institutional framework of the professional film school, for the critical issue is not simply one of promoting filmmaking practices but one of developing film art and culture on a more basic level in society.[31]

Globally today cultural policies encourage efforts aimed at developing *soft power*. To incubate the accumulation of a variety of creative talents, governments must alter their approach to culture by supporting public access, cultural diversity, freedom of expression, and strategic (medium- to long-term) work capable of giving shape to a *soft* infrastructure. There is no doubt that the latter is a crucial condition of possibility for cultural development in Hong Kong some 15 years after the Handover. Should resources be available, the possibility of multiplying the JCCA Educators' Workshop, in a way that is carefully attuned to social needs, is well worth considering. For instance, a community such as the one living in Tin Shui Wai, located in the northwestern New Territories of Hong Kong where social problems linked to the ever-widening gap between the rich and the poor are acute, would surely benefit from a truly community-based film workshop designed with young people in mind. But before thinking along such lines can begin to produce anything resembling viable options, the JCCA initiative must, quite simply, be made part of a long-term and genuinely visionary plan. It is hoped that the thinking and planning will continue, and that such activities will return, again and again, to what is truly fundamental, for this is how the growth of a civic consciousness through art, culture, and the pedagogy of film as practice will be achieved in Hong Kong.

Notes

1. Chung Po-yin, *A Hundred Years of Film and Television in Hong Kong* (Hong Kong: Joint Publishing Co., 2004), 278.
2. See Ng Ho, *Essays in the History of Hong Kong Television* (Hong Kong: Subculture, 2003).
3. See Cheuk Pak-tong, *Films from the Hong Kong New Wave Cinema* (Hong Kong: Cosmos Books, 2003); Cheuk Pak-tong, *Hong Kong New Wave Cinema (1978–2000)* (Bristol: Intellect Book, 2008).
4. The following Hong Kong tertiary educational institutions offer programs in film studies:

(1) Hong Kong Baptist University: Academy of Film, 2009; formerly Department of Cinema and Television, 1991 (with courses offered since 1971); screenplay, film/TV & digital media.

(2) Hong Kong Academy for Performing Arts: School of Film and TV, 1996; film and video production.

(3) City University of Hong Kong: School of Creative Media/Dept. of Media & Communication; creative media, digital media broadcasting, media cultures, media technology, multi-media training.

(4) Hong Kong Polytechnic University: School of Design; visual communication, digital media.

(5) Chinese University of Hong Kong: Department of Fine Arts, Department of Cultural and Religious Studies; film studies, visual culture.

(6) Lingnan University: BA Visual Studies (since 2005; as a stand-alone department, 2009); interdisciplinary; art history, cognitive film studies, and philosophical aesthetics.

(7) Open University: Creative Writing and Film Arts; joint certificate course with HK Screen-writers' Guild (1991) on film industry, genre films, with 8 months of practice (totaling 102 hours).

(8) Hong Kong Design Institute under HK Institute of Vocational Education: higher diploma programs in visual communication, animation; comics & visual effects, multimedia advertising for creative industries.

5. Jockey Club Cine Academy (JCCA), *Fostering Film Literacy in Hong Kong* (Hong Kong: Hong Kong International Film Festival Society, 2010).
6. JCCA, *Fostering Film Literacy in Hong Kong.*
7. Based on interviews the author conducted with Li Cheuk-to on April 20, 2012, and Wong Ainling on March 29, 2012, Hong Kong.
8. Interview with Li Cheuk-to on April 20, 2012, and Wong Ainling on March 29, 2012, Hong Kong.
9. Interview with Li Cheuk-to on April 20, 2012, Hong Kong. See also the *Program of the 36th Hong Kong International Film Festival* (Hong Kong: Hong Kong International Film Festival Society, 2012).
10. In 2011, a total of 20 groups were registered with a total of 195 participants. In 2012, 23 groups were registered for 98 screenings, with 177 participants.
11. A total of 124 participants (aged 15–25) were enrolled in 2011, and 133 in 2012.
12. The approximate size of the audience reached 976 (in 2011) and 355 (in 2012).
13. Shu Kei (Kenneth Ip), address at the Film in Education conference, Centre for Humanities Research, Lingnan University, Hong Kong, May 19–20, 2010.
14. JCCA, *Fostering Film Literacy in Hong Kong.*
15. Interview with Wong Ainling on March 29, 2012, Hong Kong.
16. Focus group with participants of the JCCA Educators' Workshop, at the Hong Kong Film Archive, May 5, 2012.
17. Focus group with participants of the JCCA Educators' Workshop, at Hong Kong Film Archive, May 5, 2012.
18. Focus group with participants of the JCCA Educators' Workshop, at the Hong Kong Film Archive, May 5, 2012.
19. Focus group with participants of the JCCA Educators' Workshop, at Hong Kong Film Archive, May 5, 2012.
20. Focus group with participants of the JCCA Educators' Workshop, at Hong Kong Film Archive, May 5, 2012.

21. Ka-ming Fung, cited in Ching Fong, "Film and Education Roundtable," a review of the "Film in Education" Symposium held at the Centre for Humanities Research, Lingnan University, Hong Kong, *Hong Kong Economic Times*, C3, May 24, 2010.

22. Focus group with participants of the Educators' Advanced Workshop, held immediately after the class visit the author made to the session held at the Hong Kong Baptist University on May 7, 2012, Hong Kong.

23. Johnnie To and Shu Kei's respective addresses at the "Film in Education" conference, Centre for Humanities Research, Lingnan University, Hong Kong, May 19–20, 2010.

24. There has been little increase of the overall budget of the HKIFF during the last decade, according to Li Cheuk-to, artistic director of HKIFF. Interview with the author conducted on April 20, 2012.

25. Shu Kei, address at the "Film in Education" conference, Centre for Humanities Research, Lingnan University, Hong Kong, May 19–20, 2010.

26. Courses run by the Federation of Hong Kong Filmmakers were practice based and industry oriented; they were held in 2004–2005, and then again in 2011, with funding from the Film Development Fund. The Hong Kong Screen-writers' Guild has partnered with the Open University to offer a BA in Creative Writing and Film Arts.

27. Cheuk Pak-tong, *Films from the Hong Kong New Wave Cinema*; *Hong Kong New Wave Cinema (1978–2000)*.

28. Law Kar, "The Independent Vision of Film Clubs," preface to *In Pursuit of Independent Visions in Hong Kong Cinema*, ed. Esther Cheung (Hong Kong: Joint Publishing Co., 2010).

29. JCCA, *Fostering Film Literacy in Hong Kong*.

30. Hui Po-keung, "Why Must We Take Stock of and Be Serious about Integrated Humanities/Liberal Studies?" introduction to Stephen Chan, Po-king Choi, and Po-keung Hui, *Integrated Humanities and Liberal Studies* (Hong Kong: Kwan Fong Cultural Research & Development Program, Lingnan University, 2009).

31. Interview with Li Cheuk-to on April 20, 2012, and Wong Ainling on March 29, 2012, Hong Kong.

Notes on Contributors

Moinak Biswas teaches in the Department of Film Studies at Jadavpur University. He is also the initiator of The Media Lab at Jadavpur, a place for experiments with new pedagogy for a digital environment. He has published widely in Bengali and English on Indian cinema and culture and among his English publications is *Apu and After: Revisiting Ray's Cinema* (Seagull Books, 2006). Biswas wrote and codirected the Bengali feature film *Sthaniya Sambaad* in 2009.

Yomi Braester is Professor of Comparative Literature and Cinema Studies at the University of Washington, Seattle. He directs the University of Washington, Seattle, and Summer Program in Chinese Film History and Criticism at the Beijing Film Academy. His most recent book is *Painting the City Red: Chinese Cinema and the Urban Contract* (Duke University Press, 2010).

Barton Byg teaches German and Film Studies at the University of Massachusetts, Amherst, where he is Founding Director of the DEFA Film Library and a Founding Faculty Member of the Interdepartmental Program in Film Studies. His recent research and teaching focus on such topics as Brecht and film, documentary, landscape, and color. He is author of the book *Landscapes of Resistance: The German Films of Jean-Marie Straub and Danièle Huillet* (University of California Press, 1995).

Charlie Cauchi is a doctoral candidate in the Department of Film Studies at Queen Mary University of London. Using Malta as a case study, her current research aims to provide in-depth analysis of this lesser-known example of world cinema. This study also aims to identify the reasons why Malta is able to function relatively well within the film servicing sector, operating as a place for film production for foreign projects, but is rarely able to produce films for its domestic market or exportation to a foreign market.

Stephen Chan is Professor in the Department of Cultural Studies and Associate Vice President at Lingnan University in Hong Kong. Having published on Hong Kong culture, film, literature, education, and cultural studies, Chan coordinates projects on cultural pedagogy and policy, schooling as cultural process, urban creativity, and cultural citizenship under the Kwan Fong Cultural Research & Development Programme. He serves on the Board of the International Association for Cultural Studies, representing the Asia constituency. He is a part-time member of the Central Policy Unity of the Hong Kong Government and a policy fellow of the Community Development Initiatives think tank.

Ben Goldsmith is a Senior Research Fellow in the ARC Centre of Excellence for Creative Industries and Innovation, Queensland University of Technology. He held various positions at the Australian Film, TV and Radio School from 2004 to 2010 including, Senior Researcher and Lecturer, Convener of Screen Studies, and Acting Head of the Centre for

Screen Studies and Research. He has been a Research Fellow and Senior Research Fellow at the Centre for Critical and Cultural Studies, University of Queensland, and Griffith University. His books include *Local Hollywood: Global Film Production and the Gold Coast* (University of Queensland Press, 2010, with Susan Ward and Tom O'Regan), *Directory of Australian and New Zealand Cinema* (Intellect Books, 2010, co-edited with Geoff Lealand), and *The Film Studio: Film Production in the Global Economy* (Rowman & Littlefield, 2005, with Tom O'Regan). His policy monographs include *Cinema Cities, Media Cities: The Contemporary International Studio Complex* (Australian Film Commission, 2003, with Tom O'Regan), *The Future of Local Content? Options for Emerging Technologies* (Australian Broadcasting Authority, 2001, with Julian Thomas, Tom O'Regan and Stuart Cunningham), and *Rating the Audience: The Business of Media* (London: Bloomsbury Press, forthcoming, with Mark Balnaves and Tom O'Regan).

Mette Hjort is Chair Professor of Visual Studies at Lingnan University, where she is also Associate Vice President (Quality Assurance) and Director of the Centre for Cinema Studies. She is an Affiliate Professor of Scandinavian Studies at the University of Washington, Seattle, and Adjunct Professor at the Centre for Modern European Studies, University of Copenhagen. She is the author of *The Strategy of Letters* (Harvard University Press, 1993), *Small Nation, Global Cinema* (University of Minnesota Press, 2005), *Stanley Kwan´s "Center Stage"* (Hong Kong University Press, 2006), and *Lone Scherfig's "Italian for Beginners"* (University of Washington Press, 2010). She is the editor or co-editor of a number of books, including, most recently, *Film and Risk* (Wayne State University Press, 2012) and *Creativity and Academic Activism: Instituting Cultural Studies* (with Meaghan Morris; Hong Kong University Press, 2012). A third volume in a series of interview books with Danish directors is forthcoming as *Danish Directors 3: Dialogues on the New Danish Documentary Cinema* (with Ib Bondebjerg and Eva Novrup Redvall; Intellect, 2013). Mette Hjort is a Foundation Fellow of the Hong Kong Academy of the Humanities. She co-edits the Nordic Film Classics Series with Peter Schepelern for the University of Washington Press and Museum Tusculanum.

Tom O'Regan is Professor of Cultural and Media Studies in the School of English, Media Studies and Art History at the University of Queensland, Australia. He is the co-author with Susan Ward and Ben Goldsmith of *Local Hollywood: Global Film Production and the Gold Coast* (University of Queensland Press, 2010) and with Ben Goldsmith of *The Film Studio: Film Production in the Global Economy* (Rowman & Littlefield, 2005) and *Cinema Cities, Media Cities: The Contemporary International Studio Complex* (Australian Film Commission, 2003). He is also the author of *Australian National Cinema* (Routledge, 1996) and *Australian Television Culture* (Allen & Unwin, 1992). With Susan Ward and Ben Goldsmith, he has been researching the changing environments of Australian film and television production, and with Mark Balnaves and Ben Goldsmith the broadcast ratings industry. He cofounded the cultural and media studies journal *Continuum*, acted as an editor for its first seven volumes (1987–1994), establishing it as a major international journal in the field. He was Director of the Australian Key Centre for Cultural and Media Policy (1999–2002), UNESCO-Orbicom Professor of Communication from 2002 to 2003, and Director of the Centre for Culture and Communication at Murdoch University (1996–1998).

Duncan Petrie is Professor of Theatre, Film, and Television at the University of York in the UK. He has published extensively in the fields of British and Scottish cinema, being the author of *Creativity and Constraint* in the British Film Industry (Macmillan, 1991), *The British Cinematographer* (British Film Institute, 1996), *Screening Scotland* (British Film Institute, 2000), and *Contemporary Scottish Fictions* (Edinburgh University Press, 2004).

Petrie is also the editor or co-editor of a further nine books, including *The Cinema of Small Nations* (with Mette Hjort, Edinburgh University Press, 2007). He has also published a study of New Zealand cinematography for Random House and is currently working on various projects focusing on conservatoire-style film schools.

Anna Westerståhl Stenport is Associate Professor and Director of Scandinavian Studies at the University of Illinois Urbana-Champaign, where she holds affiliate appointments in Media and Cinema Studies, Comparative and World Literature, Theatre, the Unit for Criticism and Interpretive Theory, Gender and Women's Studies, International Studies, and in the European Union Center. Dr. Stenport has been an Anna Lindh Fellow at Stanford University and is currently an Affiliate Associate Professor [Docent] of literature at Gothenburg University, Sweden. She is the author of *Lukas Moodysson's 'Show Me Love,'* published in the University of Washington's Nordic Film Classics Series, and *Locating August Strindberg's Prose: Modernism, Transnationalism, and Setting* (Toronto University Press, 2010). She is currently at work on a book on contemporary Nordic film and the digital transition.

Renata Šukaitytė is Associate Professor of Communication at Vilnius University, where she is Head of the newly established Institute of Creative Media. She has conducted substantial research on institutional and aesthetical discourses related to new media art of the Baltic States, which has resulted in a number of publications and conference papers. Her current research focuses on Lithuanian and Baltic film, particularly on its national and intercultural dimensions from the 1990s to the present. She is the editor of the *Acta Academiae Artium Vilnensis* volume entitled *Baltic Cinemas After 90's: Shifting (Hi)Stories and (Id)Entities* (Vilnius Academy of Fine Arts, 2010) and is the co-editor (with Chris Hales) of a special issue of *Acta Academiae Artium Vilnensis*, devoted to Cross-Media Art Practices (2012).

Yoshiharu Tezuka is a sociologist and media researcher who has worked as a cinematographer in Japan. He moved to the United Kingdom in the 1980s to study at the National Film and TV School; he produced and directed award-winning documentary films for television. Then in the late 1990s, he produced TV commercials for the Japanese market in Europe as the Managing Director of Chimera Films. Since 2008, he has been Associate Professor of Media and Cultural Studies at Komazawa University in Tokyo.

Evan Torner recently received a Ph.D. in German and Film Studies from the University of Massachusetts Amherst, and is now the Andrew W. Mellon Postdoctoral Fellow in German Studies at Grinnell College. While finishing his Ph.D. research, he spent the 2009–2010 academic year as a Fulbright Fellow at the Hochschule für Film und Fernsehen "Konrad-Wolf" Potsdam-Babelsberg. His publications and research focus on East German genre cinema, science fiction, and the postcolonial.

Marijke de Valck is Assistant Professor at the Department of Media Studies, University of Amsterdam. She specializes in film festivals and has frequently published on the topic. She is the author of the monograph titled *Film Festivals: From European Geopolitics to Global Cinephilia* (Amsterdam University Press, 2007) and of articles in the *International Journal of Cultural Studies, Cinema Journal, Film International* and the Film Festival Yearbooks. Marijke is cofounder, with Skadi Loist, of the Film Festival Research Network (www.filmfestivalresearch.org).

Bibliography

2006 års filmavtal. http://www.regeringen.se/sb/d/5975/a/50827.

25 Jahre HFF München. Munich: Bayerische Staatsbibliothek München, 1992.

Achtenhagen, Leonora. "Creating a film production cluster in Sweden's West: The Case of 'Trollywood.'" In *Media Clusters: Spatial Agglomeration and Content Capabilities,* edited by Charlie Karlsson and Roberg G. Picard, 354–376. Cheltenham, UK: Edward Elgar Publishing, 2011.

Agde, Günter. "Die Anfänge der Filmhochschule Potsdam-Babelsberg und ihr Gründungsrektor Kurt Maetzig: Skizzen zu einer Rekonstruktion." In *Jahrgänge: 40 Jahre HFF Konrad Wolf,* edited by Egbert Lipowski and Dieter Wiedemann, 11–28. Berlin: VISTAS, 1995.

Albisetti, James C. *Secondary School Reform in Imperial Germany.* Princeton: Princeton University Press, 1983.

Andrew, Dudley. "Time Zones and Jetlag: The Flows and Phases of World Cinema." In *World Cinemas, Transnational Perspectives,* edited by Nataša Durovicová and Kathleen Newman, 59–89. New York, NY: Routledge, 2010.

Aoyama, Shinji, Kiyoshi Kurosawa and Shigehiko Hasumi. *Eiga naga hanashi* (Cinema long talks). Tokyo: Little More, 2011.

Appadurai, Arjun. "Deep Democracy: Urban Governmentality and the Horizon of Politics." *Environment and Urbanization* 13.2 (2001): 23–43.

Asplund Carlsson, Maj, Margareta Herrman, Karin Högberg, Carina Kullgren, and Björn Mårdén. "Att göras till filmarbetare i den nya kulturekonomin." In *Att göras till filmarbetare,* edited by Margreta Herrman, 280–291. Stockholm: Nya Doxa, 2011.

Assmo, Per. "Creative Clusters—Ideas and Realities for Cluster Growth: The Example of Film i Väst in the Region of Västra Götaland, Sweden." In *Industrial Clusters and Inter-Firm Networks,* edited by Charlie Karlsson, Börje Johansson, and Rover R. Stough, 453–474. Cheltenham, UK: Edward Elgar, 2005.

———. and Roger Blomgren. *Film Production as Strategy for Regional Development—Mission (Im)Possible?* HTU Research Reports 03:01. Kungälv: Grafikerna AB, 2003.

Attard, Anthony. "Compendium of Cultural Policies and Trends in Europe: Country Profile: Malta." *Council of Europe/ERICarts,* February 2012. http://www.culturalpolicies.net/down/malta_022012.pdf (accessed May 18, 2012).

Australian National Advisory Committee for UNESCO. *Professional Training of Film and Television Scriptwriters, Producers and Directors.* Sydney: University of New South Wales, 1969.

Baldachino, Godfrey. *Worker Cooperatives with Particular Reference to Malta.* The Hague: Institute of Social Studies, 1990.

———. and Ronald G. Sultana, eds. *Maltese Society: A Sociological Inquiry.* Malta: Mireva, 1994.

Basu, Anustup. "A Memorialization without Destinying: A Revisitation of JU Media Lab's National Instruments Archive Project." *Journal of the Moving Image* 10 (2011). http://jmionline.org/film_journal/jmi_10/article_09.php (accessed November 9, 2012).

Bell, Desmond. "A Hollywood on the Clyde," *The Herald*, May 3, 1997.

Bergfelder, Tim. *International Adventures: German Popular Cinema and European Co-Productions in the 1960s.* New York, NY: Berghahn, 2005.

Berlin Talent Campus. http://www.berlinale-talentcampus.de/campus/event/hometwo (accessed May 12, 2012).

———. "General Information," Berlinale Talent Campus, April 4, 2012. http://www.berlinale-talentcampus.de/story/62/1862.html (accessed May 9, 2012).

"Beyond Cinema Speaks with Film Commissioner Peter Busuttil," Video clip on YouTube, May 26, 2012. http://www.youtube.com/watch?v=PkA4jhxTVX0 (accessed June 1, 2012).

Bhabha, Homi K. *The Location of Culture.* New York, NY: Routledge, 1994.

Binger FilmLab. "Industry." http://www.binger.nl/industry (accessed May 10, 2012).

Biswas, Moinak. "Early Films: Novels and Other Horizons." In *Apu and After, Revisiting Ray's Cinema,* edited by Moinak Biswas, 36–79. London and Calcutta: Seagull Books, 2006.

Blomgren, Roger. *Den Onda, Den Goda och Den Nyttiga–Kulturindustrin, Filmen och Regionerna.* Trollhättan, Sweden: Högskolan Väst, 2007.

Blonski, Annette. *Film and Broadcasting Training in Australia.* North Ryde: AFTRS, 1992.

Bock, Hans Michael. "Erich Pommer." In *The Oxford History of World Cinema,* edited by Geoffrey Nowell-Smith, 145. Oxford, UK: Oxford University Press, 1997.

Boissevain, Jeremy. *Saints and Fireworks: Religion and Politics in Rural Malta.* Malta: Progress Press, 1993.

Bondebjerg, Ib and Eva Novrup Redvall, eds. *A Small Region in a Global World: Patterns in Scandinavian Film and TV Culture.* Copenhagen: Filmthinktank, 2010. www.filmthinktank.org (accessed May 1, 2012).

Bondin, Ingram. "Upcoming Court Decisions on Censorship." *Times of Malta,* December 2, 2011.

Boorman, John., Fraser MacDonald and Walter Donahue, eds. *Projections 12: Film-makers on Film Schools.* London: Faber & Faber, 2002.

Borg, Joseph., Adrian Hillman and Marie Anne Laurie. *Exploring the Maltese Media Landscape.* Malta: Allied Publications, 2009.

Bourdieu, Pierre. "The Intellectual Field. A World Apart." In *Theory in Contemporary Art Since 1985,* edited by Zoya Kocur and Simon Leung, 11–18. Oxford: Blackwell Publishing, 2005.

Boyd, Chris. "School's In and Still a Class Act." *Herald-Sun* [Melbourne], August 24, 1998.

Boyle, James. *The Public Domain, Enclosing the Commons of the Mind.* New Haven and London: Yale University Press, 2008.

Bray, Mark and Steve Packer. *Education in Small States: Concepts, Challenges, and Strategies.* Oxford, England & New York: Pergamon Press, 1993.

Brockmann, Stephen. *A Critical History of German Film.* New York, NY: Camden House, 2010.

Bruce, David. *Scotland the Movie.* Edinburgh: Polygon, 1996.

Business Models and Value Chains in Audiovisual Media. Research within the Framework of the Baltic Sea Region Programme FIRST MOTION 2007–2013. Carried out by SIA Jura Podnieka studija, 2010. http://www.firstmotion.eu/art/MediaCenter/FirstMotion/Results%20and%20Outcomes/BalticSectoryStudy.pdf (accessed April 15, 2012).

Byg, Barton. "German Unification and the Cinema of the Former German Democratic Republic." In *Gegenwartsbewältigung: The GDR after the Wende,* special issue of *Michigan Germanic Studies,* guest edited by Patricia A. Simpson, 21 (1995): 150–168.

Calleja, Claudia. "Fears of Local Crew Shortages as Film Productions Flow." *Times of Malta*, February 14, 2012.

Cassar, George. "Education and Schooling: From Early Childhood to Old Age." In *Social Transitions in Maltese Society*, edited by George Cassar and JosAnn Cutajar, 51–74. Malta: Agenda, 2009.

Castoriadis, Cornelius. *The Imaginary Institution of Society*. Cambridge: Polity Press, 1987.

Central Intelligence Agency, *The World Fact Book: Malta*. https://www.cia.gov/library/publications/the-world-factbook/geos/mt.html (accessed May 2, 2012).

Centre for Cinema Studies. Lingnan University. http://www.ln.edu.hk/ccs/.

Certeau, Michel de. *The Practice of Everyday Life*. Berkeley, CA: University of California Press, 2002.

Cheuk, Pak-tong. *Films from the Hong Kong New Wave Cinema*. Hong Kong: Cosmos Books, 2003.

———. *Hong Kong New Wave Cinema (1978–2000)*. Bristol: Intellect Book, 2008.

Ching Fong. "Film and Education Roundtable." *Hong Kong Economic Times*, C3, May 24, 2010.

Choi, Jinhee and Mitsuyo Wada-Marciano. "Introduction." In *Horror to the Extreme: Changing Boundaries in Asian Cinema*, edited by Choi Jinhee and Mitsuyo Wada-Marciano, 1–12. Hong Kong: Hong Kong University Press, 2009.

Chung, Po-yin. *A Hundred Years of Film and Television in Hong Kong*. Hong Kong: Joint Publishing Co, 2004.

CILECT Conference 2011. "Exploring the Future of Film and Media Education." http://cilect.org/posts/view/114 (accessed November 7, 2012).

CILECT the International Association of Film and TV Schools. http://cilect.org (accessed November 7, 2012).

Cini, Michelle. "A Divided Nation: Polarization and the Two-Party System in Malta." *South European Society and Politics* 7.1 (2002): 6–23.

Clark, Paul. *Reinventing China: A Generation and Its Films*. Hong Kong: The Chinese University of Hong Kong, 2005.

Clarke, David. "Capitalism Has No More Natural Enemies." In *A Companion to German Cinema*, edited by Terri Ginsberg and Andreas Mensch, 134–154. Walden, MA: Blackwell, 2012.

Cook, David A. *A History of Narrative Film*. New York, London: W.W. Norton & Company, Inc., 2004.

Creative skillset. www.creativeskillset.org.

Cremona, Vicki Ann. "Politics and Identity in Maltese Theatre: Adaptation or Innovation?" *The Drama Review* 52.4 (2008): 118–144.

Danish Center for Culture and Development (DCCD). "Danfaso Culture and Development Programme for Burkina Faso, 2011–2013." http://www.cku.dk/wp-content/uploads/DANFASO-Culture-and-Development-Programme-for-Burkina-Faso.pdf (accessed November 8, 2012).

de Beauvoir, Simone. *The Second Sex*, trans. Constance Borde and Sheila Malovany-Chevalier. New York, NY: Vintage Books, 2011.

"Degree of Bachelor of Arts with Major in Film Production, University West." http://www.hv.se/extra/pod/?action=pod_show&module_instance=2&id=538&page=hv_prog.php&study_plan_id=521&show_prog=visaprog&fullwidth=true&webid=HV-91278.

Deleuze, Gilles. *Cinema 2: Time-Image*. London: Continuum, 2010.

———. and Félix Guattari. *A Thousand Plateaus. Capitalism and Schizophrenia*. London: Continuum, 2010.

Dell, Matthias. "Die Kraft des Ungenauen." *Die Tageszeitung*, April 24, 2011.

de Valck, Marijke. "Berlin and the Spatial Reconfiguration of Film Festivals." In *Film Festivals: From European Geopolitics to Global Cinephilia*, 45–82. Amsterdam: Amsterdam University Press, 2007.

———. "De rol van filmfestivals in het YouTube-tijdperk." *Boekman* 83 (2010): 54–60.

———. "Filmfestivals, coproductiemarkten en de internationale kunstcinema: het Cine-Mart model van matchmaker onder de loep." *Tijdschrift voor Mediageschiedenis* 13.2 (2010): 144–156.

———. *Film Festivals: From European Geopolitics to Global Cinephilia*. Amsterdam: Amsterdam University Press, 2007.

"DFFB Satzung und Statut." In *Deutsche Film- und Fernsehakademie Berlin (dffb). Eine Retrospektive 1966–1986*, edited by Frank Arnold, 36–43. Oberhausen: Westdeutsche Kurzfilmtage, 1989.

Diallo, Siradiou. "African Cinema Is Not a Cinema of Folklore." In *Ousmane Sembene: Interviews*, edited by Annette Busch and Max Annas, 52–62. Jackson, MS: University of Mississippi, 2008.

Dickinson, Margaret and Sylvia Harvey. "Film Policy in the United Kingdom: New Labour at the Movies." *The Political Quarterly* 76.3 (1996): 420–429.

" 'Die Zeit fährt Auto,' sagt Kästner. Der Film fährt mit, könnte man ergänzen." In *Deutsche Film- und Fernsehakademie Berlin (dffb). Eine Retrospektive 1966–1986*, edited by Frank Arnold, 26. Oberhausen: Westdeutsche Kurzfilmtage, 1989.

du Rées, Göran. *The Gunshots at Vasaplatsen*. Videodisc, Gothenburg: University of Gothenburg, 2010. http://www.film.gu.se/Forskning/Forskningsprojekt/the-gunshots-at-vasaplatsen–skotten-pa-vasaplatsen/ (accessed April 15, 2012).

Dudow, Slatan. "Die Frage des künstlerischen Nachwuchses." In *Auf neuen Wegen. 5 Jahre fortschrittlicher deutscher Film*, edited by Günter Agde, 74–77. Berlin: Deutscher Filmverlag, 1951.

Dynamics of World Cinema Project. http://www.st-andrews.ac.uk/worldcinema/ (accessed June 9, 2012).

Ebbrecht, Tobias. "Nonkonformismus und Anpassung: Überlegungen zur Rolle und Funktion der Hochschule für Film und Fernsehen in der DDR von 1954 bis 1989." In *Unter Hammer und Zirkel: Repression, Opposition und Widerstand an den Hochschulen der SBZ/DDR*, edited by Benjamin Schröder and Jochen Staadt, 277–288. Frankfurt am Main: Peter Lang, 2011.

Eccardt, Thomas. *Secrets of the Seven Smallest Microstates in Europe*. New York, NY: Hippocrene Books Inc., 2005.

Edgar, Tom and Karin Kelly. *Film School Confidential: Get In. Make It Out Alive*. New York, NY: Perigee, 1997.

Elsaesser, Thomas. "Cinephilia, or the Uses of Disenchantment." In *Cinephilia, Movies, Love and Memory*, edited by Marijke de Valck and Malte Hagener, 27–44. Amsterdam: Amsterdam University Press, 2005.

———. "Film Festival Networks: The New Topographies of Cinema in Europe." In *European Cinema: Face to Face with Hollywood*, 82–107. Amsterdam: Amsterdam University Press, 2005.

Eskilsson, Jonas, ed. *Filmblickar*. Göteborgs universitet filmhögskolan, 2012. www.filmblickar.se (accessed May 7, 2012).

Falicov, Tamara. "Migrating from South to North: The Role of Film Festivals in Funding and Shaping Global South Film and Video." In *Locating Migrating Media*, edited by Greg Elmer, Charles H. Davis, Janine Marchessault and John McCullough, 3–25. Lanham, MD: Lexington Books, 2010.

Fenech, Tonio. *Ministry of Finance, the Economy and Investment (Malta) Budget Speech 2012.* Valletta: Ministry of Finance, the Economy and Investment, 2011.

FEST 2012 International Film Festival. http://fest.pt/?lang=en (accessed May 9, 2012).

FEST FilmLab. "Home." http://filmlab.fest.pt/?lang=en (accessed May 14, 2012).

Festival de Cannes. http://www.festival-cannes.fr/en.html (accessed May 9, 2012).

Film i Väst AB. *Årsredovisning 2011.* Trollhättan: Film i Väst, 2012. http://www.filmivast.se/finans (accessed May 12, 2012).

———. *Film Factory: Film i Väst 1992–2002,* edited and text by Marit Kapla. Trollhättan: Film i Väst, 2002.

Filmarbetarutbildningen. http://www.filmarbetarutbildningen.se/ (accessed May 12, 2012).

The Film Festival Research Network. http://www.filmfestivalresearch.org/ (accessed July 30, 2012).

Filmförderungsanstalt. http://www.ffa.de (accessed May 7, 2012).

Filmhögskolan. "Film at the Valand Academy." http://www.film.gu.se/english/?languageId =100001&contentId=-1&disableRedirect=true&returnUrl=http%3A%2F%2Fwww. film.gu.se%2F.

———. "Our Vision and Strategy." http://www.film.gu.se/english/Our_vision_and_ strategy/.

Fiott, Daniel. "How Europeanized Has Maltese Foreign Policy Become?" *Mediterranean Quarterly* 21 (2010): 104–118.

"First BERLINALE TALENT CAMPUS unites 500 filmmakers from all around the world—Industry and public invited to screenings and discussions with international filmmakers." *Berlinale Talent Campus press release #4,* January 21 (2003): 1. http://www. berlinale.de/media/pdf_word/pm_1/53_berlinale_en/15_PressReleaseCampus_01_21_ 2003.pdf (accessed May 9, 2012).

Florida, Richard. *The Rise of the Creative Class: And How It's Transforming Work, Leisure, Community and Everyday Life.* New York, NY: Basic Books, 2003.

Gallasch, Peter. "Filmhochschulen in Deutschland." In *Filmhochschulen in Deutschland,* edited by Peter Gallasch, 1–6. Cologne: Katholisches Institut für Medieninformation, 1982.

Garnham, Nicholas. "From Cultural to Creative Industries: An Analysis of the Implications of the 'Creative Industries' Approach to Arts and Media Policy Making in the United Kingdom." *International Journal of Cultural Policy* 11.1 (2005): 15–29.

Geisler, Michael. *Setting the Agenda for Democracy: Television and Public Discourse in (West) Germany: from 1952 to 1989.* Forthcoming.

Generation Campus 2011. http://www.generationcampus.ru/en/info (accessed May 10, 2010).

Glaser-Müller, Gorki. "Blind eller döv?" In *Filmblickar,* edited by Jonas Eskilsson. www. filmblickar.se.

———. Fredrik Henell and Erika Malmgren. "Manifesto för vår film." Formulated February 2009. Submitted via email to Anna Stenport, May 9, 2012.

Goldsmith, Ben and Tom O'Regan. *The Film Studio: Film Production in the Global Economy.* Oxford: Rowman & Littlefield Publishers Inc., 2005.

———. and Susan Ward. *Local Hollywood: Global Film Production and the Gold Coast.* St Lucia, Qld: University of Queensland Press, 2010.

Gothenburg International Film Festival. *Statistik, Publik och Media.* Gothenburg: GIFF, 2012.

Grech, Brother Henry. *Qwiel Maltin: Gabra ta 700 Proverbju.* Malta: De la Salle Brothers, 1979.

Grech, Herman. "Malta Has Highest Free-Voter Turnout in the World." *Times of Malta*, February 15, 2009.

Griffin, Michelle. "VCA Chief Quits Amid Overhaul." *The Age* [Melbourne], July 23, 2010.

Griffith University. *A New Era in Global Partnerships: Griffith University Capability Statement.* Gold Coast: Griffith University, 2010.

Grima, Noel. "Giving 'Failures' a New Lease of Life." *Malta Independent*, January 8, 2012.

Guest, Val. "Sun Shines on Filmmakers." *Times of Malta*, October 26, 1968.

Halle, Randall. *German Film after Germany: Toward a Transnational Aesthetic.* Urbana, IL: University of Illinois Press, 2008.

Hardt, Michael and Antonio Negri. *Empire.* Cambridge, MA: Harvard University Press, 2000.

Hayden-Smith, Ian, ed. *The International Film Guide 2010: The Definitive Annual Review of World Cinema.* Columbia: Columbia University Press, 2010.

Hedling, Olof. "A New Deal in European Film? Notes on the Swedish Regional Production Turn." *Film International* 35 (2007): 8–17.

Herrman, Margaretha, ed. *Att göras till filmarbetare.* Nora: Bokförlaget Nya Doxa, 2011.

———. and Carina Kullgren. "Studentpitchen: iscensatta normer." In *Att göras till filmarbetare*, edited by Herrman, 233–253.

Herzog, Werner. "About Rogue Film School." http://www.roguefilmschool.com/about.asp (accessed May 10, 2012).

Hetrick, Judi. "Amateur Video Must Not Be Overlooked." *The Moving Image* 6.1 (2006): 66–81.

Hickethier, Knut. "Medien." In *Handbuch der deutschen Bildungsgeschichte, Band VI, 1945 bis zur Gegenwart, Zweiter Teilband, Deutsche Demokratische Republik und neue Bundesländer*, edited by Christoph Führ and Carl-Ludwig Furck, 585–630. Munich: C.H. Beck, 1998.

Hirczy, Wolfgang. "Explaining Near-Universal Turnout: The Case of Malta." *European Journal of Political Research* 27 (1995): 258.

Hjort, Mette. "Affinitive and Milieu-Building Transnationalism: The Advance Party Project." In *Cinema at the Periphery*, edited by Dina Iordanova, David Martin-Jones and Belén Vidal, 46–66. Detroit: Wayne State University Press, 2010.

———. "Danish Cinema and the Politics of Recognition." In *Post-Theory: Reconstructing Film Studies*, edited by Noël Carroll and David Bordwell, 520–532. Madison: University of Wisconsin Press, 1996.

———. "Denmark." In *The Cinema of Small Nations*, edited by Mette Hjort and Duncan Petrie, 23–42. Indianapolis & Edinburgh: Indiana University Press & Edinburgh University Press, 2007.

———. "Dogma 95: A Small Nation's Response to Globalisation." In *Purity and Provocation: Dogma 95*, edited by Mette Hjort and Scott MacKenzie, 31–47. London: British Film Institute, 2003.

———. "The Film Phenomenon and How Risk Pervades It." In *Film and Risk*, edited by Mette Hjort, 1–30. Detroit: Wayne State University Press, 2012.

———. *Lone Scherfig's "Italian for Beginners."* Washington, Seattle & Copenhagen: University of Washington Press & Museum Tusculanum, 2010.

———. "On the Plurality of Cinematic Transnationalism." In *World Cinemas, Transnational Perspectives*, edited by Nataša Durovicová and Kathleen Newman, 12–33. London & New York: Routledge, 2010.

———. *Small Nation, Global Cinema: The New Danish Cinema.* Minneapolis: University of Minnesota Press, 2005.

———. and Ib Bondebjerg, eds. *The Danish Directors: Dialogues on a Contemporary National Cinema.* Bristol: Intellect Press, 2001.

————. Ib Bondebjerg and Eva Novrup Redvall, eds. *Danish Directors 3: Dialogues on the New Danish Documentary Cinema*. Bristol: Intellect Press, 2013.

————. Eva Jørholt and Eva Novrup Redvall, eds. *The Danish Directors 2: Dialogues on the New Danish Fiction Cinema*. Bristol: Intellect Press, 2010.

————. and Duncan Petrie, eds. *The Cinema of Small Nations*. Indianapolis & Edinburgh: University of Indiana Press & Edinburgh University Press, 2007.

————. and Duncan Petrie. "Introduction." In *The Cinema of Small Nations*, edited by Hjort and Petrie, 1–20.

Hockenos, Paul. "Germans' Surprising Reaction to *Inglourious Basterds*." May 30, 2010. http://www.globalpost.com/dispatch/germany/090903/inglourious-basterds (accessed May 15, 2012).

Högberg, Karin. "Kvinnor som producenter." In *Att göras till filmarbetare*, edited by Herrman, 142–172.

Hroch, Miroslav. *The Social Preconditions of National Revival in Europe: A Comparative Analysis of the Social Composition of Patriotic Groups among the Smaller European Nations*. Cambridge: Cambridge University Press, 1985.

Hui Po-keung. "Why Must We Take Stock of and Be Serious about Integrated Humanities/Liberal Studies?" In *Integrated Humanities and Liberal Studies*, edited by Stephen Chan, P. K. Choi, and P. K. Hui, 9–22. Hong Kong: Kwan Fong Cultural Research & Development Program, Lingnan University, 2009.

Ilshammar, Lars, Pelle Snickars, and Per Vesterlund, eds. *Citizen Schein*. Stockholm, the Royal Library: Mediehistoriskt arkiv 14, 2010.

Imamura, Shohei and Tadao Sato. *The Educator Shohei Imamura* (Kyouikusha Imamura Shohei). Tokyo: Kinema Junposha, 2010.

The Impact of European Support Programmes on the Audiovisual Industry in Lithuania, a report commissioned by the Media Desk Lithuania and implemented by the KEA European Affairs in association with Norbert Morawetz. Vilnius: The Media Desk Lithuania, 2009.

International Student Film Organization. "Members Area." http://futureinfilm.com (accessed May 10, 2012).

IPSOS SRI. "AFTRS Alumni Survey: Research Findings from IPSOS SRI." *Lumina* 10 (2012): 58–187.

Iwabuchi, Koichi. " 'Soft' Nationalism and Narcissism: Japanese Popular Culture Goes Global." *Asian Studies Review* 26.4 (2002): 447–469.

Jansen, Christian. "The Performance of German Motion Pictures, Profits and Subsidies: Some Empirical Evidence." *Journal of Cultural Economics* 29 (2005): 191–212.

Jensen, Rod. "Sydney Media on the Move." *Cityscape Creative Cities* 40 (2010): 8.

Ji Zhiwei and Zhong Dafeng, eds. *Zhongguo dianying zhuanye shi yanjiu: Dianying jiaoyu juan.*[Historical Studies in the Chinese Film Profession: Volume on Film Education] Beijing: Zhongguo dianying chubanshe, 2011.

Jockey Club Cine Academy. *Fostering Film Literacy in Hong Kong*. Hong Kong: Hong Kong International Film Festival Society, 2010.

Kanagawa Eizo Gakuen. "Daigaku no secchi no shushi oyobi tokuni secchi wo hitsuyou tosuru riyuu wo kisaisita shorui," (Document that states the purposes and special reasons for the necessity of establishing the university), 2010. http://www.dsecchi.mext.go.jp/d_1010n/pdf/nihoneiga_1010nsecchi_syushi1.pdf (accessed May 10, 2012).

Kärk, Lauri. "Estonian Film: From Bear Hunt to Autumn Ball. Notes on Estonian Film History." *Kinokultura, Special Issue: Estonian Cinema* 10 (March 2010). http://www.kinokultura.com/specials/10/kark.shtml (accessed June 1, 2012).

Kaufman, Tina. "Artists [as] Educators: Film–The Balancing Act of Teaching and Making Film." *Realtime* 74 (2006): 17–18.

Klusas, Mindaugas. "Puipos tvirtovė moterų gynybai." *Lietuvos žinios* 12 (2012). http://www.lzinios.lt/Pramogos/A.Puipos-tvirtove-moteru-gynybai-video (accessed October 15, 2012).

Koslov, Vladimir. "Odessa Film Festival to Kick Off with New Format." *The Hollywood Reporter*, July 14, 2011. http://www.hollywoodreporter.com/news/odessa-film-festival-kick-new-211265 (accessed May 9, 2012).

Kosslick, Dieter. "Editorial." *Berlinale Talent Campus #7 Magazine* (2009). http://berlinale.top-ix.org/audio/website/btc_magazine_09.pdf (accessed May 11, 2012).

———. "Editorial: Let the Campus Change Your Perspective." *Berlinale Talent Campus #10 Magazine* (2012). http://berlinale.top-ix.org/audio/website/btc_magazin_2012_web.pdf (accessed May 11, 2012).

Kreimeier, Klaus. *The UFA Story*. Translated by Robert and Rita Kimber. Berkeley: University of California Press, 1999.

Kultur i Väst. *Fokus: Filmteknik för tjejer. Rapport från ett Genusprojekt*, Skriftserie 2012. Västra Götalandsregionen.

Kurosawa, Kiyoshi. *Eiga no kowai hanasi: Kurosawa Kiyoshi taidan shu* (Scary Stories of Cinema: Talks with Kiyoshi Kurosawa). Tokyo: Seidosha, 2007.

———. and Hiroshi Takahashi, Kunitoshi Manda, Akihiko Shioda, Masaki Tamura, Shinji Aoyama, Masaru Shirai, and Takehumi Tsutsui. *Eiga no jugyou: eiga bi gakko no kyoushitsu kara* (Cinema's Lessons: From Classrooms of the Film School of Tokyo). Tokyo: Seidosha, 2004.

Lang, Ian. "Film Schools in a Post-Industrial Era." Paper presented at IM 7: Diegetic Life Forms II – Creative Arts Practice and New Media Scholarship Conference, Perth, September 3–5, 2010.

Lantz, Jenny. *The Fast Track: Om vägar till jämställdhet i filmbranschen*. Stockholm: Wift, 2011.

———. *Om kvalitet. Synen på kvalitetsbegreppet inom filmbranschen*. Stockholm: Wift, 2007.

Law Kar. "The Independent Vision of Film Clubs." In *In Pursuit of Independent Visions in HK Cinema*, edited by Esther Cheung, 3–4. Hong Kong: Joint Publishing Co., 2010.

Lazzarato, Maurizio. "Immaterial Labour." Translated by Paul Colilli and Ed Emery. In *Radical Thought in Italy: A Potential Politics*, edited by Paolo Virno and Michael Hardt, 133–150. Minneapolis: University of Minnesota Press, 1996.

Linebaugh, Peter. *The Magna Carta Manifesto, Liberties and Commons for All*. Berkeley, Los Angeles & London: University of California Press, 2008.

Lockerbie, Ian. "Pictures in a Small Country: The Scottish Film Production Fund." In *From Limelight to Satellite: A Scottish Film Book*, edited by Eddie Dick, 171–184. London: SFC/BFI, 1990.

Lovink, Geert. *Dark Fiber: Tracking Critical Internet Culture*. Cambridge: The MIT Press, 2002.

Lu Hua, ed. *Dianying ren de chengzhang: Beijing dianying xueyuan bodaoxi zhuren zhi xueyuren tan* (Growing to Be Filmmakers: Talks with BFA Department Heads and Pedagogs). Beijing: Zhongguo dianying chubanshe, 2007.

Lu Meng. *Beijing Dianying xueyuan zhi* (BFA Gazette). Beijing: Beijing dianying xueyuan, 2000.

Macaitis, Saulius. "The Sixties." In *The World of Lithuanian Images. Litauische Bilderwelten*, edited by Myriam Beger, Lolita Jablonskienė, Birutė Pankūnaitė and Rūta Pileckaitė. English translation by Artūras Tereškinas, 8–17. Vilnius: Contemporary Art Information Centre of Lithuanian Art Museum, 2002.

MACC Foundation Meeting. December 16, 1952. Vincent Lungaro-Mifsud Personal Collection.

Maciuika, John V. *Before the Bauhaus: Architecture, Politics and the German State, 1890–1920*. Cambridge: Cambridge University Press, 2005.

Mackrell, Fiona. "The VCA's Sense of Renewal." *artsHub*, December 8, 2011. http://www.artshub.com.au/au/news-article/opinions/arts/the-vcas-sense-of-renewal-186732 (accessed July 27, 2012).

MacLusky, Julie. *Is There Life after Film School? In Depth Advice from Industry Insiders.* New York, London: Continuum, 2003.

Macnab, Geoffrey. "Blue Sky Thinking." *Screen International* 14 (2005).

MacPherson, Robin. *Independent Film and Television in Scotland: A Case of Independent Cultural Reproduction?* Unpublished MA diss., University of Stirling, 1991.

———. "Shape Shifters: Independent Producers in Scotland and the Journey from Cultural Entrepreneur to Entrepreneurial Culture." In *Scottish Cinema Now*, edited by Jonathan Murray, Fidelma Farley and Rod Stoneman, 222–239. Newcastle: Cambridge Scholars Press, 2009.

Majumdar, Rochona. "Debating Radical Cinema: A History of the Film Society Movement in India." *Modern Asian Studies* 46.3 (2012): 731–767.

Malta Film Commission. "Professional Training and Development for Filmmakers," March 1, 2011. http://mfc.com.mt/filebank/imagebank/pdf/MALTA%20FILM%20COM MISSION%20training%20course%20info%20for%20participants.pdf (accessed April 2, 2012).

Manovich, Lev. *The Language of New Media*. Cambridge, MA: The MIT Press, 2001.

Matsutani, Soichiro. "Kyuukan aitsugu mini-theatre wa honnto ni sonnbou no kiki nanoka?" (Mini-theaters Continue to Close Down. Is this Really a Fatal Crisis?). *Trendy Nikkei*, February 10, 2011. http://trendy.nikkeibp.co.jp/article/pickup/20110207/1034423/?ST=life&P=1 (accessed May 10, 2012).

Maxwell, Richard and Toby Miller. "Film and the Environment: Risk Off-screen." In *Film and Risk*, edited by Mette Hjort, 271–289. Detroit: Wayne State University Press, 2012.

McArthur, Colin. "The Cultural Necessity of a Poor Celtic Cinema." In *Border Crossing: Film in Ireland, Britain and Europe*, edited by Paul Hainsworth, John Hill and Martin McLoone, 112–125. Belfast: ILS/Queen's University, 1994.

———. "In Praise of a Poor Cinema." *Sight and Sound* 3.8 (1993): 30–32.

MCAST. *MCAST Prospectus: 2012/2013*. Malta: MCAST, 2012.

Meech, Peter. *Professional Film and Video Training in Scotland*. Glasgow: Scottish Film Council, 1987.

METI (Ministry of Economy, Trade and Industry; Division of Creative Industry). *Cool Japan Senryaku–Cool Japan Strategy*. http://www.meti.go.jp/policy/mono_info_service/mono/creative/index.htm (accessed February 20, 2012).

Miike, Takashi. *A Message from the Director Miike: Japan Institute of Moving Images (Nihon Eiga Daigaku: Miike Kantoku Message)*, 2011. http://k-builder.com/d/eiga/index.php?p=f_1/sub_0 (accessed March 1, 2012).

Mikos, Lothar. Interview, "Warum sind deutsche Serien so mies?" *Spiegel Online*. http://www.spiegel.de/kultur/tv/mad-men-borgia-millennium-tv-serien-weltweit-a-822803.html (accessed May 7, 2012).

Miller, Richard. "Production Financing: The Joy of Tax." *Screen International*, April 1, 2005.

Miller, Toby. "Hollywood, Cultural Policy Citadel." In *Understanding Film: Marxist Perspectives*, edited by Michael Wayne, 182–193. London: Pluto Press, 2005.

———. and George Yúdice. *Cultural Policy*. London: Sage Publication Ltd., 2002.

Ministry of Education, Japan. "About the Framework of 'Foreign Students Three Hundred Thousand Plan'" ('ryugakusei 30 man nin keikaku' kosshi no sakutei ni tuite), 2008. http://www.mext.go.jp/b_menu/houdou/20/07/08080109.htm (accessed March 6, 2012).

Mitsuru Igarashi, "Mitsuru Igarashi's *Let me speak* (Igarashi Mitsuru no ore kara mo hitokoto)." *Cinema Nest Japan OB Bokujo* (2005). http://www.cinemanest.com/OBbokujo/25th.html (accessed March 4, 2012).

Moore, Gregory. "Introduction." In *Fichte: Addresses to the German Nation*, edited by Gregory Moore, xi–xxxvi. Cambridge: Cambridge University Press, 2008.

Morris, Meaghan and Mette Hjort. "Introduction: Instituting Cultural Studies." In *Creativity and Academic Activism: Instituting Cultural Studies*, edited by Meaghan Morris and Mette Hjort, 1–20. Hong Kong & Durham: Hong Kong University Press & Duke University Press, 2012.

Mould, Oli. "Mission Impossible? Reconsidering the Research into Sydney's Film Industry." *Studies in Australasian Cinema* 1.1 (2007): 47–60.

MPAJ (Motion Picture Producers Association of Japan). http://www.eiren.org/statistics_e/index.html (accessed May 10, 2012).

Mudie, Peter. *Ubu Films: Sydney Underground Movies 1965–1970*. Sydney: UNSW Press, 1997.

Müller, Detlef K., Fritz K. Ringer and Brian Simon. *The Rise of the Modern Educational System: Structural Change and Social Reproduction, 1870–1920*. Cambridge & New York: Cambridge University Press, 1987.

Müller, Klaus-Dieter. "*Media EXIST.*" Presentation given at the HFF Potsdam-Babelsberg, October 5, 2009.

Murray, Jonathan. "Devolution in Reverse? The Scottish Executive and Film Policy 1999–2003." *Edinburgh Review* 116 (2006): 57–70.

———. "Scotland." In *The Cinema of Small Nations*, edited by Mette Hjort and Duncan Petrie, 76–92. Edinburgh: Edinburgh University Press, 2007.

NDJC (New Direction in Japanese Cinema). http://www.vipo-ndjc.jp/top.html (accessed March 10, 2012).

Nestingen, Andrew and Trevor Elkington, eds. *Transnational Cinema in a Global North: Nordic Cinema in Transition*. Detroit: Wayne State University Press, 2002.

Neumann, Roland. "Hochschule für Film und Fernsehen (Babelsberg)." *Journal of Film and Video* 44.1–2 (1992): 97.

Ng Ho. *Essays in the History of Hong Kong Television*. Hong Kong: Subculture, 2003.

NISI MASA. "Russia–Generation Campus." European Network of Young Cinema. http://www.nisimasa.com/?q=node/438 (accessed May 10, 2012).

Ni Zhen. *Memoirs from the Beijing Film Academy: The Genesis of China's Fifth Generation*. Translated by Chris Berry. Durham & London: Duke University Press, 2002.

Odessa International Film Festival 2012. http://2010.oiff.com.ua/index.en.html?show_all_site=1 (accessed May 9, 2012).

Olsberg SPI. *Building Sustainable Film Businesses: The Challenges for Industry and Government*. London: Olsberg SPI, 2012. http://www.sfi.se/sv/om-svenska-filminstitutet/Publikationer/Omvarldsanalys-och-uppfoljning/.

———. *Study of Continuous Training for Audio-visual Professionals in 32 European Countries Final Report*, February 25, 2005. http://ec.europa.eu/culture/media/programme/overview/evaluation/studies/index_en.htm (accessed April 12, 2012).

O'Mahony, Jennifer. "An Obscene Attack on Maltese Culture." *Guardian*, August 5, 2010.

O'Regan, Tom. "A National Cinema." In *The Film Cultures Reader*, edited by Graeme Turner, 139–164. London, New York: Routledge, 2002.

Pace, Roderick. "Malta and EU Membership: Adaptation and Modernisation." *Agora without Frontiers* 8.4 (2003): 365–382.

————. "Malta and EU Membership: Overcoming Vulnerabilities, Strengthening Resistance." *Journal of European Integration* 28.1 (2006): 33–49.

Parliamentary Secretariat for Tourism, the Environment and Culture. *National Cultural Policy: Malta 2011.* Malta: Parliamentary Secretariat for Tourism, the Environment and Culture, 2011.

" 'Passionen för det reala': nya rum." *Art Monitor* 9 (2010).

Paterson, Barbara. *Renegades: Australia's First Film School from Swinburne to VCA.* Ivanhoe East, Vic: The Helicon Press, 1996.

Peregin, Christian. "*Dear Dom* a Box-Office Hit." *Times of Malta,* April 4, 2012.

Petkovic, Josko. *Assessing Graduate Screen Production Outputs in Nineteen Australian Film Schools, Final Report.* Canberra: Australian Learning and Teaching Council, 2011.

Petrie, Duncan. "British Film Education and the Career of Colin Young." *Journal of British Cinema and Television* 1.1 (2004): 78–92.

————. "Creative Industries and Skills: Film Education and Training in the Era of New Labour." *Journal of British Cinema and Television* 9 (2012): 357–376.

————. "Film Schools Symposium Report for TFTV Research Committee" (2009). www.york.ac.uk/.../FILM%20SCHOOL%20SYM (accessed November 5, 2012).

————. "Theory/Practice and the British Film Conservatoire." *Journal of Media Practice* 12.2 (2011): 125–138.

————. "Theory, Practice and the Significance of Film Schools." *Scandia* 76 (2010): 31–46.

————. *Screening Scotland.* London: BFI, 2000.

PFF (Pia Film Festival). http://pff.jp/jp/whats/index.html (accessed March 10, 2012).

Philipsen, Heidi. "Dansk films nye bølge" ("Danish film's new wave"). PhD diss., University of Southern Denmark, 2005.

Pilipavičienė, Živilė. *XX a. Lietuviški vaidybiniai filmai. Filmografija* / Lithuanian Feature Films of 20th C. Filmography. Vilnius: Lietuvos muzikos ir teatro muziejus, 2003.

Poole, Mark. "This Year's Model: Saving the VCA." *Metro Magazine* 162 (2009): 126–132.

Prime Minister of Japan and His Cabinet (Chizai Senryaku Honbu). *Chiteki Zaisan Suishin Keikaku 2011.* http://www.kantei.go.jp/jp/singi/titeki2/kettei/chizaikeikaku2011_gaiyou.pdf (accessed February 20, 2012).

Prior, Sian. "Producer School Gives 'Play Lunch' New Meaning." *Sunday Age* [Melbourne], February 1, 2004.

Program of the 36th Hong Kong International Film Festival. Hong Kong: Hong Kong International Film Festival Society, 2012.

Quinn, Meredith and Andrew Urban, eds. *Edge of the Known World: The Australian Film, Television and Radio School—Impressions of the First 25 Years.* North Ryde: AFTRS, 1998.

Ranisch, Axel. *Die junge Filmszene und die alte HFF.* Advisor Prof. Helke Misselwitz. Diplomarbeit, Studiengang: Film- und Fernsehregie, 2011.

Rao, H. N. Narahari, ed. *The Film Society Movement in India.* Mumbai: The Asian Film Foundation, 2009.

Ray, Satyajit. "Education of a Filmmaker." *New Left Review* 1.141 (1983).

————. "National Styles in Cinema." In *Deep Focus, Reflections on Cinema,* edited by Sandip Ray. New Delhi: Harper Collins Publishers India, 2011.

Rayns, Tony. *Eiga: 25 Years of Japanese Cinema.* Edinburgh: Edinburgh International Film Festival, 1984.

"Realtà Appeal Reveals Worrying Attitude to Censorship–APAP." *Malta Today,* April 6, 2011.

Redvall, Eva Novrup. "More than Films and Dragon Awards: The Göteborg Interna-tional Film Festival as a Meeting Place." *Journal of Scandinavian Cinema* 2.2 (2012): 135–142.

———. "Teaching Screenwriting to the Storytelling Blind—The Meeting of the Auteur and the Screenwriting Tradition at the National Film School of Denmark." *Journal of Screenwriting* 1 (2010): 59–81.

Reljic, Teodor. "A Long Road Ahead." *Malta Today*, June 6, 2011.

———. "Censored No More—What Is the Future of Maltese Theatre?" *Malta Today*, January 24, 2012.

Romney, Jonathan. "At the Berlinale." *London Review of Books Blog*, February 17, 2012. http://www.lrb.co.uk/blog/2012/02/17/jonathan-romney/at-the-berlinale/ (accessed October 29, 2012).

Rosenthal, Daniel. "The Island of Everywhere." *Times of London*, April 19, 2002.

Rosenthal, Daniel. "Malta." In *The International Film Guide 2010: The Definitive Annual Review of World Cinema*, edited by Ian Hayden-Smith, 185–186. Columbia: Columbia University Press, 2010.

Ross, Miriam. "The Film Festival as Producer: Latin American Films and Rotterdam's Hubert Bals Fund." *Screen* 52.2 (2011): 261–267.

"Rubbing shoulders with world greats." *Malta Today*, September 26, 2004. http://www.maltatoday.com.mt/2004/09/26/tw/index.html (accessed November 6, 2011).

Rudolph, Maya E. "Chinese Cinema's Future Faces: The Power of the Old School." http://dgeneratefilms.com/critical-essays/chinese-cinemas-future-faces-the-power-of-the-old-school/#more-7169 (accessed August 1, 2011).

Rümmler, Klaus. *Hochschule für Film und Fernsehen der Deutschen Demokratischen Republik 1954–1979: Materialien.* Oberhausen: Karl Maria Laufen Verlag, 1979.

Satariano, Cecil. *Canon Fire: The Art of Making Award Winning Movies.* London: Bachman and Turner, 1973.

Scerri-Ferrante, Malcolm. "A Turning Point for the Film Industry." *Times of Malta*, October 19, 2011.

———. "Moving with the Times to Remain in the Picture." *Times of Malta*, May 26, 2012.

Schlesinger, Philip. "Creativity: From Discourse to Doctrine." *Screen* 48.3 (2007): 377–387.

Schulz, Günter. *Die DEFA (Deutsche Film Aktiengesellschaft) 1946–1990: Fakten und Daten.* Berlin: DEFA-Stiftung, 2002. http://www.defa.de/cms/DesktopDefault.aspx?TabID=981 (accessed April 15, 2012).

Schwenger, Hannes. "Medien." In *Handbuch der deutschen Bildungsgeschichte*, edited by Christoph Führ and Carl-Ludwig Furck, 341–358. Munich: C.H. Beck, 1998.

Scott, Alastair. "What's the Point of Film School, or, What Did Beaconsfield Film Studios Ever Do for Scottish Cinema?" In *Scottish Cinema Now*, edited by Jonathan Murray, Fidelma Farley and Rod Stoneman, 206–221. Newcastle: Cambridge Scholars Press, 2009.

Scott, Mathew. "The View Finder." *South China Morning Post*, November 4, 2012, The Review Section.

Seibert, Alan. "The Queensland College of Art, Griffith University 1881/1996: Past, Present and Future." *Australian Art Education* 19.2 (1996): 17–24.

Shaffer, Benny. "Philosophies of Independence: The Li Xianting Film School." *Leap* 8, April 28, 2011. http://leapleapleap.com/2011/04/philosophies-of-independence (accessed August 1, 2011).

Shand, Ryan. "Theorizing Amateur Cinema: Limitations and Possibilities." *The Moving Image* 8.2 (2008): 36–60.

Slansky, Peter C. *Filmhochschulen in Deutschland: Geschichte Typologie Architektur.* Munich: edition text+kritik, 2011.

Staff of the Academy of Television Arts and Sciences Foundation & the Staff of the Princeton Review. *Television, Film, and Digital Media Programs: 556 Outstanding Programs at Top Colleges and Universities across the Nation.* New York, NY: Random House, 2007.

Statistics Sweden, SCB. http://www.scb.se/Pages/PressRelease_305658.aspx (accessed April 20, 2012).

Stenport, Anna Westerståhl. *Lukas Moodysson's 'Show Me Love.'* Nordic Film Classics Series, edited by Mette Hjort and Peter Schepelern. Seattle & Copenhagen: University of Washington Press & Museum Tusculanum, 2012.

Stone, Melinda and Dan Streible. "Introduction." *Film History* 15 (2003): 123–125.

Stringer, Julian. "Global Cities and International Film Festival Economy." In *Cinema and the City: Film and Urban Societies in a Global Context,* edited by Mark Shiel and Tony Fitzmaurice, 134–144. Oxford: Blackwell, 2001.

———. "Raiding the Archive: Film Festivals and the Revival of Classic Hollywood." In *Memory and Popular Film,* edited by Paul Grainge, 81–96. Manchester: Manchester University Press, 2003.

Sun Xin and Gao Yu, eds. *Shi shuo: Beijing dianying xueyuan boshisheng daoshi fangtan lu* (Teachers speak: Interviews with Ph.D. advisors at BFA). Beijing: Zhongguo dianying chubanshe, 2010.

Svensk filmdatabas. http://www.sfi.se/en-GB/Swedish-film-database/ (accessed July 31, 2012).

Svenska Filministitutet. *00-talets regidebutanter och jämställdheten.* Stockholm: SFI, 2010. http://sfi.se/sv/om-svenska-filminstitutet/Publikationer/Omvarldsanalys-och-uppfoljn ing/ (accessed July 31, 2012).

———. *Hur svårt kan det vara? Filmbranschen, Jämställdheten och demokratin.* Stockholm: SFI, 2004.

———. *Regionerna i centrum.* Stockholm: SFI, 2001.

Takahashi, Mitsuteru. *Contents Kyouiku no Tanjou to Mirai (The Birth of Contents Education and its Future).* Tokyo: Born Digital, 2010.

Tezuka, Yoshiharu. *Japanese Cinema Goes Global: Filmworkers' Journeys.* Hong Kong: Hong Kong University Press, 2011.

Toeplitz, Jerzy. "The Creative Impulse in Film-Making." 12th Annual Celebrity Lecture given at the 19th Edinburgh Film Festival. September 4, 1965. Transcript held at the British Film Institute Library.

Torner, Evan. "Transnational System Schlock: The Case of Uwe Boll." *kunsttexte* 2 (2010). http://edoc.hu-berlin.de/kunsttexte/2010-2/torner-evan-2/PDF/torner.pdf (accessed July 31, 2012).

TorrinoFilmLab. http://www.torinofilmlab.it/index.php (accessed May 9, 2012).

Turner, Graeme. *Film as Social Practice.* London, New York: Routledge, 2006.

———. "Introduction" to "Industries" section. In *The Film Cultures Reader,* edited by Graeme Turner, 135–138. London, New York: Routledge, 2002.

Unassigned Interview. "Jinzai ikusei kiiman ni kiku! Eiga bi gakkou daihyou riji Matsumoto Masamichi" (Listen to the Key Person in Human Resource Training! The President of the Film School of Tokyo, Masamichi Matsumoto). *Bunka Tsushin,* April 7, 2011. http://www.bunkatsushin.com/varieties/article.aspx?bc=1&id=1005 (accessed May 10, 2012).

University of Melbourne. *The Future of Visual and Performing Arts at the University of Melbourne: A Response to the Review Committee Report on the Faculty of the VCA and Music July 2010.* Melbourne: University of Melbourne, 2010.

Vesna, Victoria, ed. *Database Aesthetics, Art in the Age of Information Overflow.* Minneapolis: University of Minnesota Press, 2007.

Wark, McKenzie. *Telesthesia, Communication, Culture and Class.* Cambridge: Polity Press, 2012.

Wik, Annika. *Inför nästa tagning: kontaktytor för unga filmskapare.* Stockholm: Svenska filminstitutet, 2012.

Wrage, Henning. *Die Zeit der Kunst: Literatur, Film und Fernsehen in der DDR der 1960er Jahre: Eine Kulturgeschichte in Beispielen.* Heidelberg: Universitätsverlag Winter, 2008.

Ying Liang. "Nothing about Cinema, Everything about Freedom." http://dgeneratefilms. com/china-today/nothing-about-cinema-everything-about-freedom-by-ying-liang/# more-9872 (accessed May 20, 2012).

Young, Colin. *The Scottish Arts Debate: Still Rolling.* STV Txd: July 1990.

Žemulienė, Laima. "Nutapytas gyvenimas už kadro." *Lietuvos diena,* June 24, 2011. http:// www.diena.lt/dienrastis/priedai/sokoladas/nutapytas-gyvenimas-uz-kadro-360441#axzz 29SRGoWTk (accessed October 15, 2012).

Zha Jianying. *Tide Players: The Movers and Shakers of a Rising China.* New York, NY: New Press, 2011.

Zhang Huijun, Hou Keming, and Xie Xiaojing, eds. *Chuancheng yu shuli: Gaodeng dianying hiaoyu yanjiu* (Transmission and Grooming: Studies in Higher Education in Film). Beijing: Zhongguo dianying chubanshe, 2006.

———. Liu Xiaolei, and Cao Kai, eds. *Dianying Yaolan: Beijing dianying xueyuan de xiandai tonghua* (The cradle of cinema: The modern fable of BFA). Beijing: Zhongguo qingnian chubanshe, 2010.

Zhong Dafeng, ed. *The Status Quo and Trends in International Film Education: Beijing 2008 Interviews on CILECT Film Education.* Beijing: BFA Internal Publication, n.d.

Zimmerman, Patricia R. *Reel Families: A Social History of Amateur Film.* Indianapolis: Indiana University Press, 1995.

Žukauskaitė, Audronė. "Ethics between Particularity and Universality." In *Deleuze and Ethics,* edited by Nathan Jun and Daniel W. Smith, 188–206. Edinburgh: Edinburgh University Press, 2011.

Index

Lightning Source UK Ltd.
Milton Keynes UK
UKOW06n1434280515

252461UK00004B/106/P